Pierre Chareau

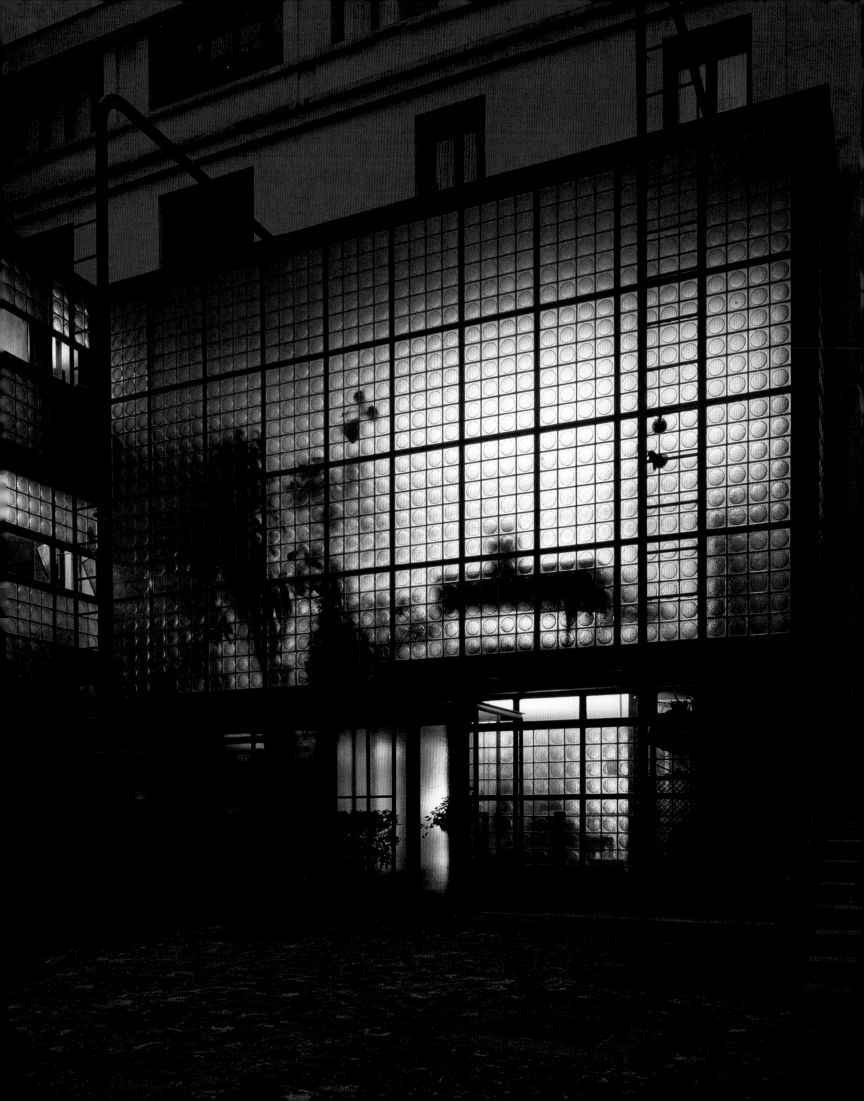

Pierre Chareau

Modern Architecture and Design

Esther da Costa Meyer

With essays by

Bernard Bauchet
Olivier Cinqualbre
Jean-Louis Cohen
Robert M. Rubin
Kenneth E. Silver
Brian Brace Taylor

The Jewish Museum, New York
Under the auspices of the
Jewish Theological Seminary

Yale University Press
New Haven and London

This book has been published in conjunction with the exhibition *Pierre Chareau: Modern Architecture and Design,* organized by the Jewish Museum, New York, November 4, 2016–March 26, 2017.

A version of the essay "Living, Literally, in a Glass House: A User's Guide," by Robert M. Rubin, appeared in *archithese* magazine (May 2012).

Translation of essays by Olivier Cinqualbre and Jean-Louis Cohen is by Christian Hubert.

Where known, Chareau's model numbers are included in captions to furniture.

The Jewish Museum
Director of Publications: Eve Sinaiko
Editorial production: Tina Henderson

Yale University Press
Publisher, Art and Architecture: Patricia Fidler
Editor, Art and Architecture: Katherine Boller
Production Manager: Sarah Henry

Designed by J. Abbott Miller and Andrew Walters, Pentagram
Set in Circular by Lineto
Printed in China through Oceanic Graphic International, Inc.

The Jewish Museum
1109 Fifth Avenue
New York, NY 10128
thejewishmuseum.org

Yale University Press
PO Box 209040
New Haven, CT 06520-9040
yalebooks.com/art

Library of Congress Control Number: 2016931377
ISBN 978-0-300-16579-1

A catalogue record for this book is available from the British Library.

The paper in this book meets the requirements of ANSI/NISO Z 39.48-1992 (Permanence of Paper).

10 9 8 7 6 5 4 3 2 1

Cover:
Interior of the Maison de Verre, detail (page 201).
Endpapers:
Le Cigar fabric (page 75).

Frontispiece:
The Maison de Verre at night.

Contents

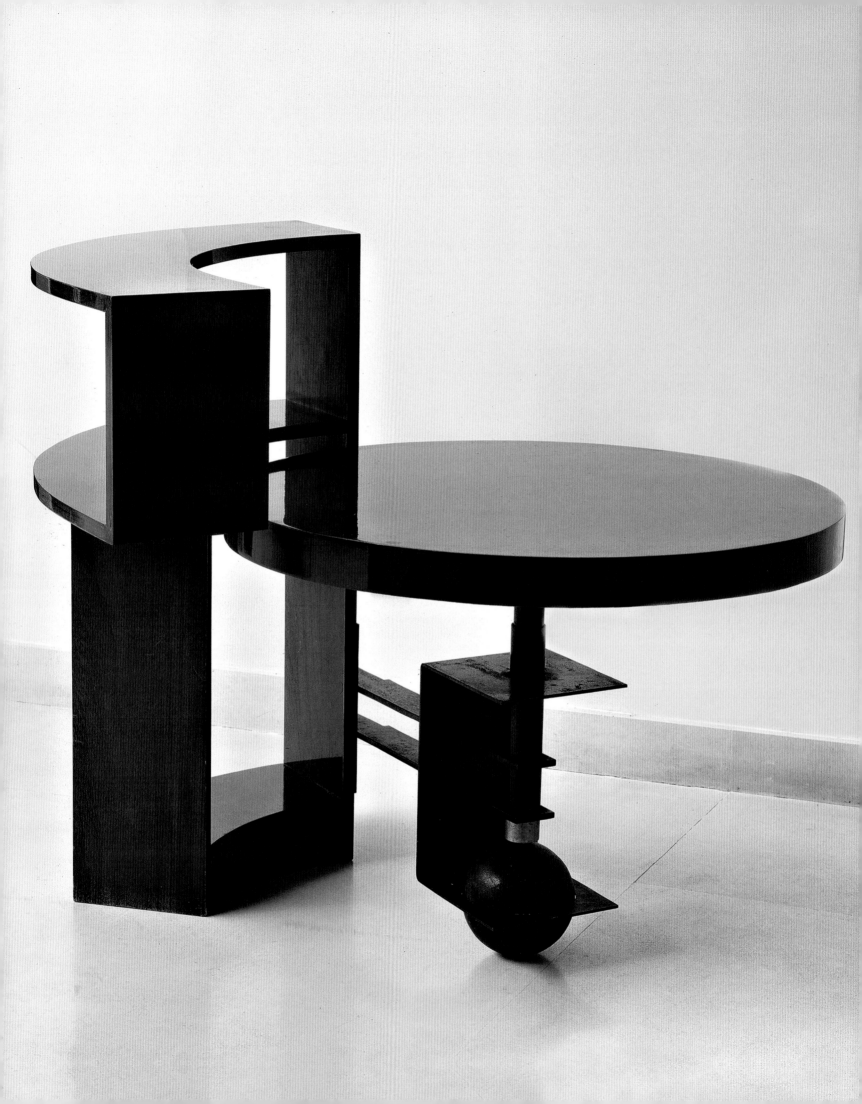

Foreword

Pierre Chareau was an exquisitely talented designer, with works ranging from furniture to interiors and even buildings. In his Maison de Verre, the modernist masterpiece he designed in Paris, he created an environment that fulfilled the functions of both a home and an artwork in a seamless example of what Le Corbusier called "a machine for living." Though known for his fondness for mechanical elements and his use of industrial materials such as steel and glass, Chareau's great gift was to pair these modernist features with traditional materials to achieve a sensual, almost anthropomorphic quality.

Chareau was always sensitive to context in his work. He was among the first twentieth-century designers to stage art—to collect and display paintings and sculptures in an intentional, conscious, modern setting. He created contexts for art and environments, just as this exhibition and publication, in turn, do for Chareau's own work. The Jewish Museum, in partnership with the Centre Pompidou, is thus presenting a singular artist in the social, political, and cultural context of his time: Paris in the 1920s and 1930s, and, after the Nazi occupation of France forced him to flee, New York City during World War II.

In interwar Paris, many patrons of modernism were Jewish, as were most of Chareau's own clients; he himself had Jewish roots. Moving in these avant-garde circles, he collaborated with leading designers and architects and knew many of the most interesting artists of his generation— Picasso, Braque, Lipchitz, Modigliani; he saw his own work as part of that modernist context. In our exhibition this artistic exchange continues, with Chareau's visionary works contextualized by Diller Scofidio + Renfro's innovative installation, which immerses audiences in Chareau's world through the use of technology.

While Chareau is greatly esteemed by architects and designers, he is less familiar to the general public, and remains more influential than well-known. The Jewish Museum addresses this oversight by sharing his stunning designs with a broader audience and celebrating his visionary aesthetic. Thanks to a rich collaboration with the Centre Pompidou, and many generous loans from other collections, we are able to expose a new audience to Chareau and to see his work embraced by a new generation of lovers of art and design.

This volume and the exhibition it accompanies have been tremendous undertakings, and we are grateful to the many people who contributed to their success. Nothing would have been possible without Esther da Costa Meyer, whose deep immersion in Chareau scholarship has elevated the project to the highest level. First proposed to Joan Rosenbaum, the previous director at the Jewish Museum, in 2008, this effort took many years to bring to fruition; it is a great pleasure for us to realize this shared vision at the museum. Olivier Cinqualbre, chief curator at the Musée National d'Art Moderne, Centre Pompidou, worked closely with Professor da Costa Meyer, and we are grateful for his support.

Chareau's works have been innovatively presented by Elizabeth Diller of Diller Scofidio + Renfro; Abbott Miller and his team at Pentagram did their usual excellent work on this volume.

We extend our gratitude to the wonderful and talented staff at the Jewish Museum for all their hard work. Esther da Costa Meyer was ably supported by Daniel Palmer, Leon Levy Assistant Curator; and two Blanksteen Curatorial Interns, Anna Meixler and Leah Salovey. Crucial assistance was also provided by Jens Hoffmann, Deputy Director, Exhibitions and Public Programs; Ruth Beesch, Deputy Director, Program Administration; and Norman Kleeblatt, Susan and Elihu Rose Chief Curator. Thanks to Elyse Buxbaum and her team for securing the necessary funding and to the stellar press team. And a warm thank-you goes to David Goldberg and Sabina Avanesova in the Director's Office of the Jewish Museum.

Thanks to Bernard Bauchet, Olivier Cinqualbre, Jean-Louis Cohen, Robert M. Rubin, Kenneth E. Silver, and Brian Brace Taylor for their thoughtful essays. A special thanks to Robert M. Rubin and Stéphane Samuel, owners of the Maison de Verre, for being such faithful stewards of Chareau's legacy. Coordinating and editing the book was the Jewish Museum's exceptional editor, Eve Sinaiko. Al Lazarte, Senior Director of Operations and Exhibition Services, and his staff produced the exhibition with their customary skill.

Many private collectors and institutions have been generous with loans, and we offer them our heartfelt gratitude. As always, the Jewish Museum is sustained and encouraged by the enthusiastic support of its Trustees, under the capable leadership of Board Chairman Robert Pruzan and President David Resnick.

Claudia Gould, Helen Goldsmith Menschel Director, The Jewish Museum

Bernard Blistène, Director, Musée National d'Art Moderne, Centre de Création Industrielle, Centre National d'Art et de Culture Georges Pompidou

Table and bookcase, c. 1930
(page 116).

Donors and Lenders to the Exhibition

Pierre Chareau: Modern Architecture and Design is made possible by The Jerome L. Greene Foundation.

JLGreene

Additional support is provided by The Peter Jay Sharp Exhibition Fund, Tracey and Robert Pruzan, Susan and Benjamin Winter, The Grand Marnier Foundation, Design Within Reach, Marie-Josée and Henry Kravis, and the Leon Levy Foundation.

This publication is made possible in part by the Dorot Foundation and the Barr Ferree Foundation Fund for Publications, Department of Art and Archaeology, Princeton University

The Jewish Museum gives special thanks to the Cultural Services of the French Embassy.

LENDERS

Art Institute of Chicago

Ateliers Chana Orloff, Paris

Baltimore Museum of Art

Carolyn and Preston Butcher, Menlo Park, California

Cooper Hewitt, Smithsonian Design Museum, New York

Geoffrey Diner Gallery, Washington, DC

Wendy Fisher, New York

Audrey Friedman and Haim Manishevitz

Galerie Anne-Sophie Duval, Paris

Galerie Karsten Greve, Cologne

Galerie Lefebvre, Paris

Galerie Vallois, New York and Paris

Janet Ginsberg, Vermont

Felix Hagnö collection, Sweden

Hirshhorn Museum and Sculpture Garden, Smithsonian Institution, Washington, DC

Jensam Foundation, New York

Kasper Collection of Drawings and Photographs

Paolo Kind, London

Barbara and Richard S. Lane

Scott Mueller

Musée des Arts Décoratifs, Paris

Musée National d'Art Moderne, Centre Pompidou, Paris

Museum of Modern Art, New York

National Museum of American History, Smithsonian Institution, Washington, DC

National Museum of Modern Art, Tokyo

Private collections

Robert M. Rubin

Miguel Saco, New York

Solomon R. Guggenheim Museum, New York

Dominique Suisse

Ulmer Museum

University of Arizona Museum of Art, Tucson

University of Michigan Museum of Art, Ann Arbor

Victoria and Albert Museum, London

Virginia Museum of Fine Arts, Richmond

Vitra Design Museum, Weil am Rhein

Wadsworth Atheneum Museum of Art, Hartford

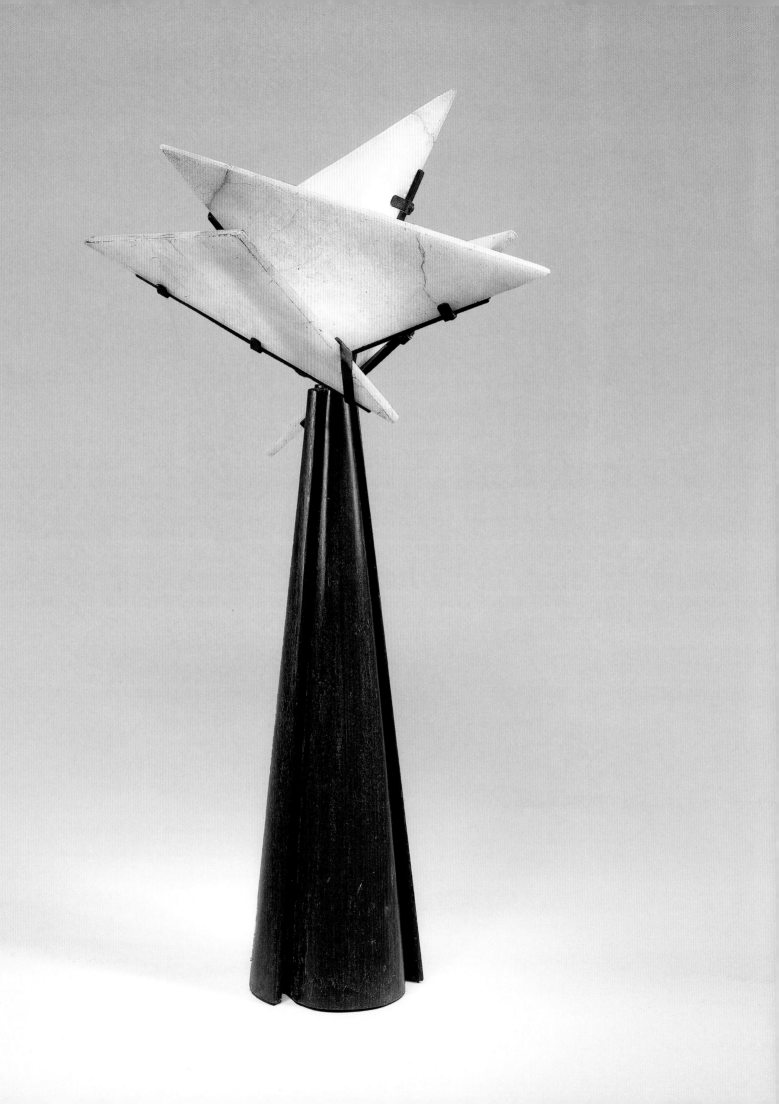

Preface and Acknowledgments

From the outset, *Pierre Chareau: Modern Architecture and Design* was to be a thorough reconsideration of an artist more admired than studied. Among designers and collectors, Chareau is best known for his elegant furniture in wood and metal, infused with Parisian chic and, increasingly, with a Machine Age aesthetic. Among architects he is celebrated for his *magnum opus*, the Maison de Verre, widely admired though not always acknowledged as a key work in the twentieth-century canon. These two areas of Chareau's work are rarely considered as a single oeuvre. Almost none of his interiors survive intact, except in documentary photographs, so the unity of his creative vision has largely been lost. To confront this problem was my curatorial starting point. Another challenge, common to any exhibition or publication on architecture and design, was to overcome the impossibility of bringing buildings and interiors into the space of the museum, or onto the pages of a book. With the help of archival photographs, I have sought to present Chareau's work as a unified, comprehensive vision, though one interrupted by economic and political upheavals. Chief among these was the arrival of the Nazis in France, which precipitated his flight and subsequent exile in the United States. Establishing Chareau's Jewish roots, which had never been mentioned in the literature, was central to this project.

Pierre Chareau: Modern Architecture and Design has been many years in the making; I first proposed it to the Jewish Museum in 2008. This book, and the exhibition it accompanies, would not have been possible without the enthusiastic backing of Claudia Gould, Helen Goldsmith Menschel Director at the Jewish Museum; she gave it her undivided attention and active support. I also wish to express my deep gratitude to her predecessor as director, Joan Rosenbaum, who first accepted my proposal and generously helped set it on its path.

This exhibition also marks the Jewish Museum's first partnership with the Centre Pompidou in Paris, and I am deeply grateful to Bernard Blistène, Director of the Musée National d'Art Moderne, for the important loans from the Pompidou's rich holdings. Ruth Beesch, Deputy Director, Program Administration, offered expert advice every step along the way, and guided this project to a successful conclusion. Daniel S. Palmer, Leon Levy Assistant Curator, put his remarkable investigative talents to tracking down Chareau's furniture and art. All shared the same commitment to recovering the forgotten narratives of lives, careers, and cultural environments interrupted or shattered by economic and political dislocation and a devastating world war.

I warmly acknowledge Norman Kleeblatt, Susan and Elihu Rose Chief Curator, for putting his curatorial expertise and suave diplomatic skills at our disposal. The museum's talented and dedicated staff worked tirelessly and with enormous zeal: Jennifer Ayres, Exhibitions Manager; Nelly Silagy Benedek, Director of Education; Elyse Buxbaum, Director of Development; Blakely Caswell, Associate Registrar; Rachel Herschman, Curatorial Assistant for Publications; Michelle Humphrey, Rights and Reproduction Coordinator; Marisa Kurtz, Curatorial Department Coordinator; Molly Kurzius, Associate Director of Communications; Al Lazarte, Senior Director of Operations and Exhibition Services; Julie Maguire, Senior Registrar; Jonah Nigh, Director, Major Gifts; Anne Scher, Director of Communications; Kirsten Springer, Visual Resources Coordinator; Sarah Supcoff, Deputy Director, Marketing and Communications; and Anna Meixler and Leah Salovey, Blanksteen Curatorial Interns. My thanks as well to Mason Klein, Curator, for his encouragement in the early stages of this project.

I am especially indebted to the Jerome L. Greene Foundation, and to Christina McInerney and Spencer Harper III: their vision, support, and assistance have been instrumental in enabling us to tackle an exhibition of this scale.

Several curators from other institutions selflessly offered help: Olivier Cinqualbre, Chief Curator at the Musée National d'Art Moderne, Paris, was instrumental

La Religieuse table lamp, c. 1925
(page 138).

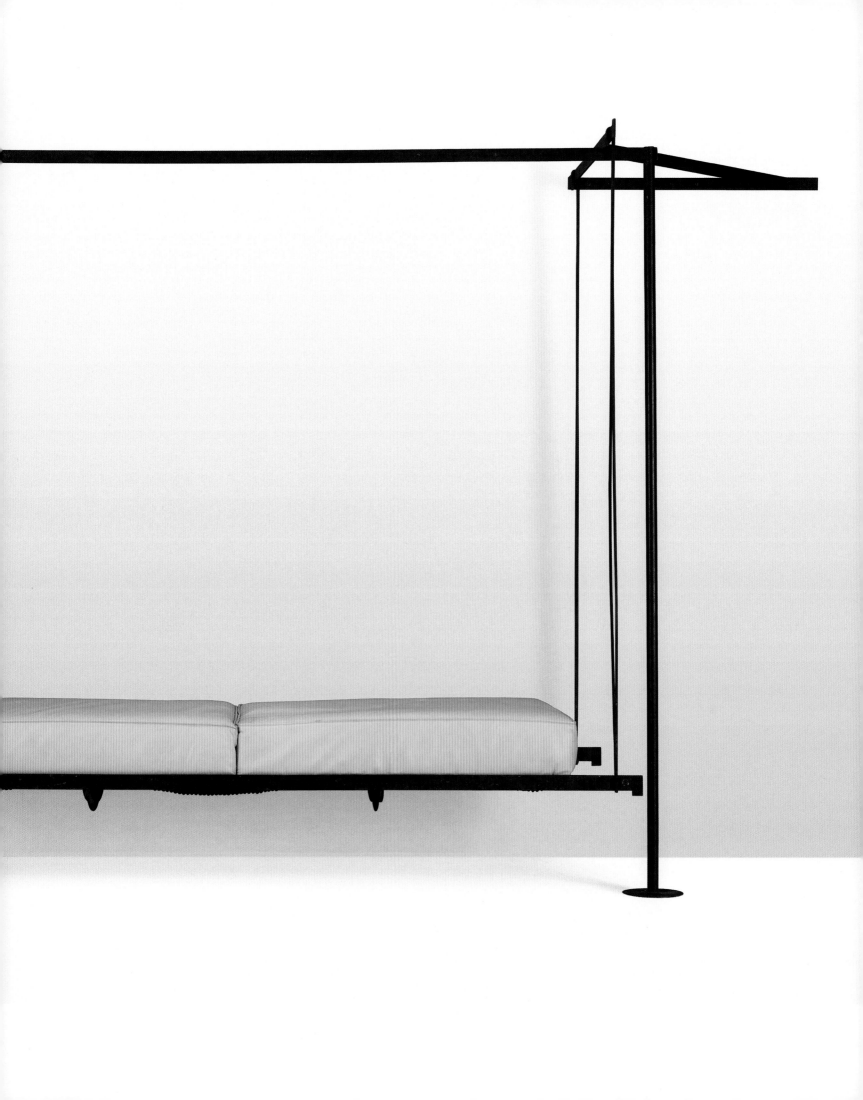

in securing loans and giving advice. I am also grateful to Barry Shifman, Virginia Museum of Fine Arts; Paul Galloway, Museum of Modern Art; Ann Stephen, University Art Gallery, University of Sydney; Hélène Leroy, Service des Musées de France; and Kida Takuya, National Museum of Modern Art in Tokyo. My thanks as well to Kay Peterson, Archives Center, National Museum of American History, Smithsonian Institution; Romana Breuer, Museum für Angewandte Kunst; Annie Farrar, Hirshhorn Museum and Sculpture Garden; Megan Fontanella, Solomon R. Guggenheim Museum; Roberta Frey Gilboe, University of Michigan Museum of Art; Patricia Hickson, Wadsworth Atheneum Museum of Art; Laurent Le Bon, Director, Musée Picasso; Ariane Lelong-Mainaud, Association pour la Défense de l'Oeuvre de Joan Miró; Olivia Miller, University of Arizona Museum of Art; Christine Pinault, Picasso Administration; Katy Rogers, Director, Robert Motherwell Catalogue Raisonné; Katy Rothkopf, Baltimore Museum of Art; Vanessa Haight Smith, Smithsonian Institution Libraries; Verane Tasseau; and Cynthia Trope and Gregory Herringshaw, Cooper Hewitt, Smithsonian Design Museum.

Olivier Gabet, Director of the Musée des Arts Décoratifs in Paris, was extremely helpful and extended the aid of his staff: Evelyne Possémé, Raphaèle Billé, Isabelle Fournel, Hélène Andrieux, and Hélène Brishoual. Fabrice Hergott, Director of the Musée d'Art Moderne de la Ville de Paris, was equally generous with important loans. Dorothée Charles, Program Officer, Visual Arts, Architecture, Design, at the French Consulate New York offered help and advice. At Princeton University, I thank Sandra Brooke, Nicola J. Shilliam, and Rebecca K. Friedman from Marquand Library and the staff of the Rare Books Room of Firestone Library, as well as Susan Lehre and John Blazejewski in the Department of Art and Archaeology. Kenneth Frampton kindly shared his great knowledge of Chareau with us. In Paris, Michel Dreyfus contributed valuable information from his own research on the Bernheim family. For their exceptional assistance I am grateful to Amandine Fabre-Dalsace, Janet Hawkins and Herbert Kasper, Joelle Kayden, Ariane Tamir of Ateliers Chana Orloff, and Harry Fischman. To the many lenders—individuals, museums, and galleries—who generously allowed Chareau's works to be seen by the public, I offer my deep gratitude. Robert M. Rubin deserves my sincere thanks for opening the Maison de Verre to the Trustees of the Jewish Museum, and for lending several items from his collection. Warmest thanks also to the specialists who aided in the search for Chareau's works and the art from his collection: Barbara Deisroth; Julie Hillman; Diana Howard; Jane Richards; at Phillips: Meaghan Roddy; at Sotheby's: Caitlyn P. Frank and Emily Kaplan; at Christie's: Carina Villinger, Allison Whiting, Amy Indyke, Hannah Byers, and Grace Dubuque; at Marlborough Gallery: Sebastian Sarmiento.

None of Chareau's exquisite interiors survive in their entirety. In this respect, the collaboration of Elizabeth Diller and Ricardo Scofidio of Diller Scofidio + Renfro has been absolutely essential. In conjuring the daring exhibition design, they did far more than shun the rigor mortis of the static period room. Throughout the process of gestation, they probed the ways in which display of freestanding furniture can communicate meaning in our time, now that the original settings are gone. My sincere thanks as well to their gifted young colleagues Kumar Atre, Matthew Johnson, Jaffer Kolb, Lindsey May, and Roy Peer.

It is the catalogue that survives any exhibition. Eve Sinaiko, Director of Publications, deserves special credit for her ability to forge a harmonious whole from the individual voices of these gifted authors. We have had an ideal partner in J. Abbott Miller, who, together with his team at Pentagram, was responsible for the polished elegance of the book design. Such an ambitious publication was made possible only by the generous support of the Barr Ferree Fund from Princeton University and our co-publisher, Yale University Press. My thanks to Patricia Fidler, Katherine Boller, Heidi Downey, and Sarah Henry for bringing this beautiful volume to fruition.

Every project benefits from the generosity of the many people who support, challenge, and help shape the ultimate outcome. I can hardly express the debt I owe to the friends and colleagues who contributed essays to this publication: Bernard Bauchet, Olivier Cinqualbre, Jean-Louis Cohen, Robert M. Rubin, Kenneth E. Silver, and Brian Brace Taylor. They added enormously to the scope and depth of both the exhibition and the book, and I thank them here for having embarked on this journey with me.

My husband, Christopher Hailey, never flagged in his support during all the years when our life—though unfortunately not our home—was taken over by Chareau's furniture.

Esther da Costa Meyer
Guest Curator

Detail of Chareau's suspension seat
(page 114).

PIERRE CHAREAU

Pierre Chareau: A Life Interrupted

Esther da Costa Meyer

Pierre Chareau had little more than ten years of indisputable success, from roughly 1919 to 1932—between the end of World War I and the rise of fascism. The two decades before the war were little more than an extended apprenticeship; the two decades that followed were overshadowed by social and economic upheavals and, after 1940, exile in America. It is difficult to speak of continuities in a life afflicted by so many disruptions. At its best, Chareau's work was a creative, if sometimes reluctant, confrontation with the very discontinuities of an era in which craft was giving way to assembly-line production, elite patronage to a mass market, and the precious materials of the natural world to the hard-edged surfaces forged by an industrial age. His life and career were absorbed by the need to come to terms with a world in transition, a time when democratic societies were threatened by the rise of powerful dictatorships.

Not much is known about Chareau's early life. He was born in Bordeaux in 1883 to Georges Adolphe Benjamin Chareau and Esther Carvallo. His father was a wine merchant who moved to Paris in the late 1890s. In 1904 Chareau married Louise Dorothee Dyte, known as Dollie, who was to play a major role in his life. Chareau seems to have failed his entrance exams at the École Nationale Supérieure des Beaux-Arts, though his wife

Pierre Chareau in 1925.

claimed that he studied for a year under one of its professors.[1]

Chareau began his professional life working for the British manufacturing firm Waring and Gillow in 1899 and rose through the ranks to become head draftsman. With offices in England and France, the firm produced period-style furniture for ocean liners, hotels, and public buildings. His years there gave Chareau a solid foundation in furniture design and production, and drove home the importance of display and elegantly furnished showrooms. Although his early projects for the firm were historicist and unadventurous, as one can see from the sole surviving photographic example, this changed after World War I, during which he served in the artillery (page 17). Discharged in 1919, he set up on his own as an independent designer, and his postwar work shows how keenly he had followed the modern decorative arts.

THE SOCIÉTÉ DES ARTISTES DÉCORATEURS

By 1923 Chareau was accepted into the prestigious Société des Artistes Décorateurs. This extraordinarily talented group included artists of radically different tendencies, from neohistoricist approaches to innovative responses to the requirements of modern life. The

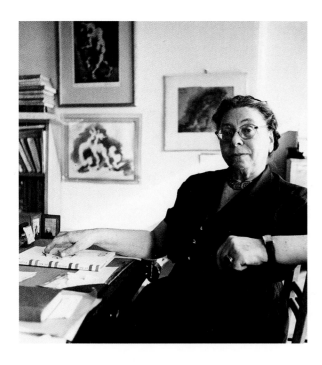

Dollie Chareau in the Chareaus' New York apartment in the 1940s or 1950s. On the wall behind her are works on paper by Jacques Lipchitz, a close friend. Pierre and Dollie Chareau Collection, Princeton University Library.

artistes décorateurs specialized in creating unified interiors, combining fine craftsmanship and luxurious materials with an emphasis on style and taste. A room by Émile-Jacques Ruhlmann, for example—sleek, stylish, bathed in luxury—was a perpetual *fête galante.* Its hothouse atmosphere was redolent of an aristocratic past of ritualized elegance, with visits paid and received amid refined furnishings. The tutelary influence of the eighteenth century hovered over many French decorative artists, such as Louis Süe and his partner, André Mare, André Groult, or Paul Follot, who took calculated risks, updating established historical formulas. Furniture, wrote the contemporary critic Jean Laran, had to please and be comfortable, but it also had to make patently clear "the social class to which we belong or would like to appear to belong."[2]

Another major source of inspiration for the decorative arts was Africa, though an Africa whose forms and textures were seen largely through the prism of colonial stereotypes. The exotic materials used by Pierre Legrain, Marcel Coard, or Michel Dufet, as well as their thematic choices, all accorded with a worldview in which the hegemony of the West remained unquestioned. Far Eastern influence was equally popular. Jean Dunand and Eileen Gray excelled in lacquer, as did their younger contemporary Gaston Suisse. Materials and forms borrowed from China or

Japan were common, as was the influence of ancient Egypt. From fine woods to ivory, coral, and horn, the palette of the *artistes décorateurs* was predicated on extractive economies of far-flung empires. Chareau, like his peers and clients, was a child of his time. Although he rejected intricate marquetry, he often used ivory details. In a beautiful nursery shown at the Salon des Artistes Décorateurs in 1923, Chareau used wallpaper designed by Jean Lurçat, based on a colonial venture, the trans-Saharan expedition of 1922, organized by the automobile company Citroën (page 76).[3] Likewise, Chareau's dining room for the Indochinese pavilion in the colonial section of the Exposition Internationale des Arts Décoratifs et Industriels Modernes (1925), executed with bilinga wood from Gabon, was part of this geographically wider world of France's imperial modernity (page 42).[4]

To succeed in a field crowded with superb French *ensembliers* (interior designers who conceived of each room as a whole), Chareau had to carve a niche for himself with a distinctive signature style. His was characterized by clean lines and unadorned surfaces veneered in exotic woods such as amaranth, ebony, rosewood, and Macassar. Because he rejected ostentatious opulence, he attracted clients who preferred more discreet affirmations of wealth. The early furniture was cloaked in retrospect, soft to the touch, self-contained. "There, all is order and loveliness / Luxury, calm and voluptuousness," wrote a critic admiringly, quoting Baudelaire's famous poem, "L'Invitation au Voyage."[5] But to maintain a place in the limelight required sustained originality, and Chareau soon showed an unparalleled ability to hold seemingly incompatible materials in tension: rare woods, prohibitively expensive and polished to enamellike surfaces, juxtaposed without transition to rough-hammered components in wrought iron. This approach was not a purely aesthetic choice but reflects his own ambivalent stance, torn between the calm gentility of a past he was loath to abandon and the edgy tempo of modern life. Chareau loved the slow give and take with his clients and with the craftsmen who assisted him, and the sensuous joy of materiality. He delighted in

Dining room in an apartment on Boulevard Raspail, Paris, designed by Chareau for Waring and Gillow before 1914. Chareau's style, while elegant, is still quite conventional, and shows little of the experimentation occurring at the time.

Living room in the Paris apartment of Hélène Bernheim, designed by Chareau in 1923.

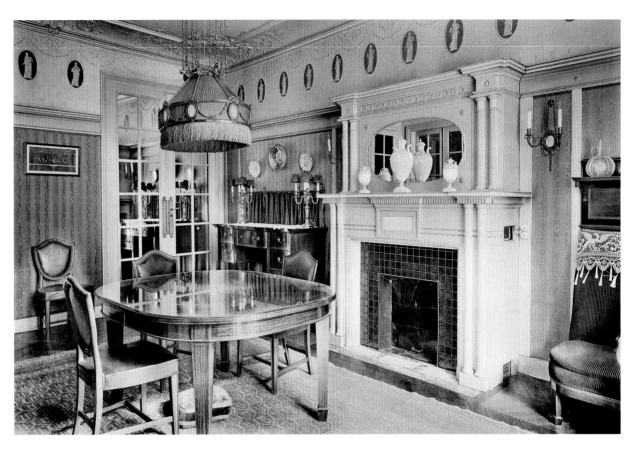

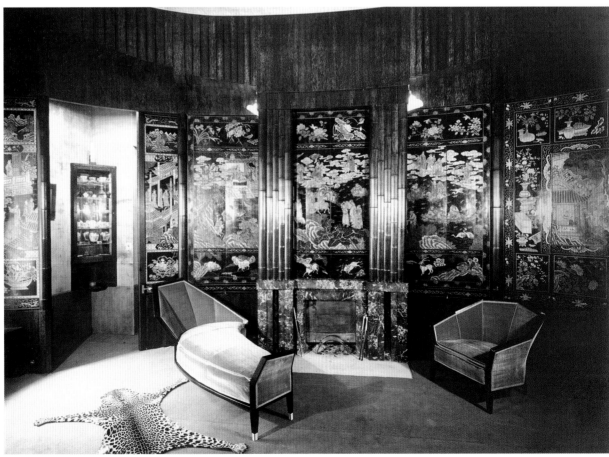

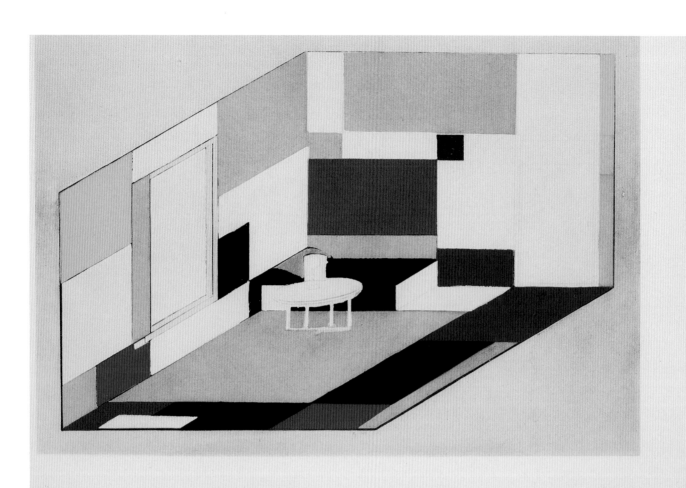

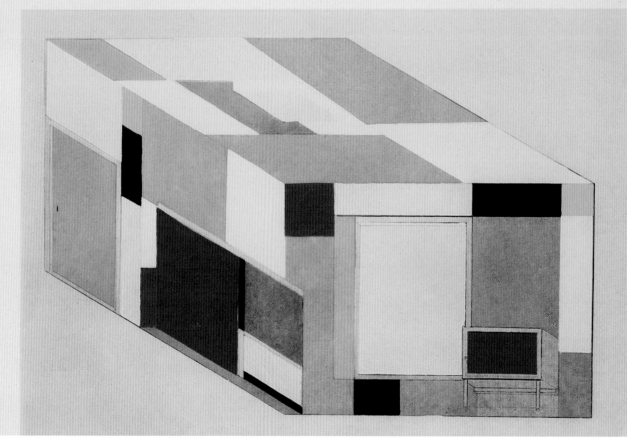

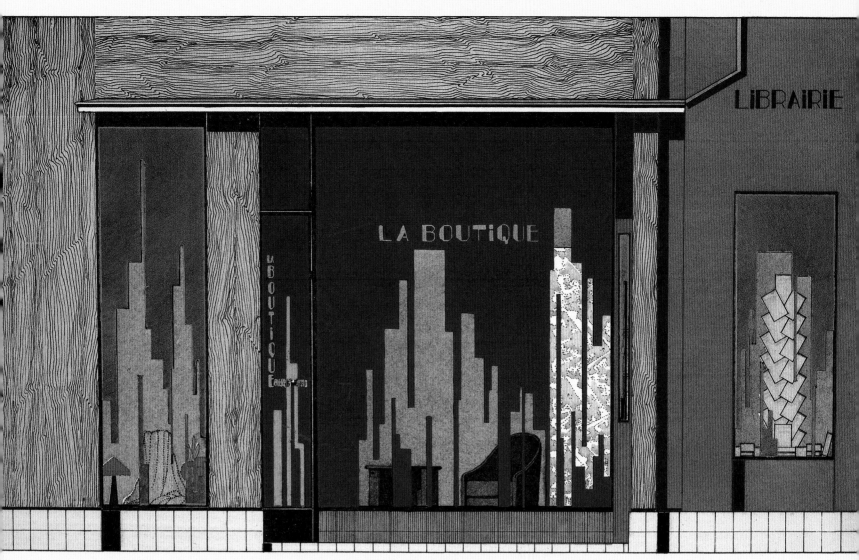

Drawing for La Boutique, Chareau's shop on the Rue du Cherche-Midi, Paris, 1927.

Opposite

Piet Mondrian, designs for the library study of Ida Beinert, the "Salon de Madame B," 1926, published by Chareau in his 1929 portfolio *Meubles*. Chareau's publication was very progressive for its time, emphasizing the use of metal furniture. This image, the only pochoir in the publication, shows his interest in the avant-garde. Curiously, Chareau's caption reads, "Mondrian, architect in Paris."

the lustrous finish of wood, showing the beauty of the grain, and the virtuoso treatment of iron that encoded the gestures left by his gifted ironsmith, Louis Dalbet. Yet he was equally concerned with utility and sought to strip away the dross of applied ornamentation.

For Chareau, design was never simply a matter of disposing furniture pieces in a given room. Rather, it was about shaping space itself, or what he called *architecture intérieure.* He sought a perfect integration of design and architecture. It is not by chance that he published a striking pochoir by Piet Mondrian in his portfolio *Meubles,* in which furniture and architecture form an indissoluble whole.[6] To this end, he went far beyond the usual role of interior decorator, knocking down walls to create an unbroken continuum, often with the use of sliding partitions so that his rooms, as the critic Christian Zervos pointed out, "give the impression of movement."[7] Another means by which he unified architecture and furniture can be seen in his highly original and sculptural treatment of ceilings, often peeling back layer after layer to achieve nuanced light effects and dramatize his interiors (pages 53–57). Lighting remained a constant preoccupation, and he designed exquisite alabaster fixtures that, positioned expertly around the room, enhanced the atmosphere with poetic accents (pages 32, 61, 130, 132–33, 136).

The *artistes décorateurs* or *ensembliers*—neither term does justice to the range of their work—were purveyors of exquisite custom-made goods for a very select clientele. The rich needed to singularize themselves by means of modern furnishings that flaunted precious materials and labor-intensive techniques, or, if they did not favor ostentation, sheer ingenuity. By exhibiting their work at the annual salons while catering to their

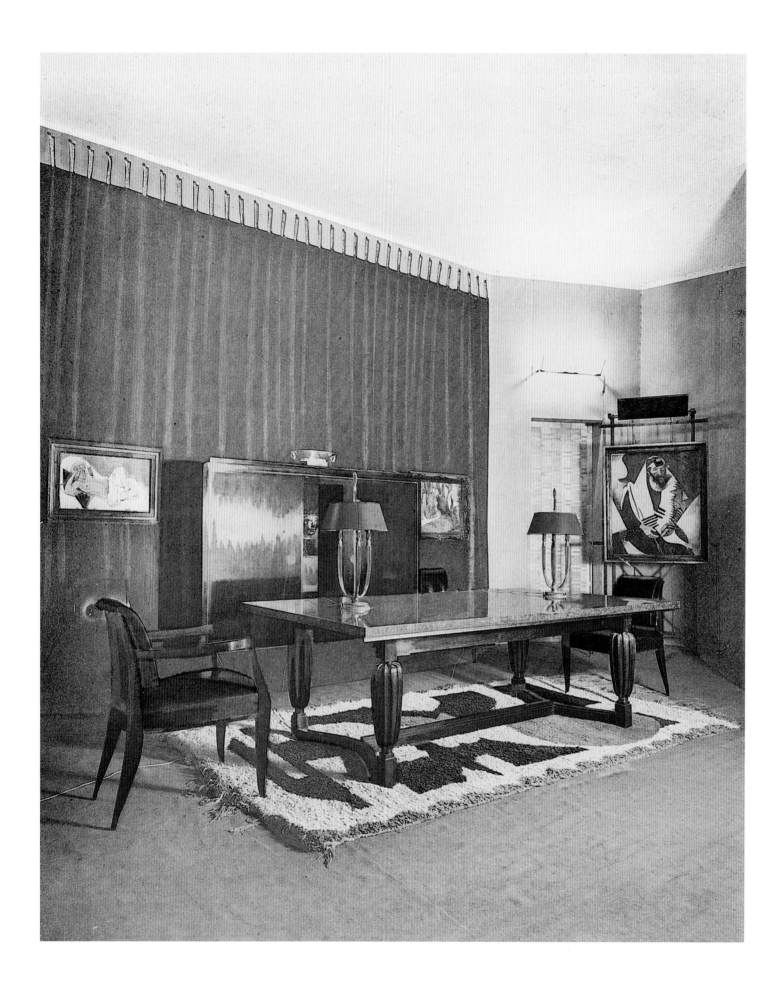

Émile-Jacques Ruhlmann, dining room pochoir print, 1925. On the right, the easel in wrought iron was made by Chareau and Louis Dalbet, and displays Marc Chagall's *Praying Jew*.

patrons' taste for exclusivity, the *ensembliers* shuttled between public and private spheres. Ensembles were a language by which elites communicated ideas of domesticity, sociability, gender, and class, and did their part in "legitimating social differences."[8] At the same time, the designers themselves rarely came from the same class as their patrons, and the modernists, who prized simplicity and utility, were aware of the contradictions that divided their work from their more egalitarian aspirations. Many well-heeled clients themselves shared these ideals. Chareau, together with Francis Jourdain, Georges Djo-Bourgeois, René Herbst, Robert Mallet-Stevens, and Charlotte Perriand, soon formed a dissenting group within the Société des Artistes Décorateurs. Their flat, unbroken surfaces, rejection of ornament and historicism, and use of new materials sought to wed domestic comfort with the exigencies of modern life beyond superannuated notions of style.

Although they vied for clients competitively and exhibited in the same venues—the Salon d'Automne and the Salon des Artistes Décorateurs—the profession was intensely collaborative. French designers often curated exhibitions that showed the work of several colleagues. Chareau's designs appeared in interiors by other noted furniture makers, as one can see in a beautiful pochoir print by Ruhlmann. Two of the most impressive interiors of the time, Jacques Doucet's studio at Neuilly and the villa of Charles and Marie-Laure de Noailles at Hyères, had pieces by many of the great *artistes décorateurs,* including not only Chareau but also Eileen Gray, Sonia Terk Delaunay, and Charlotte Perriand, part of the large contingent of women who entered the field during the 1920s (page 44). Chareau worked with many of them, incorporating their designs into his interiors and his portfolio, *Meubles.* Some, such as the bookbinder Rose Adler and the textile designer Hélène Henry, were clients as well as friends and bought occasional pieces from him.

Collaboration changed the nature and the meaning of the "ensemble." Although tightly knit compositions by a single designer did not disappear, they coexisted with interiors composed by several hands, while retaining a strong consistency of style. At times, Chareau even included older pieces of furniture in his interiors, showing a more open and forgiving approach. Paris's most important department stores reinforced this trend:

all had their own design studios, headed by important *artistes décorateurs,* whose interiors, produced for sale, were the fruit of teamwork. Léon Moussinac, one of the period's most incisive critics of the decorative arts, attacked the error of creating a "harmony" so inflexible that "the introduction of an exterior element might suddenly destroy it." His implacable conclusion summed up this more flexible attitude: "an ensemble is not a spectacle."[9] The idea of the *Gesamtkunstwerk,* in which all parts of the interior come together in a stylistic whole, still lingered, but the notion of closure was beginning to dissolve.

Many designers had showrooms and sold individual furniture pieces directly to the public. In 1924 Chareau opened his own little shop, La Boutique, in the Rue du Cherche-Midi on the Left Bank (page 19). Here he sold cushions and hand throws, as well as the work of his friends—fabrics by Henry, accessories by Adler, and carpets by Lurçat, Jean Burkhalter, and Philippe Hosiasson, which Chareau distributed under the label La Boutique. Next door, another friend, Jeanne Bucher, opened a gallery showing art by Pablo Picasso, Georges Braque, Juan Gris, Max Ernst, Joan Miró, Henri Matisse, and other members of the avant-garde whom Chareau knew.[10] A second shop, on Rue Nollet on the Right Bank, where the Chareaus had their home and workshop, displayed his furniture.

It was Chareau's entry for the Exposition Internationale des Arts Décoratifs et Industriels Modernes in 1925 that finally brought him wider recognition. The Société des Artistes Décorateurs had decided to collaborate on a single project, a proposal for a French embassy in a large villa. The design of the ambassador's library fell to Chareau (pages 50–51). This is the only one of his interiors that has come down to us more or less intact. In one of the rooms allotted to him, he invented an ingenious enclosure that opened and shut like a fan, isolating the desk. This was a flexible armature that he often used to give greater control over the environment, creating a spatial envelope that could expand and contract. Chareau himself described his library as a "folly," partly because the palmwood he used was very hard to work with.[11] Here as elsewhere, he included the work of friends: a rug by Lurçat, fabrics by Henry, and sculpture by Jacques Lipchitz. Chareau also designed a *salle de repos* (lounge) for the embassy, adjoining a gym by his friend Francis Jourdain (page 22).

In France and abroad, major figures in architecture and design took note of Chareau's growing success. This was a golden age for the French decorative arts, not least because of the high level of discourse by critics. Well-informed and sophisticated, they were the

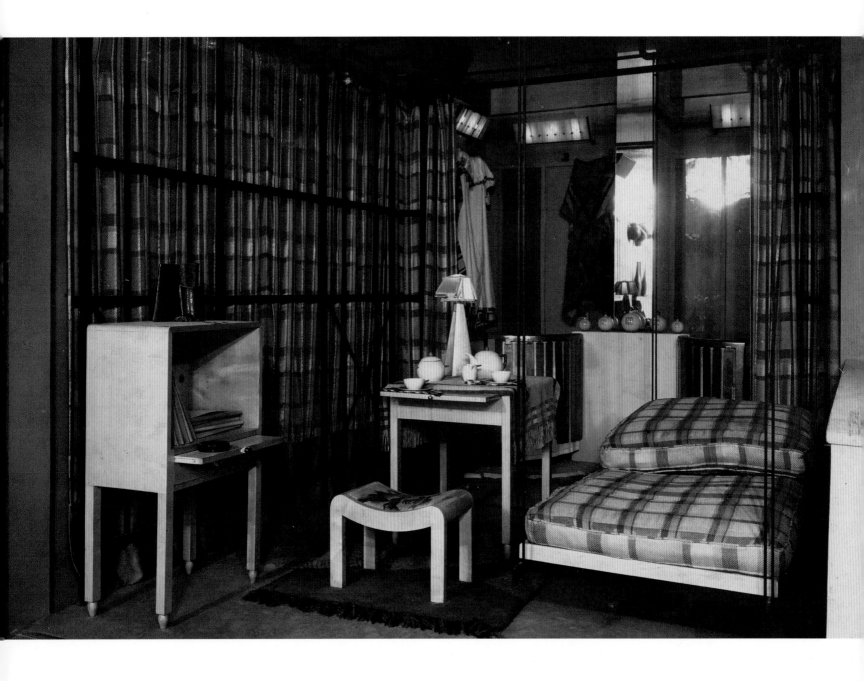

Chareau also designed furniture for a lounge in the
proposal for a French embassy suite at the Exposition
Internationale des Arts Décoratifs et Industriels
Modernes, 1925. The textiles are by Hélène Henry.

Cover of the magazine *La Ciutat y la Casa* (1926),
published in Barcelona, with a pochoir by Chareau.

LA CIVTAT & LA CASA

REVISTA D'ARQUITECTVRA, ARQVEOLOGIA & BELLS OFICIS

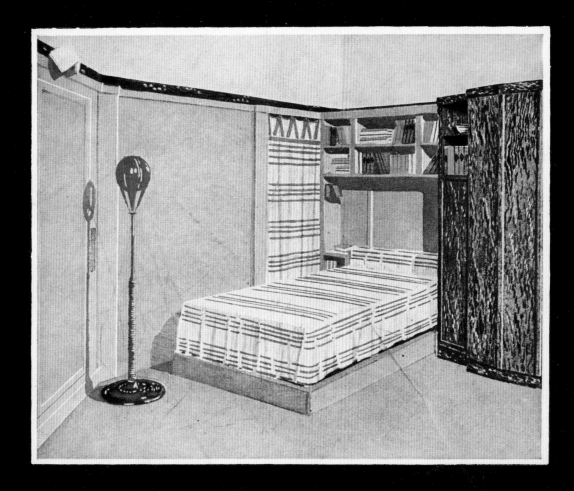

EDICIONS ROMANIQVES
CORTS CATALANES, 754
BARCELONA

ANY II

ART NOV

N.º 5

TRES PESSETES

24

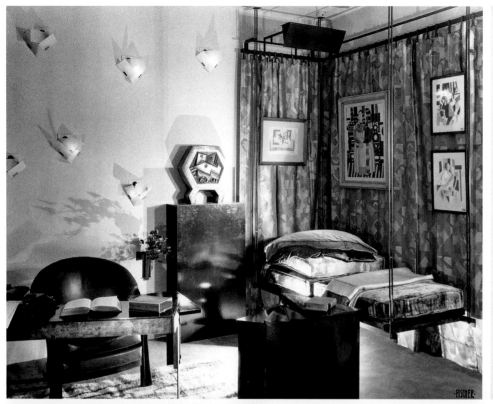

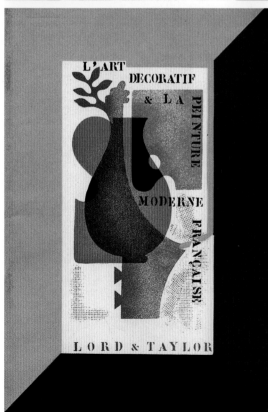

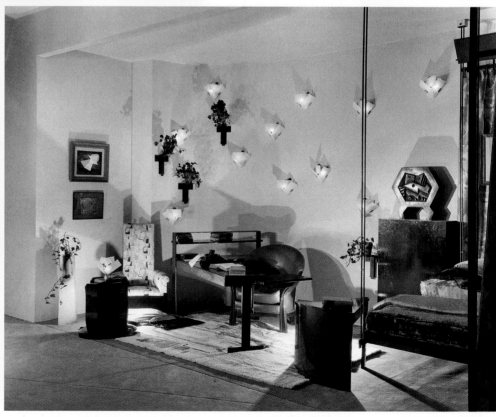

perfect interlocutors for the designers, whom they both challenged and supported in their writings, published in lavish, beautifully produced magazines: *Les Arts de la Maison, Art et Décoration, Mobilier et Décoration, L'Amour de l'Art, L'Art Vivant, La Renaissance de l'Art Français et des Industries de Luxe, Feuillets d'Art*. In 1925 Le Corbusier and Henry van de Velde published works by Chareau in two important books, *The Decorative Art of Today* and *Der Neue Stil in Frankreich*. Chareau's furniture graced the cover of Léon Moussinac's important book *Le Meuble Français Moderne* and, the following year, of the Catalan magazine *La Ciutat y la Casa*.[12]

In the United States, Eugene Clute included three works by Chareau in his influential 1926 publication *The Treatment of Interiors*.[13] Two years later, the designer's first pieces arrived in New York for an exhibition of French decorative arts at the department store Lord and Taylor. The show was officially opened by Paul Claudel, the distinguished poet and playwright who was at the time the French ambassador to the United States. Dorothy Shaver, who curated the show, states in the catalogue that the organizers had chosen to focus on "the two important schools in France today—that of the rationalists as evidenced by the work of Pierre Chareau and Francis Jourdain, and that of the traditionalists, as expressed by Ruhlmann and Süe et Mare." The goal, she continued, was "a closer alignment of the artist and manufacturer in the production of beautiful objects for general consumption."[14] Chareau's display, singled out by critics, revealed his cultural ambitions and curatorial skills: it included a bas-relief by Lipchitz, an oil painting and two watercolors by Fernand Léger, two oil paintings by Gris, and a drawing by Picasso. There was also a carpet by Burkhalter. The show, designed by the architect Ely Jacques Kahn in collaboration with Lucien Vogel, editor of *Vogue,* set a record for attendance. In his favorable review, Lewis Mumford wrote that one could hardly see the furniture for the crowds. Yet Mumford feared that his compatriots would imitate what they saw: "American art can no more be 'modern French' than it can be Louis XVI." He ends, echoing Shaver, by advocating that American designers cooperate more closely with industry and embrace mass production.[15]

FILM

If Chareau seemed to cater to an exclusive clientele, his ideas nonetheless reached a mass audience through his work for film. Film offered decorative artists an exceptional showcase for their work, glamorizing it in narratives with broad emotional appeal. Early cinema was a platform where designers worked in a radically different medium: what counted here was not the freestanding piece of furniture but its image on celluloid. This placed a huge burden on the decor, as the furniture had to accommodate both technical and narrative constraints. The monocular camera lens deformed perspective. Profiles, shapes, and colors often had to be drastically changed. Designers learned by trial and error to avoid dispersing furniture of normal dimensions far from the foreground unless there were actors nearby to give it a sense of scale.[16] Chareau thus had to reproduce his signature pieces without their usual refinements of material and detail, and suggest color and texture by other means. Designers had to use unusual hues to convey the desired tonalities in black and white, or a subtle play of grays. Materials, too, had to be travestied in order to produce the needed effect. Fake marble, for instance, looked much more authentic on screen than did the genuine thing.[17]

More importantly, film created a new role for furniture. The architect and designer Robert Mallet-Stevens, who produced sets for several films, wrote frequently on the subject: "Modern architecture does not serve only as cinematic décor but leaves its mark on the mise en scène, it exceeds its frame: architecture 'acts.'"[18] Léger had said as much in his essays on the *objet-spectacle:* "Every effort in the line of spectacle or moving picture, should be concentrated on bringing out the values of the *object*—even at the expense of the subject."[19] And ever since the introduction of the close-up, the object was acknowledged for its dramatic power.[20] Collaboration between film directors and designers was particularly important before the advent of sound. In silent film, the sets had to carry the burden of speech: "Everything should speak to the eyes."[21] As Mallet-Stevens put it: "The décor should present the character before he even appears; it must show his social status, his tastes, his habits, his way of life, his personality."[22] Yet such cooperation brought to light a glaring contradiction between the aristocratic vision implicit in the decorative arts as they were understood in France at the time—predicated on unrepeatable, auratic works of art—and the more democratic vocation of cinema, which transformed those works into reproducible images for the eye alone.

The director Marcel L'Herbier commissioned Chareau to design furniture for his films *L'Inhumaine* (1924), *Le Vertige* (1926), and *L'Argent* (1928). Chareau also worked on *La Fin de Monte-Carlo* (1927), directed by Henri

Study designed by Chareau for an exhibition on French decorative arts at Lord and Taylor, New York, 1928; poster, designed by Fernand Léger, and advertisement for the event.

Étiévant and Mario Nalpas. *L'Inhumaine* (released in North America as *The New Enchantment*) was intended as a prelude to the 1925 exhibition of the decorative arts. Every visible piece of hardware in it was designed by France's great names; in this the director was clearly influenced by the ideas of the film theoretician Ricciotto Canudo, who argued that film should be "a synthesis of all the arts," that is, a *Gesamtkunstwerk*.[23] Paul Poiret designed the costumes for the female star, Raymond Templier furnished jewelry, and Jean Puiforcat, René Lalique, and Jean Luce provided the decorative objects that adorned the sets. Darius Milhaud's score is lost, but the film includes scenes choreographed by Jean Börlin and the Ballets Suédois. Mallet-Stevens designed the modernist architecture, and Alberto Cavalcanti and Claude Autant-Lara created the dining room and the winter garden of the heroine's villa. Léger produced the famous modernist laboratory of the hero; Dufet and Poiret's Atelier Martine contributed furniture.

In its studied informality, Chareau's design for the heroine's stylish boudoir suggests her more intimate, sensitive side, and anticipates what will be revealed to the spectator only at the end of the film. His own commitment to the "synthesis of all the arts" can be seen in his carefully staged interiors, and even in his work for film, where paintings, sculpture, and interior architecture are beautifully coordinated. A Picasso collage (*Glass and Bass Bottle on a Table,* 1913), the same that can be seen in photographs of Chareau's study, appears in the background near a screen by Jean Lurçat (pages 70–73).

Le Vertige is an even richer anthology of the decorative arts, if weaker as a film. Mallet-Stevens was again in charge of the architecture, Marie Laurencin and Robert Delaunay provided paintings, Sonia Terk Delaunay designed the textiles and clothing, and the heroine was dressed by Maison Drecoll and Germaine Lecomte. Each interior is organized like a salon of decorative arts, picture perfect, with the work of different artists blending harmoniously. Lurçat provided tapestries and paintings, Jourdain and Atelier Martine, furniture. Chareau's refined pieces were given pride of place in several scenes. Captured up close, they are so often paired with the immaculately groomed hero, played by Jaque Catelain, that they almost serve as a proxy for him.

Chareau is rarely mentioned in regard to L'Herbier's film *L'Argent* (1928), based on Émile Zola's novel *The Kill,* perhaps because his furniture plays a smaller role in this tale of lust and greed. *L'Argent,* however, was a big-budget affair featuring Antonin Artaud and Brigitte Helm (made famous in Fritz Lang's *Metropolis* of 1927). Magnificently dressed by French couturiers and bedecked with Art Deco jewels by Templier, Helm plays the seductive femme fatale, suffused with light and steeped in luxury. Chareau's furnishings are associated exclusively with her; they are discreet signifiers of modern taste and beauty, though they appear only as part of the backdrop and do not suggest psychological affinities.

Chareau was also involved in the Coopérative Internationale du Film Indépendant, which promoted films by forging networks outside official circuits and organizing private screenings. The Parisian branch was not particularly active, and only two screenings are known to have occurred. The first, on May 23, 1930, took place in the house of Pierre and Dollie Chareau, where the German experimental filmmaker Walter Ruttmann showed *Weekend,* a sound collage recorded on film stock, without images.[24] Rose Adler attended, mentioning in her journal the warm atmosphere of the event and the efforts of the Chareaus to make sure the film was well-received.[25] Chareau may have been introduced to Ruttmann through his client Hélène de Mandrot. In 1929, a year after hosting the first congress of CIAM (the International Congresses for Modern Architecture), which Chareau attended, she again opened her chateau at La Sarraz to the first Congrès International du Cinéma Indépendant, in which both Ruttmann and Chareau's friend Moussinac participated.

On October 3, 1930, the Chareaus attended a private screening of Luis Buñuel's *L'Age d'Or,* financed by Charles and Marie-Laure de Noailles. Artistic Paris attended in force: the composers Maurice Ravel, Georges Auric, Darius Milhaud, Francis Poulenc, and Cole Porter; the painters Picasso, Braque, Ernst, Miró, Lipchitz, Duchamp, Léger, and Man Ray; fellow designers such as Jean-Michel Frank and Djo-Bourgeois, Le Corbusier, and Mallet-Stevens; and, among others, writers Jean Cocteau, André Gide, André Malraux, Paul Valéry, and Gertrude Stein.[26] And yet, for all his interest in avant-garde film, Chareau resisted some of its corollaries. When asked by a sympathetic critic about the influence of cinema on the decorative arts—patent in the case of L'Herbier's films—he answered angrily: "I don't understand how you can entertain such an idea. Cinema is something different, a commercial enterprise, born in a materialist era. . . . It is a means, a consequence, not a root. And above all, it is not creative."[27] Granted, film was not yet universally accepted as art. But Chareau understood what was at stake: film's mobility and reproducibility—its capacity to reach a mass audience—placed practitioners trained in the traditional decorative arts in a position of decided ambiguity.

THE CRASH

The Wall Street crash and the worldwide Depression that followed dealt a terrible blow to the field of the decorative arts, as it swept away the lifestyle of those who commissioned bespoke goods. Chareau's patrons remained loyal, but the resources that enabled custom-made interiors had largely vanished. In the economic downturn, designers were forced to lay off trusted artisans of many years' standing, giving rise to deep-seated fears of deskilling. Yet the Depression also reinforced political and social ideals, underscoring the need for mass production that eventually split the Société des Artistes Décorateurs. Its modernist wing increasingly objected to the elitism institutionalized by the organization, and in 1929 it broke away to form the Union des Artistes Modernes; Chareau lent his support but did not join the new society immediately.

One of the new group's central goals was to reach a wider public with affordable, mass-produced design without class-specific markers such as rare and costly materials. Ironically, the next year, the older Société des Artistes Décorateurs did just that when it invited the Deutscher Werkbund to exhibit. This organization brought together designers and industrialists to improve the standards of the nation's mass-produced goods. The impressive German Section—a suite of five rooms furnished with sleek, sharp-edged design in glass and tubular steel—focused on the work of the Bauhaus during the last years of Walter Gropius's leadership.[28] Metal furniture was hardly unknown in France, where it had been used by several designers, most notably Perriand, Pierre Jeanneret, and Le Corbusier, who was well acquainted with the Werkbund. Chareau himself had made use of it and had written approvingly of metal furniture in his elegant 1929 publication *Meubles*. But the cool assurance of the German displays, their formal austerity, and their overriding theme—communal

Exhibition of the Deutscher Werkbund at the Société des Artistes Décorateurs, Paris, 1930. The interiors were by Walter Gropius, Marcel Breuer, Herbert Bayer, and László Moholy-Nagy.

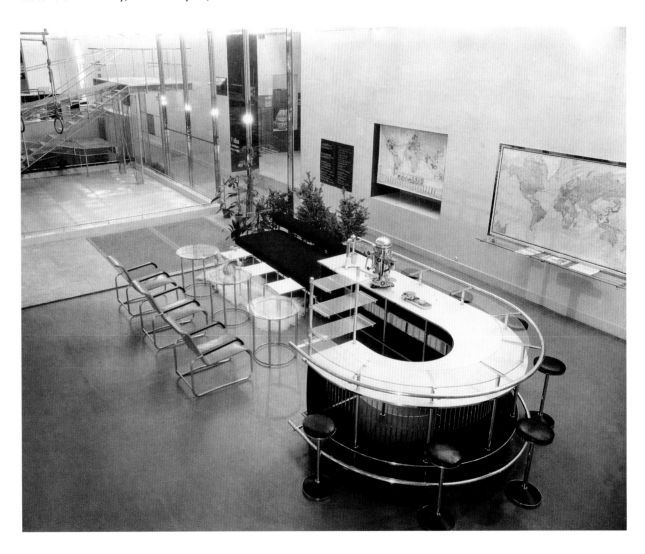

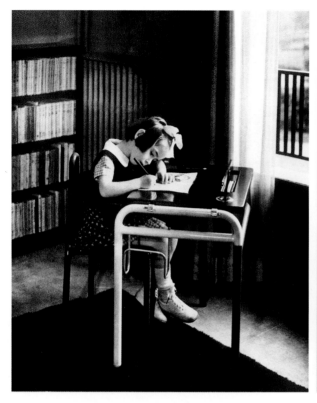

Furniture for schoolchildren designed
by Chareau for the Compagnie Parisienne
d'Ameublement, 1936. Chareau had hoped
to mass-produce this design.

Life-size maquette designed by Chareau for
a steel cabin in an ocean liner, commissioned
by the Office Technique pour l'Utilisation
de l'Acier (OTUA), 1934.

housing (with its whiff of social engineering)—must
have both attracted and shaken the French designers.
Chareau loved to contrast hard and soft materials, the
grain of precious woods, the tactile pleasures of throws
and wall hangings (pages 64–65). Not for him the cold
comforts of Marcel Breuer's chic chairs. The pieces
he produced with his ironsmith, Dalbet, were cultural
goods, charged with symbolic capital, and he was
reluctant to embrace mass production: "The very idea of
uniformity is odious to me. One may desire its advent,"
he declared in 1925, "but submitting to its tyranny is
repugnant."[29]

And yet Chareau faced the new demands of the
age with wit and originality. A series of post-craft
designs in steel, less individualized and destined for
the collectivity—compact cabin interiors for ships,
stackable furniture for schoolchildren—show him
trying to work with industry in mind, although he did
not succeed in mass-producing his work for a broader

public. He also incorporated steel in his customized
pieces with excellent results.

Chareau was now struggling financially. In a bleak,
bitter article published in 1935, he wrote movingly:
"Architecture is a social art. It is both the crowning of all
the arts and an emanation of the mass of mankind; the
architect cannot create unless he hears, understands
the voice of millions of men; unless he suffers their
misfortunes, fights at their side to deliver them. . . . He
uses the iron they have forged. Gives material life to
the theories they have conceived. He helps them live,
produce, create, consume."[30] This newfound solidarity
and erosion of class boundaries did not come easily
to someone whose previous work had been based on
very different social premises. In the works of the 1930s,
Chareau was able to transcend the mystique of craft
and its romantic attachment to unmediated natural
materials, yet his interest in the "mass of mankind" was
overshadowed by the loss of his trusted artisans, whose
services he could no longer afford.

PATRONAGE

Despite these vicissitudes, Chareau remained deeply
attached to his patrons; his life, career, and legacy
would have been entirely different without the extraor-
dinary relationships he enjoyed with them. These were
friendships that exceeded traditional designer-client
relationships.

The brothers Émile and Edmond Bernheim, successful in the real-estate business, gave Chareau several architectural commissions, including his first built work, a clubhouse in Beauvallon, near Saint-Tropez, completed in 1927.[31] Beauvallon marked Chareau's earliest collaboration with the Dutch architect Bernard Bijvoet, who became his partner in all subsequent architectural projects in France. That same year Edmond Bernheim asked Chareau to design Vent d'Aval, a country villa in the Côte d'Azur, which he did with the help of Bijvoet. In 1926 their nephew Paul Bernheim had turned to Chareau to provide the interiors of the Grand Hôtel in Tours, including a private apartment for himself and his wife (pages 58–61, 260–61).

Chareau's most famous commission, the Maison de Verre in Paris (1928–32), was designed for Edmond Bernheim's daughter Annie and her husband, Jean Dalsace.[32] Chareau had already made the furniture and interior of their first apartment, on the Boulevard Saint-Germain. They were cultivated and discriminating in their tastes, and like the elder Bernheims, recommended Chareau to friends and family. Their new home functioned as the epicenter for an important segment of the French intelligentsia. Dalsace, who had joined the Communist party in 1920, was acquainted with a coterie of left-leaning writers such as Louis Aragon, Paul Éluard, and André Breton. Chareau participated in many of the cultural events that took place in the Maison de Verre, where he met members of the intellectual elite and fellow artists such as Max Ernst, Joan Miró, and Jean Lurçat. The site of lectures, concerts, and social events, the house became famous early on, and foreign architects often asked to visit it.[33]

Annie's cousin Madeleine Bernheim and her husband, Edmond Fleg, were also staunch supporters of Chareau and, like the Dalsaces, remained close to Dollie long after his death. In 1924 Fleg published an important essay on Chareau, who designed their apartment in Paris, and in 1928 gave his only known public lecture there, accompanied by slides (page 30).[34] This was followed by a highly unusual guided tour of the flat with the Chareaus and the Flegs leading parts of the audience by turns. Fleg (born Flegenheimer) was a prominent

The interior of the first apartment of Jean and Annie Dalsace on the Boulevard Saint-Germain, Paris, designed by Chareau, commissioned in c. 1923. It featured fabric-covered walls, fur pillows, and velvet upholstery on the divan. Left: the sitting room; right: Chareau's 1925 pochoir print, based on it.

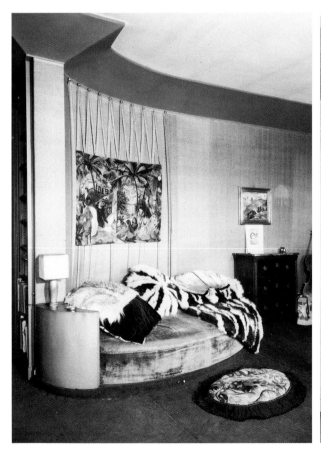
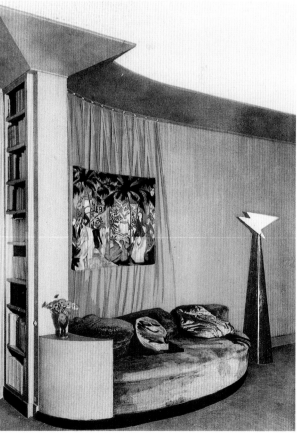

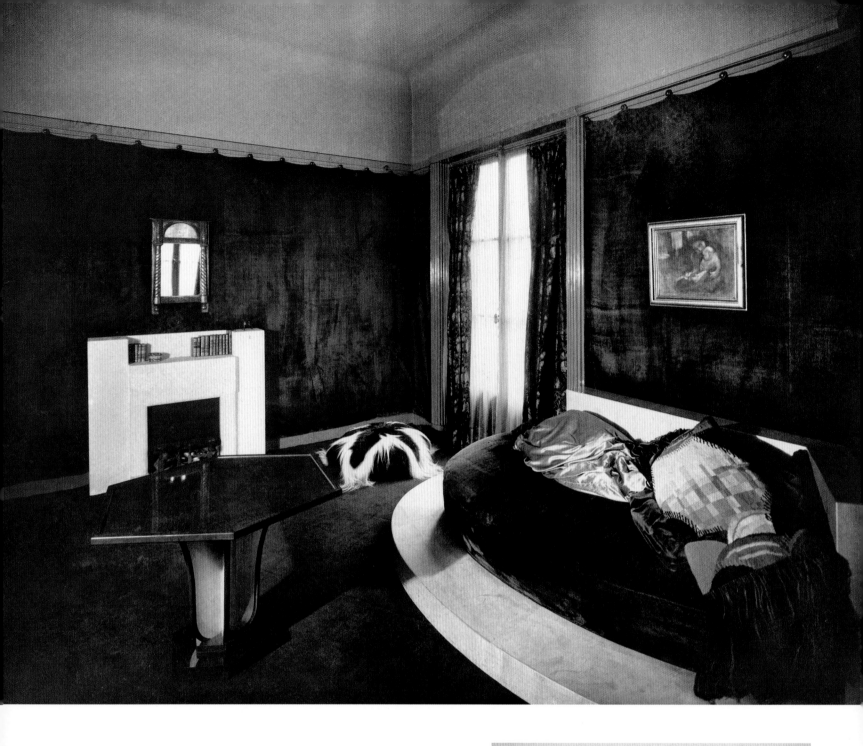

The apartment of Madeleine and Edmond Fleg, 1A Quai aux Fleurs, Paris, designed by Chareau, 1920.

Advertisement for Chareau's two shops published in the *Nouvelle Revue Française*, 1927, listing, significantly, light fixtures, fabrics, wallpaper, and exhibitions of modern paintings.

intellectual and playwright who made Judaism the core of his writing. In 1929 Chareau produced stage sets for Fleg's *Merchant of Paris* at the Comédie Française. The play is a critical reinterpretation of Shakespeare's *Merchant of Venice* in which Shylock is transformed into an altruistic Jew who donates his factory to his workers. Chareau had considerably less freedom here than in his cinema sets, since the characters were not meant to be fashionable members of high society, and his designs received mixed reviews.[35]

The Chareaus loved the performing arts and had their own little salon long before the Maison de Verre was built. They counted musicians, artists, dancers, and architects among their friends: Chana Orloff, Lipchitz, Milhaud, Poulenc, Lurçat, Henry, the poet and critic Max Jacob, Mallet-Stevens, the modiste Paul Poiret, the dancer Djémil Anik, and the actors Georges and Ludmilla Pitoëff.[36] Rose Adler recalled the general warmth of their hospitality in her journal: "Pierre and Dollie create hyphens with their hearts."[37] Yet Dollie confided in a letter that "those with whom we were intimate were above all our clients."[38] There is no denying the gravitational pull of emulation: as the circle of clients grew, the Chareaus became patrons themselves and began collecting art. Surrounded by so many intellectuals, it is not surprising that Chareau branded his interiors, as we would say today, with remarkable avant-garde work by his friends. By doing so he was also claiming a place for himself in the rarefied sphere of the arts. This same strategy led him to advertise his work not in the magazines of the profession such as *Art et Décoration* or the elegant *Les Arts de la Maison,* as did his peers, but rather in *La Nouvelle Revue Française,* which was addressed to the literary intelligentsia.

DOLLIE CHAREAU

It is largely through Dollie's letters and interviews that we know something about Chareau's personal life. Born in London, Dollie came from a distinguished Sephardic family that had produced generations of physicians. When she was fifteen her father died, and as a result of bad investments Dollie and her mother

found themselves in need of income: "At fifteen, I had never done my own hair nor put on my shoes. At sixteen I was nursery governess to seven children."[39] Eager for independence, Dollie left for Paris. She was a gifted English teacher who inspired lifelong affection among her pupils, two of whom were the cousins Annie Dalsace and Madeleine Fleg. Dollie was the glue that held Chareau's personal and professional life together: she worked closely with her husband, running his two shops and taking care of the business correspondence. It was Dollie who designed the fashionable cushions one sees in some of her husband's interiors, and on occasion she even exhibited her own work.[40] When necessary, she taught English, and later French, to help support their household. When she was in the United States, Dollie also translated several essays from the French, including some by Jacques Lipchitz, Georges Vantongerloo, and Tristan Tzara.[41]

Cultured and well-spoken, Dollie had studied piano as a child and loved languages and literature. "I have been reading intensely (I read in the night having so little time by day) in English. I am passionately moved by Katherine Mansfield letters and Journal," she wrote to a cousin in 1932.[42] "We read a lot of Rilke who mysteriously was the high point of this summer," she recalled in the late 1930s.[43] Anaïs Nin, their neighbor at Louveciennes, where the couple had a country house, recorded in her journal: "I did not make friends with them at the time because I heard her voice over the hedge, telling the gardener or the maid what to do, and it was so loud and strong and authoritative that I shied away from her invitations. For me, at the time, she became another plump, forceful, domineering mother. I was very ashamed of my aloofness when she wrote me the first fan letter I ever received on the publication on my book on [D. H.] Lawrence."[44]

Despite Dollie's centrality in her husband's life and work, not much has been written about her in the literature on Chareau. Nor was she ever photographed in their home, as was her husband, standing in their beautifully designed living room full of works of art—still labeled in our day as the apartment of Pierre Chareau (page 226). In her lifetime, gender roles remained traditional, and scholarship has followed suit, overlooking her role in this extraordinary partnership. In her day, Dollie was greatly admired for her warmth and friendship. The Australian modernist John Joseph Wardell Power drew a Surrealist portrait of her in 1938. Almost ten years later, Miró inscribed one of his drawings, once in her possession, *Hommage à Madame Chareau, avec toute ma respectueuse sympathie.*

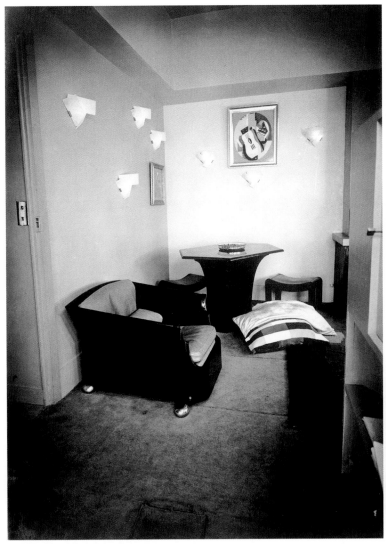
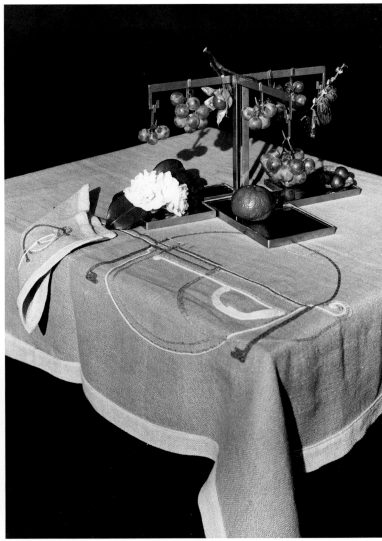

Interior by Pierre Chareau with a cushion
probably by Dollie Chareau.

Dollie designed cushions, throws, tablecloths, and
linens. Chareau's silver-plated grape holder
(page 147) appears here on one of her tablecloths.

John Joseph Wardell Power, *Portrait of Dollie Chareau,*
1938. Ink on paper. Rare Books and Special Collections
Library, Fisher Library, University of Sydney. The portrait
was exhibited in 1938 at Galerie Jeanne Bucher, next door to
Chareau's shop in Paris.

Joan Miró, *Homage to Madame Chareau,* 1947. Color wax
crayon and ink on paper, 10 × 7½ in. (25.5 × 19 cm). Private
collection. The artist's inscription, "with all my respectful
sympathy," suggests the warmth of their friendship.

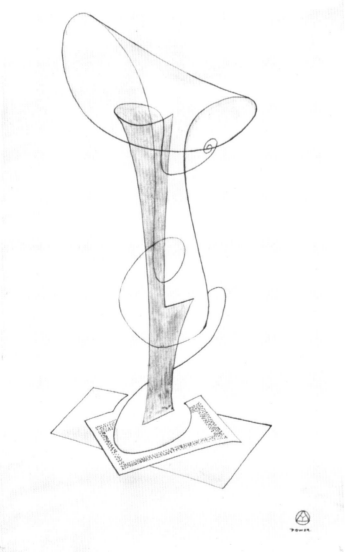

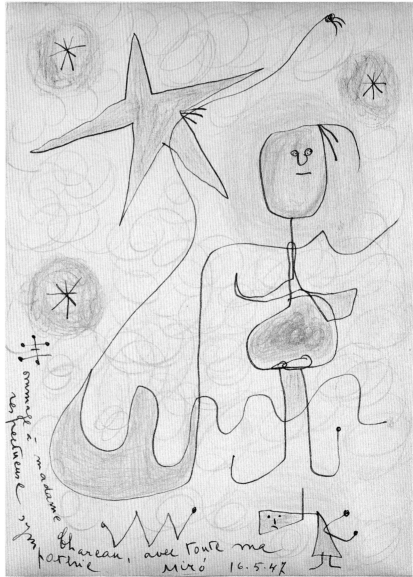

JEWISH IDENTITIES

Chareau's Jewish roots have never been mentioned in publications on his work, and it is to Dollie that we owe valuable information in this respect. Chareau, she wrote to her cousin Harold Rubinstein, was raised a Catholic though "with much Sephardim Jewish blood," a reference, no doubt, to her mother-in-law, Esther Carvallo. Dollie goes on to say that in her own family, intermarriage with an Ashkenazi (like her mother) was considered a mésalliance; "strangely enough," she adds, "I have found that same feeling in my mother-in-law; almost antisemitic in her relations with Jews who were not Mediteraneen."[45] Chareau did not regard himself as Jewish, and he is buried, presumably at his own request, in a Roman Catholic cemetery on Long Island. After his death, Dollie wrote wistfully to their close friend Lipchitz, reminiscing about the Christmas Eve parties that she and her husband used to give at their house in Paris.[46]

And yet Chareau's Jewish identity, which forced his flight from France during World War II, seems to have been taken for granted by his contemporaries. "I think of the Pierre Chareaus in danger because they are Jews,"

Anaïs Nin noted in her diary during the winter of 1939.[47] Until the German occupation, Paris had a large cohort of Jewish designers and architects, including Rose Adler, Jacques Adnet, André Léon Arbus, Gabriel Englinger, Jean-Michel Frank, Noémi Hess, Philippe Hosiasson, Renée Kinsbourg, Claude Lévy, Claude Meyer-Lévy, Bolette Natanson, André Salomon, Charles Siclis, and Noemi Skolnik. There was also a long list of Jewish artists, such as Lipchitz or Orloff, whose work Chareau

The offices of the Lignes Télégraphiques et Téléphoniques (LTT), Paris, designed by Chareau, 1932. The approach he adopted here differed markedly from that he used for his domestic settings. Everything exudes an air of understated elegance, clarity, and calm efficiency; glass partitions separate the different spaces and the metal file cabinets and furniture.

Some of the furniture seized by the Nazis during the Occupation was stored at the Magasin Lévitan, a furniture shop on the Rue du Faubourg Saint-Martin, Paris. Chareau furniture belonging to Roger Waller and Robert Dalsace appears in the inventory of impounded goods compiled after World War II.

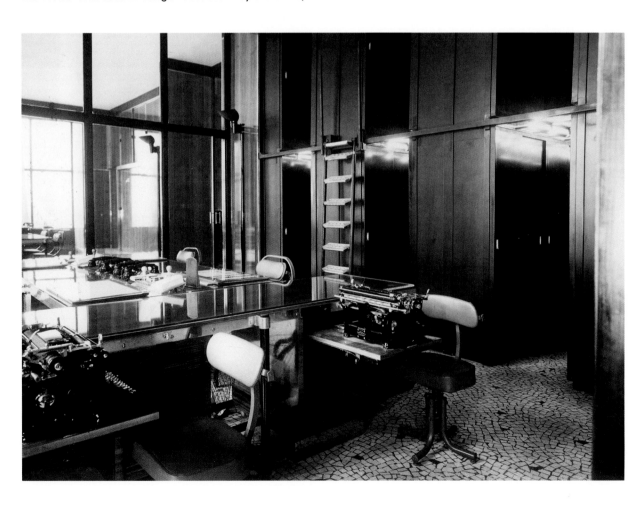

NUMERO de classement	NUMERO O.B.I.P.	ESTAMPILLE	DESCRIPTION	PROPRIETAIRE
№ класси-фикации	№ О.Б.И.П.	Мастерская	Описание	Владелец
Item number	O.B.I.P. number	MARK	DESCRIPTION	OWNER
Laufende Nummer	O.B.I.P. Nummer	MARKE	BESCHREIBUNG	EIGENTÜMER

TABLES ET BUREAUX — СТОЛЫ (ПИСМЕННЫЕ И ПР.) — TABLES AND WRITING-DESKS — TISCHE UND SCHREIBTISCHE

BUREAUX

14090	38.271	De Bardyere	Mobilier de bureau comprenant : un bureau, loupe d'amboine et acajou, cinq tiroirs au milieu, deux de chaque côté, dessus aménagé pour recevoir une glace en verre, quatre pieds très forts, quatre chaises acajou velours chamarré ; une table carrée, dessus marbre, incrustations sycomore blanc	M. Gaston Lazard
14091	38.482	Blanqui	Table-bureau de noyer marron ciré ; pieds à godrons, plateau de glace, doublée soie verte brochée, deux tiroirs avec serrures, larg. env. 70 cm, long. env. 120 cm .	M. André Schuck
14092	33.122	Charreau	Bureau en poirier, entrées serrure ivoire	M. Roger Waller
14093	33.326	Pierre Chareau	Mobilier de bureau médical comprenant : une table bureau noyer verni, avec tablettes latérales se tirant en petits pupitres — tiroirs à glissière, un fauteuil de bureau en noyer verni, couvert de cuir vert ; deux fauteuils noyer verni, couverts en velours tête de nègre, un canapé noyer verni, recouvert velours tête de nègre	M. Robert Dalsace
14094	49.407	Dumas	Table bureau acajou verni, dessus drap gris-clair, recouverte d'une grande glace biseautée ; un fauteuil assorti	M. Pierre La Mazière
14095	32.020	Gallery	Bureau en chêne clair, drap havane, avec fauteuil	M. Andre Kahn
14096	41.109	»	Table bureau acajou avec bronzes	M. François Doutriaux
14097	37.954	Jallot	Petit bureau à cylindre, amboine clair et ivoire	M. Paul Rosenberg
14098	41.201	Henri Kahn	Mobilier de petit fumoir comprenant : un bureau arrondi ; une bibliothèque en laque rouge foncé, un grand canapé-lit en velours marron foncé ; un large fauteuil en velours marron foncé	M. Charles Steindecker
14099	32.583	Krieger	Table bureau acajou et cuivre, larg. env. 170 cm	M. Paul Etlin
14100	33.324	Lincke	Bureau de dame à cylindre, marqueterie, acajou et bronzes	Mme René Mayer
14101	50.600	Linton	Petit bureau acajou, pliant, style anglais	M. Jacques Martignan
14102	38.482	Maggi	Table bureau chêne clair ciré, sculpté à main. Léger creux ménagé dans le plateau et dans ce creux glace, doublée de soie brochée, décor feuilles stylisées de ton bleu-gris-argent, deux tiroirs avec serrure à motif floral sculpté, long. 135 cm, larg. 80 cm	M. André Schuck

often used in his exhibitions, as well as a number of important critics who lent their support to contemporary art: Waldemar George (pseudonym of Jerzy Waldemar Jarocinski), Gustave Kahn, André Levinson, Claude Roger-Marx, Gabrielle and Léon Rosenthal. Among the great Jewish art dealers were Josse and Gaston Bernheim, Daniel-Henry Kahnweiler, the Rosenberg brothers, Arnold Seligman, Wilhelm Uhde, and Georges Wildenstein. All flourished, but with the advance of the left-wing Front Populaire and the accession of Léon Blum as prime minister in 1936, all experienced the backlash of the anti-Semitic Right that followed.[48]

Jewish identity was equally relevant when it came to Chareau's clients. Dalbet, his masterful ironsmith, kept records of the orders sent by Chareau's office. As their names indicate, the majority were Jewish. In addition to the Bernheim, Dalsace, and Fleg families, there were, among numerous others, Edmond Bomsel, Georges Boris, Philippe-Jacques Didisheim, Daniel Dreyfus, Madame Jacques Errera, Maurice and Hélène Farhi, Roger Gompel, Charles Guggenheim, Jacques Heim, Alexandre Israel, Marcel Kapferer, Pierre and Georgette Lévy, Armand Moss, Madame Reifenberg, Fernand Simon, the Teplankys, Julia Ullmann, and Raymond Weill (pages 29, 30, 47, 56, 163). Some are known only by surname—Adès, Bodenheimer, Elkan, Grumbach, Lévy, Lévy-Deker, Moscovitz. The list is not complete, as many of Chareau's pieces did not require Dalbet's aid.

These clients were for the most part members of the prosperous upper middle class—writers, attorneys, doctors, intellectuals, government bureaucrats, successful businessmen. Edmond Bomsel, a friend of the Surrealist poet André Breton, was a lawyer and publisher; Pierre Lévy edited the avant-garde magazine *Bifur*.[49] Alexandre Israel and Georges Boris were close to Léon Blum, serving in his cabinet and ministries. Jean Marx, another brilliant intellectual, promoted French culture in the Ministry of Foreign Affairs. In 1932, when work was scarce, he commissioned Chareau to design the Paris offices of the telegraph and telephone company Lignes Télégraphiques et Téléphoniques (LTT) with modern metal furniture (page 34).[50] Chareau, of course, had many supportive non-Jewish clients, but the story of his large Jewish patronage deserves focused investigation, not least because of their shared persecution during the war.

On June 14, 1940, the German army occupied Paris and marched in triumph down the Champs-Élysées. In July, Chareau left for Morocco, where he remained until December, waiting for a visa to the United States. One wonders why he did not go to England, where Dollie had friends and cousins. According to the photographer

Thérèse Bonney, who owned several pieces by Chareau and shot many of his interiors, Chareau had earlier turned down an offer to go to the United States: "But why should I leave my friends, and my home?"[51] Now, eleven years later, he probably hoped to rekindle that same interest in his work.

Dollie stayed behind. In late 1940 or early 1941 she wrote a card—from Vichy, of all places—to Louis Moret, Chareau's young Swiss associate, informing him that her husband was in New York, and that she was giving lessons while awaiting his return.[52] In staying, Dollie was taking a major risk. In October 1940 the collaborationist Vichy government began arresting foreign and French Jews. Anaïs Nin saw her at a party in April 1941. Dollie, she noted, "sent Pierre away from France at a time when he might have been put in a concentration camp as a Jew. 'He was the valuable one to save,' she said. 'The one who could not be replaced. And he is helpless in life, so I stayed to dispose of our belongings and raise a little money for the trip. I am giving French lessons, if you know anyone who is interested.'"[53] Dollie only made her way to safety in the United States a year after her husband, although we don't know under what circumstances.

Chareau's Jewish friends and clients in France struggled through different destinies. Roger Gompel, director of the Paris-France Society, was interned at the deportation camp at Royallieu and survived to write a moving account of his experience.[54] Madeleine Fleg's brother, Léonce Bernheim, a gifted lawyer and politician, was arrested with his wife by the Gestapo and sent to Auschwitz, where they both perished.[55] Some of Chareau's patrons managed to flee and preserve all or most of their belongings, but many others had their goods confiscated when, after June 30, 1940, the German occupiers ordered all art objects of the French state, as well as "art objects and historical documents belonging to private parties, and notably to Jews," to be placed in "safety."[56] Furniture was handled by the Möbel-Aktion, or furniture operation.[57] Exceptional pieces were taken temporarily to the Jeu de Paume museum.

Some of Chareau's Jewish clients were victims of spoliation. According to the *Repertory of Goods Stolen in France During the War, 1939–45,* Charles Guggenheim lost a great many pieces of historic furniture and between two and three thousand books, while Roger Gompel lost a sideboard.[58] The records of the notorious Nazi task force, the Einsatzstab Reichsleiter Rosenberg (ERR), includes thirty-one works of art taken from Marcel Kapferer.[59] In 1941 the Gestapo took thirty-two boxes of books from the home of Edmond and Madeleine Fleg.[60] Although modern furniture was not

always recorded, two interiors that Chareau had done for the physician Robert Dalsace (unrelated to Jean Dalsace) were sequestered, as was a desk belonging to Roger Waller.[61] The work of identifying and locating cultural goods seized by the Nazis continues to this day.

The cultural biography of Chareau's furniture has yet to be written.[62] Today, his works are increasingly finding their way to the market, their value enhanced by his resistance to mass production and his firm belief in the ethics of making. These unique pieces are also a testimony to the intricate web of relationships that bound the Chareaus to both patrons and craftsmen, the community of taste and skill that formed the coordinates of their private and professional lives. As such, each of Chareau's pieces is a mute witness to a rarefied cultural milieu as well as to its violent destruction. The diaspora of objects and the circuitous routes by which they have found their way to new owners, museums, or high-end showrooms traces the afterlife of cultural artifacts and the sometimes tragic events that become the indelible inlay of their history.

NOTES

1. Dollie Chareau, "Pierre Chareau," *L'Architecture d'Aujourd'hui,* no. 31 (September 1950): vii; Olivier Cinqualbre, "Un Destin en Pièces," in *Pierre Chareau, Architecte: Un Art Intérieur,* exh. cat. (Paris: Centre Pompidou, 1993), 13.

2. Quoted in Léon Moussinac, *Le Meuble Français Moderne* (Paris: Hachette, 1925), 42. All translations, unless otherwise indicated, are the author's.

3. Ernest Tisserand, "Chronique de l'Art Décoratif: La Chambre à Coucher, Pour Avoir Frais; L'Art Décoratif au Cinéma," *L'Art Vivant*, no. 39 (August 1926): 586. Tisserand reviewed the nursery favorably but deplored the warlike theme of the wallpaper in a room for children.

4. Chareau's last project before leaving France in 1940 was a home for a colonial soldier for the exhibition *France d'Outre-Mer,* organized by the Ministry of the Colonies. The furniture was made with wood recycled from containers.

5. Ernest Tisserand, "Chronique de l'Art Décoratif: La Chambre à Coucher, Le Métal," *L'Art Vivant,* no. 38 (July 1926): 537. Charles Baudelaire, "L'Invitation au Voyage," published in *Les Fleurs du Mal* (1857): "Là, tout n'est qu'ordre et beauté, / Luxe, calme, et volupté." Baudelaire goes on to talk of gleaming pieces of furniture burnished by the passing years.

6. Pierre Chareau, *Meubles* (Paris: Éditions d'Art Charles Moreau, 1929).

7. Christian Zervos, "Architecture Intérieure: Enquêtes," *Cahiers d'Art,* no. 1 (January 1926): 14.

8. Pierre Bourdieu, "Introduction," in *Distinction: A Social Critique of the Judgment of Taste,* trans. Richard Nice (Cambridge, MA: Harvard University Press, 1984), 7.

9. Moussinac, *Le Meuble Français Moderne,* 50, 64.

10. Nadine Lehni and Christian Derouet, *Jeanne Bucher, Une Galerie d'Avant-Garde, 1925–1946: De Max Ernst à de Staël* (Geneva: Skira; Strasbourg: Musées de la Ville de Strasbourg, 1994).

11. Georges Le Fèvre, "Déclarations de Quelques Décorateurs," *L'Art Vivant,* no. 12 (June 15, 1925): 28.

12. Le Corbusier, *L'Art Décoratif d'Aujourd'hui* (Paris: G. Crès, 1925); Henry van de Velde, *Der Neue Stil in Frankreich* (Berlin: Wasmuth, 1925); Moussinac, *Meuble Français Moderne; La Ciutat y la Casa* (Barcelona), no. 5 (1926).

13. Eugene Clute, *The Treatment of Interiors* (New York: Pencil Points, 1926), 104–6.

14. Dorothy Shaver, *An Exposition of Modern French Decorative Art,* exh. cat. (New York: Lord and Taylor: 1928), n.p. For the show, see also Walter Rendell Storey, "France Sends Us Her Decorative Art; A Current Exhibit Reveals the Striking Developments in New Modern Forms," *New York Times Magazine* (February 19, 1928); "Shows French Art to Test Its Value; Lord and Taylor Opens Exhibit of Modern Interiors and Decorative Objects," *New York Times* (February 29, 1928); "French Art Moderne Exposition in New York: Lord and Taylor's Imports Work of Famous Artists," *Good Furniture Magazine* (March 1928): 119–22; Walter Rendell Storey, "Decorative Art a Blend of Many Ideas," *New York Times* (June 16, 1929).

15. Lewis Mumford, "Modernist Furniture," *New Republic* (March 21, 1928): 154–55. "Art Exhibit Closes," *New York Times* (April 8, 1928). In 1930–31 Chareau exhibited at the International Exhibition of Metalwork and Cotton Textiles at the Boston Museum of Fine Arts, the Metropolitan Museum of Art, the Art Institute of Chicago, and the Cleveland Museum of Art. See Charles R. Richards, *International Exhibition of Metalwork and Cotton Textiles: Third International Exhibition of Contemporary Industrial Art* (Portland, ME: Southworth Press, 1930).

16. Émile Sedeyn, "La Décoration Moderne au Cinéma," *L'Art et les Artistes,* no. 20 (October 1921–February 1922): 159.

17. Léon Moussinac, "Le Décor et le Costume au Cinéma," *Art et Décoration* (July 1926): 138.

18. Robert Mallet-Stevens, "Le Cinéma et les Arts, l'Architecture," *Les Cahiers du Mois,* nos. 16–17 (1925): 95; *Le Décor Moderne au Cinéma* (Paris: Charles Meunier, 1928).

19. Fernand Léger, "A New Realism—The Object (Its Plastic and Cinematographic Value)" (1926), originally published in *Little Review* (Paris) 11, no. 2 (Winter 1926): 7–8; repr. in *Theories of Modern Art: A Sourcebook by Artists and Critics* (Berkeley: University of California Press, 1970), 279. Emphasis in the original.

20. As the critic and film director Jean Epstein wrote, "Moreover, cinema is a language, and like all languages it is animistic; it attributes, in other words, a semblance of life to the objects it defines." Jean Epstein, "On Certain Characteristics of Photogénie" (1924), in *French Theory and Criticism: A History/Anthology, 1907–1939,* vol. 1, ed. Richard Abel (New York: Princeton University Press, 1988), 316.

21. Sedeyn, "Décoration Moderne au Cinéma," 154–55.

22. Quoted in Luc Wouters, "Cinéma et Architecture," in Jean-François Pinchon et al., *Rob Mallet-Stevens: Architecture, Mobilier, Décoration* (Paris: Sers, 1986), 100.

23. Ricciotto Canudo, "La Leçon du Cinéma," *L'Information,* no. 286 (October 23, 1919), repr. in *L'Usine des Images* (Paris: Nouvelles Éditions Séguier, 1995), 43. On this issue see also Prosper Hillairet, *"L'Inhumaine,* L'Herbier, Canudo, et la Synthèse des Arts," in *Marcel L'Herbier: L'Art du Cinéma,* ed. Laurent Véray (Paris: Association Française de Recherche sur l'Histoire du Cinéma, 2007), 101–8.

24. Ruttmann, flush with the success of his *Berlin: Die Sinfonie der Großstadt* (1927), wanted to capture the acoustic landscape of Berlin's urban environment. Walter Ruttmann, "Berlin als Filmstar," *Berliner Zeitung* (September 20, 1927), repr. in *Walter Ruttmann: Eine Dokumentation,* ed. Jeanpaul Goergen (Berlin: Freunde der Deutschen Kinemathek, 1989). A second showing of *Weekend,* on June 20, 1930, was hosted by the Dalsaces, who were among Chareau's earliest patrons; Christophe Gauthier, *La Passion du Cinéma: Cinéphiles, Ciné-Clubs et Salles* (Paris: École des Chartes, 1999), 201.

25. The Chareaus had already hosted Ruttmann in their country house at Louveciennes and introduced him to their circle of intellectual friends. Rose Adler, *Journal, 1927–1959,* ed. Hélène Leroy, preface by François Chapon (Paris: Éditions des Cendres, 2014), 19, 37.

26. Mo Amelia Teitelbaum, *The Stylemakers: Minimalism and Classic Modernism, 1915–1945* (London: P. Wilson, 2010), 102.

27. Quoted in André Gain, "Le Cinéma et les Arts Décoratifs," *L'Amour de l'Art,* no. 9 (September 1928): 326–27.

28. Paul Overy, "Visions of the Future and the Immediate Past: The Werkbund Exhibition, Paris 1930," *Journal of Design History* 17, no. 4 (2004): 337–57.

29. Quoted in Guillaume Janneau, *Formes Nouvelles et Programmes Nouveaux* (Paris: Bernheim Jeune, 1925), 9.

30. Pierre Chareau, "La Création Artistique et l'Imitation Commerciale," *L'Architecture d'Aujourd'hui,* no. 9 (September 1935): 68.

31. Dollie claims that it was Edmond Bernheim who allowed Chareau to "realize his dream of becoming an architect"; Dollie Chareau, "Pierre Chareau," vii.

32. On the Maison de Verre, see the essay by Brian Brace Taylor and Bernard Bauchet in this volume, where Chareau's collaboration with the engineer Bernard Bijvoet is discussed. Bijvoet's role was of enormous importance, though it is difficult to reconstruct how the two men worked together.

33. *Pierre Chareau: Archives Louis Moret* (Martigny, Switz.: Fondation Louis Moret, 1994), 12.

34. Edmond Fleg, "Nos Décorateurs: Pierre Chareau," *Les Arts de la Maison* 2 (Winter 1924): 17–27. On the lecture, see Liliane Sarcey, "La Visite de l'Appartement," *Conferencia,* no. 23 (November 15, 1926): 538–39.

35. It was reviewed by Maurice Brillant, who mentions Chareau's sets, in "Les Oeuvres et les Hommes," *Le Correspondant* (March 25, 1929): 935–39. Illustrations appear in *La Petite Illustration Théâtrale,* no. 429 (May 4, 1929). On Fleg, see Edmond Fleg, *Pourquoi Je Suis Juif* (Paris: Les Éditions de France, 1928).

36. René Herbst, *Un Inventeur: L'Architecte Pierre Chareau* (Paris: Éditions du Salon des Arts Ménagers, 1954), 9–10.

37. Adler, *Journal, 1927–1959,* 19.

38. Dollie's letter is quoted in Marc Vellay and Kenneth Frampton, *Pierre Chareau: Architect and Craftsman, 1883–1950* (New York: Rizzoli, 1990), 27. On Chareau's collecting and his relationship with contemporary artists, see Kenneth E. Silver's essay in this volume.

39. Dollie Chareau, *My Father* (Pawlet, VT: Banyan, 1960), 8.

40. In 1939 Dollie had an exhibition of her work at the Galerie Jeanne Bucher-Myrbor, Paris.

41. Among her translations are *Juan Gris, 1887–1927,* exh. cat., intro. by Jacques Lipchitz, trans. from the French by Dollie Pierre Chareau (New York: Buchholz Gallery, distrib. by Wittenborn, 1944); *Georges Vantongerloo, Paintings, Sculptures, Reflections,* trans. from the French by Dollie Pierre Chareau and Ralph Manheim (New York: Wittenborn, Schultz, 1948); and *Henri Rousseau,* exh. cat. (New York: Sidney Janis Gallery, 1951). For Robert Motherwell's anthology *Dada Painters and Poets* (New York: Wittenborn, Schultz, 1951), she translated a letter by the writer Jacques-Henry Levesque. Nin mentioned that Dollie was translating stories from *Under a Glass Bell;* Anaïs Nin, *The Diary of Anaïs Nin,* vol. 4, ed. Gunther Stuhlmann (New York: Harcourt, Brace, 1969), 60–61.

42. Dollie Chareau, letter to Harold Rubinstein, 14 August 1932, Pierre and Dollie Chareau Collection, box 1, Department of Rare Books and Special Collections, Princeton University Library. Dollie's English, like her French, was idiosyncratic.

43. Quoted in *Pierre Chareau: Archives Louis Moret,* 105. The poet Rainer Maria Rilke was a friend of Jean Lurçat and the Pitoëffs.

44. Nin, *Diary of Anaïs Nin,* 3:110.

45. Dollie Chareau, letter to Harold Rubinstein, 1 February 1932, Pierre and Dollie Chareau Collection, box 1, Department of Rare Books and Special Collections, Princeton University Library. Harold Rubinstein was a solicitor and playwright. He and Dollie had the same great-grandfather.

46. Dollie Chareau, letter to Jacques Lipchitz and his wife, 20 December 1959, Jacques Lipchitz Papers, Archives of American Art, Smithsonian Institution, Washington, DC.

47. Nin, *Diary of Anaïs Nin,* 3:4.

48. After the outbreak of the Spanish Civil War, Chareau, like many of his friends, signed the manifesto "Déclaration des Intellectuels Républicains au Sujet des Événements d'Espagne," published in *Commune; Revue Littéraire Pour la Défense de la Culture* (December 1936).

49. On Lévy, see Catherine Lawton-Lévy, *Du Colportage à l'Édition—BIFUR et les Éditions du Carrefour, Pierre Lévy, un Éditeur au Temps des Avant-Gardes* (Geneva: Éditions Métropolis, 2004), 112–14.

50. On Marx, see André Reboullet, "Jean Marx (1884–1972) Entre-Deux-Guerres," in *Changements Politiques et Statut des Langues: Histoire et Épistémologie, 1780–1945,* ed. Marie-Christine Kok-Escalle and Francine Melka (Amsterdam: Rodopi, 2001), 119–27.

51. Thérèse Bonney and Louise Bonney, *Buying Antique and Modern Furniture in Paris* (New York: Robert M. McBride, 1929), 41.

52. *Pierre Chareau: Archives Louis Moret,* 110.

53. Nin, *Diary of Anaïs Nin,* 3:110.

54. Roger Gompel, *Le Camp Juif de Royallieu-Compiègne 1941–1943* (Paris: Éditions Le Manuscrit, 2007), 21–110.

55. Michel Dreyfus and Catherine Nicault, "Léonce Bernheim, Avocat et Militant Sioniste," *Archives Juives* 47 (January 2014): 146–53.

56. Quoted in Rose Valland, *Le Front de l'Art: Défense des Collections Françaises, 1939–1945* (Paris: Plon, 1961), 235.

57. Sarah Gensburger, *Images d'un Pillage: Album de la Spoliation des Juifs à Paris, 1940–1944* (Paris: Éditions Textuel, 2010).

58. In 1947–49 the French government produced a multivolume documentation of stolen works, the *Commandement en Chef Français en Allemagne, Répertoire des Biens Spoliés en France Durant La Guerre 1939–1945,* 8 vols., with 6 supplements and index. For the furniture, see Ministry of Culture and Communication, "Répertoire des Biens Spoliés en France Durant la Guerre 1939–1945," vol. 3, *Meubles,* http://www.culture.gouv.fr/documentation/mnr/RBS/T_3.pdf. For the books, see Mémorial de la Shoah, "Liste Définitive," http://www.memorialdelashoah.org/upload/minisites/bibliotheques_spoliees/document/personnes.pdf.

59. ERR Project, "Cultural Plunder by the Einsatzstab Reichsleiter Rosenberg: Database of Art Objects at the Jeu de Paume," http://www.errproject.org/jeudepaume.

60. Commission Française des Archives Juives, "Nouvelle Liste de Personnes Spoliées," http://www.cfaj.fr/publicat/Nouvelle_liste_spolies_janv_2011.pdf.

61. Furniture by Chareau belonging to Robert Dalsace and Roger Waller appears in the *Commandement en Chef Français en Allemagne,* 3:507.

62. On this concept, see Igor Kopytoff, "The Cultural Biography of Things: Commoditization as Process," in *The Social Life of Things: Commodities in Cultural Perspective,* ed. Arjun Appadurai (Cambridge: Cambridge University Press, 1986), 64–91.

Interior Design

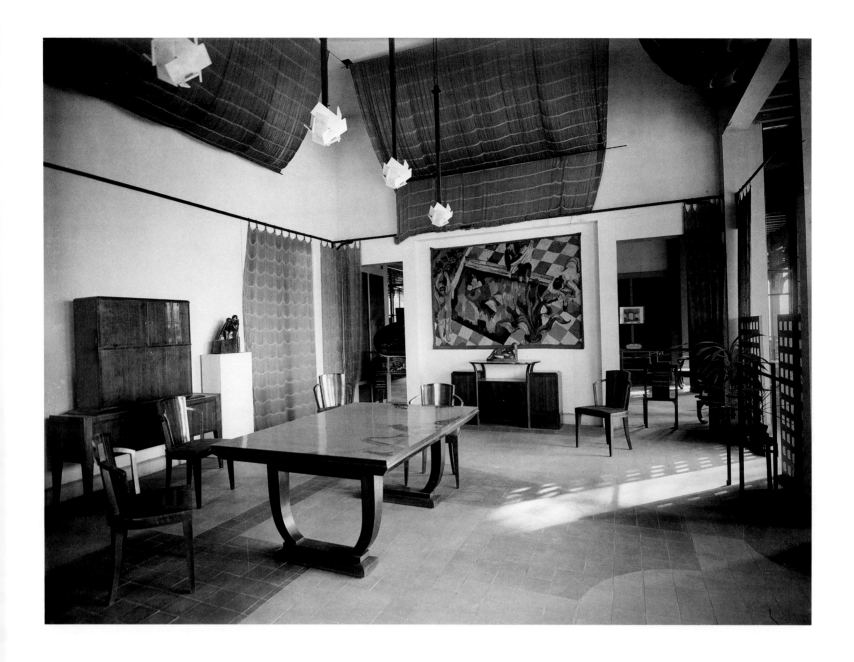

Dining room, Indochinese pavilion, Exposition
Internationale des Arts Décoratifs et Industriels
Modernes, Paris, 1925, with furniture by Chareau and
sculptures by Chana Orloff.

Chareau, dining room, Indochinese pavilion, Exposition
Internationale des Arts Décoratifs et Industriels
Modernes, Paris, 1925. Gouache on paper, 8½ ×
11¼ in. (21.5 × 28.5 cm). Musée National d'Art Moderne,
Centre Pompidou, Paris

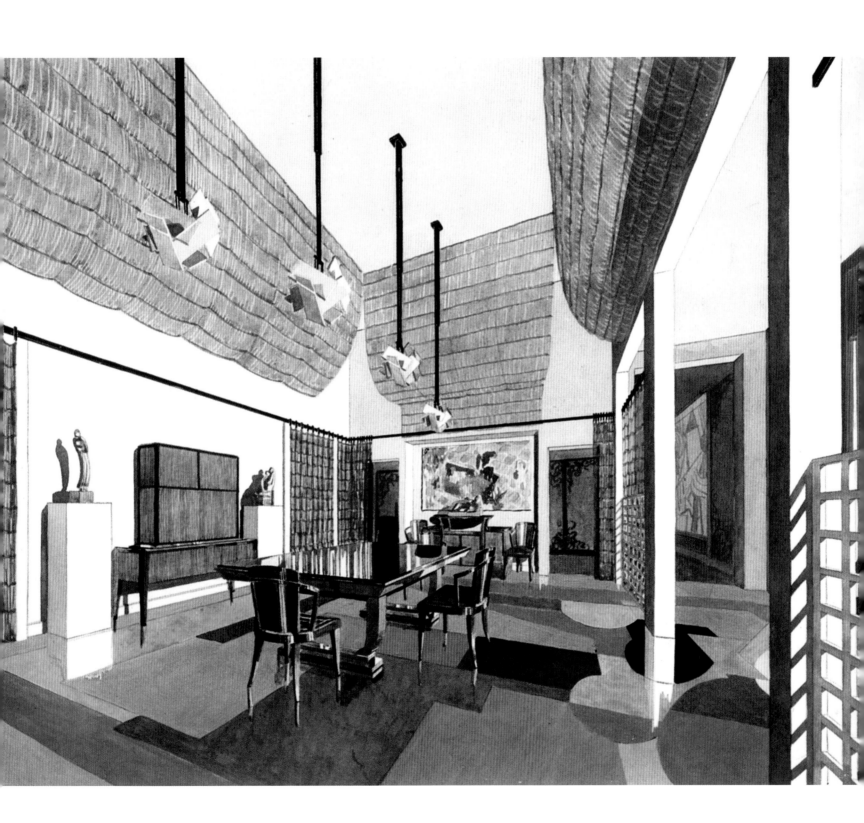

44

The Villa Noailles at Hyères, in the south of France, was
commissioned by Charles and Marie-Laure de Noailles and
designed by Robert Mallet-Stevens, 1923–27. The mirror,
framed by two wall lamps, is by Chareau, as are the armchair
and stool at center, upholstered in a printed fabric
designed by the painter Raoul Dufy.

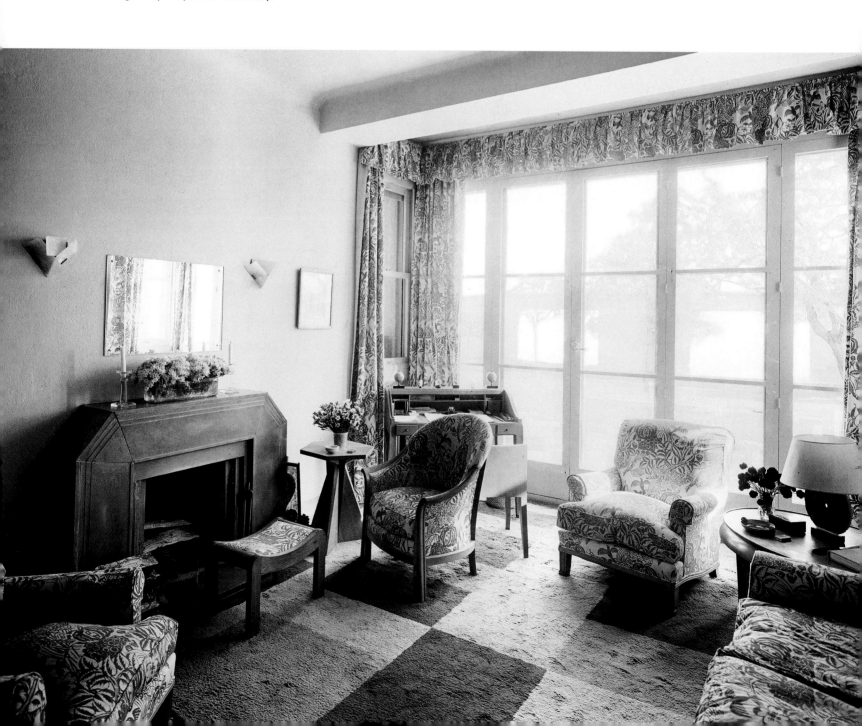

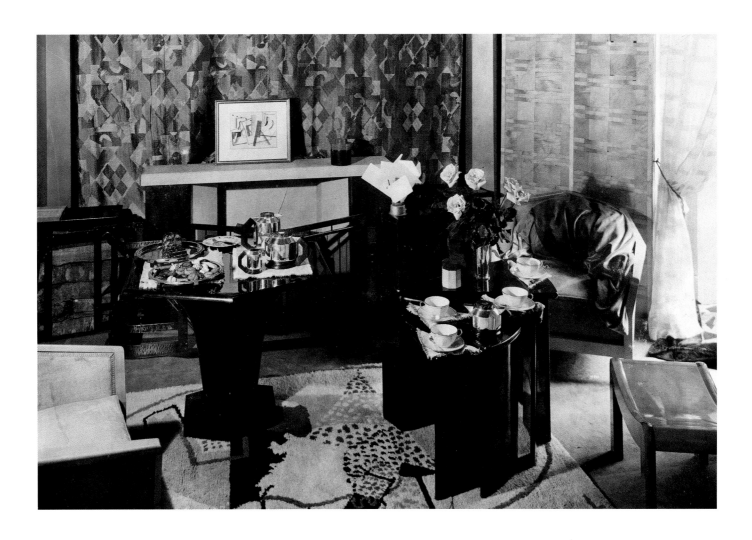

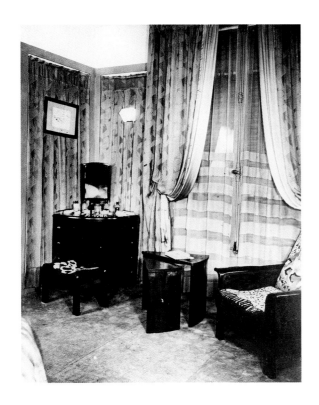

Furniture ensemble by Chareau, c. 1925, with pedestal table (MB170), occasional table (MB106), stool (SN1), and armchair (MF172), and silverware by Jean Puiforcat.

Dressing room designed by Chareau with fan table, vanity, stool, and armchair, c. 1925.

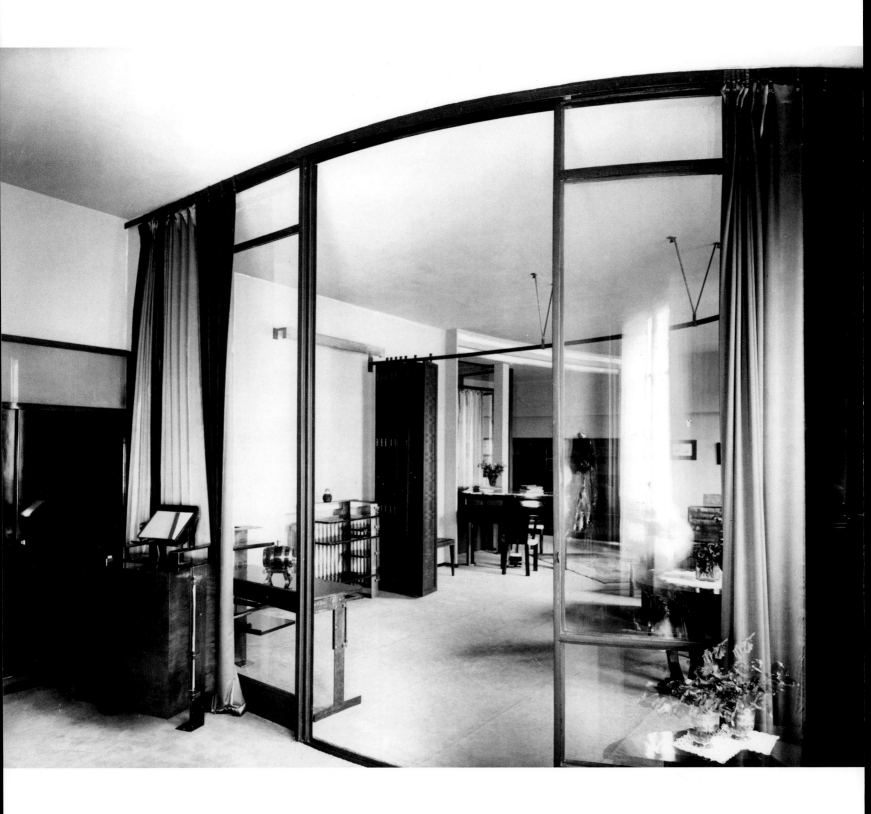

Apartment of Maurice and Hélène Maus-Bloch Farhi,
designed by Chareau, Paris, 1930–31.

Living room of the Daniel Dreyfus apartment in Paris, with a movable partition, designed by Chareau, 1932.

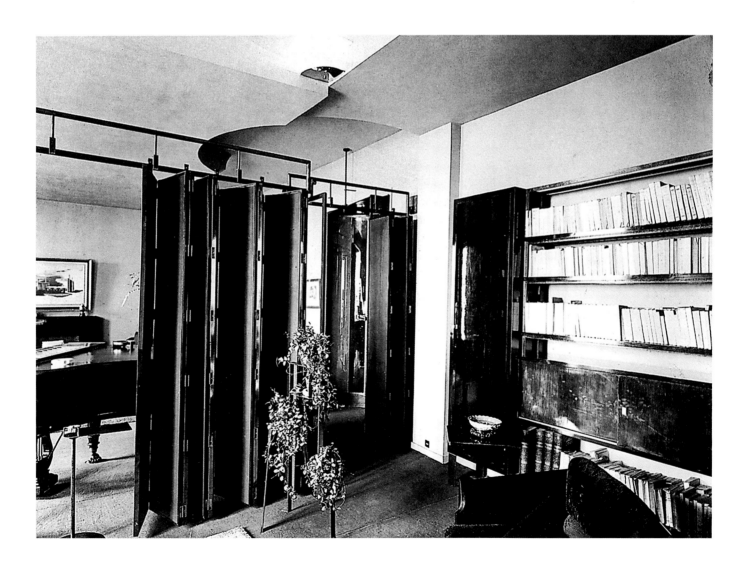

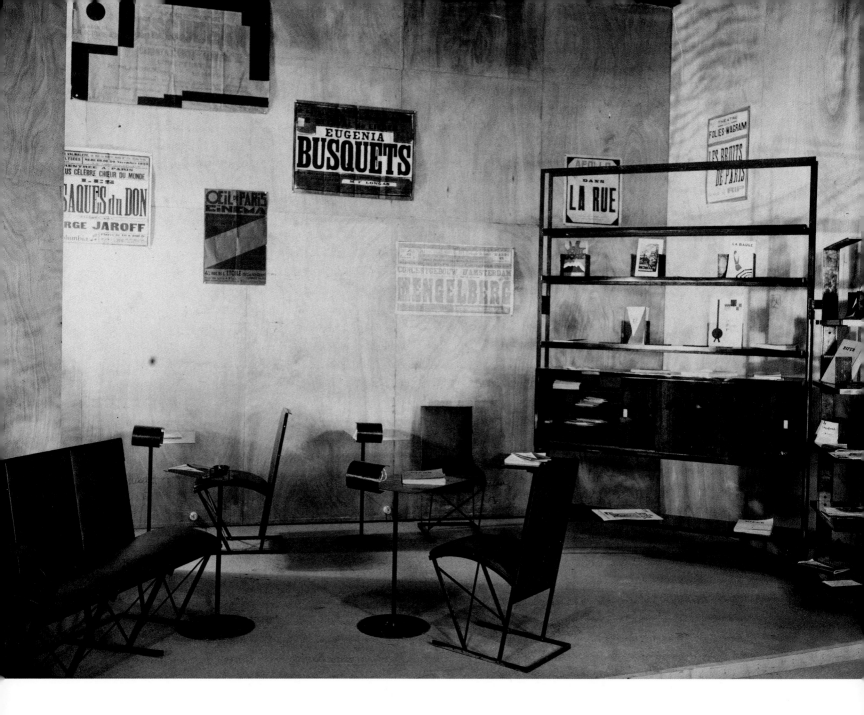

The Union
des Artistes Modernes

In 1929 progressive designers broke away from the
Société des Artistes Modernes to found the Union
des Artistes Modernes (UAM). One of their first
projects was to design the headquarters of the weekly
magazine *La Semaine à Paris.* Chareau, who was
invited to participate, produced metal furniture for
several interiors in collaboration with Louis Dalbet, and
was singled out for his daring use of black moleskin
(imitation leather) on the ceiling.

Office of *La Semaine à Paris,* 1929, with
metal bench (MP671), chairs (MC767),
and bookshelves by Chareau in walnut
and wrought iron. The ensemble was
shown at the Salon d'Automne that year.

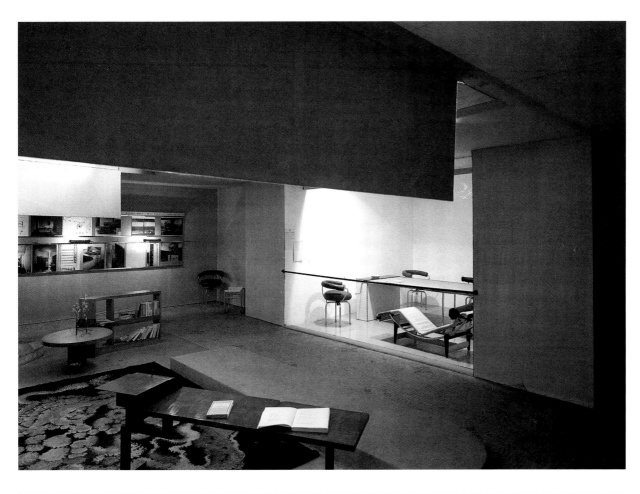

The first exhibition of the Union des Artistes Modernes, Paris, 1930. In the foreground is a display of works by Chareau: a pearwood desk, and a small desk and corner cabinet in mahogany. Other works are by Charlotte Perriand, Le Corbusier, and Pierre Jeanneret.

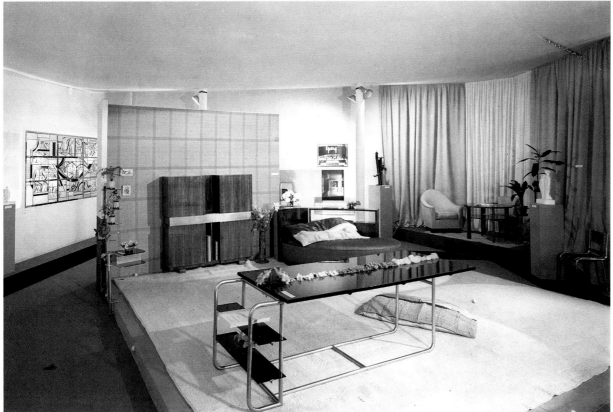

The fourth exhibition of the Union des Artistes Modernes, Paris, 1933. Chareau showed a glass-mosaic table, a divan, and a sideboard.

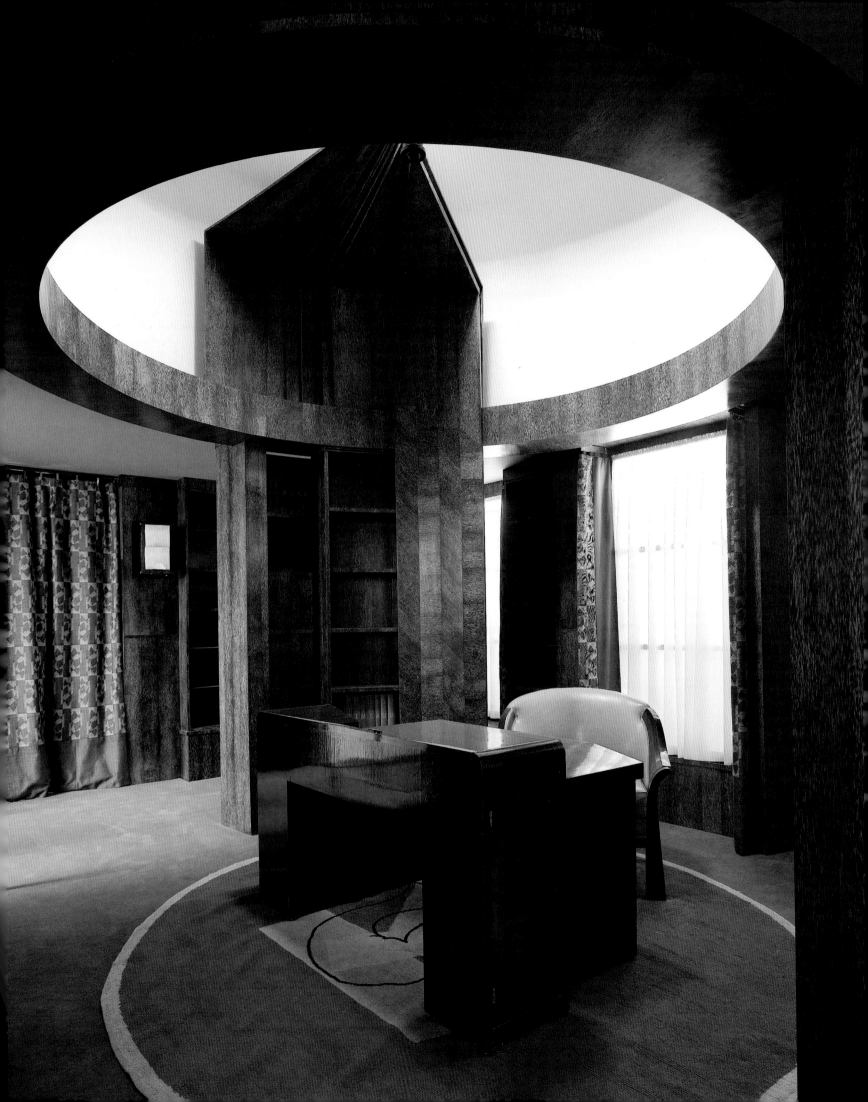

A variation on the French embassy library and study,
designed by Chareau in 1927.

Opposite
Library and study designed by Chareau for a
proposed French embassy, created for the 1925
Exposition Internationale des Arts Décoratifs
et Industriels Modernes, Paris.

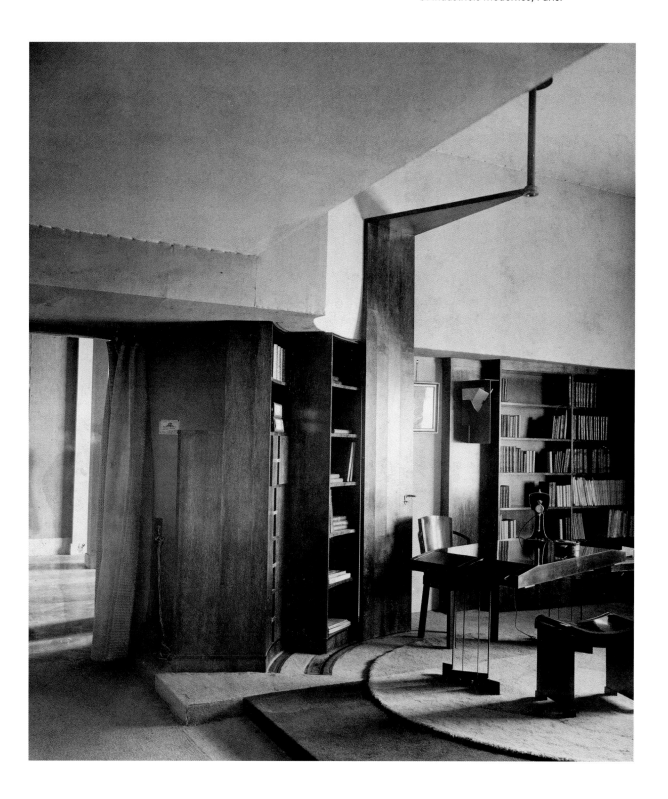

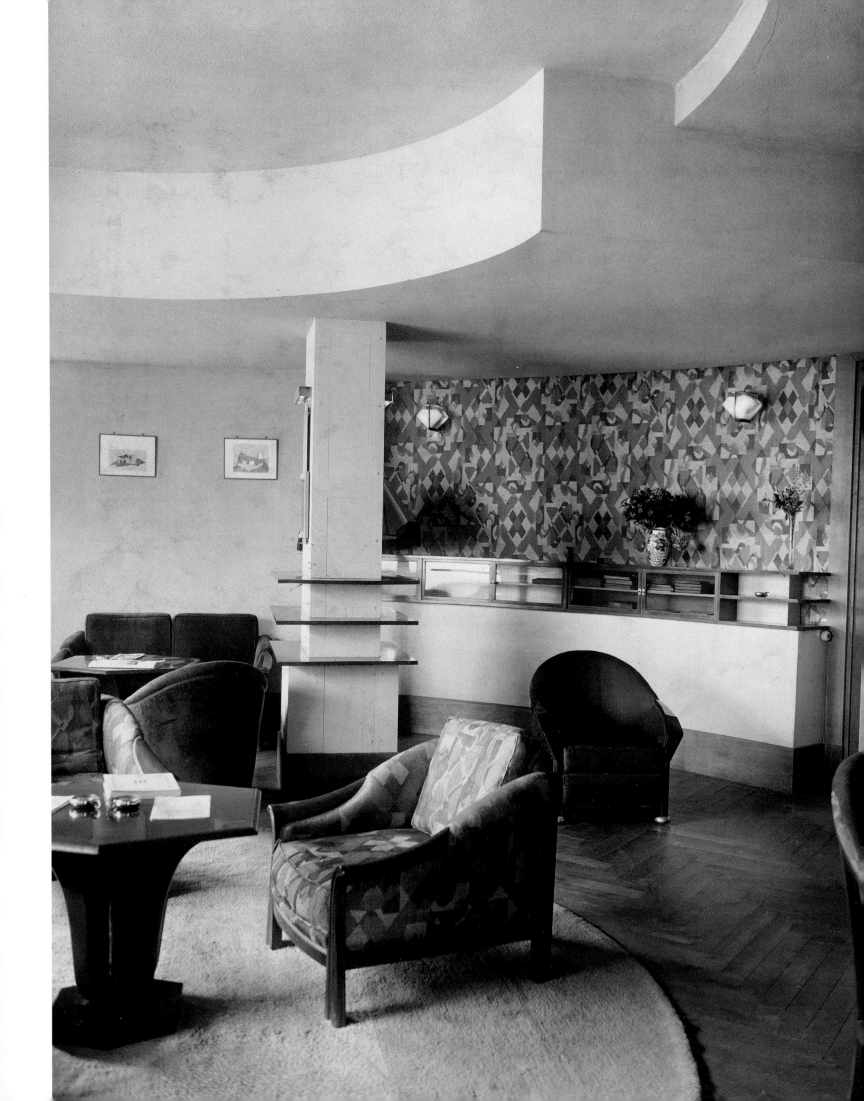

Ceilings

Few of Chareau's interiors were designed for new construction. Most often he had to insert them into traditional apartment buildings, many dating to the nineteenth century. To weld architecture and design into a harmonious whole, he often knocked down walls and inserted sliding partitions to create larger, fluid rooms. With artful placement of lamps and fixtures, he contrasted natural and artificial light. Most distinctively, he found an infinite variety of ways to alter and shape the ceiling, making it a crucial element of the interior, rather than a passive part of the background.

A dropped ceiling designed by Chareau conceals lighting, with a lamp on the side.

Opposite
Salon in the Grand Hotel de Tours, 1927, with armchairs (MF158 and SN37) and table (MB170) by Chareau.

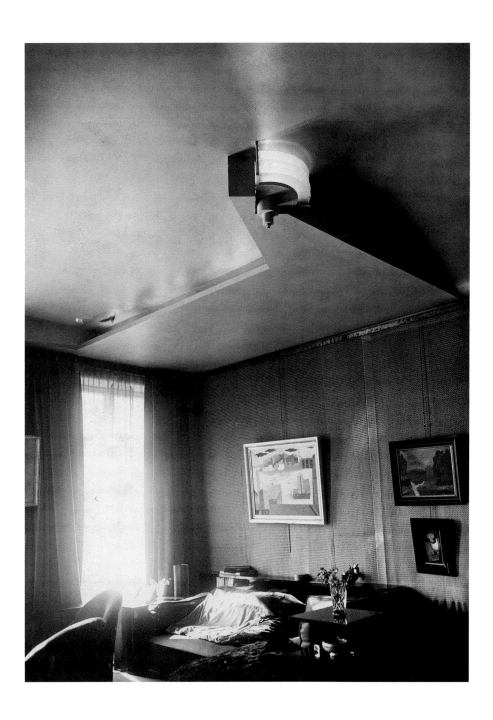

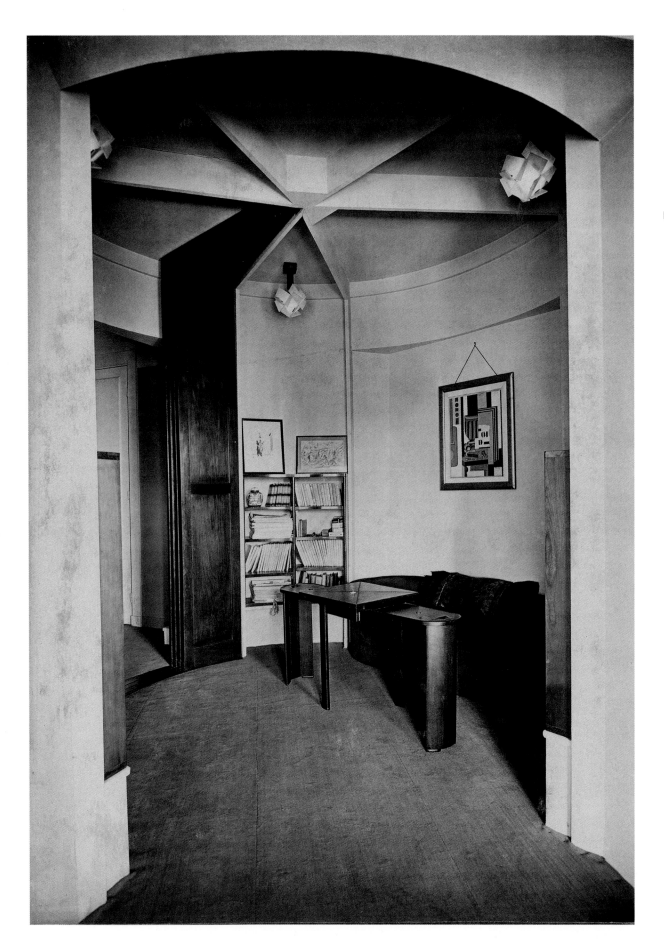

The Lanique apartment, Paris, 1923–24, with Chareau's characteristic fan-shaped enclosure. Fernand Léger's 1925 *Still Life (The Glass)* hangs on the wall above a *Handkerchief* game table designed by Chareau.

A vaulted ceiling designed by Chareau, with wallpaper by Jean Lurçat.

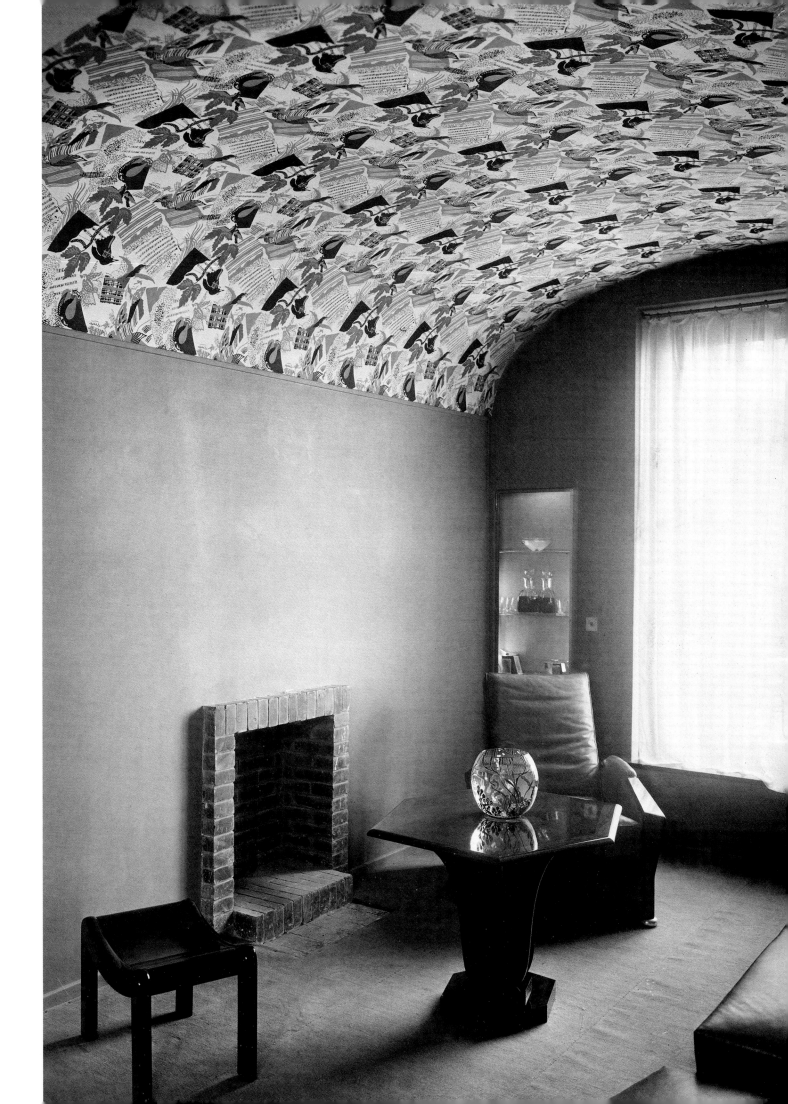

Chareau's dining room in Villa Reifenberg,
built by Robert Mallet-Stevens, 1927–28, at
8 Rue Mallet-Stevens, Paris.

A living room designed by Chareau, c. 1928.

The Grand Hôtel, Tours

In 1926 Paul Bernheim asked Chareau to design the interiors of the Grand Hôtel in Tours in central France. This was Chareau's first large-scale commission beyond one-family apartments, and he rose to the occasion with a suite of rooms, each with distinctive furniture, colors, and textures, according to its function.

The smoking room had adjustable fan-shaped mahogany panels that opened and closed, separating it from the bar, green leather lounge chairs, and walls of mahogany tiles. The floor was gray and green rubber. The small tables were mahogany and wrought iron.



The *bar-fumoir* shows one of Chareau's layered ceilings with unexpected lighting effects.

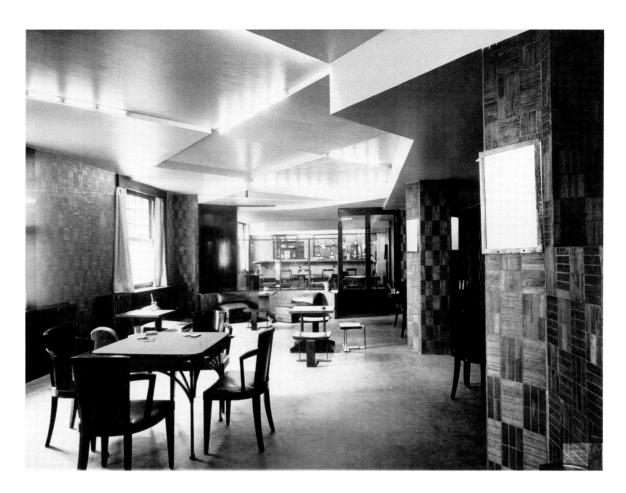

Furniture in the dining room was oak. Lighting was in bands of small alabaster plaques inset into walls and ceiling.

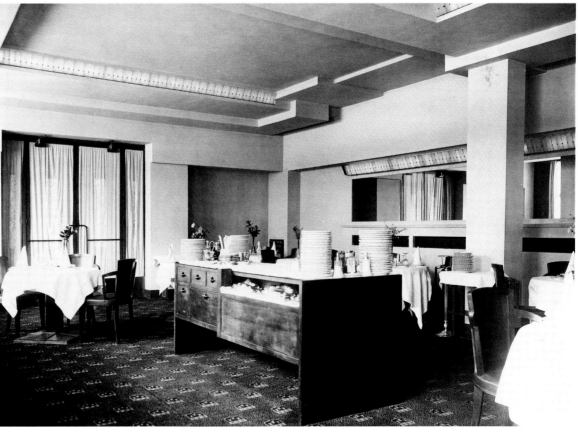

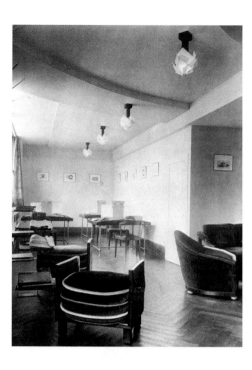

The writing room.

The reading room of the Grand Hôtel had silver
patterned wallpaper and oak furniture upholstered in velvet
or in brown-and-silver or gold-and-silver fabric.

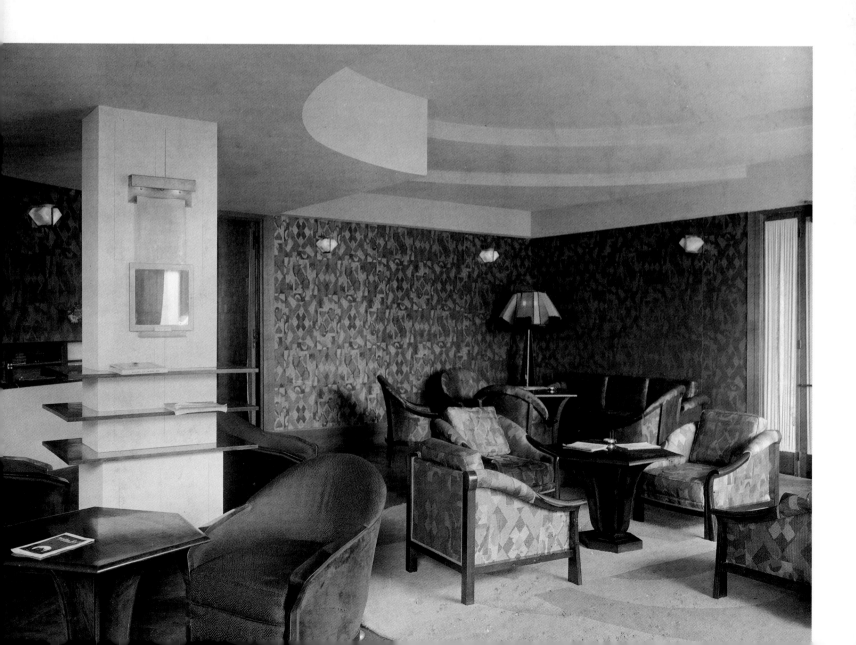

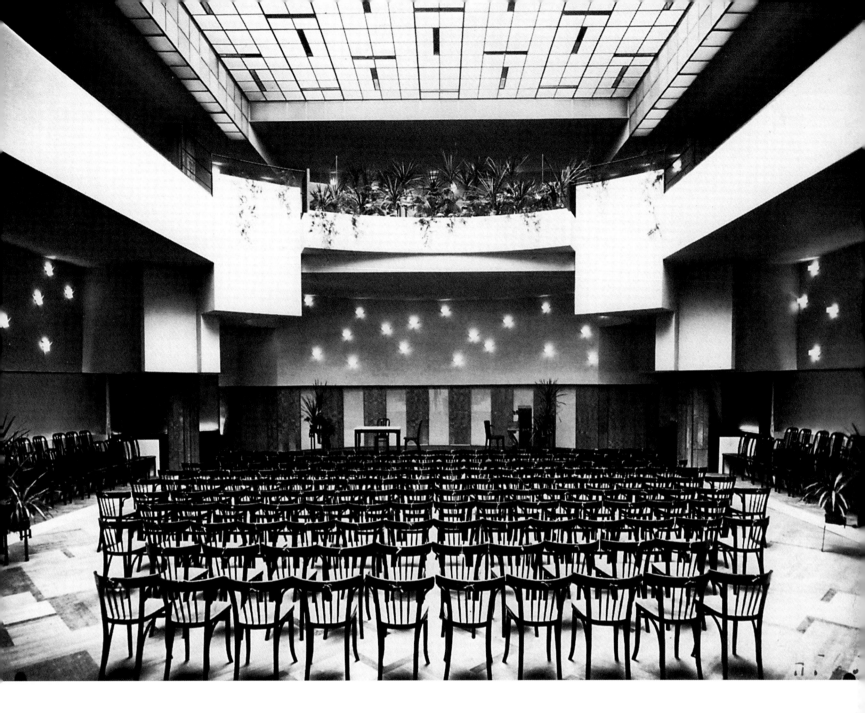

The auditorium, with an elegant glass ceiling and
alabaster sconces on the walls.

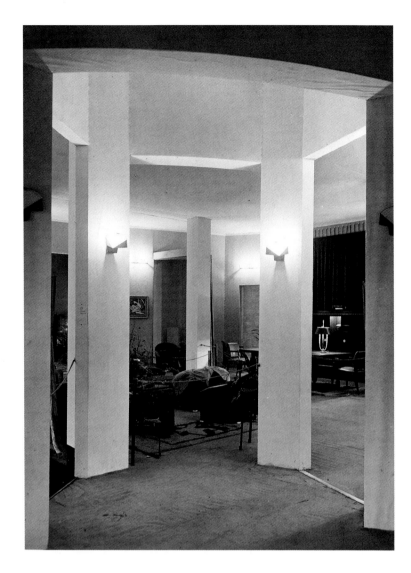

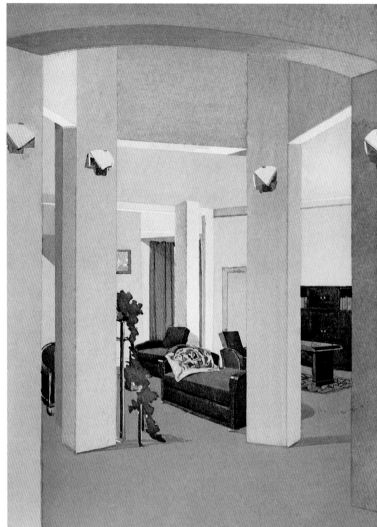

A vestibule with furniture designed by
Chareau, shown at the Salon d'Automne, 1924.

Pochoir print based on the display at the Salon,
published in *Les Arts de la Maison*
(Winter 1924).

Pochoir Prints

A suite of furniture exhibited by Chareau in 1922, published in *Les Arts de la Maison* (Winter 1924). Chareau's signature pieces could be combined in endless variations and adapted to rooms of different dimensions and characteristics.

Pochoir prints, based on the use of stencils, were a favored means of expression of the *ensembliers* of the 1920s and 1930s, who reproduced entire interiors in vivid color. The painstaking work by hand transformed the print into a form of art aimed at the elite and published in luxurious portfolios.

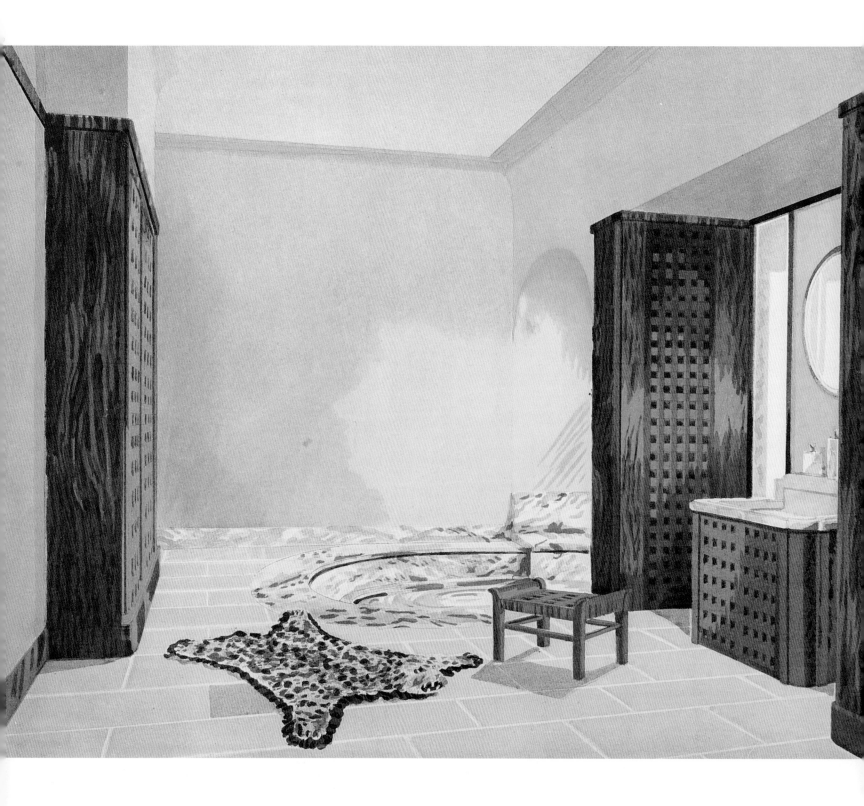

A bathroom designed by Chareau, shown at the Salon d'Automne, 1920, published as a pochoir print in Jean Badovici's 1925 portfolio *Intérieurs Français*.

A bedroom designed by Chareau for Edmond and Madeleine Fleg, Paris, 1920, published as a pochoir print in Jean Badovici's 1925 portfolio *Intérieurs Français*.

A bedroom designed by Chareau for the Dalsace family, 1919, published as a pochoir print in Jean Badovici's 1925 portfolio *Intérieurs Français*.

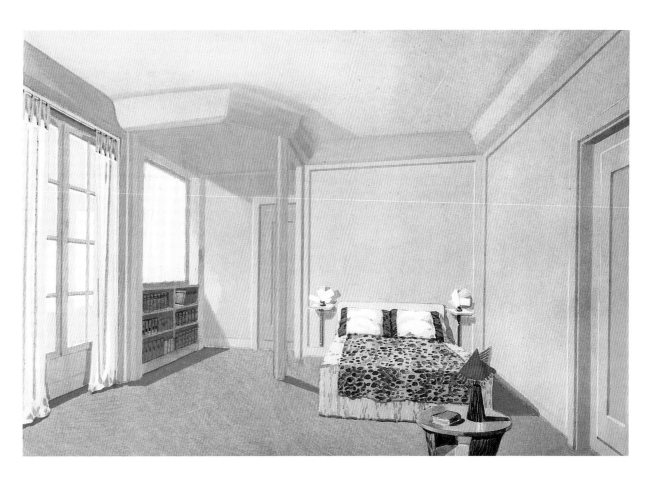

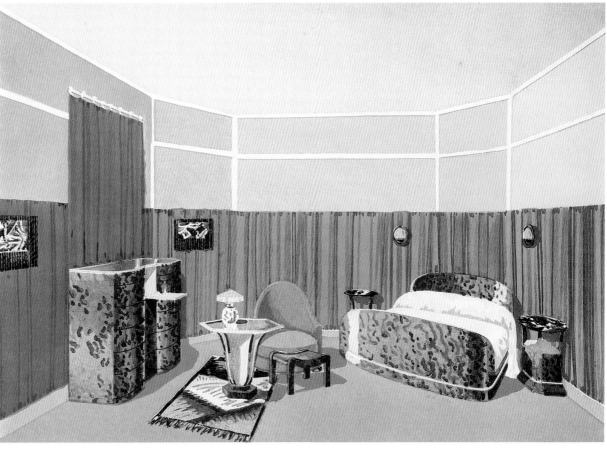

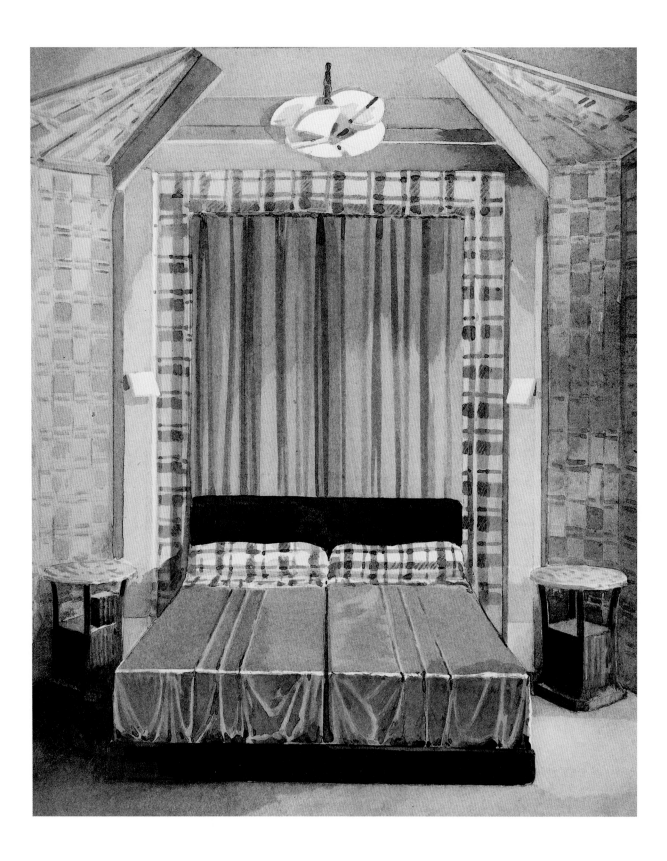

A bedroom shown by Chareau at the 1922
Salon des Artistes Décorateurs, published
as a pochoir print in *Les Arts de la Maison*
(Winter 1924). The ceiling lamp is reproduced
on page 137.

Gouaches

Chareau produced a series of beautiful interiors in gouache. Although these were presented with the same plunging perspectives as the pochoir prints, they usually had a sharper definition that allowed for a clear view of details and textures.

Chareau, sketch for a living-room suite in tubular metal, designed for the third exhibition of the Union des Artistes Modernes, 1932
Gouache on paper
Private collection, Paris

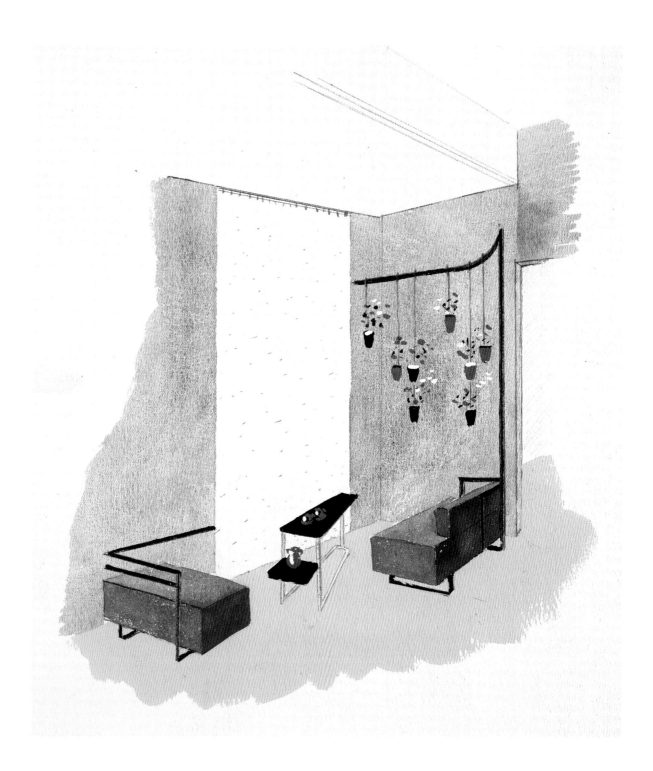

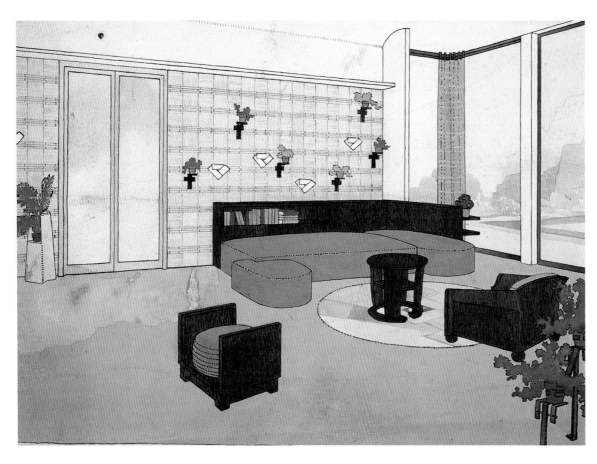

Chareau, sketch for a
living room, c. 1930
Gouache on paper
Private collection, Paris

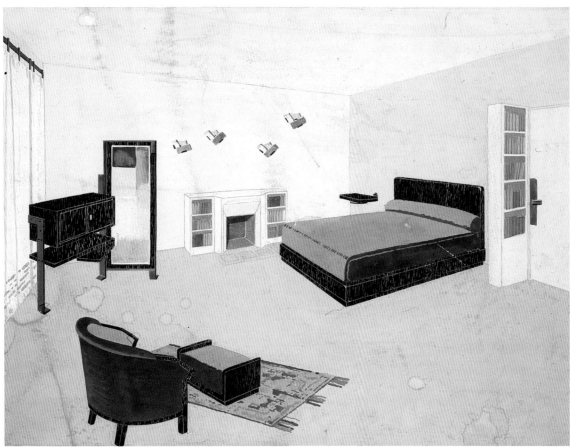

Chareau, sketch for a
bedroom, c. 1925
Gouache on paper
Private collection, Paris

Chareau, sketches for a
bedroom (right) and living room
(below), c. 1929
Gouache on paper
Private collection, Paris

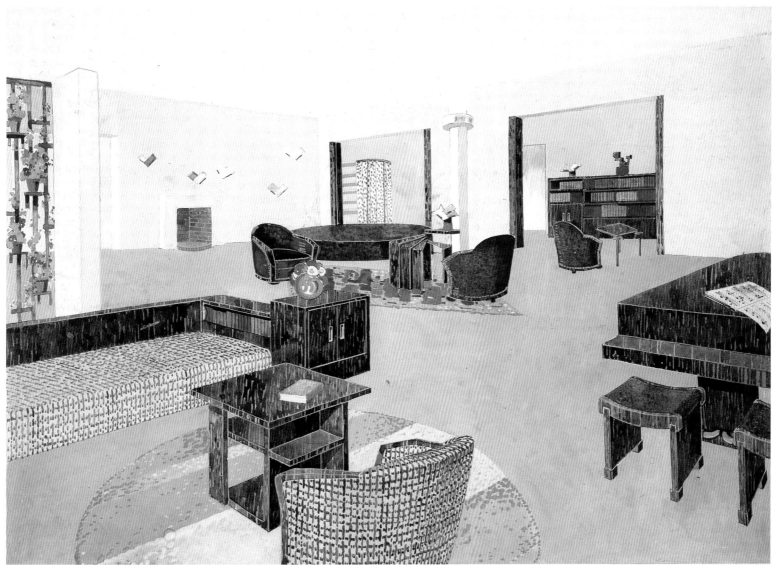

Film

Chareau contributed furniture to three films by the avant-garde director Marcel L'Herbier, *L'Inhumaine* (1924), *Le Vertige* (1926), and *L'Argent* (1928), and one by Henri Étiévant and Mario Nalpas, *La Fin de Monte-Carlo* (1927).

The boudoir of the heroine in Marcel L'Herbier's *L'Inhumaine*, with furniture by Chareau and a screen by Jean Lurçat. In the background is a Picasso collage, *Glass and Bass Bottle on a Table*, 1913, that also appears in a photograph of Chareau's own apartment.

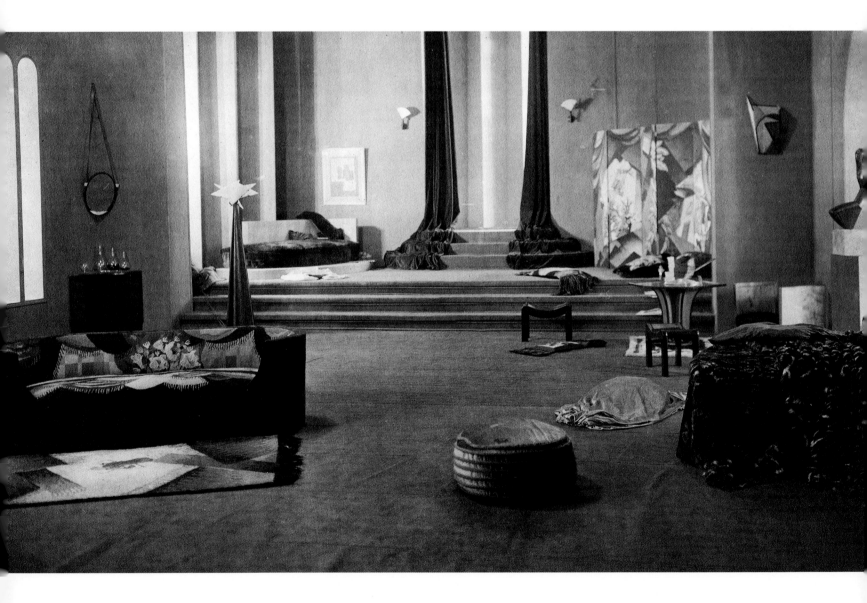

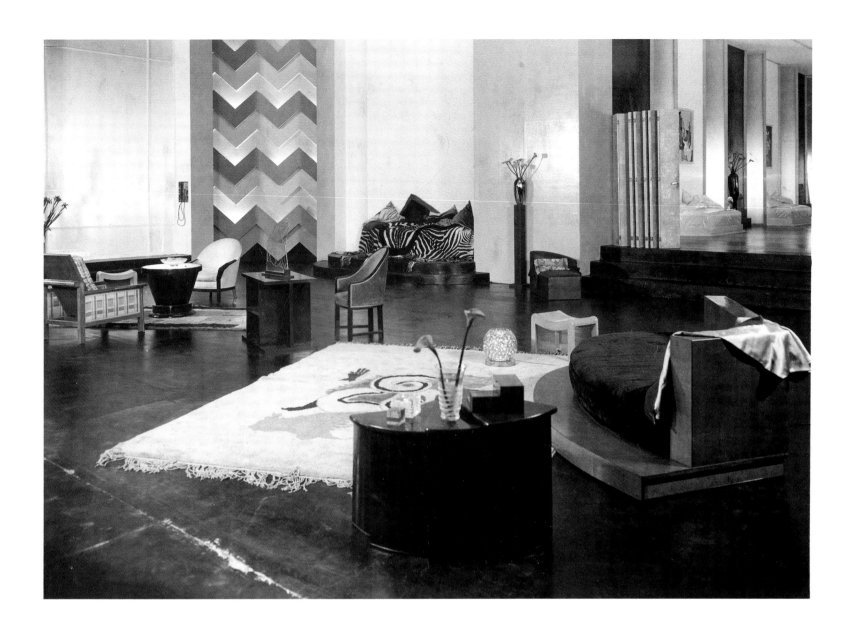

For L'Herbier's *L'Argent,* Chareau
provided his fan table and several
side tables and chairs, including a
chauffeuse, a wooden stool, and
club chairs.

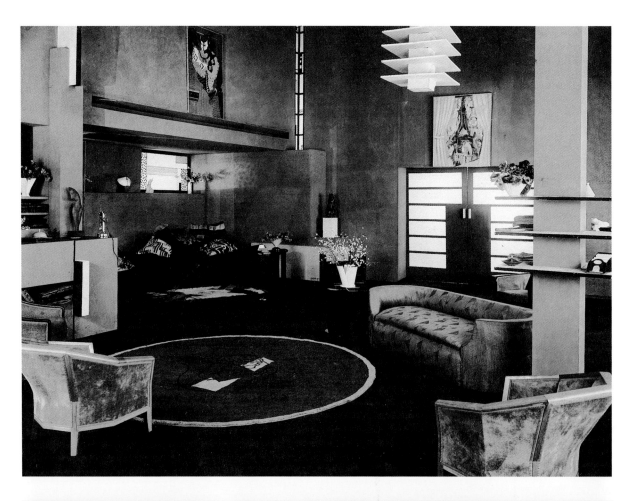

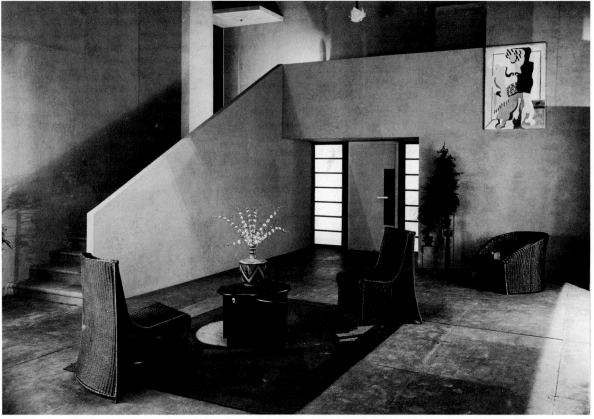

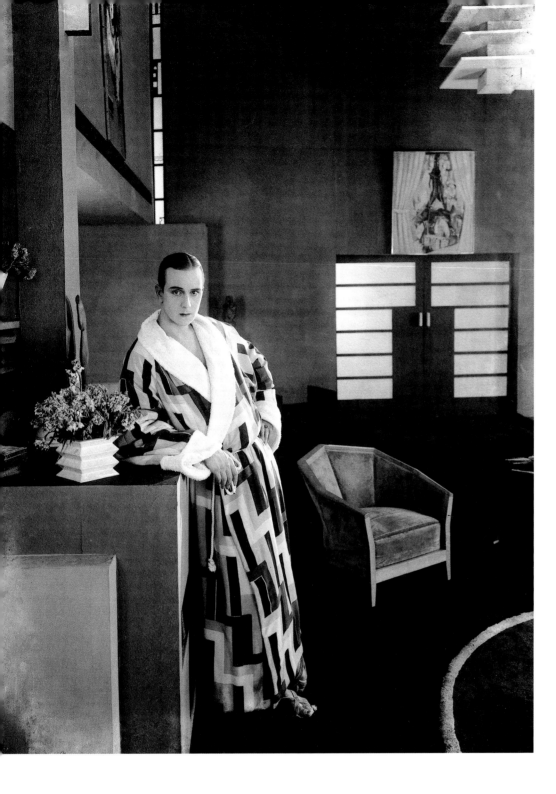

L'Herbier's *Le Vertige* has furniture by
Chareau, architecture by Robert Mallet-
Stevens, sets by Alberto Cavalcanti,
Chareau, and Fernand Léger, and carpets
and a picture by Jean Lurçat. The actor
Jaque Catelain wears a "Simultaneous" robe
by Sonia Terk Delaunay; in the background
is a painting by Robert Delaunay, *The Tower
Behind Curtains*, 1910.

Opposite, above
Le Vertige, with chairs and sofa by Chareau,
Jean Lurçat's painting *The Algerian Woman,*
1924, and a Lurçat carpet.

Opposite, below
This set from L'Herbier's *Le Vertige* includes
Chareau's wicker furniture and Jean Lurçat's
painting *The Moroccan,* 1925.

Furnishing fabric, 1924
Designed by Jean Burkhalter for Chareau
Block-printed linen, 39⅜ × 51 in. (100 × 129.5 cm)
Victoria and Albert Museum, London

Furnishing fabric, 1920
Designed by Chareau
Block-printed linen,
38⅝ × 50⅝ in. (98 × 128.5 cm)
Victoria and Albert Museum, London

Le Cigar fabric, 1920–30s
Designed by Hélène Henry for Chareau
Rayon, two-color complementary weft
twill weave self-patterned by areas of
plain and twill interlacing,
30¼ × 50½ in. (76.8 × 128.3 cm)
Art Institute of Chicago, Grace R. Smith
Textile Endowment

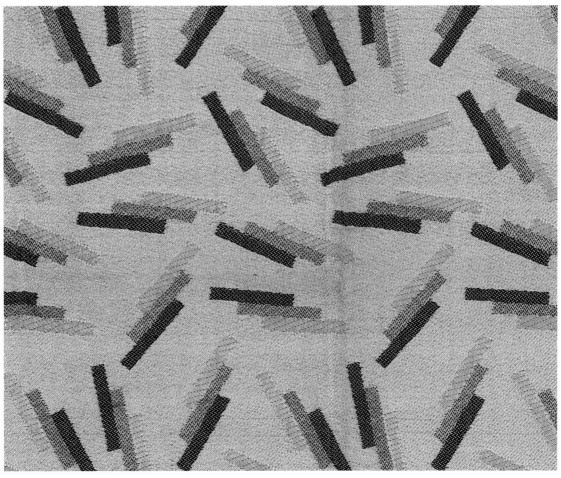

Wallpaper

In his workshop, Chareau distributed wallpaper designed by Jean Lurçat and other colleagues under his La Boutique label. He himself occasionally designed wallpaper, textiles, and apparently carpets, but generally used the work of his friends in his interiors.

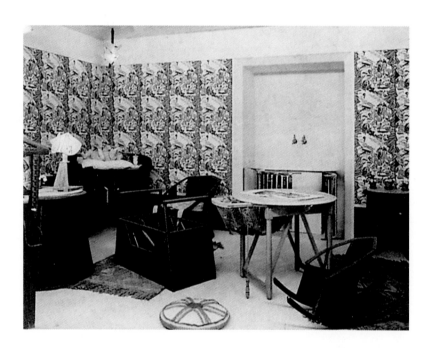

A nursery shown at the Salon des Artistes Décorateurs, 1923, designed by Chareau; the wallpaper has a motif of cars, planes, and tanks, referring to an expedition in the Sahara by the Citroën automobile company in 1922. The Citroën name appears on a tank at upper right.

Opposite
Wallpaper designed by Jean Lurçat
for Chareau, 1923
Block print on paper, 18⅞ × 20⅛ in. (48 × 51 cm)
Cooper Hewitt, Smithsonian Design Museum,
New York, gift of Mrs. Cornelius Sullivan

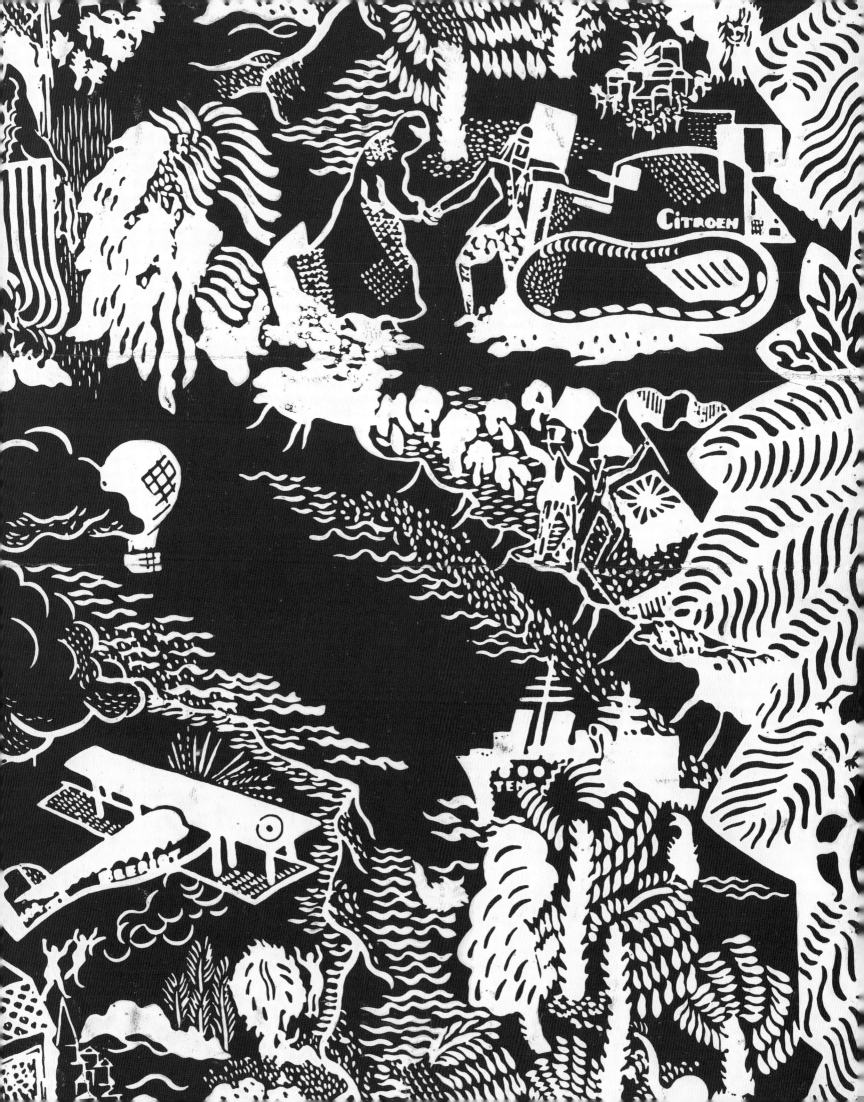

Wallpaper design with musical instruments, c. 1927
Designed by Jean Lurçat, probably for Chareau

Opposite
One Who Loves Writes on the Walls, wallpaper, c. 1924
Designed by Jean Lurçat for Chareau
Block print on paper, 18⅞ × 20⅛ in. (48 × 51 cm)
Cooper Hewitt, Smithsonian Design Museum, New York,
gift of Mrs. Cornelius Sullivan

One Who Loves Writes on the Walls, wallpaper, c. 1924
Designed by Jean Lurçat for Chareau
Block print on paper, 18⅞ × 20⅛ in. (48 × 51 cm)
Cooper Hewitt, Smithsonian Design Museum, New York,
gift of Mrs. Cornelius Sullivan

Opposite
One Who Loves Writes on the Walls, wallpaper, c. 1924
Designed by Jean Lurçat for Chareau
Block print on paper, 18½ × 18¾ in. (47 × 47.5 cm)
Cooper Hewitt, Smithsonian Design Museum, New York,
gift of Mrs. Cornelius Sullivan

Block-printed wallpaper
designed by
Jean Lurçat, 1927.

Opposite
Wallpaper designs with
Surrealist musical motifs,
1925–35, distributed
by Chareau.

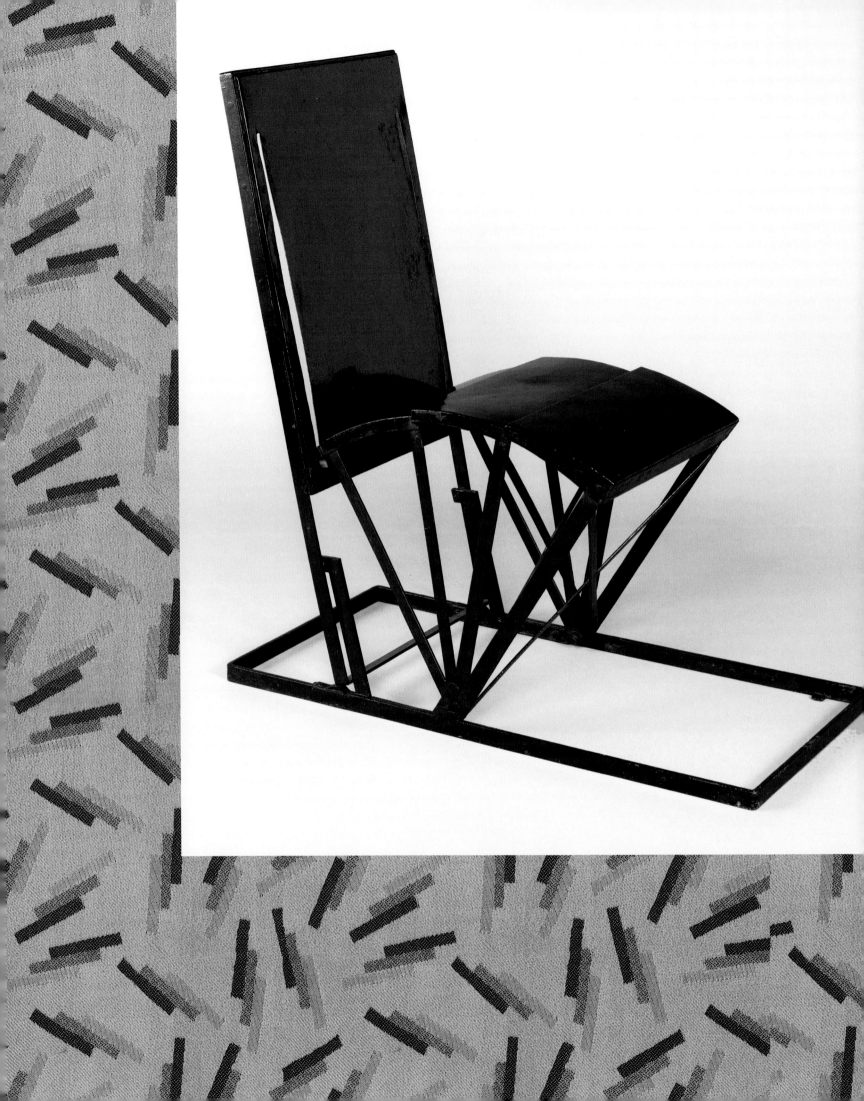

The Unclassifiable Pierre Chareau

Olivier Cinqualbre

After forgetting him for some thirty years, history has remembered Pierre Chareau only as the designer of a single unique building, the Maison de Verre, and as the author of a number of pieces of furniture coveted by certain collectors. It took a pioneering work of scholarship, followed by an exhibition and catalogue, to bring broader attention to his rich and varied career. In these endeavors, his creative output in numerous fields was identified, documented, and analyzed; with many new discoveries, the corpus of work was expanded. A chronology was developed: furniture, interior design, and architecture were integrated in an almost natural progression from object to space, and from decoration to architecture. These classifications have helped to clarify the scope of Chareau's work, and the chronology has established order and sequence. This research has necessarily privileged particular aspects of the work, and set up hierarchies of one area over another.[1]

Chareau's career was concentrated within a relatively short time frame, from the end of World War I to the Great Depression, which struck France fully in 1932. In personal terms, this is the span from his demobilization after the war through a decade of success to an abrupt drop in commissions. This was followed by a period of decreasing work, culminating in his departure from

Europe after the fall of France in World War II, and a last period of exile in the United States. Essentially, he had a mere thirteen years in which to fully exercise his creativity. Yet during this brief period he produced a wealth of extraordinary work; notably, he merged several fields of activity usually considered quite discrete. Chareau's work is marked by a remarkable unity. To understand that aspect of his art, we must reassess his early years, when his approach and vision were established.

Chareau is celebrated as an architect, but produced very few built works. He is a furniture designer whose creations are architectural in conception. He is, in short, difficult to classify. Soon after his death in 1950, his inner circle of friends paid him tribute in a book entitled *Un Inventeur: L'Architecte Pierre Chareau*, published in 1954. As the title suggests, the aim was to confirm Chareau's reputation and legacy. The term *inventor* could not have been more apt; *architect* extends the idea. In the preface, the furniture designer Francis Jourdain sought to capture Chareau's personality with a range of descriptive terms: he was a master of the precious, of the rare, of beauty; a nonconformist, a modern man, a risk taker, a precursor, a poet. "As a poet we may call him an *inventor*," Jourdain declared. "Indeed, it was because he was a poet that he was an *inventor*. Refusing to see any solution to a problem as definitive and not subject to improvement, the inventor had something of the

Folding chair (page 159).

rebel about him." Friendship certainly influenced this enthusiastic judgment, yet one can sense in Jourdain's vocabulary—the proliferation of categories, the use of terminology as recherché as it is precise—a desire to go beyond the mere superficial assertion that Chareau was uncategorizable, to investigate his inventiveness more deeply. At the same time, he had no doubts about Chareau's status as architect: "Chareau never ceased work as an architect, whatever task he took up. He applied his gifts of invention to think through the residence—not to decorate it, but to organize it as a function of the inhabitant, to take into account the resident's material needs without ignoring the spiritual ones."

Like Jourdain, the architect and designer René Herbst sought in the main text of the book to extricate Chareau from constraining rubrics: he is neither just decorator nor just architect. Herbst draws on the words of others with whom Chareau worked: Jean Dalsace, Chareau's friend and the client for the Maison de Verre; and the architect Bernard Bijvoet, his former associate; as well as citing the critics Raymond Cogniat and Gaston Varenne, both of whom stressed the breadth of Chareau's work.[2]

For his friends and contemporaries, then, Chareau was unquestionably an architect, and he no doubt agreed. True, he had not received classical training in the profession, as he had failed the entrance exam for the École Nationale Supérieure des Beaux-Arts.[3] Nor did he train under the masters; he never worked in the studios of major architects. His area of expertise was furniture, and he got his training by working at the important British firm Waring and Gillow. His apprenticeship—what little we know about it—occurred over the ten years he worked there. According to his wife, Dollie, he started out tracing patterns and ended up as head designer.[4] World War I interrupted this early career. Five years later, when Chareau resumed work, he set out on his own, establishing a furniture design business. Presumably he started with furniture because he had experience in that field and was able to obtain commissions.[5] Making a name for himself seems to have been Chareau's priority, and it was crucial to gain introduction into a circle of clients. But if architecture was the objective, furniture design appears to have been a fruitful diversion.

From the outset Chareau displayed mastery in furniture design. A few important early commissions enabled him to develop an extremely personal style. This does not mean that he had no precedents. The influence on him not only of Waring and Gillow but also of modernist Austrian architects—especially Josef Hoffmann—may be seen in his early armchairs and sofas.

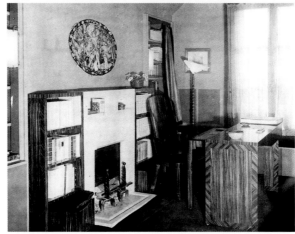

Chareau, drawing of a doctor's consulting room. Reproduction from *Intérieurs I* (1924).

The doctor's consulting room exhibited at the Salon d'Automne, 1919. The ensemble was designed by Chareau for Dr. Jean Dalsace, nine years before he commissioned the Maison de Verre.

This early style is sometimes called "archaic." His first solo commission was to furnish an apartment belonging to a young couple, Jean Dalsace and Annie Bernheim, who were to become among his most ardent patrons, owners of the Maison de Verre. Dalsace was a physician, and the home included a suite of office furniture. The designs for the commission were exhibited in the 1919 Salon d'Automne, where they attracted considerable attention. The suite comprised a desk, armchairs, a couch, and a bookcase, all executed in strong-grained Macassar ebony. While the desk appears massive, its forms are simple, pure, and geometric, with sharp angles. It is purged of decorative elements, its only flourish the use of the striped ebony, which softens the austerity of the design. It is ingeniously functional, with an extensible writing surface and clever storage compartments. Such

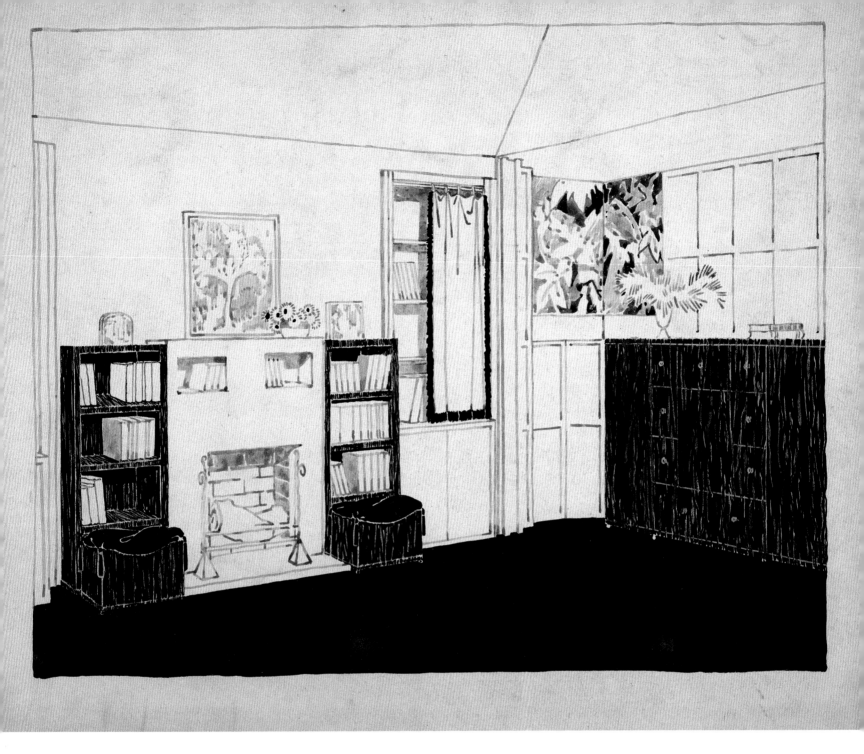

Preliminary design for the office of Dr. Dalsace
Ink, gouache, and watercolor on paper, 10½ × 14½ in.
(26.7 × 36.7 cm). Musée des Arts Décoratifs,
Arts Graphiques, Paris

The desk, chairs, and sofa (SN38) are of striped Macassar
ebony. The desk has an extensible center piece, an early
example of Chareau's love of movable parts.

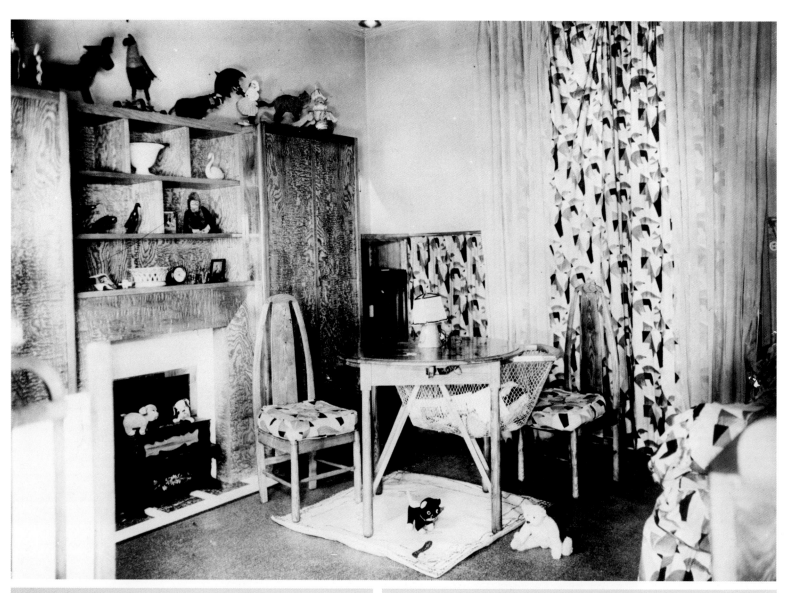

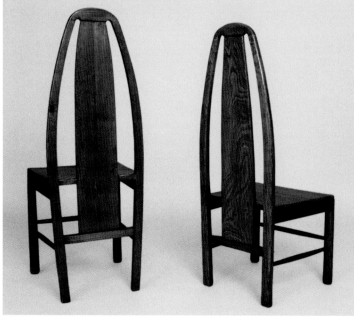

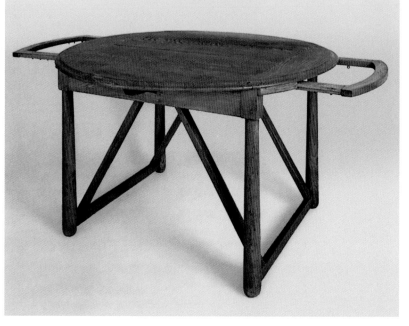

Maquette of a "home for intellectual workers," designed by Chareau and exhibited at the Salon des Artistes Décorateurs, 1923; left: front facade; right: garden facade.

Opposite
A children's nursery, or "children's corner," designed by Chareau and exhibited at the Salon des Artistes Décorateurs, 1923. Nursery furniture: changing table; crib; table originally with net basket for toys; pair of chairs, one with short legs for a nursing mother.

features—hidden, movable, and multipurpose parts— were to become a Chareau signature.

As one critic commented at the time, Chareau "embellished his clear, logical constructions with precious woods and rejected superfluous decoration in his exploration of the play of beautiful volumes and surfaces in sober and sumptuous materials."[6] In this early furniture, we can readily see how Chareau borrows from the vocabulary of architecture. It did not take long for the critics to notice this distinctive quality, with one observing that he "does not so much pursue originality and unusual forms as seek to realize his ideas about architecture through the exploration of solutions to the current problems [of design]. . . . Pierre Chareau remains a constructor. The lines of his furniture are created through a subtle play of planes and volumes."[7]

Chareau exhibited his creations at the Salon des Artistes Décorateurs and the Salon d'Automne. Although his style and vision were not always wholeheartedly accepted, most observers recognized the quality of his designs, accepted his work as that of an architect, and appreciated his modernism—even if that term was not yet universally employed.[8]

The year 1923 was productive for Chareau. At the Salon des Artistes Décorateurs he exhibited a nursery, or "children's corner," and a maquette for a "house for intellectual workers." We have a little information on the nursery from photographs of the installation and some surviving pieces of furniture. It was probably created for the young Dalsace children. Chairs, table, cupboards, and a fireplace surround were executed in pale wood with sleek lines, dressed with fabric in a strong geometric pattern. Among its ingenious inventions was a round table with netting strung underneath to hold toys.

We know the "house for intellectual workers" through two small photographs of the maquette reproduced in magazines, together with some commentary and, in one publication, a brief interview with Chareau. It seems to have been Chareau's first architectural study. Was it a form of research for him? A theoretical proposition? Or will we learn one day that the "intellectual workers" he had in mind were his wife and himself? Or perhaps it was for a potential commission, designed with a client in mind?

The texts that accompany the photographs do not answer these questions, but describe and praise Chareau's approach:

> In all our exhibitions of decorative art, Pierre Chareau has shown himself to be our best interior designer. Here he reveals himself to be an excellent architect. In their critiques, Deshairs, Jeannot, Viallat, and Warnok have consistently declared that architecture should take precedence over decorative art. Pierre Chareau's model for an "intellectual worker" demonstrates that they are perfectly correct. Chareau designs his furniture as an architect. He is a constructor. His interiors, unlike those by many other designers, are created with construction in mind, not fashion. His model is full of ingenious new touches. It is a solid and well-ordered ensemble. At the center lies the workspace—the brain—with the various services for the house grouped around it. The house is an attractive and well-defined white mass, with a front garden that features a sculpture by Lipchitz at the center.[9]

Because of the small size and grainy quality of the reproductions, and the angles from which the model was shot, we can discern more about the elevations than about the volumes, so the pictures are of limited help in understanding Chareau's full plan. The design is for a modern villa composed of a play of cubic volumes, with roof terraces and a central block that rises above the other volumes and dominates them, pierced by functional perforations. There is no preconceived aesthetic. The images show two facades, presumably the front and back, facing the street and garden. The first is more closed, the second more open (a function, no doubt, of the orientation and landscape). Although it is resolutely modern, the villa retains traces of

classical composition, notably in the symmetry of its overall volumes and in some details—oculi to either side of the entry, the treatment of chimneys, and so on. Confident though this early design is, and committed to the development of a modern style, it does not yet convey a sense of full mastery, and Chareau's concept is not significantly different from those of his modernist colleagues.

Asked by a magazine critic about the design, Chareau took the opportunity to set forth some of his ideas about domestic architecture. He explained:

> I wanted to render certain ideas concretely. What should the residence of an intelligent, cultivated family be like—one that would not create undue difficulties for them? In other words, what are the needs of such a family, and what means would normally be available to them? That's the issue. Does my maquette seem abstract? It's because the problem is a general one: the architectural solutions that it offers shouldn't be applied identically in every instance. The builder should use whatever materials are available, whether at the foot of the Alps or on the Basque coast. With a plan of this sort, wouldn't it be a mistake to assume in advance what materials would be used? It's the architect's role, his profession, to design real buildings. What's interesting is to develop general concepts.[10]

Within the 1923 salon was a component dedicated to modern architecture. Its organizer was the architect Robert Mallet-Stevens, about the same age as Chareau and considered one of the French representatives of modern architecture. A graduate of the École Spéciale d'Architecture in Paris, he had as yet few projects to his name, but he was a regular participant in the salons. In 1922 he had published *Une Cité Moderne,* a portfolio of drawings for a proposed city, which had earned him considerable notice.[11] The reviewer of *L'Oeuvre* wrote:

> *Modern Architecture*—an exhibition in a completely new spirit—is worthy of note in the Salon des Artistes Décorateurs: organized by Mr. Mallet-Stevens, it consists of models of modern architecture, with contributions from Adolphe Dervaux, Plumet, Pol Abraham, Jacques Bonnier, Chareau, Sézille, Ventre, Guimard, Tony Garnier, Siclis, Temporal, Sauvage, Tronchet, Thiers, Bassompierre, de Rutté, Servin, Roux-Spitz, Molinié, Nicod, Ponthieu, Roubille, Recoux, Laquerrière, Huillard, Grevel, Chareau, and Djo-Bourgeois. This is the first time a presentation of architecture has been put forward in such an objective manner.[12]

Here Chareau found himself among a learned assembly of architects comprising several generations, both precursors and the younger set, the famous and the unknown, but all proponents of modernism (albeit expressed in a variety of forms: the well-tested ones of the older designers and those of the recent arrivals, still free from practical constraints). Chareau thus found himself in the company of Tony Garnier and Henri Sauvage, Pol Abraham and Michel Roux-Spitz, as well as Georges Djo-Bourgeois, a former student now close to Mallet-Stevens.

Modern architects appeared again at the 1923 Salon d'Automne, but with some changes in the lineup. The section on urban design focused on shops: Francis Jourdain's ceramics shop, a haberdasher's by Djo-Bourgeois, a shoe store by René Herbst, and a bookstore by Mallet-Stevens. Chareau was not among them. Chareau was missing from the architectural section, preferring to focus on a suite of furniture in "a boudoir with a bathroom" (opposite and page 92). The project was reviewed in *Les Arts de la Maison,* which once again highlighted the architectural qualities of Chareau's work:

> Chareau has a clearly architectonic conception of objects. Each of his furniture pieces aspires to become architecture. This accounts for their characteristic breadth of conception. . . . This approach has also inspired him to adhere to the architectural principle of making every part express a well-defined purpose. The construction and elegant organization of Chareau's furniture reminds us on the one hand of durability—with its rejection of the ephemeral—and on the other of decorum and harmonious movement of line. The volumes express the balance of opposing forces. The robust bases provide clear responses to the downward thrust of weight that no object can avoid. . . . With this

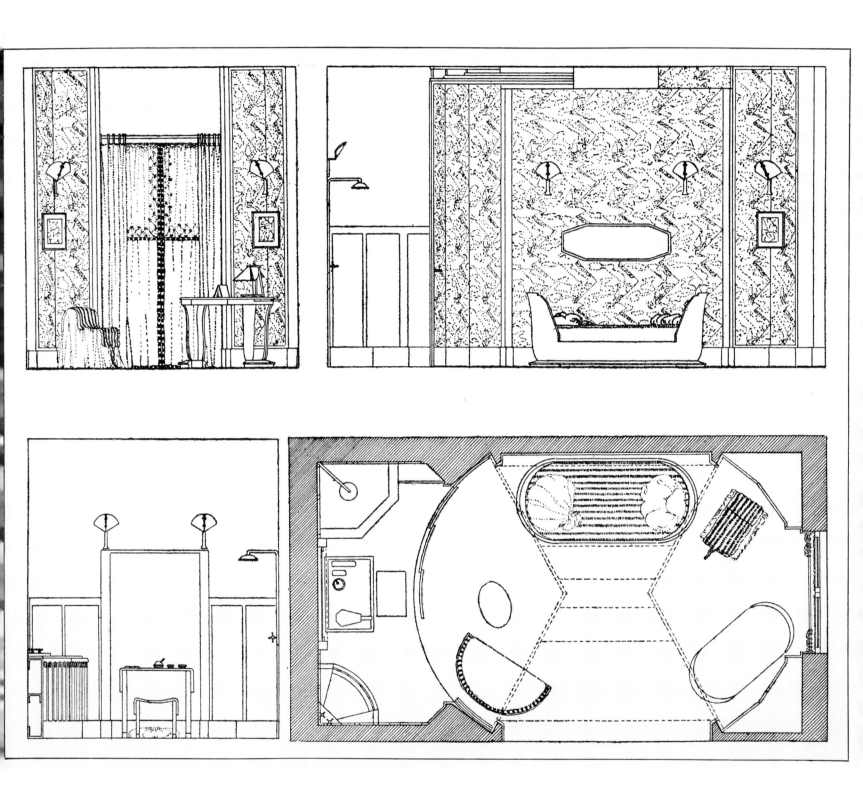

Chareau designed his interiors like an
architect, in plan and elevation. This drawing
is for a boudoir with a bathroom, exhibited at
the 1923 Salon d'Automne (page 92).

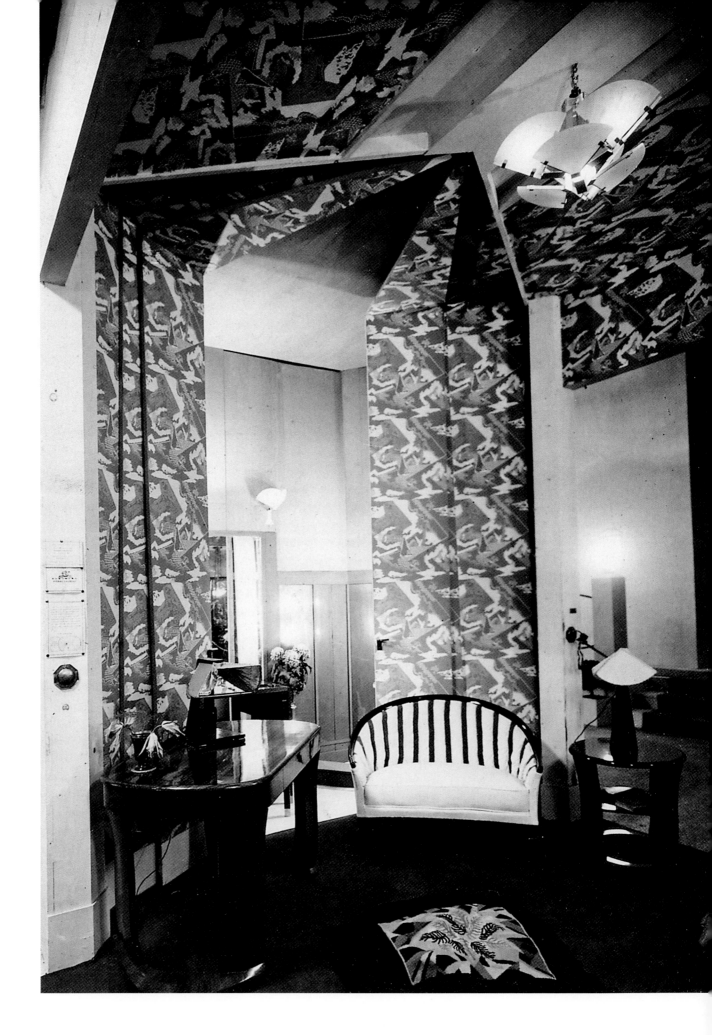

The boudoir designed by Chareau and exhibited at the 1923 Salon d'Automne. One of Chareau's signature sliding fan partitions divides the sitting-room area from the bathroom. Wall and ceiling are covered in strongly patterned wallpaper.

approach, this artist distinguishes himself from other designers. As he considers a piece of furniture a true piece of construction, he gives it a base similar to that of a building. Instead of having feet that barely touch the ground, his furniture rests on a solid base that resembles a foundation wall.[13]

The originality of these pieces and the coherence of the ensemble merit further attention. The snakewood desk has a broad surface with demilune ends, punctuated by two side pulls and a front drawer. The legs are curved, and each pair rests on a crescent-shaped foot. A low table echoes the same profile on a smaller scale. A bed and a low bookcase take up the same play of curves, but through vertical and horizontal surfaces, not in elevation. The result is that each piece is clearly part of a family, but as a group they exhibit an astonishing variety of solids and voids.

One reviewer was captivated less by the quality of the individual pieces than by the fan-shaped movable wall, one of Chareau's most celebrated designs:

> The bedroom by [Louis] Sognot [is] one of the most original in this salon, along with that of Chareau, who generously shares his ideas with his colleagues; these sometimes take undue advantage. His latest invention is a fan-shaped screen. It can easily be used to divide a bedroom from a bath, or one can do away with the separation if one prefers. It is a new means for combining three rooms into one: bedroom, bathroom, and boudoir. The constraints of our dwellings and the difficulties of life make this necessary for many people.[14]

The fan is both the principle and the form that Chareau employed for his boudoir. He later developed the same concept in some of his furniture (the fan tables), in his interiors (the small salon in the Lanique apartment, 1923–24), and to the fullest extent in design for a model French embassy at the 1925 Exposition Internationale des Arts Décoratifs et Industriels Modernes in Paris (pages 117, 54, 50). The fan is movement and rotation. Chareau's wooden fan tables are not autonomous units that slide under one another. Instead, they pivot to increase the size of the table surface. The same holds true for an occasional table made entirely of metal, whose surface area is multiplied by thin sliding planes of steel.

In his interiors, these fan-shaped panels, with a horizontal upper part that deploys and draws the vertical panels along with it, are used to create different spaces—to separate spaces as well as to combine them. They offer a preview of his apartment designs of the 1930s in which movable partitions provide spatial structure (pages 46, 47). At first, these were covered in wallpaper. Later they were sheathed in unusual wood veneers. And they did not simply delimit spaces vertically; by closing off or opening up at the ceiling, and thus either admitting or shutting off diffuse upper light, Chareau could put an entire environment into motion. To make these walls function, he employed various clever technical devices case-by-case, but one principle informs this system and creates all its magic: the dematerialization of the axis of rotation. With a pivot at the head and guide rails on the floor, the panels can be arranged without any inconvenient central support, allowing the space to remain open and its use flexible. This same principle was applied (without the fan) for the rotating curved glass door that opens onto the main stair in the Maison de Verre; there, the use of transparent material amplifies the vista (page 204).

In 1924 Chareau maintained his momentum. He continued to participate in exhibitions and salons, which earned their share of notice in the press. As his work received increasing attention, articles began to appear about him alone.

Once again the year opened with a group architecture exhibition in Paris, this time organized by the Friends of the École Spéciale d'Architecture. *Architecture and the Related Arts* ran from March 22 to April 30. The initiative came from Mallet-Stevens, who was by then a professor. His aim was to present work by his students that had been produced according to criteria established by the Urban Arts section of the previous year's Salon d'Automne. As one columnist noted, "A few well-known elders were there: the presence of Francis Jourdain and Pierre Chareau communicated their interest in their younger colleagues."[15] The exhibition was considerably more significant than this offhand comment suggests. It included a number of artists, architects, and graduates of the school, as well as several members of the Dutch De Stijl group, invited by Mallet-Stevens. All were

resolutely committed to modernism. Oddly, Chareau was not listed in the catalogue, either under the rubric of architect or in the section on furniture. Other than the "house for intellectual workers," noted in press clippings, we don't know what he showed.

That busy spring, Chareau's furniture was also included in an exhibition of decorative arts organized by the Union Centrale des Arts Décoratifs, and other pieces designed by him appeared in the film *L'Inhumaine* by Marcel L'Herbier (page 70). This was followed by the Salon des Artistes Décorateurs, which Chareau helped to organize, inviting designer friends to take part in a presentation on public and private spaces entitled *Reception and Intimacy in a Modern Apartment*. In the Salon d'Automne, he exhibited a rosewood bed with snakewood panels. In the Urban Arts section, he created a design for a storefront in collaboration with the master metalworker Louis Dalbet.[16] Though a temporary installation, it was nonetheless a carefully thought-out work of architecture—a precursor to Chareau's real shop, La Boutique, which he opened toward the end of the year at 3 Rue du Cherche-Midi. He already had his own small workshop, at his home at 54 Rue Nollet. The new space allowed him to have a showroom in the heart of Paris (page 19).[17]

When the Exposition Internationale des Arts Décoratifs et Industriels Modernes arrived in 1925, launching the Art Deco movement, Chareau the architect was not yet fully formed. He had not yet carried out a commission for a building or dealt with site, budget, or construction issues. He had rubbed elbows with Garnier and Sauvage in exhibitions of maquettes, had exhibited alongside Mallet-Stevens, and had been close to Le Corbusier and Pierre Jeanneret, but those architects had designed their own presentations, the former in the accepted style, the latter in a modernist one. On this occasion Chareau remained within the framework in which he excelled, fine interior design. He was one of a group of designers who together produced an installation, a proposal for a model French embassy with reception rooms and living quarters. The library and study designed by Chareau was a masterpiece: a room in beech and palmwood veneer, framed by a sliding fan partition. It fused a number of his recent ideas: the fan partition, concealed ceiling lighting, streamlined furniture with movable parts, the use of precious woods, and collaboration with other artists (pages 50–51).

The work was a milestone for him. He was awarded the Légion d'Honneur, and the work was sold to the government. It led to several private commissions and much increased visibility. In addition to interior design, he now began to carry out commissioned architectural work: he designed a clubhouse for the Hôtel de Beauvallon golf course and a villa at Vent d'Aval, based on his 1923 idea for a worker's house (pages 260–61). Most important, as a result of this success he was able to move beyond outdated debates about aesthetics to become an incomparable inventor. In the realm of furniture design, he began to produce a radical and strikingly architectural series in wood and metal, including desks, stools, dressing tables, and linen chests (pages 119, 124, 140, 143). In architecture he conceived the Maison de Verre—that concentrated mass of inspired innovations.

During the economic crisis of the 1930s, Chareau continued to produce both architecture and furniture equally, wherever he found commissions. This duality, a defining feature of his work, seems to have come naturally to him. In addition, he authored a volume on furniture in the *Art International d'Aujourd'hui* series and served as the commissioner of the architecture section at the French pavilion for the 1935 Brussels Exposition Universelle et Internationale, exhibiting the work of several colleagues, including Le Corbusier. He was a founding member of the Congrès Internationaux d'Architecture Moderne (CIAM, the International Congresses for Modern Architecture), in 1928, and a prominent member of the Union des Artistes Modernes (UAM).[18]

He designed school furniture—perhaps his only experience with mass production (shown at the Salon d'Automne in 1936, page 28)—and built a small house in the country for his friend Djémil Anik in Bazainville in 1937 (page 262). He also made studies for a ship's stateroom, commissioned by the Office Technique pour l'Utilisation de l'Acier (OTUA), an organization of steel-construction professionals (1934; page 28), and a design for a steel apartment building (1938). The 1937 Exposition Internationale in Paris, devoted to the arts and technologies of modern life, provided another example of his range of work, split this time between a pavilion for the UAM (with the architects Georges-Henri Pingusson, Francis Jourdain, and André Louis), where he designed a reception room with red-leather armchairs, mirror, metal tables, rattan doors, and raffia curtains, and the Pavillon des Temps Nouveaux (Le Corbusier and Pierre Jeanneret, architects), where he exhibited a model for a park. Because no image of

Chareau, sketch for the library and study of a proposed French embassy, created for the 1925 Exposition Internationale des Arts Décoratifs et Industriels Modernes. Watercolor and pencil on cardboard, 15¾ × 11¾ in. (40 × 29.7 cm). Musée des Arts Décoratifs, Paris.

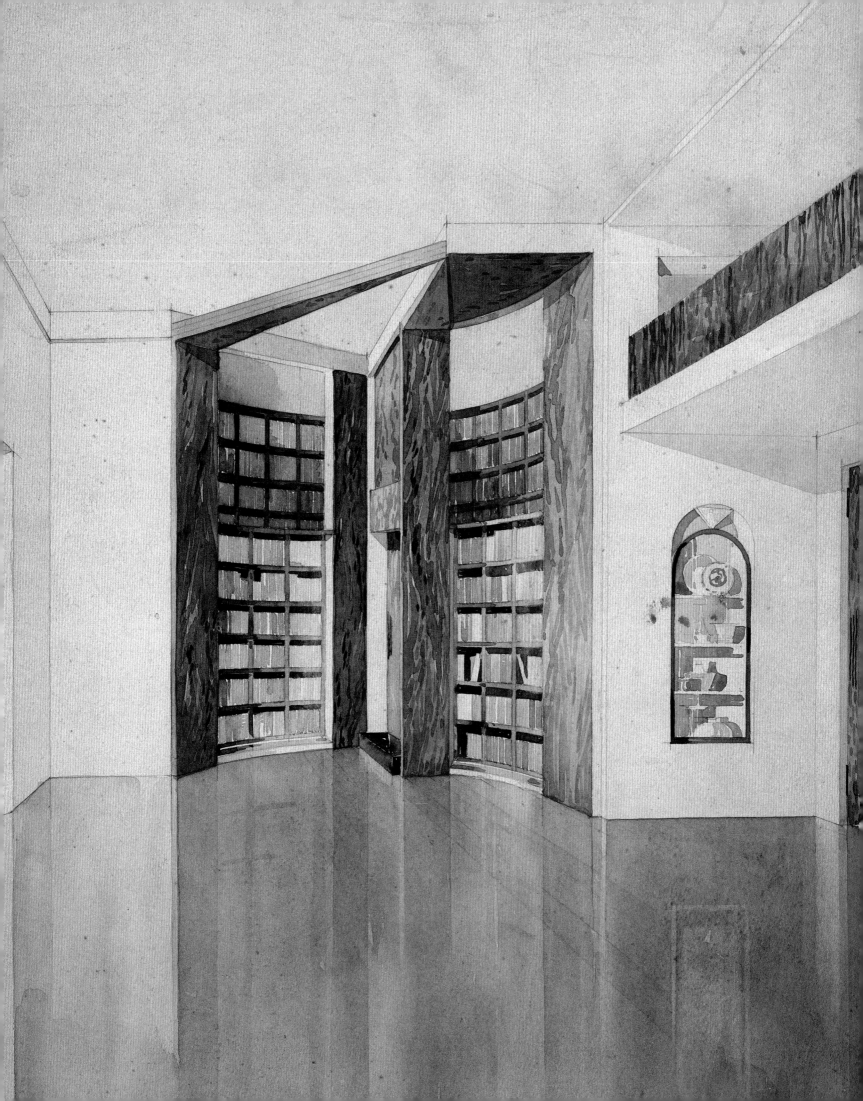

the design remains, we do not know which part of the construction or landscape he was responsible for.[19]

Perhaps it was only at the very end of his life, in the United States, that the architect supplanted the creator of furniture?

NOTES

1. The exhibition *Pierre Chareau, 1883–1950,* held at the Centre Pompidou (November 3, 1993–January 17, 1994), was accompanied by an extensive publication: Olivier Cinqualbre et al., *Pierre Chareau, Architecte: Un Art Intérieur,* exh. cat. (Paris: Centre Pompidou, 1993); see especially the chronology, 13–33. Also important is the work of Marc Vellay and Kenneth Frampton, *Pierre Chareau: Architecte-Meublier* (Paris: Éditions du Regard, 1984); English ed., *Pierre Chareau: Architect and Craftsman, 1883–1950* (New York: Rizzoli, 1990), with catalogue. The private archives of the Vellay and Dalsace family include information relating to the Maison de Verre, but few archival materials survive on other aspects of Chareau's life and work, including his furniture and design business.

2. René Herbst, *Un Inventeur: L'Architecte Pierre Chareau,* preface by Francis Jourdain (Paris: Éditions du Salon des Arts Ménagers, 1954), 4–5. Shortly before his death, Chareau sought to mount an exhibition of his work at the Museum of Modern Art in New York, and also contacted the Musée National d'Art Moderne in Paris, but his efforts were unsuccessful; Dalsace/Vellay family archives.

3. Olivier Cinqualbre, "Un Destin en Pièces," in Cinqualbre, *Pierre Chareau, Architecte,* 13.

4. Dollie Chareau, "Maison d'Été pour un Peintre à Long Island," *L'Architecture d'Aujourd'hui,* no. 30 (July 1950): 51.

5. Other architects started out in a similar way. Robert Mallet-Stevens, for example, trained as an architect at the École Spéciale d'Architecture de Paris. Before he received commissions to design dwellings, he published numerous articles and drawings in the press, designed interiors, and created theater sets. Once established, he counted Paul Poiret and the Noailles family among his wealthy and adventurously modern clients; Olivier Cinqualbre, ed., *Mallet-Stevens: L'Oeuvre Complète* (Paris: Centre Pompidou, 2005).

6. Michel Dufet, "Deux Décorateurs Modernes Chareau et Lurçat," *Feuillets d'Art,* no. 1 (1921): 40.

7. "Pierre Chareau," *Mobilier et Décoration d'Intérieur,* no. 1 (November–December 1922): 27.

8. For an appreciation of Pierre Chareau, in terms of both his relation to the various tendencies in French decorative art and his role as a leader of a school of thought, see Elise Koering, "The 1920s: Pierre Chareau among Artist Decorators," in *Architect Pierre Chareau: Architect of the House of Glass, a Modernist in the Time of Art Deco* [in Japanese], ed. Olivier Cinqualbre, exh. cat. (Tokyo: Shiodome Museum and Kajima Institute, 2014), 141–44.

9. "Constructor—La Page de l'Architecture," *Arlequin,* no. 2 (June 1923): 27. I am indebted for this information to Jean-François Archieri, who has conducted crucial research in the general press, digging up forgotten reviews in magazines and newspapers.

Artworks by Chareau's friends, especially those of Jacques Lipchitz, often figured prominently in the ensembles that Chareau exhibited at the salons. Was the presence of a miniature model of one of his sculptures in front of the dwelling another example of this approach, or an indication to a possible client? See Kenneth E. Silver's essay in this volume for a more detailed exploration of this practice. Did Chareau hope to build a studio for Lipchitz? When the sculptor commissioned Le Corbusier and his cousin Pierre Jeanneret for that project, was he choosing a tougher professional instead of his friend? The dating of these projects, and their possible relation to one another, remains to be investigated, at any rate.

10. Chareau, quoted in G. J., "L'Exposition des Arts Techniques de 1925," *Bulletin de la Vie Artistique* (October 1, 1925): 412–15. Asked to imagine what the dwelling of tomorrow would be like, he responded, "Clearly the house of tomorrow must provide the basic services, especially food and shelter. Wisdom would recommend that private furnishings be reduced to their least complicated form; construction itself will be driven by a focus on hygiene; [the future] will be the reign of logic. Perhaps Montalembert was correct in predicting that 'an immense ennui threatens to be the characteristic of future civilization.' But people will live better, and convenience will compensate for uniformity. . . . The very idea of uniformity is odious to me. . . . One may desire its advent, but submitting to its tyranny is repugnant. On this point, my personal feelings are in conflict with my rational thought. I've studied houses in which every floor had a different distribution of spaces, different details. If an interior layout has ingenious personal touches, it's not necessary to lock it into a set of bare concrete cubes. Taste and sensibility have their rights, as much as pure logic does."

11. Robert Mallet-Stevens, *Une Cité Moderne* (Paris: Charles Massin, 1922).

12. "L'Oeuvre Littéraire et Artistique—Dans les Galeries—Notes d'Art—L'Architecture Moderne," *L'Oeuvre* (May 15, 1923): 5; Mallet-Stevens, *Cité Moderne*.

13. "Réalisation et Projets: Boudoir par Chareau," *Les Arts de la Maison* (Fall–Winter 1923): 45, 46, 48. The reviewer lauds the completeness of Chareau's vision: "We can praise Chareau for having followed the example of Eupalinos, the admirable constructor imagined by Paul Valéry; his work in architecture encompasses objects, buildings, the bodies of mortals, and their highest thoughts."

14. Gaston Varenne, "L'Art Urbain et le Mobilier au Salon d'Automne," *Mobilier et Décoration* (July–December 1923): 181–82.

15. *Art et Décoration* (April 1924): 5.

16. This was his first project with Dalbet, who thereafter worked frequently with Chareau, not only producing the metal components of his furniture and lamps but also creating many elements in his apartment interiors and in the Maison de Verre.

17. As did his contemporary, the interior and furniture designer Eileen Gray, who had opened her shop, Galerie Jean Désert, two years earlier at 217 Rue du Faubourg Saint-Honoré. On the similarities and relations between Chareau and Gray with respect to the decorative arts, see Elise Koering, "Eileen Gray et les Arts Décoratifs: Un Autre Regard," *FabricA,* no. 4 (2010): 114–42. For a discussion of their architectural relationship, see Olivier Cinqualbre, "L'Architecture à l'Épreuve du Trait," in *Eileen Gray,* exh. cat. (Paris: Centre Pompidou, 2013), 122–27. Madame Dreyfus, who worked at the Rue Nollet workshop toward the end of the 1920s, recalled that the space, though small, was sufficient to allow the presence of collaborators; interview with Bernard Bauchet and Olivier Cinqualbre, April 1991.

18. Chareau was not at the founding of this group (1929), but joined the following year.

19. Le Corbusier was in charge of the accompanying publication, which served as both an architectural presentation of the pavilion and a catalogue of the exhibition. It notes that Chareau's work could not be reproduced because a photograph of it had not been supplied in time; Le Corbusier and Pierre Jeanneret, *Des Canons, des Munitions? Merci! Des Logis . . . SVP* (Boulogne-sur-Seine, France: Éditions de l'*Architecture d'Aujourd'hui,* 1938).

Furniture

Pair of stools (SN1), c. 1920–21
Designed by Chareau
Sycamore, 19 in. (48.3 cm) high
Galerie Vallois, Paris

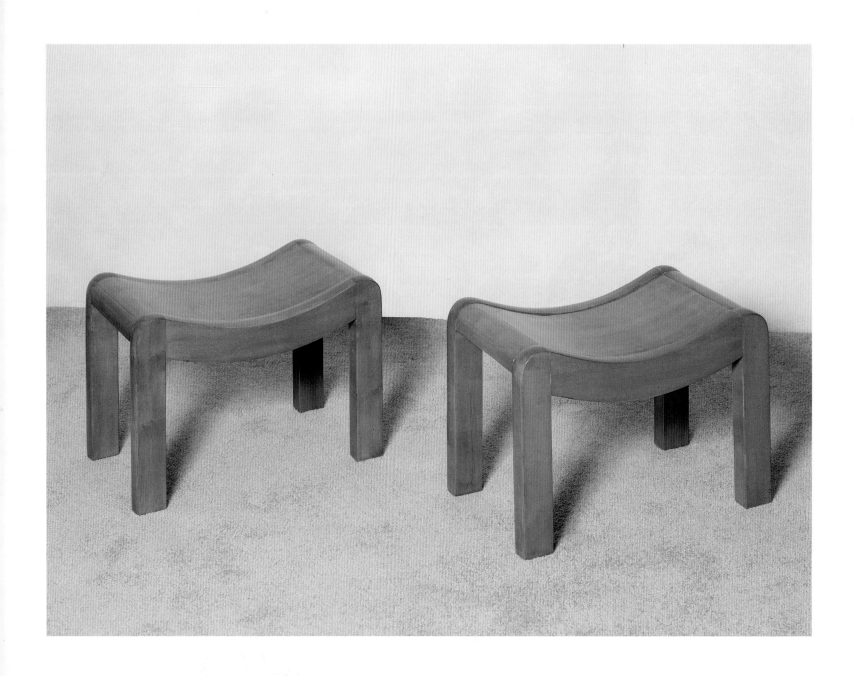

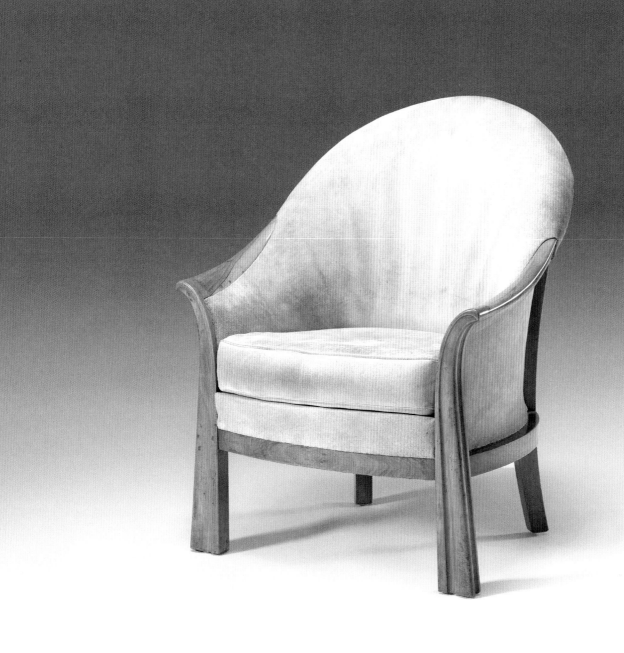

Armchair (MF208), 1925
Designed by Chareau
Bleached mahogany and suede,
33¼ × 26½ × 24½ in. (84.5 × 67.3 × 62.2 cm)
Virginia Museum of Fine Arts, Richmond,
Gift of Sydney and Frances Lewis

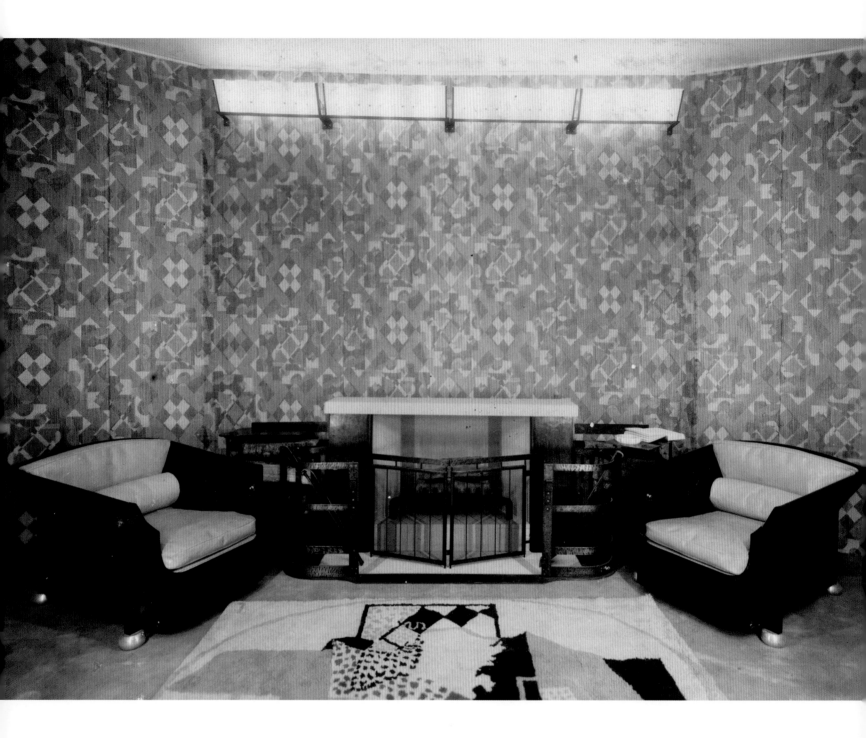

Theme and Variation

Although Chareau never really engaged in mass production, he produced small series of similar design with slight variations, as one can see in this armchair and in the photograph of an interior.

Installation by Chareau at the Salon des Artistes Décorateurs, 1924, with armchairs (MF1050), fireplace accoutrements by Louis Dalbet, and a carpet, by an unknown designer, produced by La Boutique (PT807).

Club chair (MF1050), c. 1924–26
Designed by Chareau
Rosewood, silvered metal, and upholstery,
23⅝ × 27½ × 31½ in. (60 × 70 × 80 cm)
Virginia Museum of Fine Arts, Richmond,
Gift of Sydney and Frances Lewis

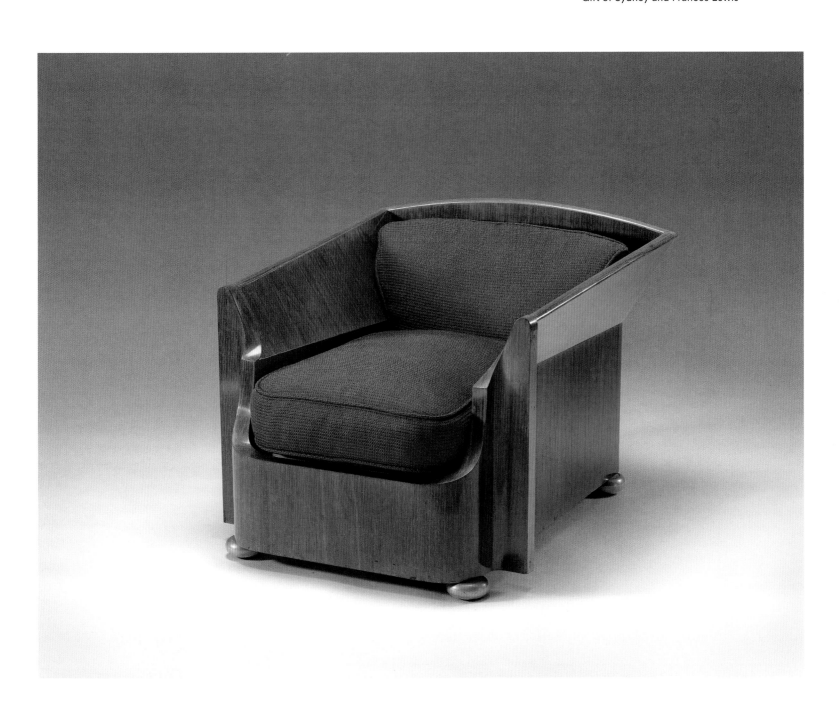

Upholstered armchair (MF220), c. 1922
Designed by Chareau
Amaranth, silver-plated brass, and velvet upholstery,
33⅛ × 27⅜ × 33½ in. (84 × 69.5 × 85 cm)
Private collection

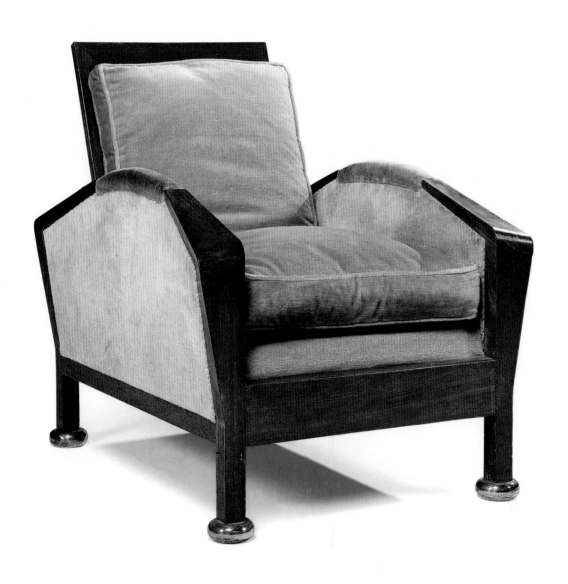

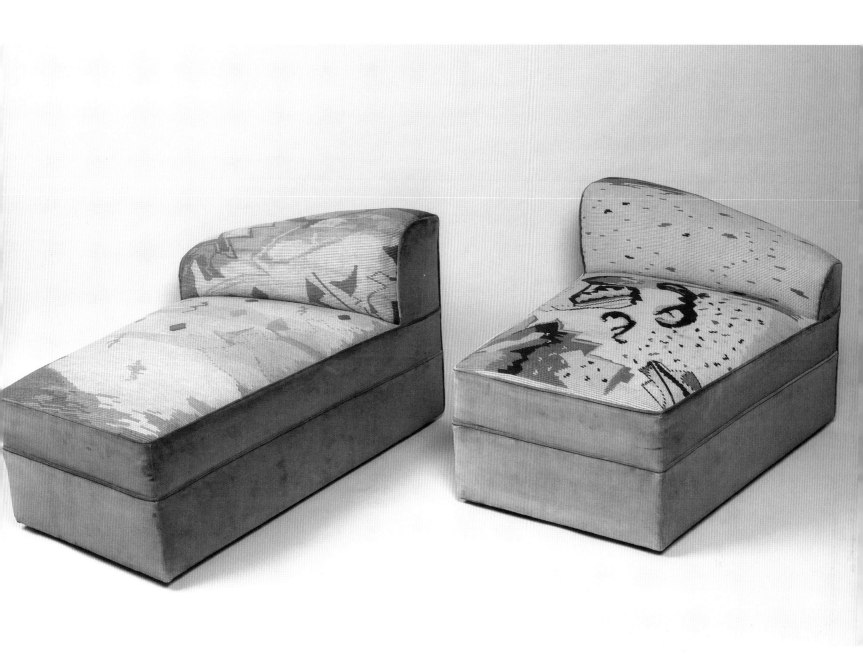

A pair of fireside (chauffeuse) chairs (MF313), c. 1926
Designed by Chareau, with upholstery
fabric designed by Jean Lurçat
Velours and tapestry, 23½ × 27½ × 35½ in.
(59.7 × 69.9 × 90.2 cm)
Galerie Anne-Sophie Duval, Paris
Chareau designed several versions of these lovely
low chairs, called chauffeuses, in different kinds
of upholstery.

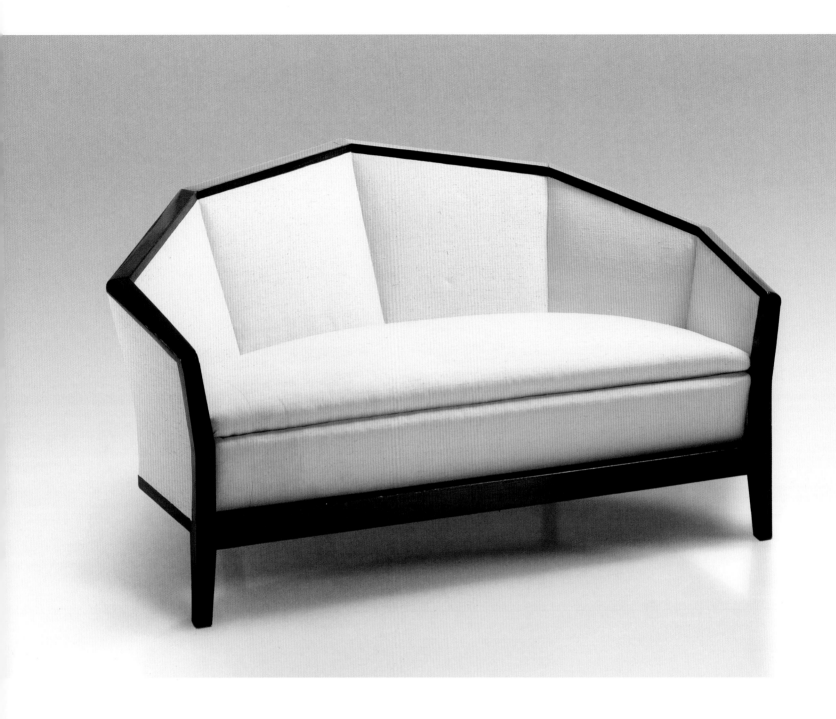

Sofa (MP174bis), c. 1923
Designed by Chareau
Rosewood, 28¼ × 54⅜ × 32½ in.
(71.8 × 137.9 × 88.9 cm). Galerie Karsten
Greve, Cologne

Preparatory drawing for hexagonal and
round-backed armchairs, designed by
Chareau, published in *Les Arts de la Maison*
(Winter 1924).

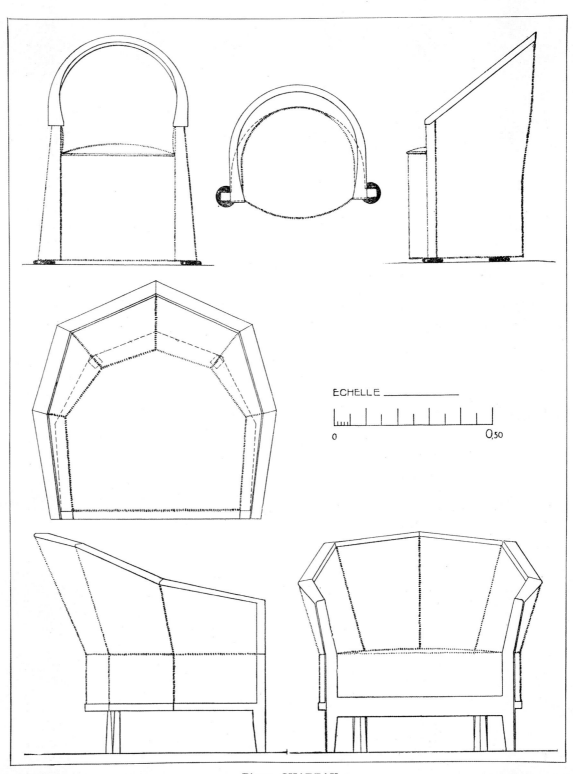

ECHELLE

0 0,50

Pierre CHAREAU
Fauteuils, 1924

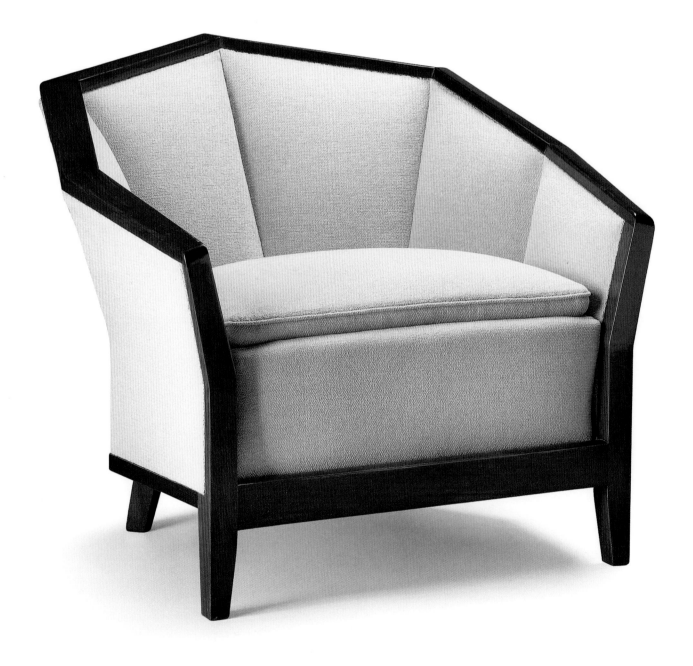

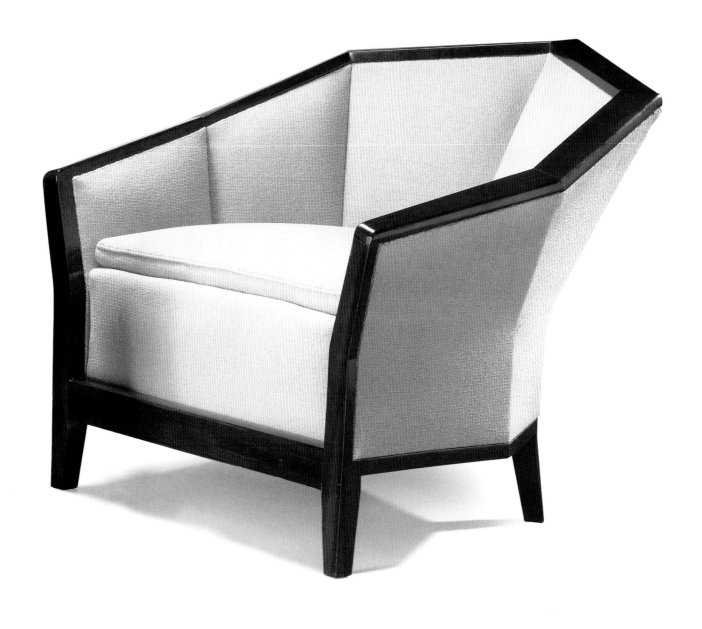

Pair of hexagonal armchairs (MF172), c. 1924
Designed by Chareau
Rosewood with velvet upholstery,
25¾ × 30¼ × 28 in. (65.5 × 77 × 71 cm)
Private collection

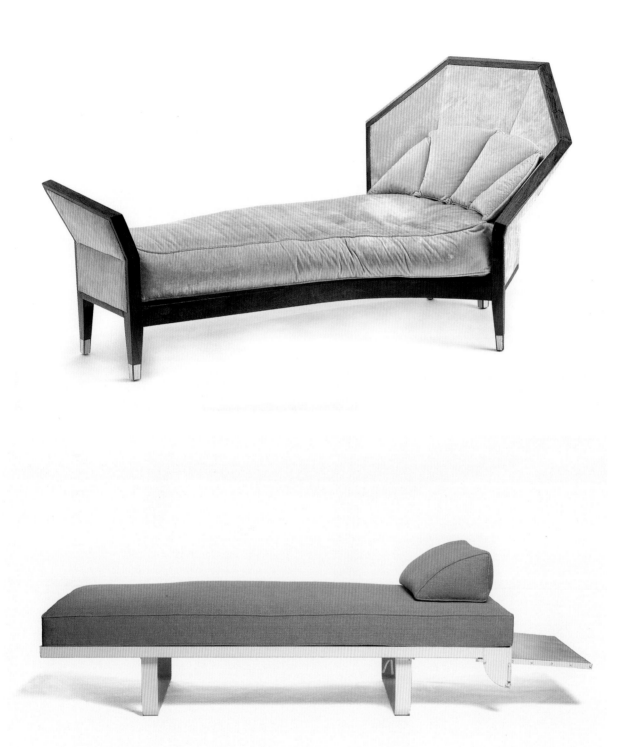

Sofa with pivoting side table (MB960), c. 1928
Designed by Chareau
Patinated wrought iron and bubinga wood;
sofa: 28⅛ x 64⅜ x 32⅝ in. (71.5 x 163.5 x 83 x cm);
table: 31¼ in. (79.5 cm) diameter
Private collection

Opposite, above
Méridienne (MP167) five-legged daybed, c. 1925
Designed by Chareau
Rosewood, ivory, and velvet, 32 × 71⅝ × 37⅜ in.
(81.3 × 182 × 95 cm)
Museum für Angewandte Kunst, Cologne

Opposite, below
Divan with pivoting shelf, c. 1932
Designed by Chareau
Painted metal, parchment-covered wood, and upholstery,
23¼ × 76 × 31¾ in. (59 × 193 × 80.5 cm)
Musée des Arts Décoratifs, Paris,
gift of the heirs of Rose Adler, 1961

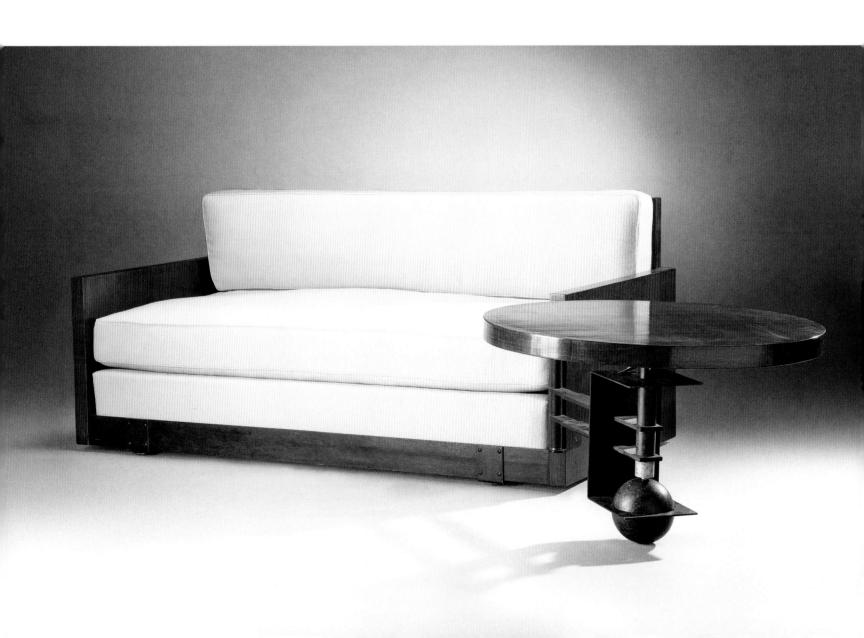

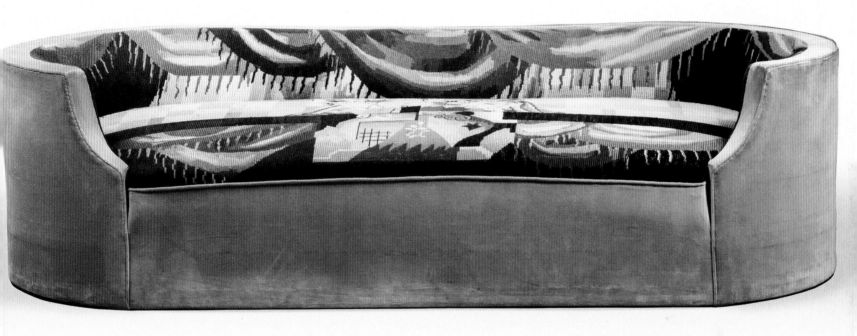

Corbeille sofa (MP169), 1923
Designed by Chareau, with upholstery
designed by Jean Lurçat
Velours and tapestry, 23½ × 77¼ × 17¼ in.
(59.7 × 196.1 × 43.9 cm)
Audrey Friedman and Haim Manishevitz

Opposite
Jean Lurçat, sketch for an upholstered corbeille sofa
by Chareau, published in *Feuillets d'Art* (1922).

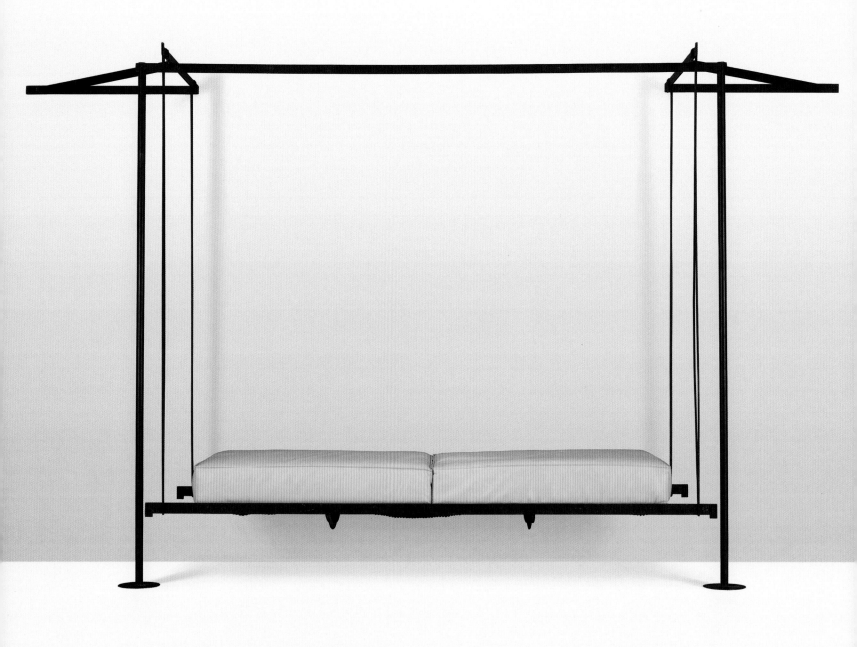

Suspension seat (EF928), c. 1925
Designed by Chareau
Wrought iron, 78¾ × 90½ × 36⅝ in. (200 × 230 × 93 cm)
Private collection
Chareau designed several suspended seats and beds
around 1925. This seat, with two legs, is attached to
the wall. A suspended bed appears in the lounge
he designed for the model French embassy, the Lord
and Taylor exhibition of 1928, and an unidentified
interior (pages 22, 24, 236).

Chareau, sketches for furniture, c. 1923–27
Gouache on paper
Private collection, Paris

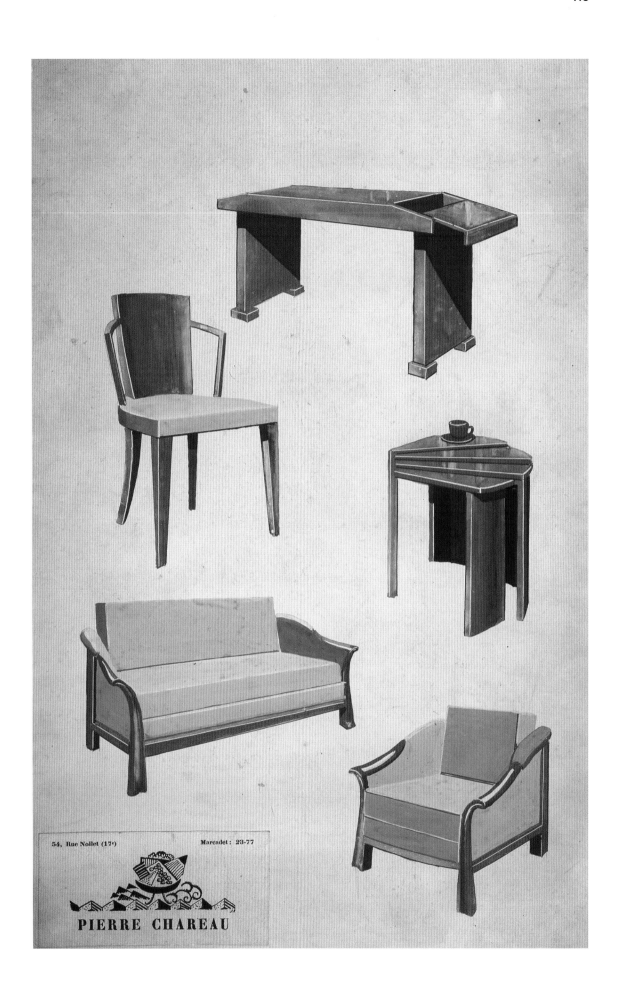

54, Rue Nollet (17e) Marcadet : 23-77

PIERRE CHAREAU

Table and bookcase (MB960), c. 1930
Designed by Chareau
Walnut and black patinated wrought iron, 36½ ×
45¼ × 8 in. (92.7 × 114.9 × 20.3 cm); table: 23½ in.
(59.7 cm) high, 33¾ in. (85.7 cm) in diameter
Galerie Vallois, Paris

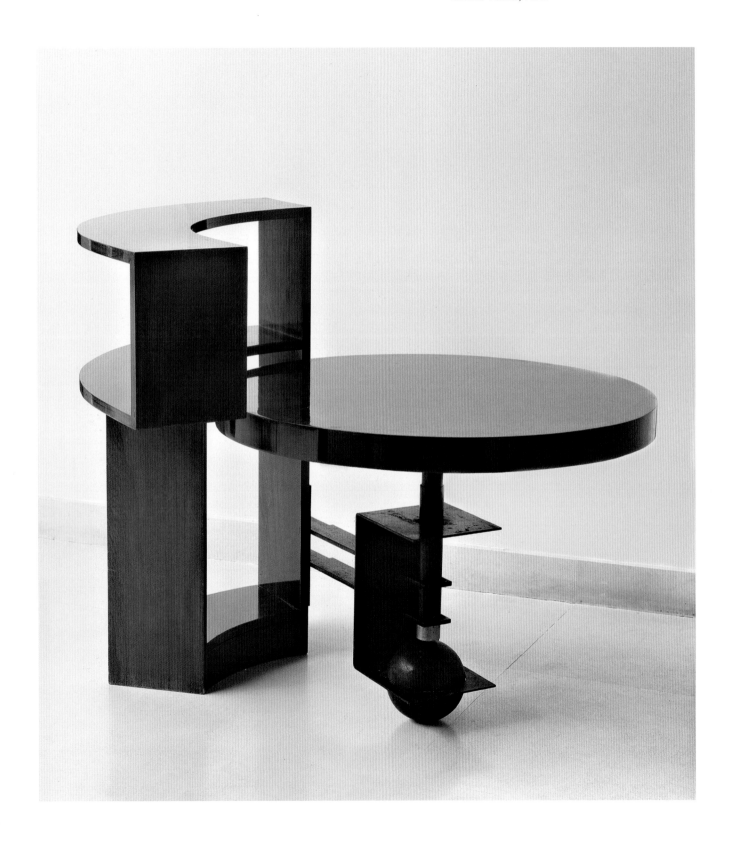

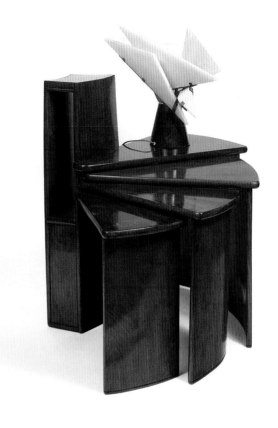

Chareau, sketch for a fan table, 1923–24
Pencil on tracing paper, 15¾ × 11¾ in. (40 × 30 cm)
Musée National d'Art Moderne,
Centre Pompidou, Paris

Telephone table (MB152) and
La Petite Religieuse table lamp, c. 1924
Designed by Chareau
Table: walnut and patinated wrought iron, 34¾ × 40⅛
(extended) × 15 in. (88.3 × 101.9 × 38.1 cm); lamp: walnut,
patinated wrought iron, and alabaster, 16⅛ in. (41 cm) high
Private collection

Low table (MB130), c. 1923–25
Designed by Chareau
Amaranth, glass, and metal, 21½ ×
26¾ × 19 in. (54.5 × 68 × 48.3 cm)
Private collection

Dressing table with cosmetic cabinet
(MS418), c. 1927
Designed by Chareau
Sycamore and wrought iron, 65⅜ ×
37⅜ × 11¾ in. (166.1 × 95 × 30 cm)
Musée d'Art Moderne de la Ville de Paris

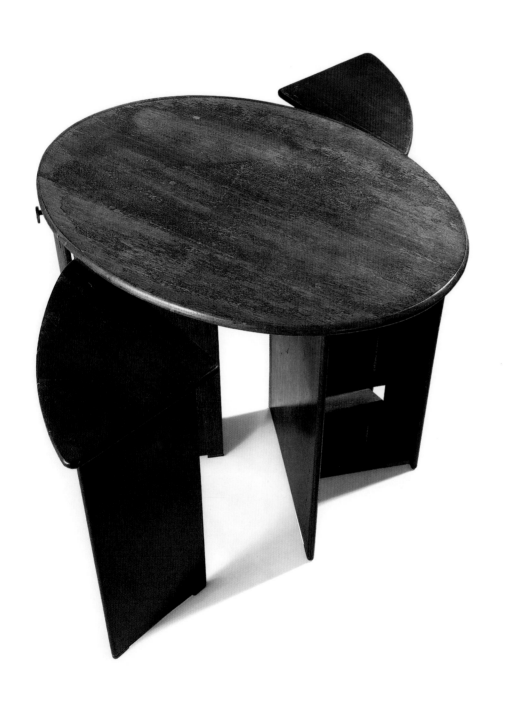

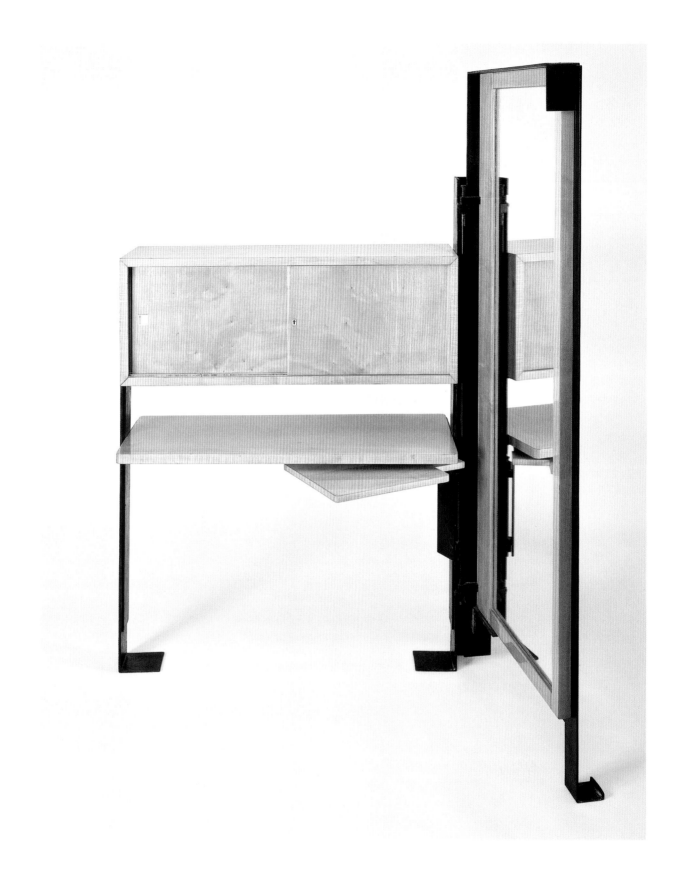

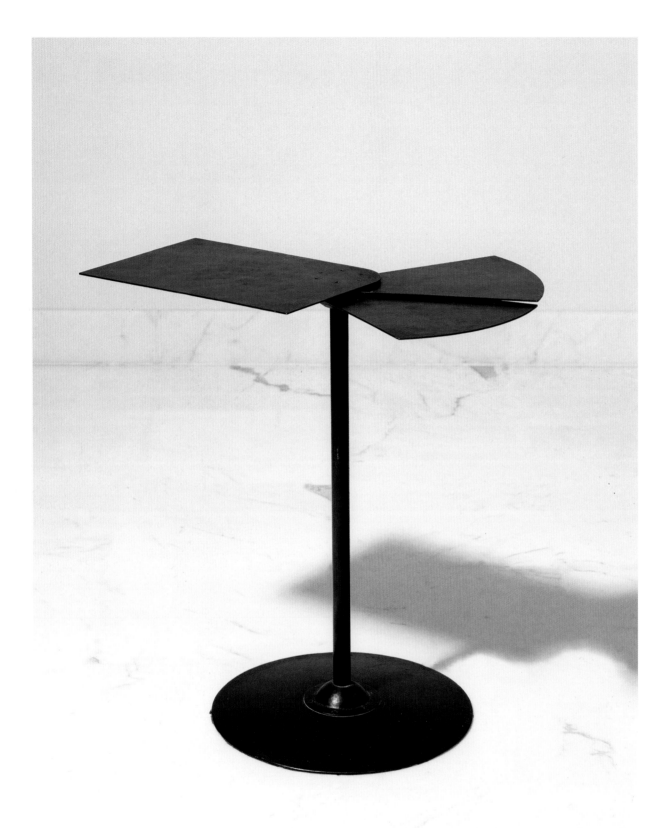

Propeller table (SN9), 1929
Designed by Chareau
Patinated wrought iron,
25⅞ × 19¾ × 6⅛ in.
(65.5 × 50 × 15 cm)
Galerie Karsten Greve,
Cologne

Smoker's pedestal table
with adjustable leaves
(SN9), c. 1929
Designed by Chareau for
the Hôtel de Beauvallon
golf clubhouse
Patinated wrought iron,
28 × 21¼ × 15⅜ in.
(71 × 54 × 39 cm)
Private collection

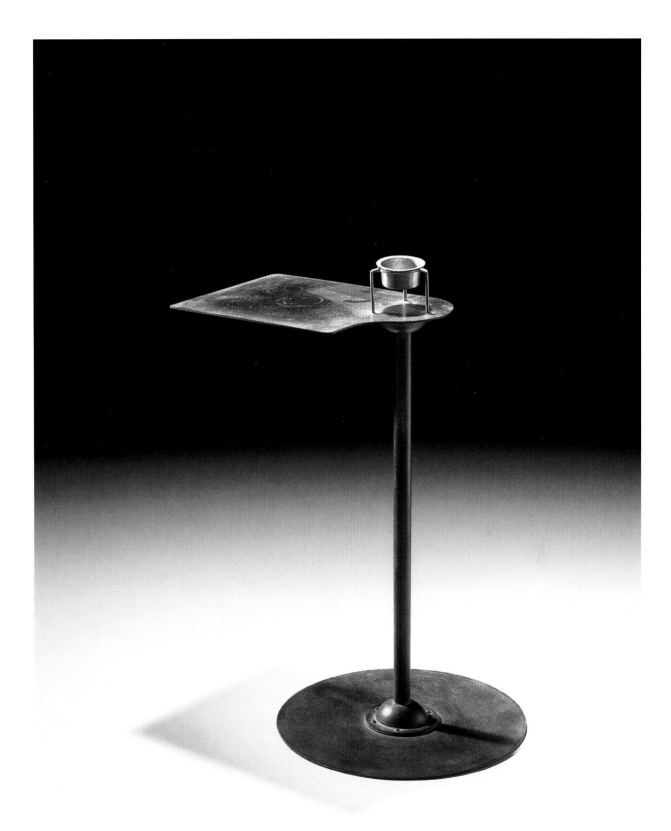

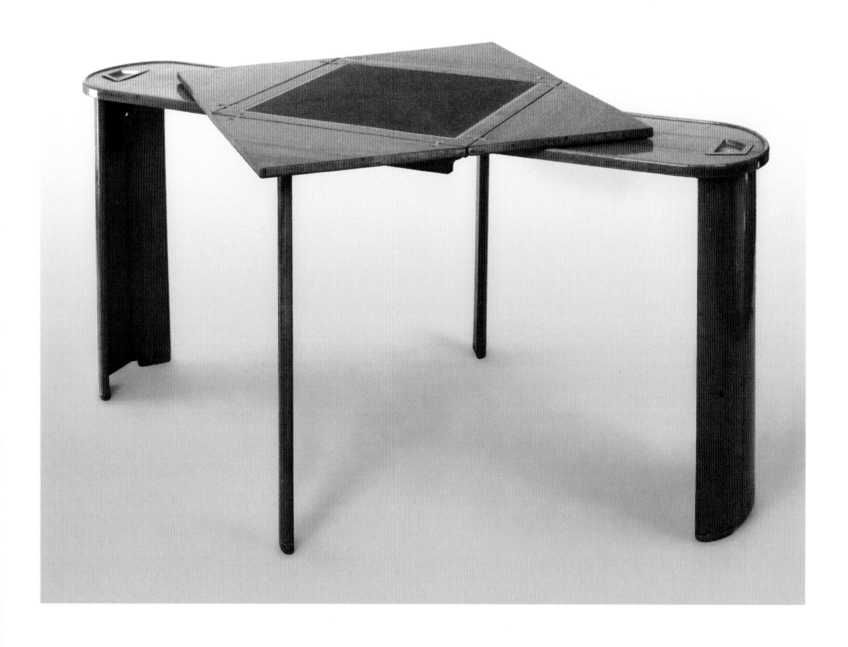

Handkerchief folding game table
(MB241), c. 1929
Designed by Chareau
Walnut, bronze, felt, and brass,
27⅛ × 57⅛ × 20½ in.
(69 × 145 × 52 cm)
Private collection, Paris
Left: open; right: closed.

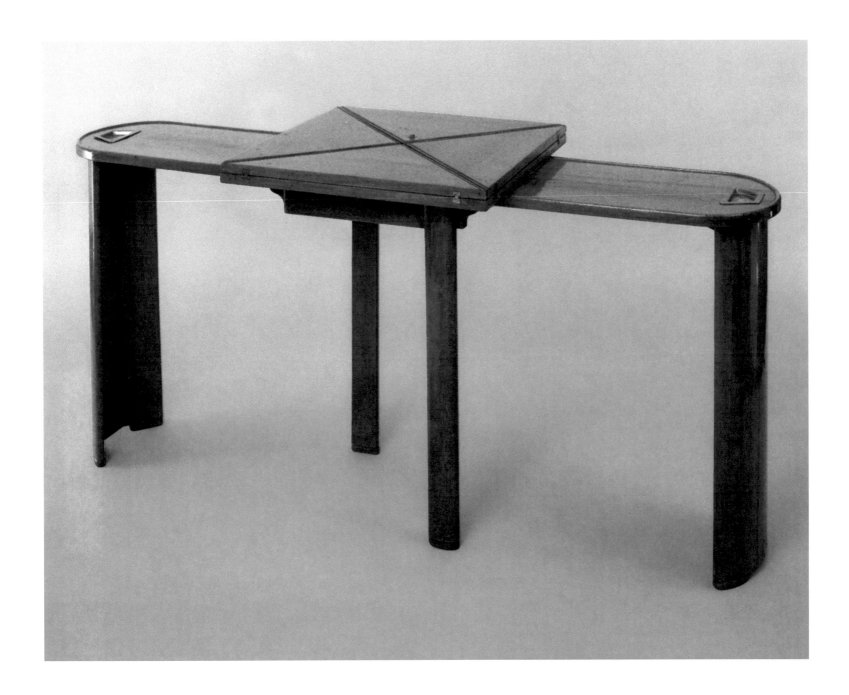

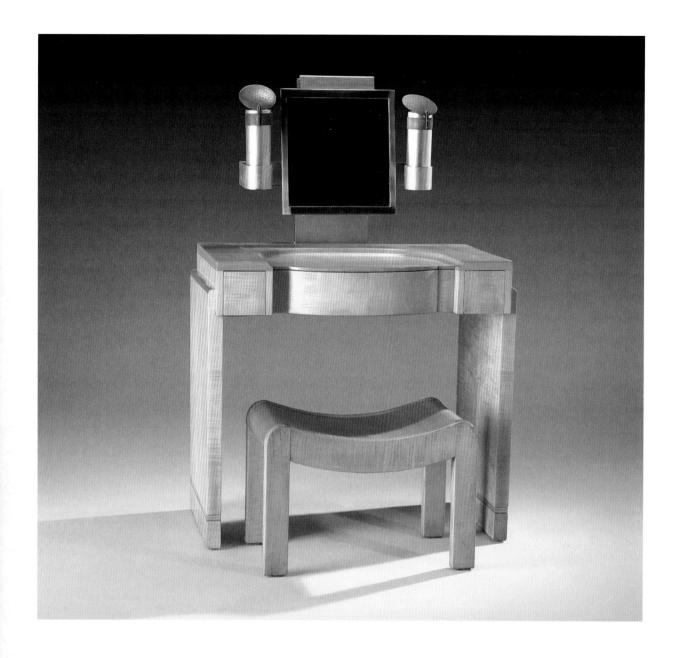

Dressing table and stool ensemble
(MS423 and SN1), c. 1926
Designed by Chareau
Sycamore and metal dressing table: 44⅞ ×
30⅞ × 16⅞ in. (114 × 78.5 × 43 cm); stool: 14 in.
(35.5 cm) high
Private collection

Dressing table and stool ensemble with sliding patinated
wrought-iron mirror (MS1009 and SN1), 1926–27
Designed by Chareau
Sycamore, sapele, and sycamore veneer dressing table:
39⅜ × 41¾ × 36¼ in. (100 × 106 × 92 cm) with mirror open;
stool: 13⅞ in. (35.5 cm) high
Private collection

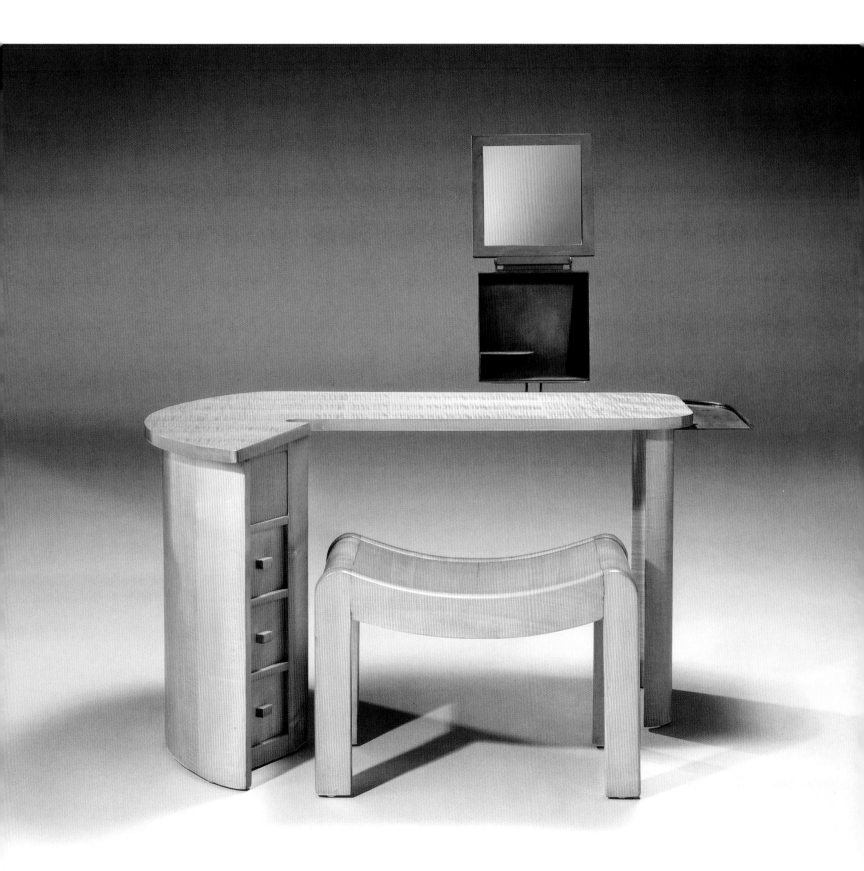

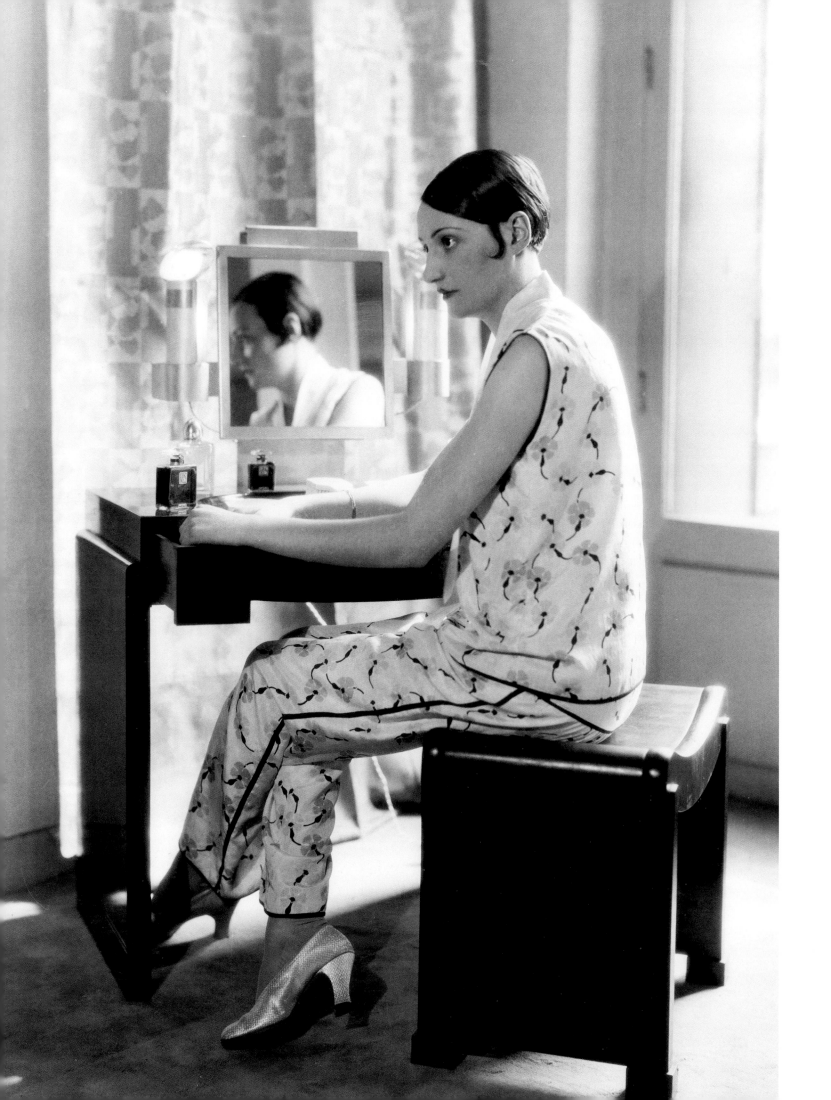

Rosewood desk (MS1009) and folding mirror, both
designed by Chareau, 1927.

Opposite
Woman at a dressing table (MS423) designed by Chareau,
c. 1926–27.
The mahogany dressing table has an attached wrought-
iron mirror with hinged cylindrical lamps. The model
wears pajamas by Lucien Lelong in white crepe de chine
with a cornflower pattern. A bottle of Tout Le Long
perfume stands on the vanity.

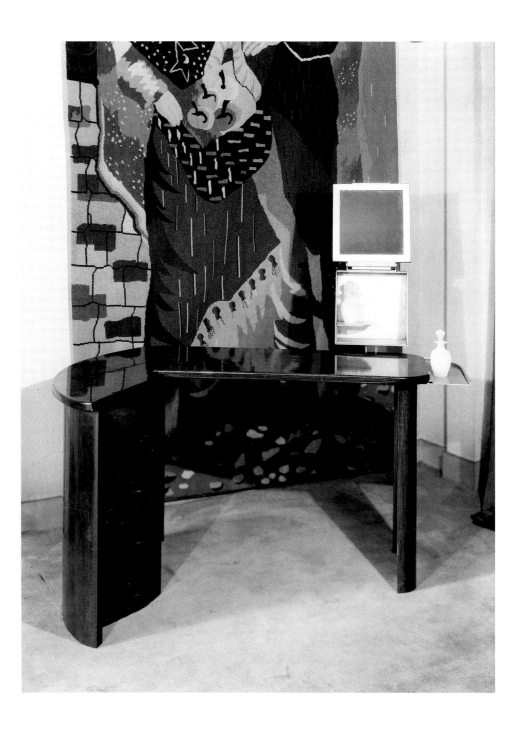

Chareau, sketch for wooden desk, c. 1920
Watercolor on paper
Private collection, Paris
Chareau's interest in Chinese furniture may be seen
in the feet of this desk.

Opposite, above
Chareau, sketch for a side table flanked by two
marble stands, c. 1925
Watercolor on paper
Private collection, Paris

Opposite, below
Double bed with pivoting side table, c. 1930
Designed by Chareau for his secretary, Marie Foulon
Rosewood and patinated wrought iron, with
mattress and cushions upholstered in velvet,
23¼ × 80¾ × 74¾ in. (59 × 205 × 190 cm)
Private collection

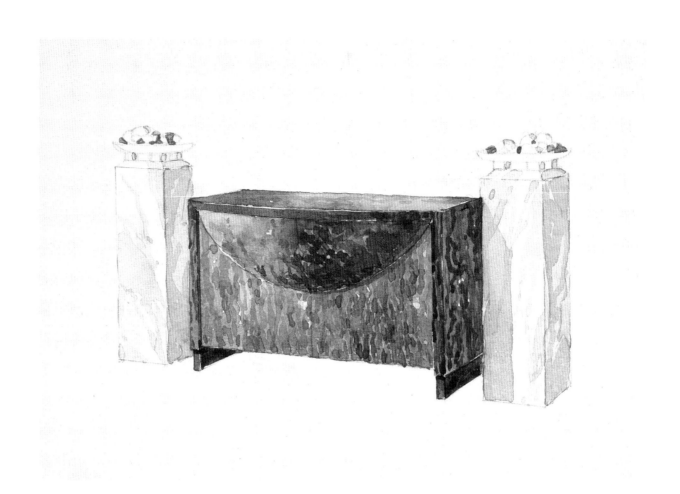

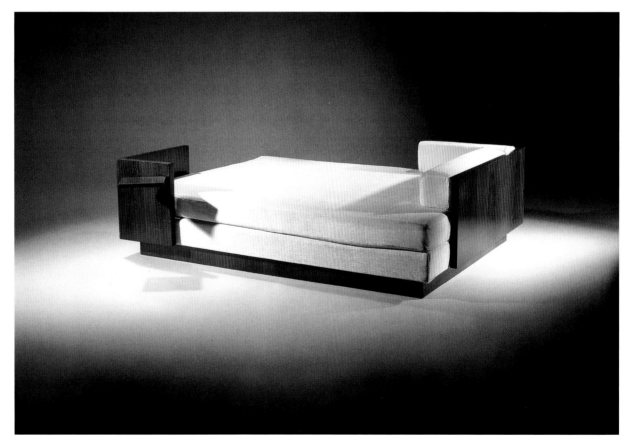

Lighting

Chareau disliked homogenous lighting and staged different parts of his interiors with his inventive light fixtures. Alabaster shades produced a soft, diffuse glow, which he varied in scale and intensity, at times using several tiny alabaster sconces affixed to the wall, or joining sets of them in ribbons to underscore the line or curve of a ceiling. Some of his pieces are almost sculptural, thanks to the help of the ironsmith Louis Dalbet, who executed the parts in patinated wrought iron.

Pair of table lamps (LP625), c. 1926
Designed by Chareau
Alabaster and silver-plated metal, 6 × 5⅛ × 3¼ in. (15.2 × 13 × 8.3 cm) each
Private collection

Wall sconce (LA550), c. 1927
Designed by Chareau
Metal and alabaster, 15⅛ × 14¾ × 4½ in. (38.4 × 37.5 × 11.4 cm)
DeLorenzo Gallery, New York

Table lamp (LP180), c. 1923
Designed by Chareau
Patinated wrought iron and alabaster, 11¼ × 9⅞ × 8½ in. (28.5 × 25 × 21.5 cm)
Private collection
Examples of this design were exhibited at the Salon d'Automne, Paris, 1923.

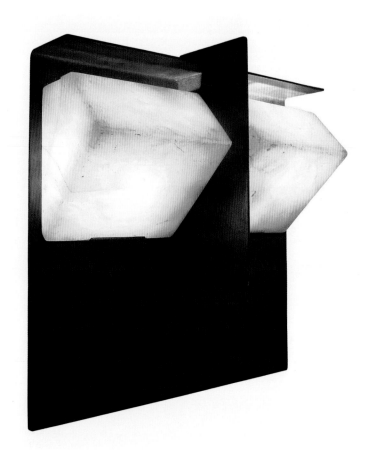

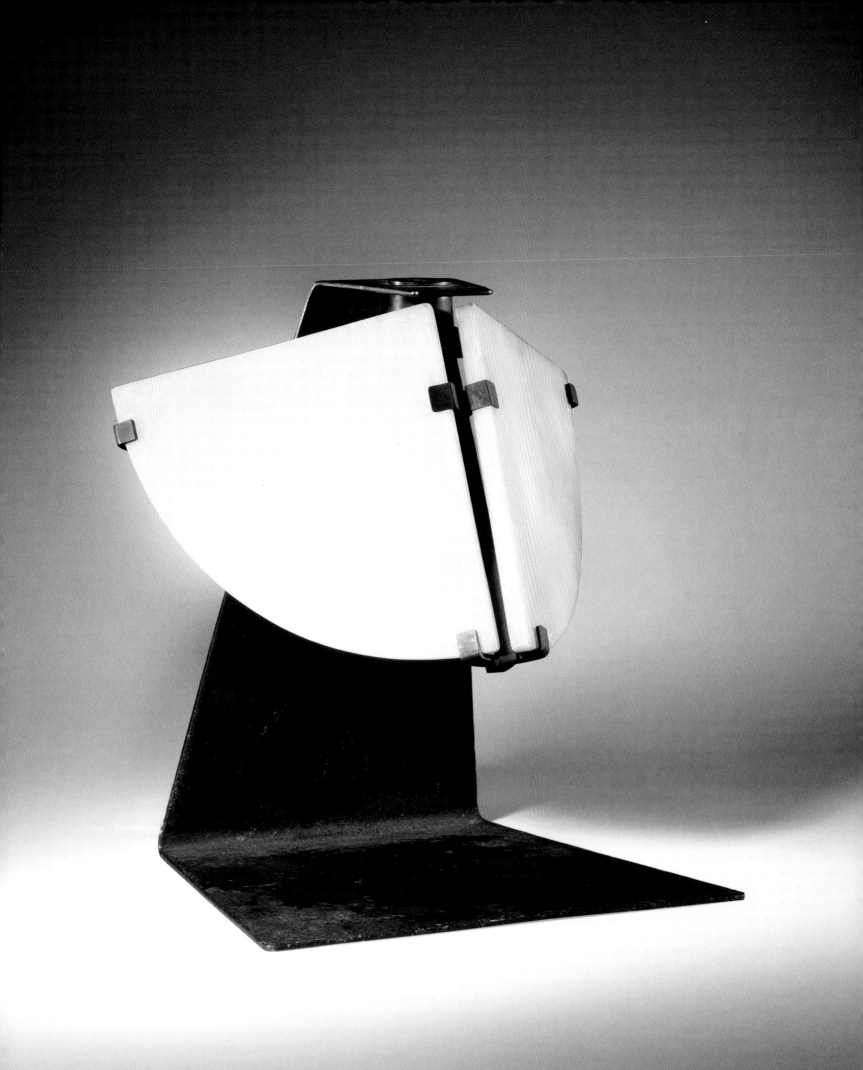

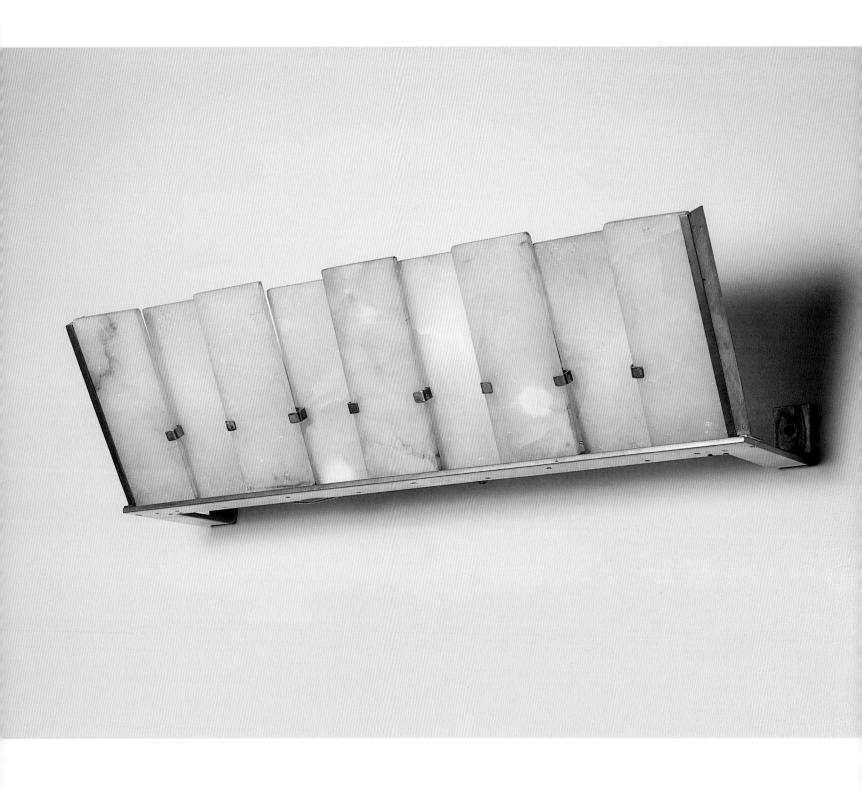

Wall sconce, c. 1924
Designed by Chareau
Alabaster and black patinated metal,
8¼ × 9⅞ × 5⅞ in. (21 × 25.1 × 14.9 cm)
Galerie Vallois, Paris

Opposite
Sconce, c. 1923
Designed by Chareau
Alabaster and nickel-plated metal, 23¼ in. (59.1 cm) high
Galerie Vallois, Paris

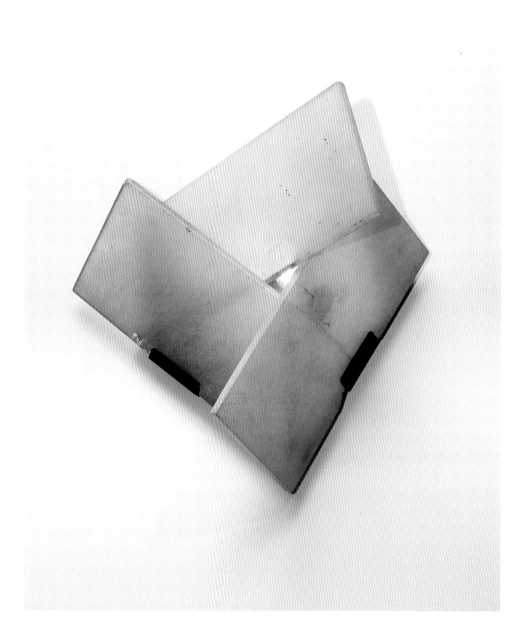

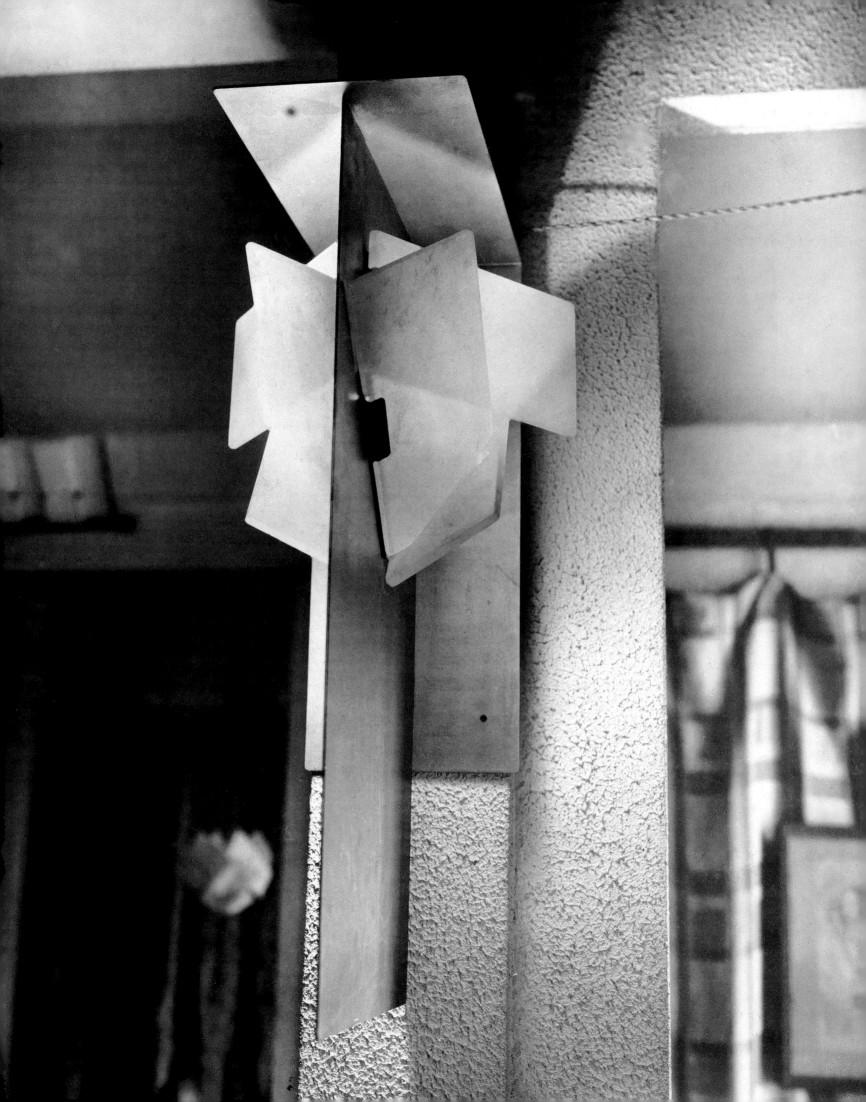

Alabaster and metal appliqué lamp (LA555),
designed by Chareau, c. 1924.

Chandelier, c. 1925
Designed by Chareau
Wrought iron and alabaster
Light refracts through panes of glass set at angles.
A Chareau mirror hangs on the wall;
his wrought-iron plant stand is at right.

Wall lamp, 1927–28
Designed by Chareau
Wrought iron and alabaster
This was designed for Villa Reifenberg,
built by Robert Mallet-Stevens, 1927–28,
at 8 Rue Mallet-Stevens, Paris.

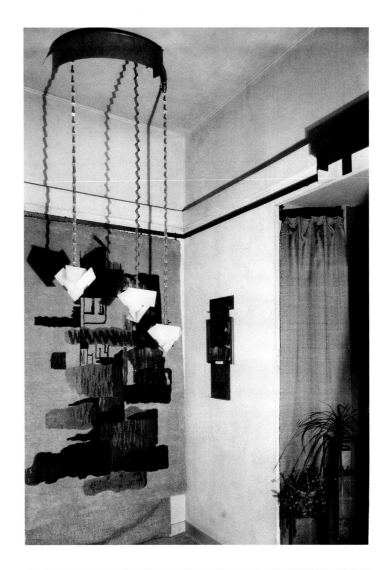

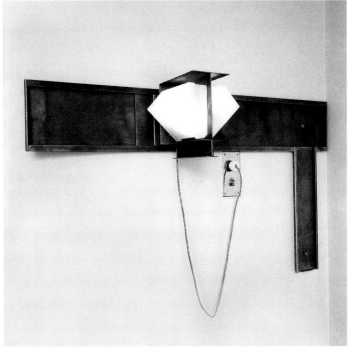

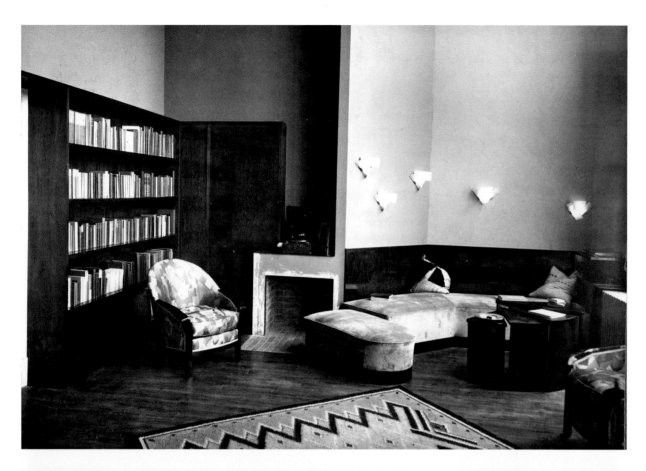

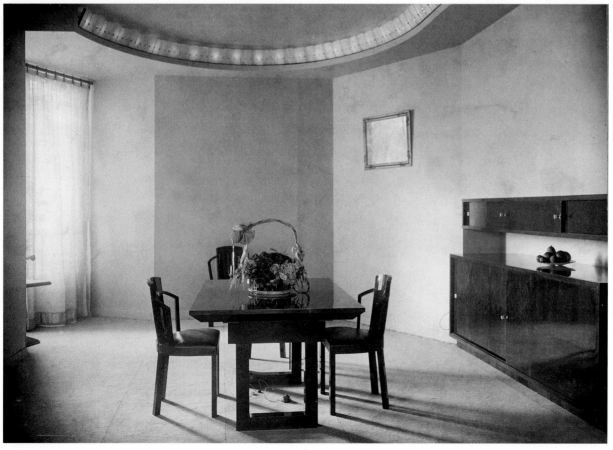

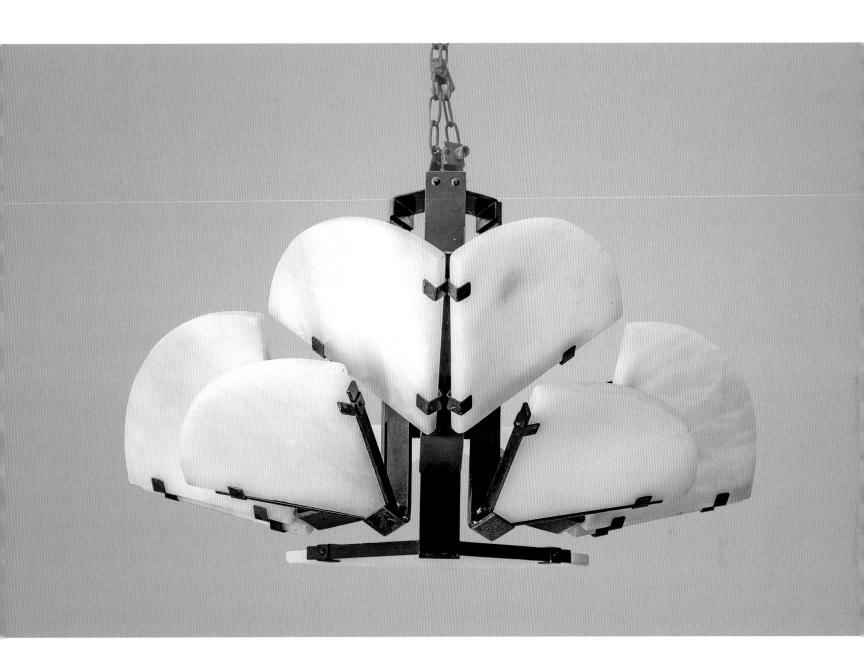

Ceiling lamp, c. 1923
Designed by Chareau
Patinated brass and alabaster, 12¼ × 17¾ × 17¾ in.
(31 × 44 × 44 cm)
Galerie Karsten Greve, Cologne

Opposite, above
A living room with alabaster sconces, armchair (MF732),
and fan table (MB106).
Designed by Chareau, c. 1928.

Opposite, below
A dining room with a row of alabaster lamps edging the
curved ceiling, designed by Chareau, c. 1927.
The table is similar to one that belonged to both Robert
Dalsace and Julia Ullmann (page 167).

Small, Medium, Large

Chareau's designs often had anthropomorphic
allusions. Some of his most popular light fixtures
were those called *La Religieuse* (the nun), as the
alabaster lampshade resembles the white cornette
worn by nuns. These came in three different sizes.

La Religieuse table lamp, c. 1925
Designed by Chareau
Mahogany and alabaster, 31½ in. (80 cm) high
Private collection

La Religieuse floor lamp (SN31), 1923
Designed by Chareau
Alabaster and hammered brass,
67⅜ × 17¾ × 21⅝ in. (171 × 45 × 55 cm)
Musée National d'Art Moderne,
Centre Pompidou, Paris

Opposite
La Religieuse floor lamp (SN31),
designed 1923, executed c. 1927
Designed by Chareau
Rosewood, alabaster, and patinated metal,
73½ in. (186.7 cm) high
Private collection

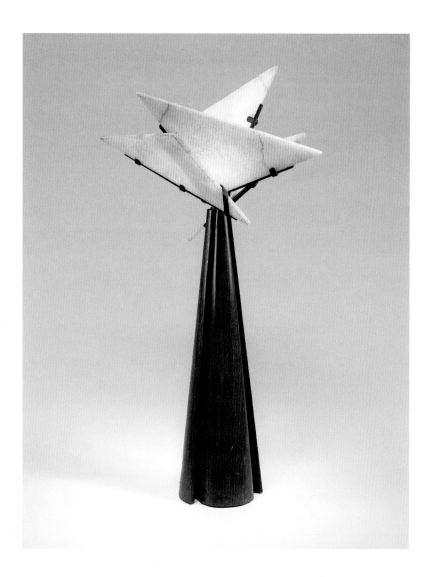

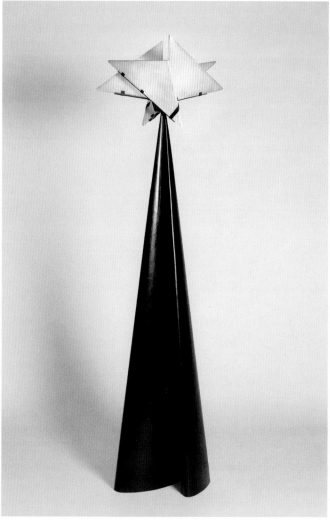

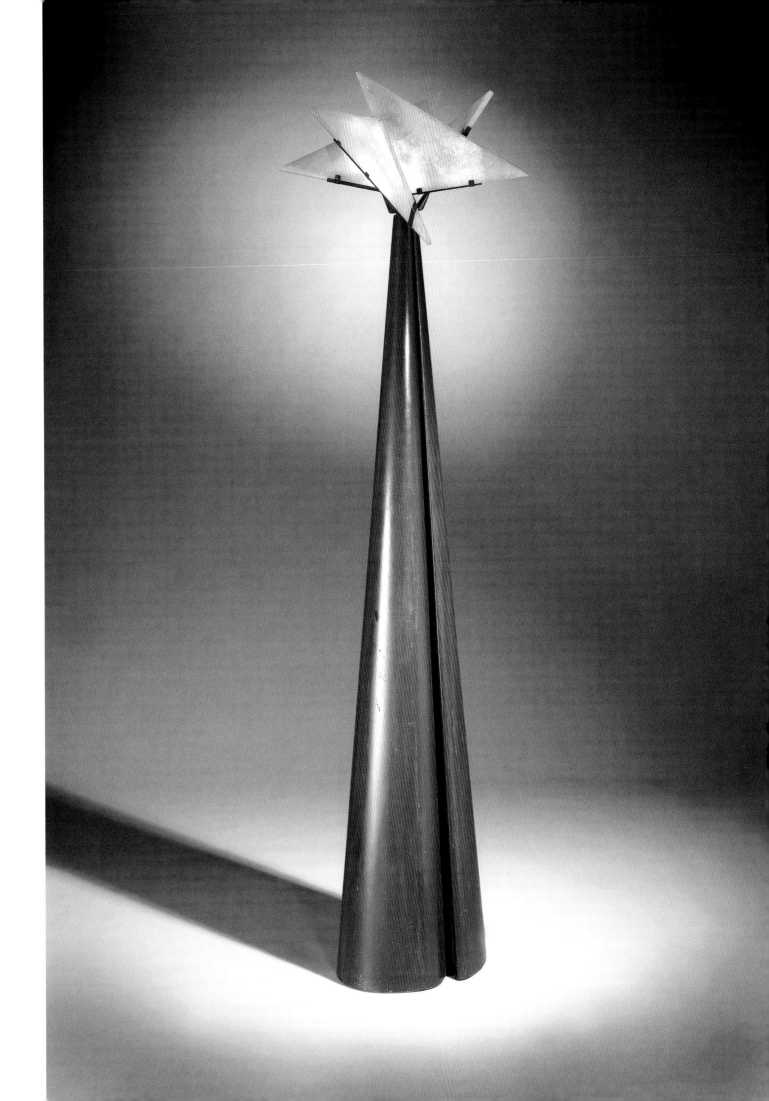

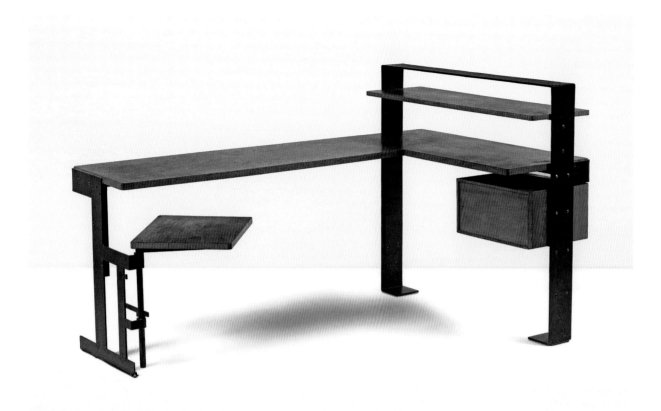

Desk (MB405), 1927
Designed by Chareau
Walnut and patinated metal,
36⅜ × 63 × 39⅜ in. (92.5 × 160 × 100 cm)
Private collection

Desk with a phonograph (MB513), c. 1928
Designed by Chareau for Dollie Chareau
Walnut and metal

Opposite, above
Desk (MB212), 1925
Designed by Chareau for the French embassy
Rosewood veneer on oak and mahogany, steel handles,
29⅞ × 55⅛ × 30¼ in. (76 × 140 × 77 cm)
Musée des Arts Décoratifs, Paris

Opposite, below
Desk, 1925
Designed by Chareau
Rosewood veneer on mahogany and oak,
29⅞ × 55⅛ × 30¼ in. (76 × 140 × 77 cm)
Audrey Friedman and Haim Manishevitz
Several variations of this writing desk are known.

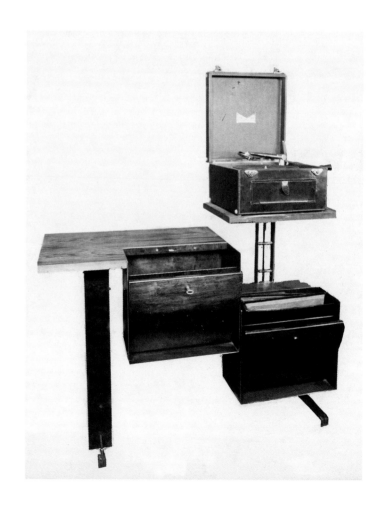

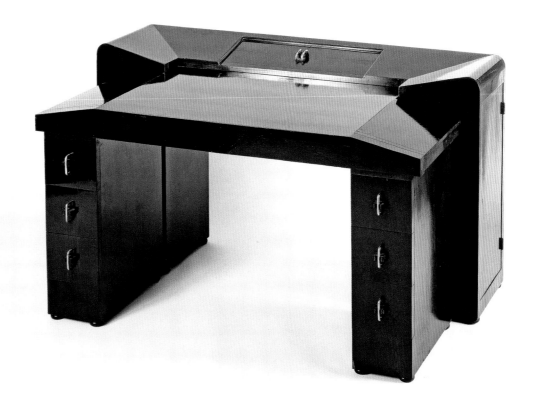

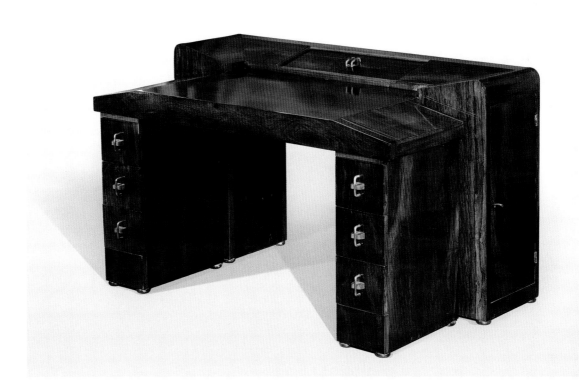

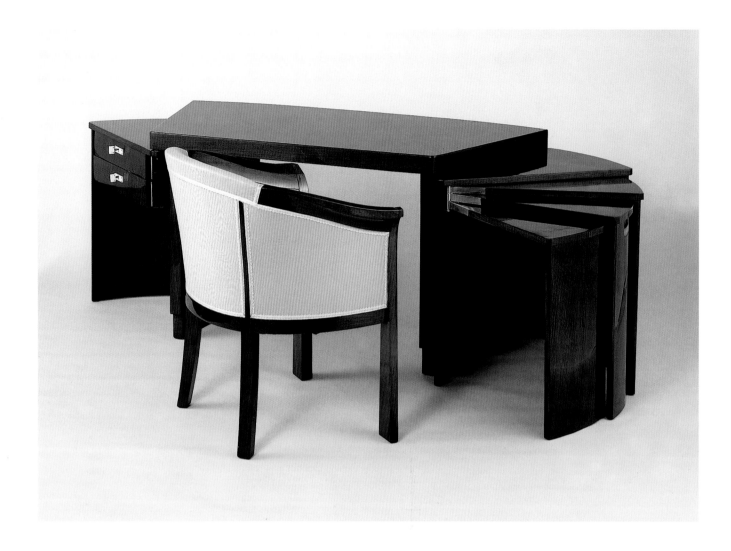

Desk and chair, c. 1928
Designed by Chareau
Rosewood, 27½ × 69¼ × 27⅛ in.
(70 × 176 × 96 cm)
National Museum of Modern Art, Tokyo

Linen chest (MA373), c. 1928
Designed by Chareau
Walnut and black patinated
wrought iron, interior in sycamore,
27½ × 38¼ × 15¾ in.
(69.9 × 97.2 × 40 cm)
Galerie Vallois, Paris

Wall-mounted shelf unit with fixed and
pivoting shelves, c. 1930
Designed by Chareau
Wrought iron with nickel-plated patina
and walnut, 54 in. (137.2 cm) high;
35 × 38⅛ × 24⅝ in.
(88.9 × 96.8 × 62.6 cm) closed
Galerie Vallois, Paris

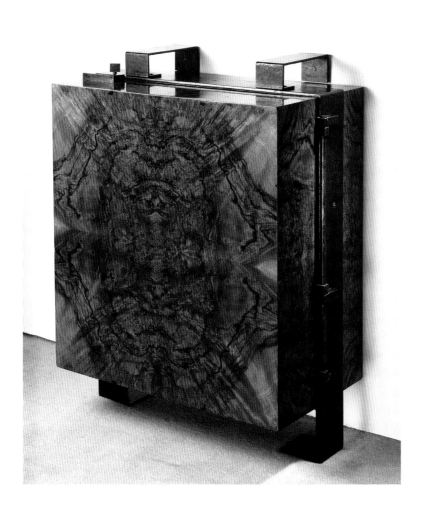

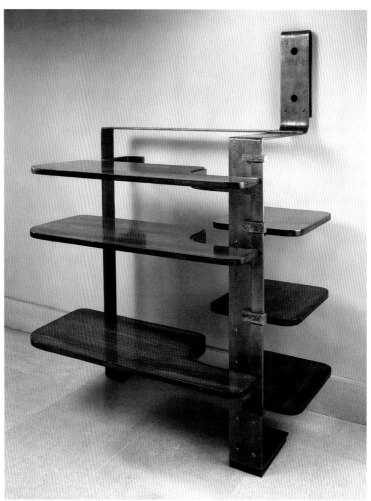

Letter holder, c. 1930
Designed by Chareau
Folded lacquered metal, 6¾ × 4 × 7⅛ in.
(17 × 10 × 18 cm)
Musée National d'Art Moderne,
Centre Pompidou, Paris

Coat rack, c. 1932
Designed by Chareau for the Maison de Verre, Paris
Duralumin tubing, 82⅝ × 35⅜ × 11¾ in.
(210 × 90 × 30 cm)
Musée National d'Art Moderne,
Centre Pompidou, Paris

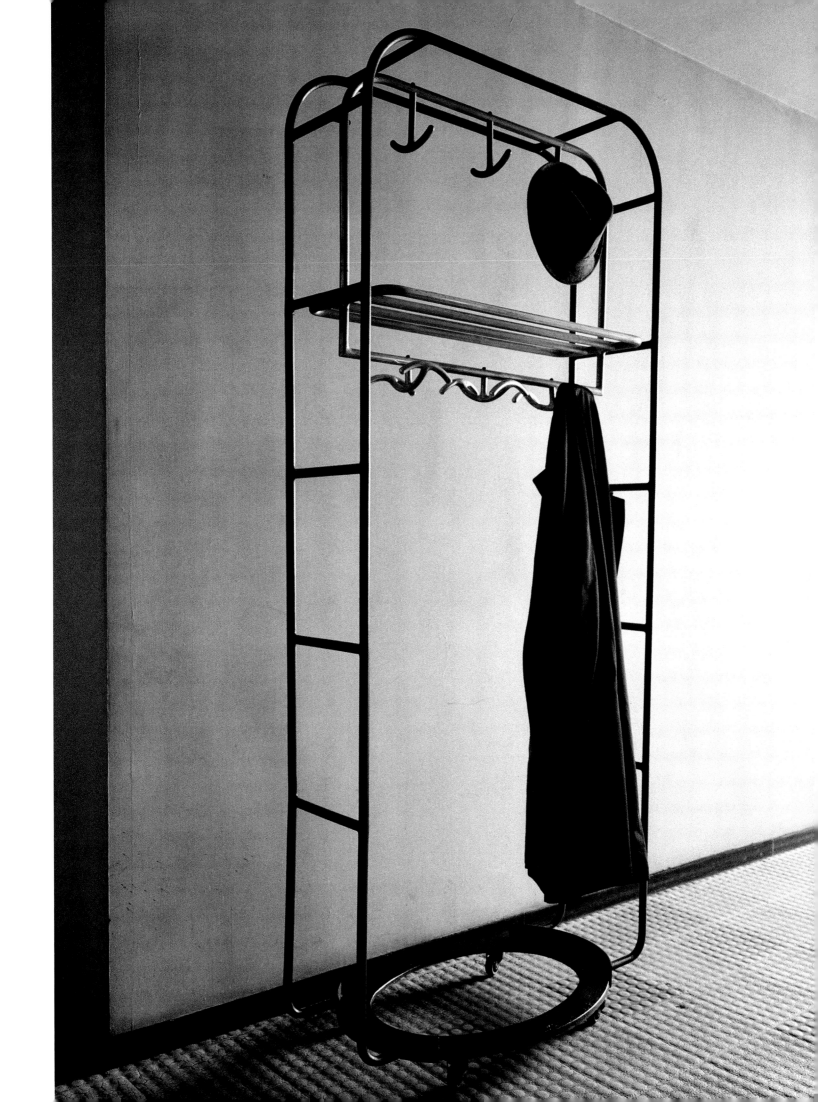

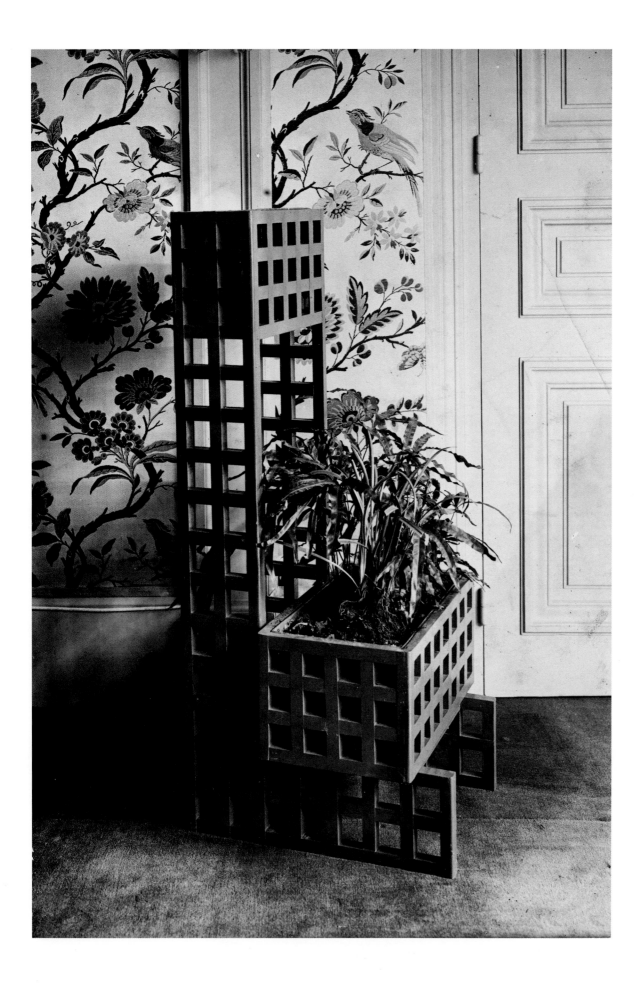

Grape cluster display stand, c. 1930
Designed by Chareau
Metal with mirror base, 6⅞ × 3 × 4 in.
(17.5 × 7.5 × 10 cm)
Musée National d'Art Moderne,
Centre Pompidou, Paris
A variant appears on page 32.

Opposite
Plant stand, designed by Chareau, showing
the influence of Josef Hoffmann and Vienna's
Wiener Werkstätte.

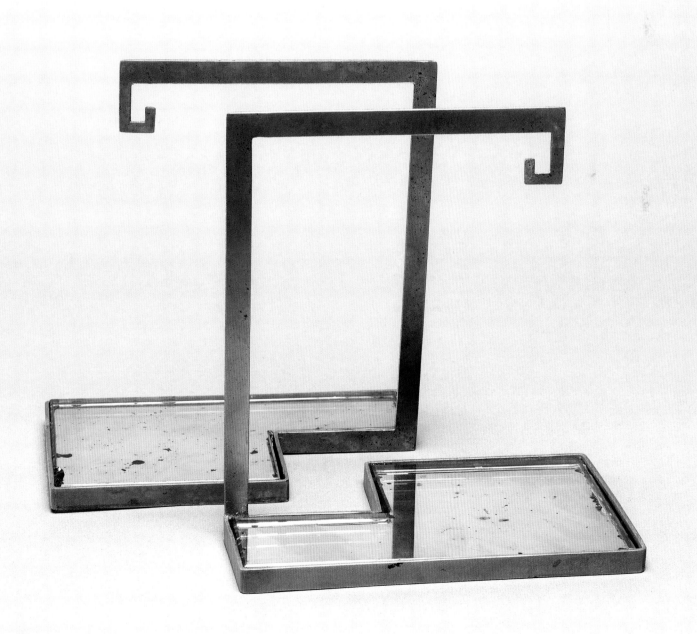

Plant stand (PF35), c. 1923
Designed by Chareau
Wrought iron, 41½ × 19¼ in. (103 × 49 cm)
Private collection

Wall-mounted plant bracket in wrought iron (PF83),
designed by Chareau, c. 1925.

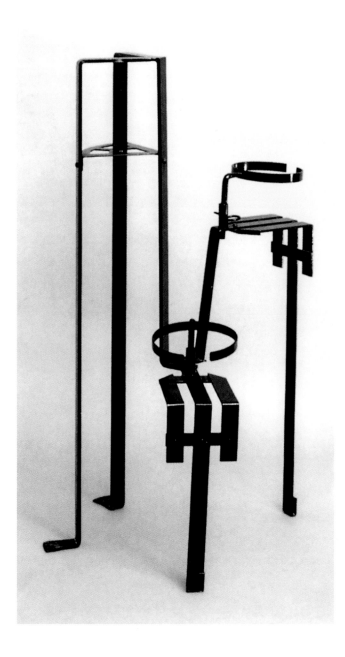

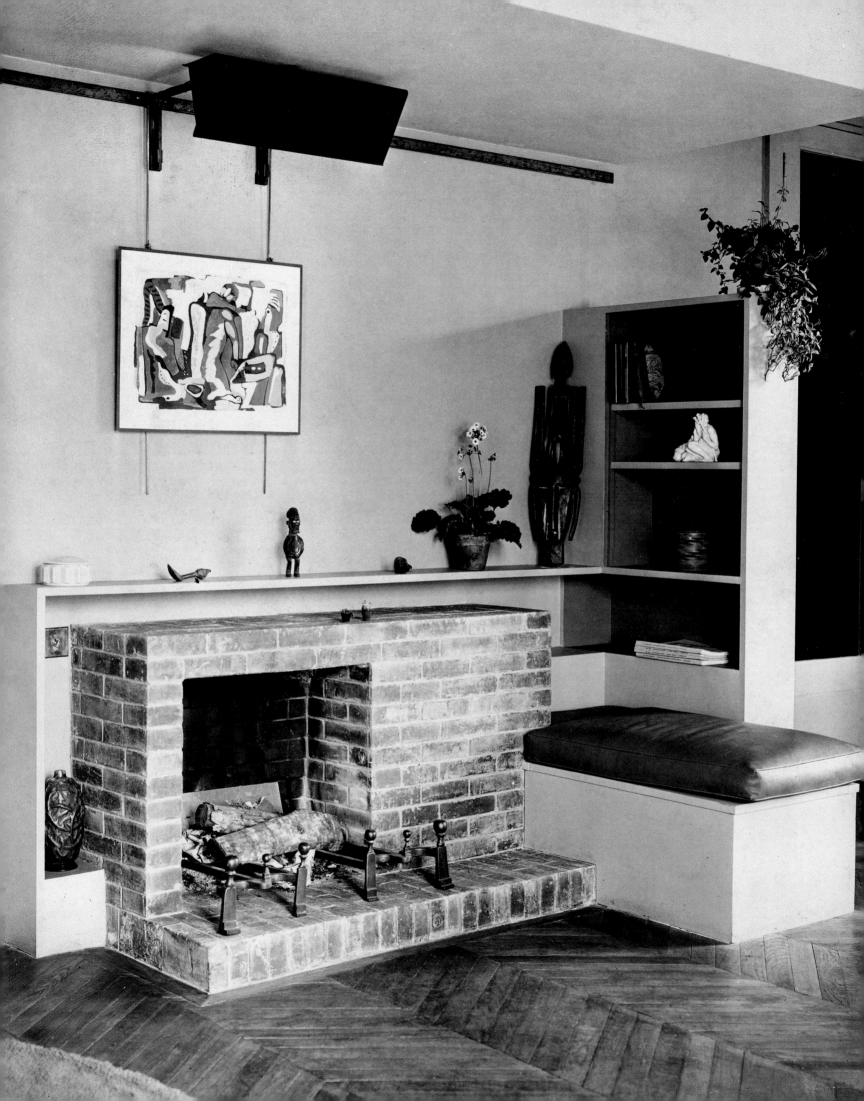

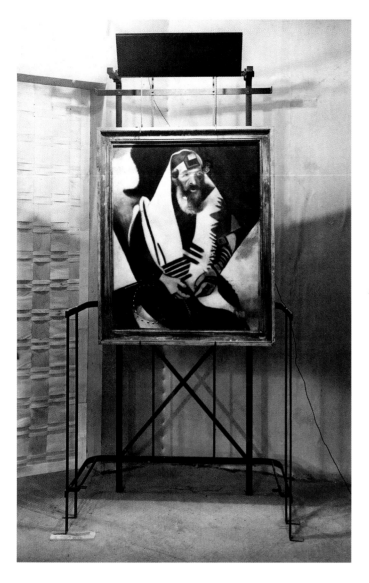

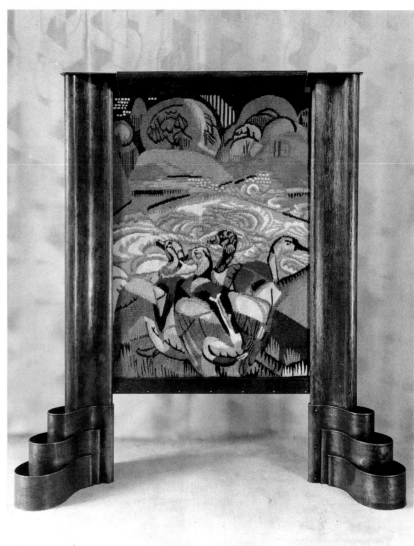

Displaying Art

An art collector himself, Chareau was particularly intent on integrating his furniture with his patrons' art collections, whether tapestries, Chinese lacquer screens, avant-garde art, or African sculpture. Paintings were sometimes hung from an ingenious form of track light, so that lamp and artwork could be repositioned together. Conversely, his exquisite freestanding easel for Chagall's *Praying Jew* centers the spectator's attention by isolating the work from its surroundings.

Wrought-iron standing frame (PW280), designed by Chareau before 1925 for Marc Chagall's 1914 painting *The Praying Jew*.

Screen with tapestry (PE209), designed by Chareau.

Opposite
Living room with lamp and artwork on a combined track, designed by Chareau. A fireplace surround adjoins a built-in seat and shelves for the display of small sculptures.

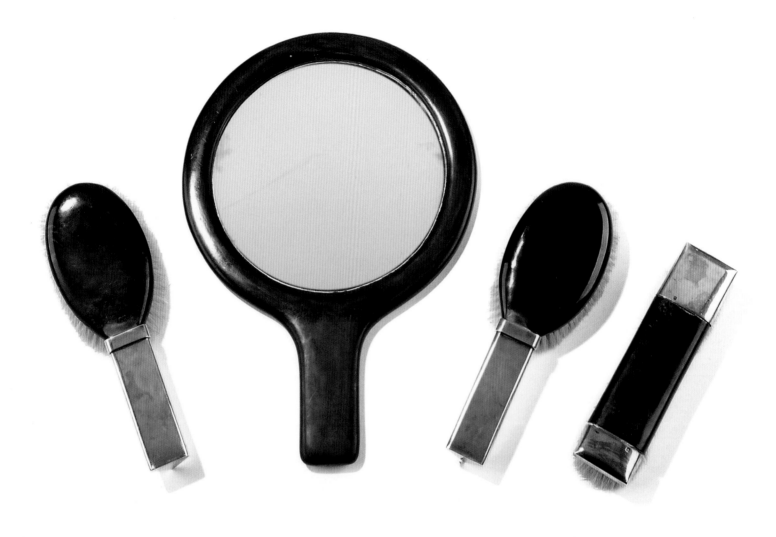

Vanity set (hand mirror, two hair brushes,
and clothes brush), c. 1925
Designed by Chareau
Silver, tortoiseshell, and mirror; mirror:
14⅛ in. (36 cm) high, 9⅞ in. (25 cm) diameter
Private collection

Desk set (inkwell, paper knife, letter rack, blotting
pad, pen tray, hand blotter, and ruler), c. 1929
Designed by Chareau
Silver metal and wood; paper knife:
13¾ in. (35 cm) long
Private collection

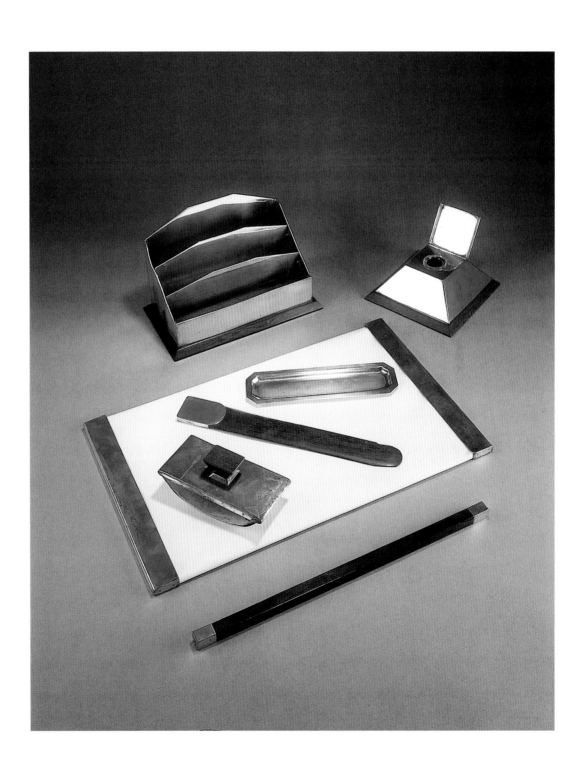

Illuminated triptych mirror (MG820/821), c. 1930
Designed by Chareau
Patinated steel, alabaster, and mirror,
22 × 18½ × 4¾ in. (56 × 47 × 12 cm) closed;
22 × 34¼ × 4¾ in. (56 × 87 × 12 cm) open
Private collection

Adjustable sliding wall mirror (MG311/312), c. 1928
Designed by Chareau
Nickel-plated and black-painted wrought iron with ivory pull,
for the apartment of Robert Mallet-Stevens,
29¾ × 13 in. (75.5 × 33 cm)
Private collection

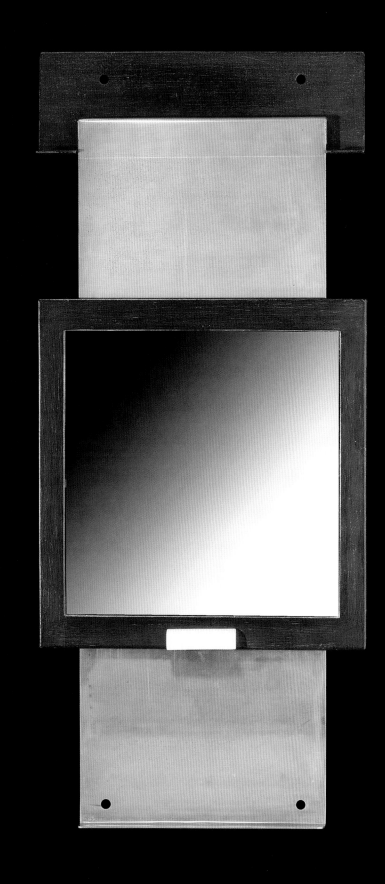

Wicker Furniture

French designers loved wicker and straw for the beautiful effects they produced. Chareau designed several pieces of furniture in *lakane,* wicker, a durable but lightweight material that lent itself to informal spaces such as nurseries and lounges (page 76).

Living room with lacquered wicker armchair (MF19) and tea table, corbeille sofa (MP169), alabaster lamp and sconce, and metal plant stand. The dining room, with chairs upholstered by Jean Lurçat, can be seen behind the curtains. Designed by Chareau, c. 1926.

Chaise longue in rattan and light stand (MP13), designed by Chareau, c. 1923–27.

A group of rattan chairs, designed by Chareau, c. 1923.

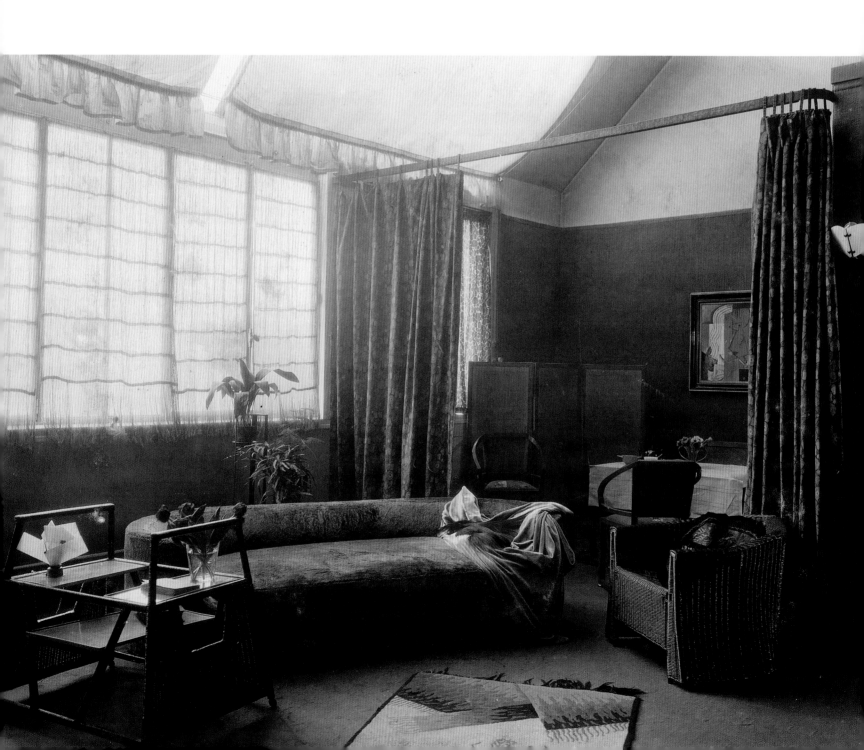

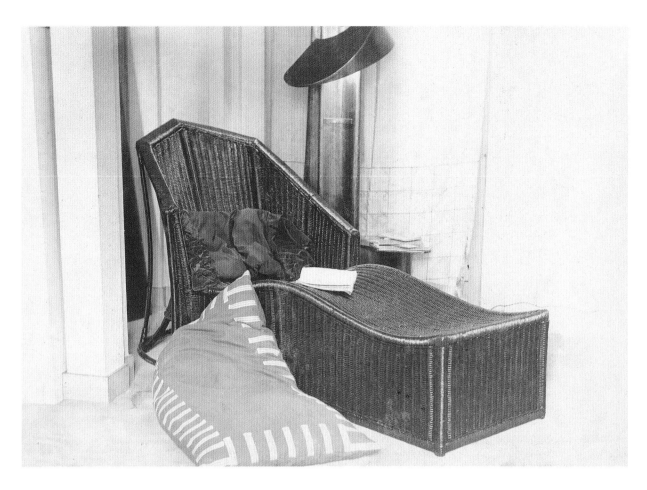

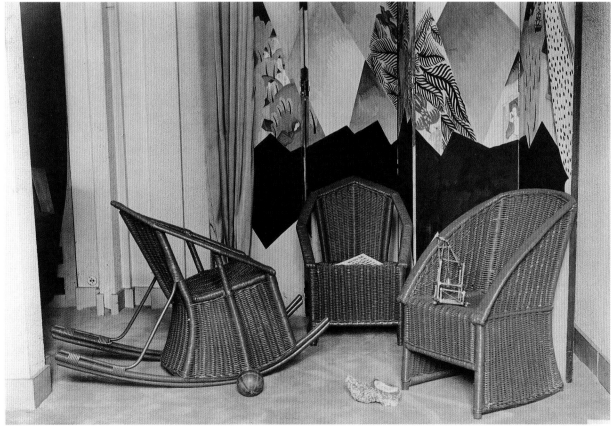

P. CHAREAU.

Chareau, sketch for furniture for a living
room, date unknown
Gouache and pencil on paper on cardboard,
6⅜ × 11½ in. (16.2 × 29.2 cm)
Musée des Arts Décoratifs, Paris

Pair of wicker chairs for a children's room,
c. 1925
Designed by Chareau
Private collection

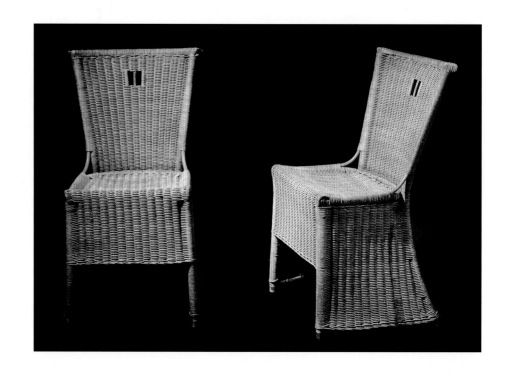

Folding chair (MC767), 1927
Designed by Chareau
Metal, paint, and rattan, 31½ × 22½ × 14 in.
(80 × 57 × 35.5 cm)
Musée National d'Art Moderne, Centre
Pompidou, Paris

Folding chair (MC763), 1927
Designed by Chareau
Metal and paint, 29½ × 31½ × 14⅛ in.
(75 × 80 × 36 cm)
Musée National d'Art Moderne, Centre
Pompidou, Paris
There are several variants of this chair,
upholstered in leather or rattan, both fixed
and folding, for a single person or more. Some
versions had an attached metal smoker's table.

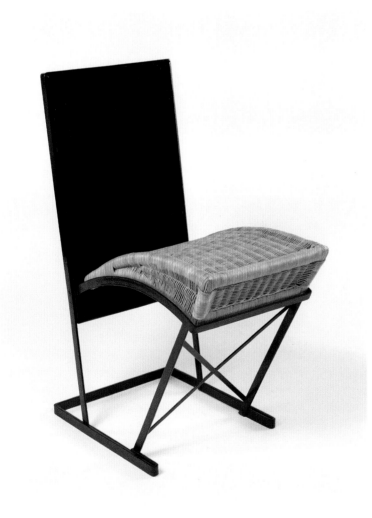
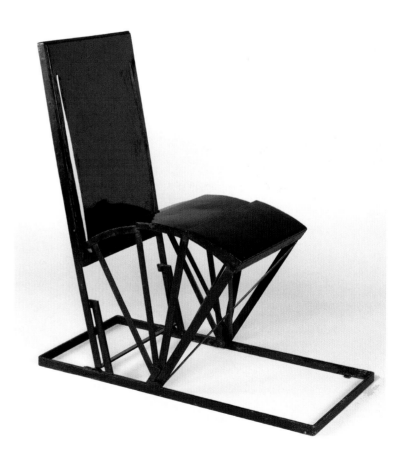

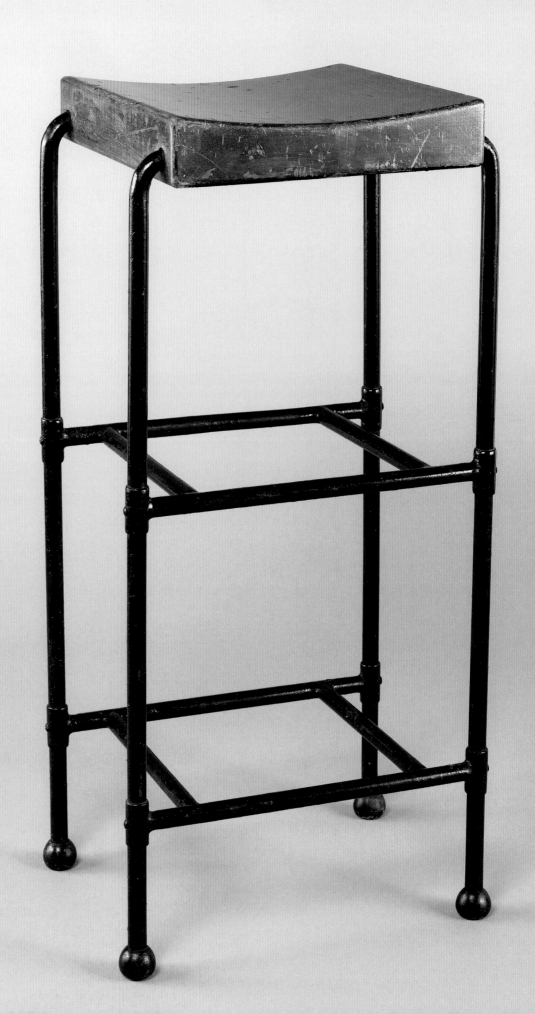

Barstool (MT344), 1927
Designed by Chareau
Metal, wood, and paint, 35⅜ ×
16½ × 13⅞ in.
(90 × 42 × 35.1 cm)
Musée National d'Art Moderne,
Centre Pompidou, Paris
These stools were used in the
Beauvallon golf club and
the Grand Hôtel de Tours.

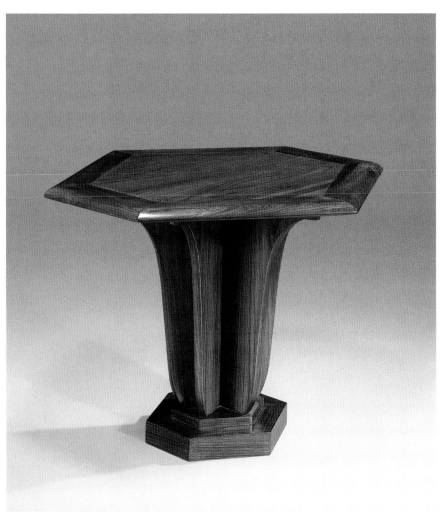

Tulip Designs

In 1923 Chareau designed several pieces of furniture—table, bed, bookshelf—characterized by the gentle curve of the supporting members, which evoke the petals of the tulip.

Pedestal table (MB170), c. 1926
Designed by Chareau
Rosewood, 19¾ × 30¾ × 29⅞ in.
(50 × 78 x 76 cm)
Private collection

Side table with shelves, c. 1923
Designed by Chareau
Walnut, 52 in. (132.1 cm) high
Galerie Vallois, Paris

Daybed (MP102), 1923
Designed by Chareau
Rosewood, with fabric designed by Hélène Henry,
33 × 81 × 19 in. (83.8 × 205.7 × 48.3 cm)
Galerie Anne-Sophie Duval, Paris

Chareau, sketch of a tulip bed and bookcase, from
Les Arts de la Maison (1923).

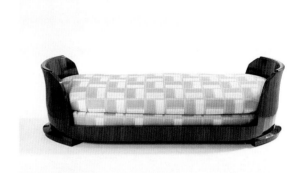

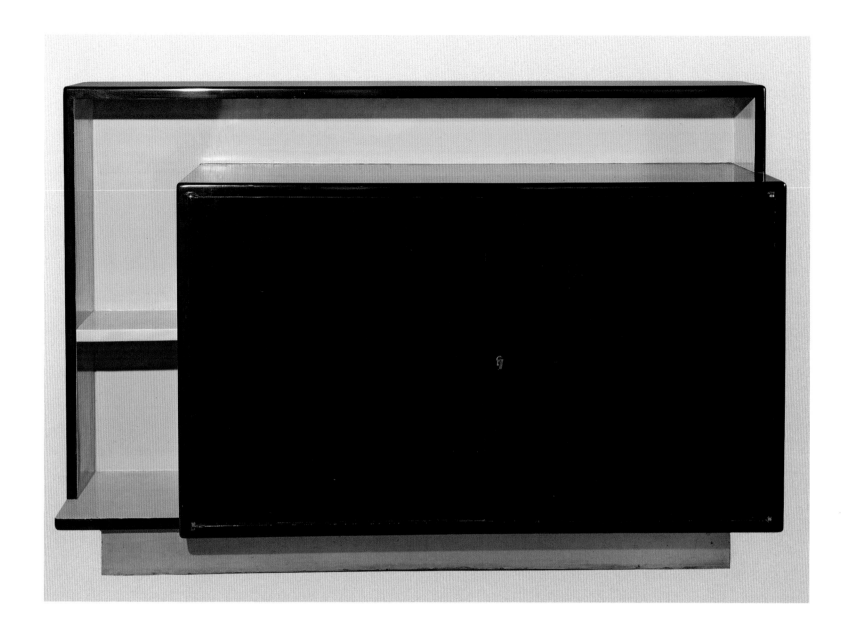

Suite of Furniture Created
for Julia Ullmann

Chareau designed a bedroom set in mahogany and
sycamore, 1925–27, and a credenza and matching table
in lacquered wood and glass, 1929, for Julia Ullmann.

Asymmetrical bicolor credenza, c. 1928
Designed by Chareau
Lacquered wood, 16½ × 58½ × 38 in.
(41.9 × 148.6 × 96.5 cm)
Miguel Saco, New York

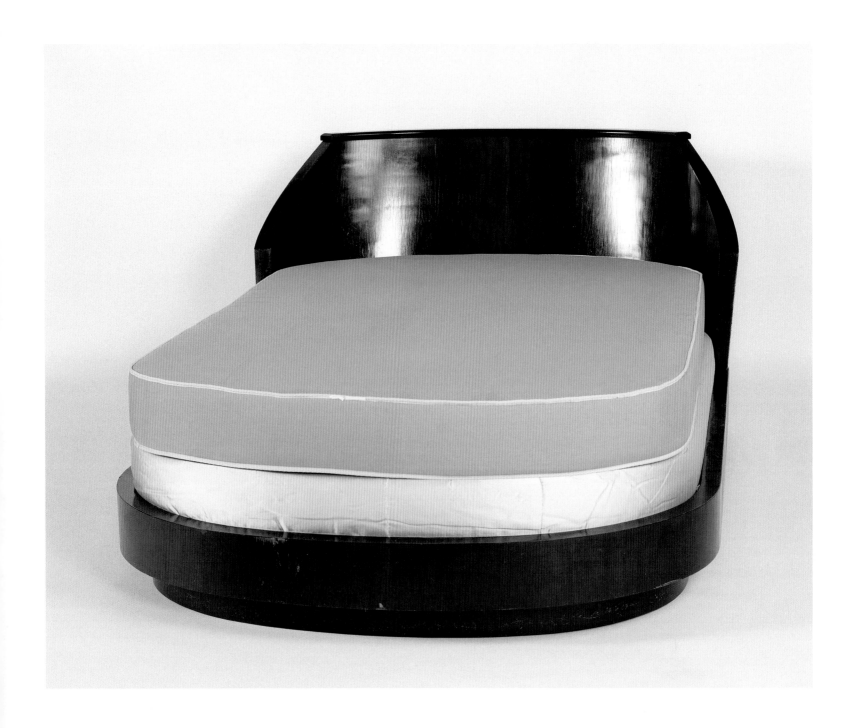

Bed (MP389), 1925
Designed by Chareau
Mahogany and sycamore, 31½ ×
74¾ × 63 in. (80 × 190 × 160 cm)
Musée National d'Art Moderne,
Centre Pompidou, Paris

Armoire, 1925
Designed by Chareau
Mahogany and sycamore, 51⅛ × 43¼ ×
19¾ in. (130 × 110 × 50 cm)
Musée National d'Art Moderne, Centre
Pompidou, Paris

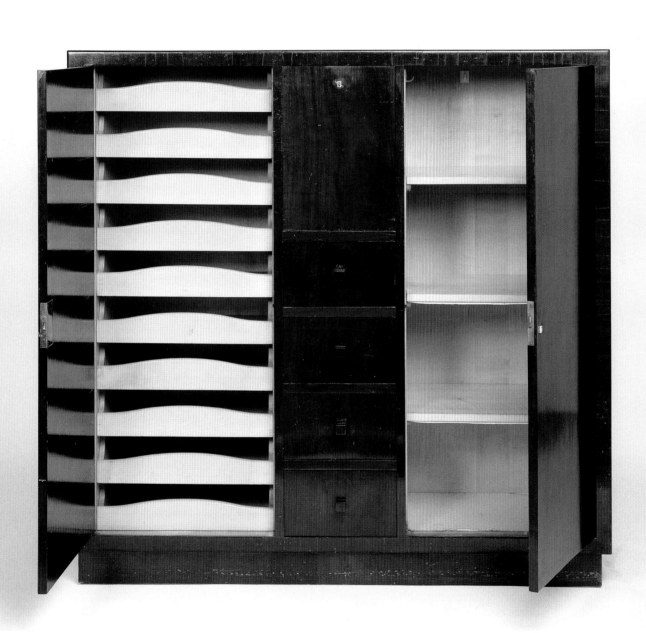

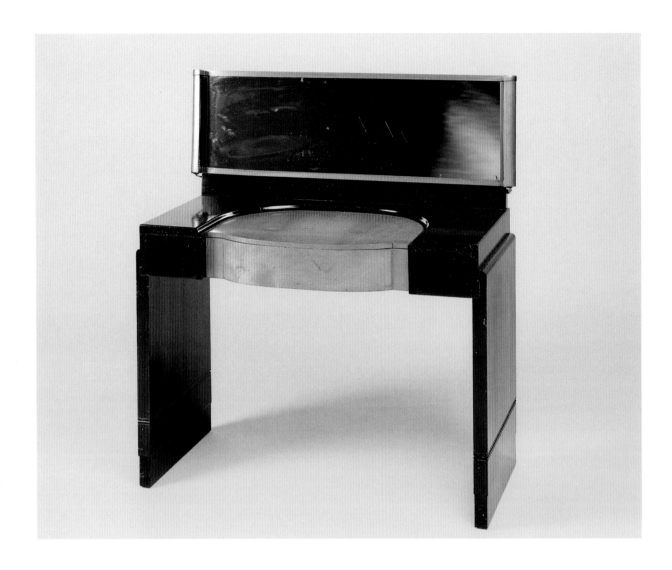

Dressing table, c. 1925–27
Designed by Chareau
Mahogany and sycamore, with mirror,
31½ × 25⅝ × 15¾ in. (80 × 65 × 40 cm)
Musée National d'Art Moderne,
Centre Pompidou, Paris

Seat for dressing table, 1925–27
Designed by Chareau
Musée National d'Art Moderne,
Centre Pompidou, Paris

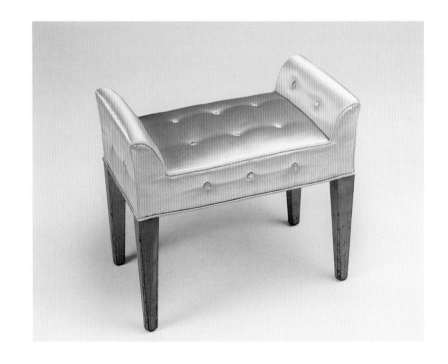

Bicolor table (MB413),
c. 1927
Designed by Chareau
Knotty walnut and lacquer
Paolo Kind, London

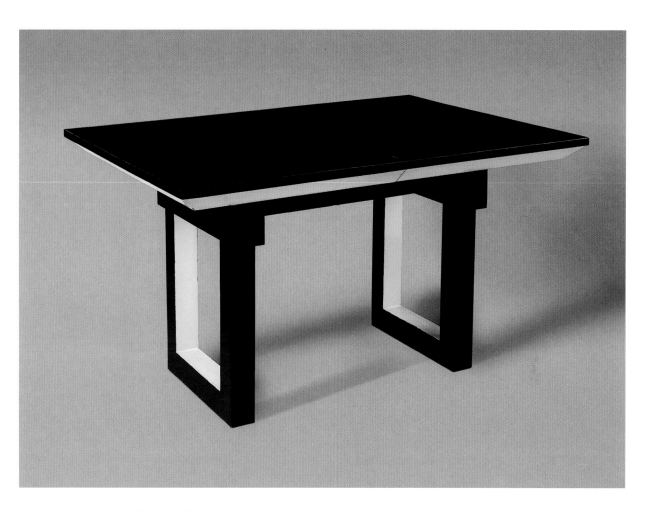

Chareau, sketch for a
wood dining table (MB413)
in bicolor lacquer, for Dr.
Robert Dalsace and Julia
Ullmann, c. 1926
Gouache on paper
Private collection, Paris

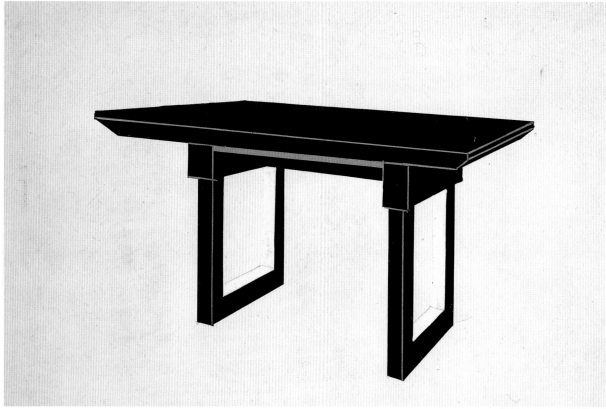

Drawings Done in the United States

We have no information on the furniture that Chareau designed during his years in the United States. In New York, he was not able to collaborate with highly skilled artisans or an ironsmith of genius like Louis Dalbet, as he had in Paris. The few drawings that survive from the early 1940s show sleek, simplified contours and a reliance on glass and metal.

Chareau, sketch for a trolley, c. 1941–43
Pencil and gouache on paper, 5¾ × 5¾ in.
(14.5 × 14.5 cm)
Musée des Arts Décoratifs, Paris

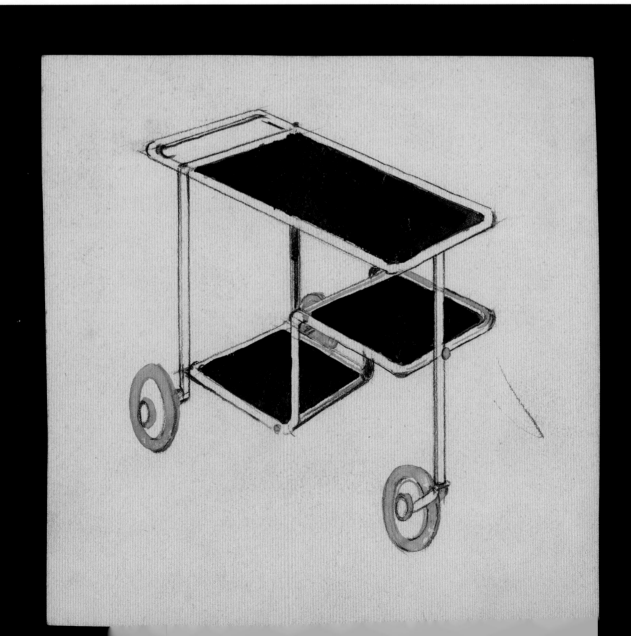

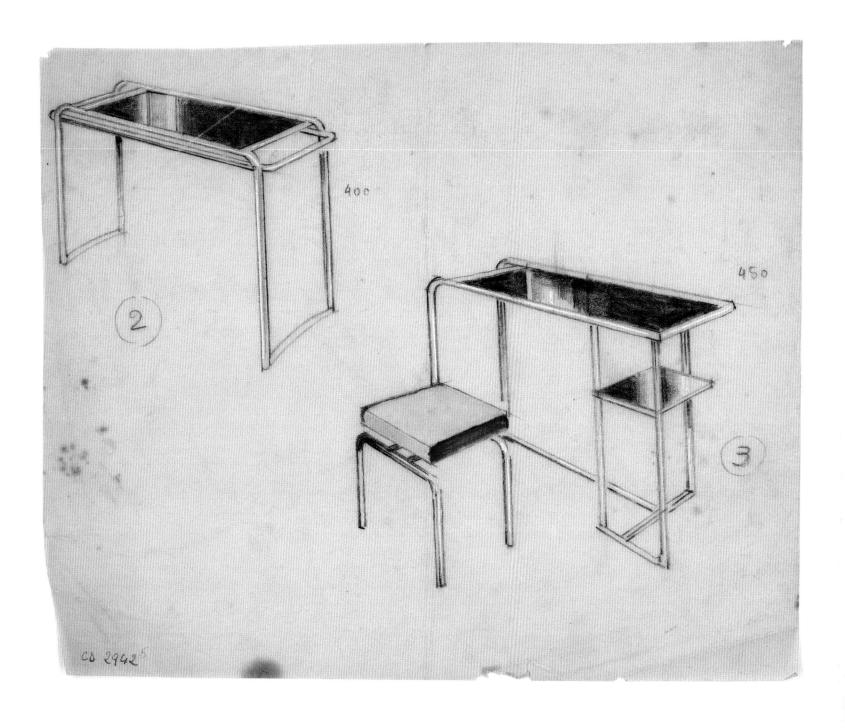

Chareau, sketch for two tables and a stool, c. 1941–43
Pencil, gouache, and white highlights on tracing paper,
8⅛ × 10 in. (20.7 × 25.4 cm)
Musée des Arts Décoratifs, Paris

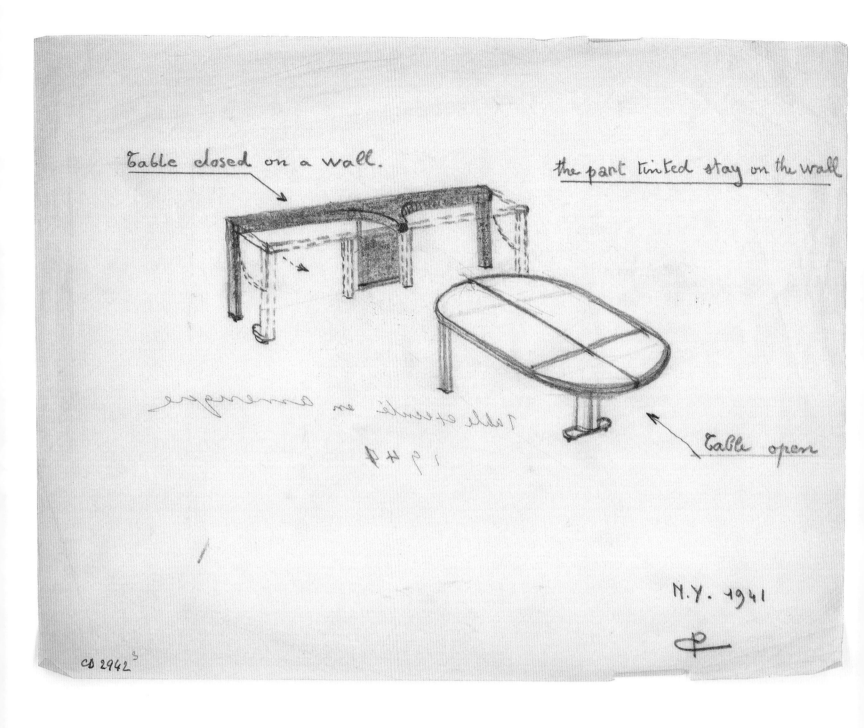

Table closed on a wall.

the part tinted stay on the wall

Table etendu en cremaque
1941

Table open

N.Y. 1941

CD 2942³

Chareau, drawing for a folding table, 1941
Black and red pencil on tracing paper, 9⅛ × 11¾ in.
(23.1 × 30 cm)
Musée des Arts Décoratifs, Paris

Chareau, sketch for a desk, 1941
Red pencil on tracing paper mounted on cardboard,
7½ × 9⅝ in. (18.9 × 24.5 cm)
Musée des Arts Décoratifs, Paris

Chareau, sketch for a table, c. 1941–43
Pencil on tracing paper, 2⅞ × 6⅛ in. (7.2 × 15.7 cm)
Musée des Arts Décoratifs, Paris

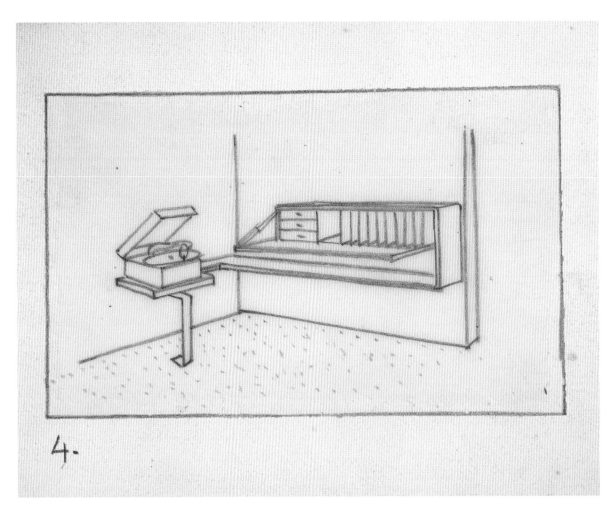

4.

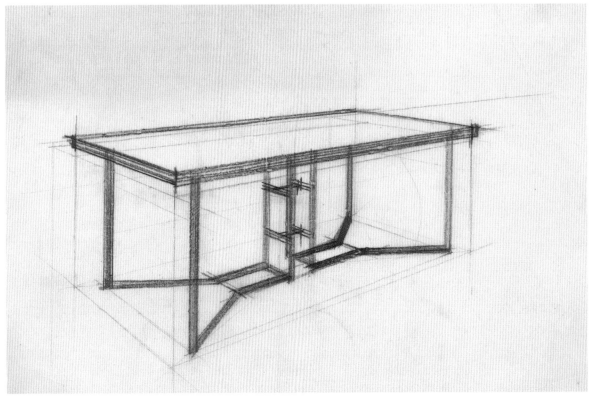

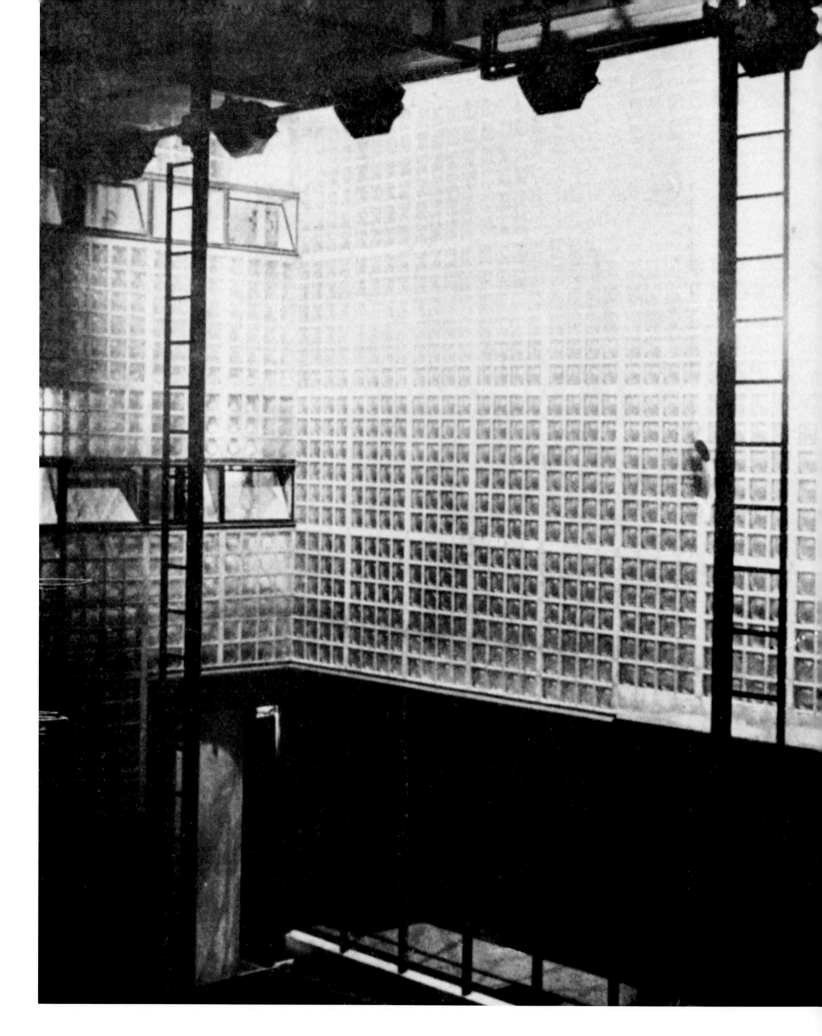

The Maison de Verre

Brian Brace Taylor
and Bernard Bauchet

One doesn't discover the Maison de Verre gradually, or perceive it from afar; rather, one encounters it precipitously. Passing under a porte cochère from a street in central Paris, one enters the courtyard of a typical nineteenth-century bourgeois building to confront an enigmatic facade consisting almost entirely of square, textured glass bricks, each marked with a convex circle to form an overall pattern. Spanning nearly the whole width of the courtyard and supported on thin columns, it rises from the second-floor level to a height of three floors. Day and night, the translucent glass remains visually impenetrable. The effect is not simply that of a glass curtain in the architectural sense but of a stage curtain, about to reveal wonders (pages 196–97).

Imagine the consternation and awe that struck members of the press in 1931, when the architect Pierre Chareau first introduced them to the Maison de Verre. The interior was not yet complete; only the glass facades at front and back were in place. Local and international journalists, not knowing what to make of this extraordinary structure, sought metaphors to render it comprehensible to their readers: it resembled an igloo, a beehive, an aquarium; it was "one huge window."

Night view of the main facade of the Maison de Verre in 1933, soon after its completion; the original spotlights are illuminated, rendering the glass bricks nearly opaque.

When they visited the vast, double-height space of the salon inside, they drew parallels with courtyard houses of ancient Greece or Andalusian Spain (page 199). The analogy that undoubtedly came closest was the idea that this was a house and a theater rolled into one.[1] This feature was strongest at night, when the front facade was illuminated by five powerful spotlights mounted on steel ladders. (Floodlights on the rear facade are mounted on hanging brackets to produce a similar effect.) The interior, with its balconies, suspended stairs, and moving panels and screens, conveyed the same impression of drama; the implication was inescapable: this was a setting for spectacle.

The extensive use of glass is notable here. Because the glass bricks of the facade are translucent rather than transparent, it is impenetrable when viewed from without, while allowing abundant natural light to enter. At night, when the interior is illuminated, the house glows, but only a few shadows can be seen within. Chareau commented in 1932, "I wanted to draw a veil between the inhabitants and the outside world, like the canvas of a tent."[2]

The principal architect of the Maison de Verre, Chareau began his professional career before World War I as a draftsman in the Paris branch of the British furniture firm Waring and Gillow, engaged in the interior decoration of buildings and steamships, and restoring existing structures such as theaters.[3] He was thirty-five years old when he returned from the war and decided

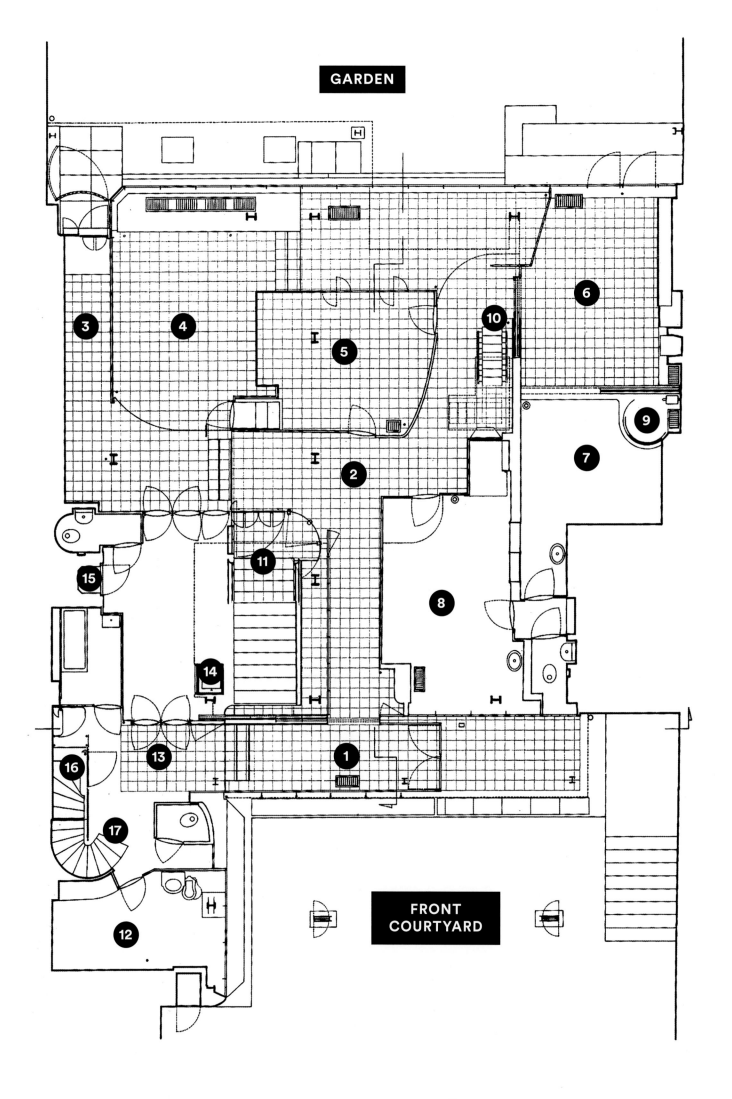

GARDEN

FRONT
COURTYARD

to start his own practice as an interior decorator, furniture designer, and eventually *ensemblier* and architect. Those who knew him recall that he said little in public unless caught up in defending an idea, a principle, or a standard; then he was ardent, convincing, and intractable. Chareau was also a passionate theatergoer and lover of ballet, often returning several times to see the same performance. It is altogether natural that someone who took such a keen interest in the technical aspects of theatrical production, as well as the execution of choreography and human gesture in dance, should interject something of these concerns into his own work—an aspect especially visible in the Maison de Verre.

On entering the courtyard at 31 Rue Saint-Guillaume today, one is already participating in a performance that a multitude of characters, from patients of the doctor who commissioned it to houseguests, service personnel, family members, and later residents, have been enacting for more than eighty years. Every visit to the house is memorable, because it is a space that has neither precedent nor successor.

The Maison de Verre presents itself to the uninitiated visitor as an enigma. While the first-floor facade offers a limited view inside the building through panels of full-height, steel-framed transparent glass, the entrance door is almost invisible to one side—and indeed there is little to indicate that the building is a house (page 200). To the right of the door is an unobtrusive upright post with three doorbell buttons, labeled "Visits," "Doctor," and "Service," imposing a preordained classification on callers. Unusually for a bourgeois dwelling even today, one entrance serves all. There is no door handle, but there is a keyhole; without a key, one must wait for the door to be opened from within.

As the buttons imply, the building served as both a home for the Dalsace family and a medical office for Dr. Jean Dalsace. Thus the bell summoned either a maid or the doctor's secretary. For a service call, a pathway leads straight ahead along the facade to a perpendicular wing of the house, also sheathed in glass brick and with inset steel-framed lights. This houses the cellar, kitchen, and a maid's room at top, all accessed by an internal stair.

The ground floor of the main wing is dedicated to the doctor's medical practice, consisting of a reception area; waiting, consultation, and examination rooms; and a small laboratory. Dalsace was a gynecologist, and in a variety of ways Chareau rendered this space preeminently as the realm of women. The patient or visitor is continually on view, constantly subject to the gaze of the nurse or secretary—and incidentally of the other patients in the waiting room. She is also under the gaze, metaphorically speaking, of a large portrait of the doctor's wife by the painter Jean Lurçat, which hangs immediately next to the secretary's office. A bust of Madame Dalsace by the Cubist sculptor Jacques Lipchitz also observes from above a bookcase in the doctor's office (page 210). The patient can also be seen from the second-floor petit salon, part of the residential area of the house, which overlooks the doctor's reception area. When her turn is called, she must traverse a glazed corridor between the waiting room and the garden facade. This is filled with direct and reflected light on both sides: one wall is the garden facade of the building, composed of transparent glass and the same square, translucent glass bricks as the main facade; the other wall is made up of the floor-to-ceiling glass panels of the reception room, where the secretary sits. Arriving at the doctor's office, she enters the realm of the medical gaze.

One of the doctor's principal requirements was that there should be a maximum amount of natural light throughout his first-floor consulting suite. A second requirement was that hygienic materials should be employed. Extensive use of metal and glass, both relatively strong, smooth, and durable, met his

conditions. He conceded that many of his patients might be made momentarily uncomfortable by the use of glass everywhere. The choice of translucent glass for many of the interior and exterior walls was thus an astute decision on the part of both architect and client (pages 193, 201).

What Chareau conceived was a venue for viewing and being viewed, expressly designed to facilitate *le regard,* the gaze. The term, as used by the postmodern psychoanalyst Jacques Lacan, refers to a condition of modernity in which we are always, uneasily, subject to the observation of others. It is, thus, a form of spectacle, carried out not in the theater but in everyday life. For Lacan, and indeed for Chareau, the awareness of being thus exposed is not necessarily negative. "Isn't there a satisfaction of being in that gaze," Lacan writes, "which envelops us and makes of us first of all beings who are gazed at, but without anyone letting on? The spectacle of the world, in this sense, appears to us as *omnivoyeur,*" all-seeing.[4]

A guest of the family, as amazed and intrigued as a patient by a first impression of the facade, would ring and be invited in through the same front door. He or she would discover the first floor by walking down the same corridor to the reception area. At that point, a visitor is standing between the professional offices and the threshold of the domestic realm. Turning sharply left, one encounters a semicircular pivoting door made of transparent, curved glass, paired with a perforated black metal screen (page 204). This swings open silently to allow entry for a single person, in a gesture that may be compared to pulling open a curtain. To the right of this are more of these metal panels, which can be folded open independently or, together with a solid sheet of glass, can be pushed open. This ensemble exemplifies the screening devices that Chareau deployed throughout the spaces upstairs in the living quarters, creating veils between or around spaces, rather than solid barriers.

Visible through these doors is a monumental floating staircase leading up to the residential zone. One has no choice but to ascend—which is slightly unnerving since the stairs have no handrails. As one ascends, the full extent of the two-story, glass-brick front facade becomes apparent, shimmering and lucent. This provokes a sensation of entering a mysterious other world, bathed in cool, diffuse daylight or artificially floodlit at night. Because the stairway has no risers, light enters between the steps, giving the impression that one is on a ladder floating upward. One is impelled forward and up, and once again the effect is dramatic.

More theatrical still is the way one's progress is orchestrated. A landing at the top of the stairs provides a stage for the homeowner to stand and greet her guests against the backdrop of the glass facade wall. At night this wall has a glowing golden aura, against which a figure is a stylized silhouette. Chareau created this almost operatic moment with Madame Annie Dalsace in mind.

Next, as one comes up the stairs and passes this landing, one's gaze, hitherto fixed on one's host, shifts abruptly, turning 180 degrees. Thus one discovers the vast second-floor grand salon. The scale and depth of this open area (it can scarcely be called a mere room) are difficult to ascertain because its limits are not clearly defined. Occupying about one-third of the second floor, it was conceived as a large theaterlike hall for receptions. It is a space with multiple screens—fixed, built-in panels of wood or perforated metal—and sliding doors. The edifice's structural steel columns are exposed, running the full height of the house. Guests arriving from the grand staircase can be seen from numerous vantage points by people already inside, including from a third-floor mezzanine. This is spectacle par excellence: a semipublic domain devoted to performance, to seeing and being seen (page 199).

The second floor comprises this immense salon, a dining room next to the kitchen, Dr. Dalsace's private study, and a small sitting room called the petit salon, with a tiny conservatory for plants (pages 202, 203). The grand salon is directly behind the main facade, whose immense gridded glass screen forms one wall, rising to double height. The dining room is an adjacent open area that flows into it, demarcated by being set two steps lower.

Beyond this on the garden side is the petit salon, where Madame Dalsace received guests. It is an intimate space, accessible only from the dining room, and by a retractable stair from the master bedroom above. Two features of it are extraordinary from both a cultural and a technological standpoint. The wall that looks out on the back garden is composed of a series of panels of steel, brass, leather, and felt, set in wooden frames bolted onto steel frames from outside. Above these are transparent glass windows; the upper segment of these is fixed, while the middle segment slides up and down like the windows of old railway carriages, thanks to an intricate system of springs and counterbalances. The solid lower half of each panel obstructs a view of the garden when one is seated. Exceptionally ingenious is the retractable stairway that leads from the petit salon up to the master bedroom on the third floor. It resembles a ship's ladder and can be folded into the ceiling when not in use. Both of these features run counter to conventional expectations in a bourgeois apartment.

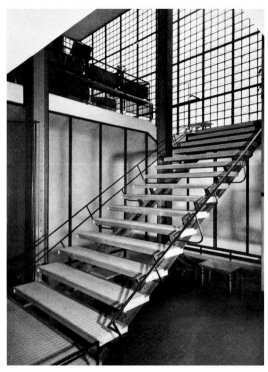

A signature Chareau feature throughout the house is its many concealed or built-in components. These include a dumbwaiter, closets, shelves, and various kinds of lighting. Stairs from the second to the third floor are partially hidden behind a series of vertical screens, which are slightly separated from one another to allow the passage of light and fleeting glimpses into the grand salon below. At the top of these stairs, two passageways intersect: one overlooking the double-height space of the salon, with a balcony railing composed of bookcases and cabinets on one side and a row of solid doors to the bedrooms and closets on the other, and the other leading to the maid's bedroom and laundry room in the service wing.

The bedrooms and baths in the Maison de Verre are as unique and untraditional as are the glass facades. It is in these spaces that one perceives the social and cultural vision of a modernist architect combined with the technical prowess of the master craftsman. Chareau wrote, "Architecture is a social art. It is both the crowning achievement of all the arts and something which emanates from the masses [of men]. The architect can only create if he listens and understands the voices of millions of men, if he suffers as they do, if he struggles along with them to save them. He employs iron that they have forged, he guides them toward the future because he knows what belongs to the past."[5]

"Veiled" spaces continue to abound, especially those enclosed by perforated screens. And now another invention appears, the "living wall" that separates the

The monumental stairway to the second floor.

At night, a resident receiving her guests at the top of the monumental main stairway is framed as a silhouette by the glass facade, illuminated from outside by the floodlights in the front courtyard.

corridor from the bedrooms. It is lined with deep closets that can be opened both from the corridor and from the bedroom. The floor-to-ceiling doors curve slightly outward and are painted in black lacquer; no distinction is made between bedroom doors and closet doors, except that the former are set back farther from the corridor. Accessed from the bedrooms or bathroom side, the metal closet doors incorporate wooden fixtures in the hollow of the door to accommodate storage for shoes and clothing. If these closets are opened on both sides at the same time, one can see from one space to the other.

Curiously, the principal point of access to the master bedroom is through the master bathroom. Double doors give entry to the parents' space of personal hygiene, where metal and glass surfaces continue to predominate. Historically, the French only began the widespread inclusion of toilets inside dwellings at the beginning of the twentieth century. Culturally, they generally prefer to separate toilets from bathing facilities; thus the parents' private toilet is off their bedroom and not in the bathroom. (The children must use toilets located

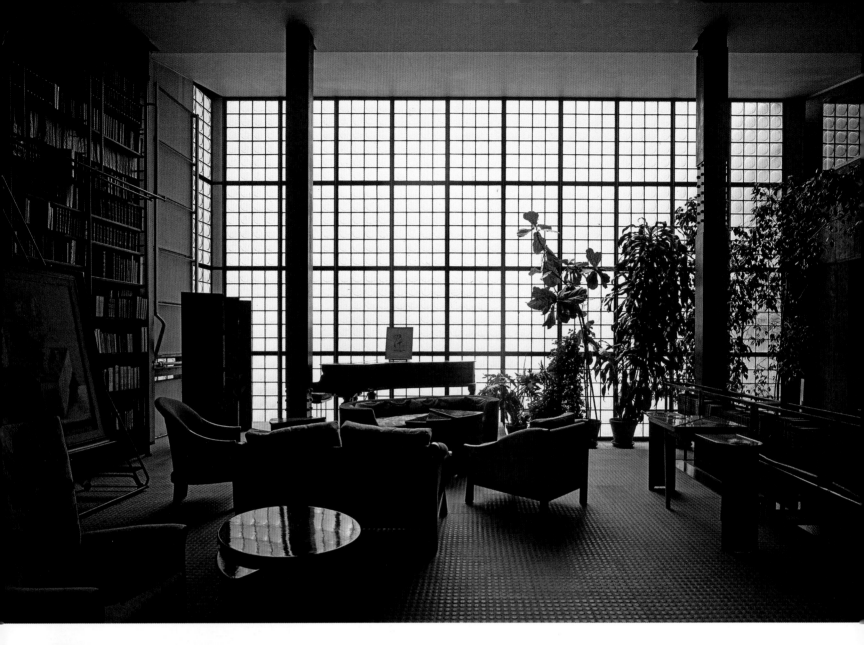

The grand salon, view toward the
front facade glass wall.

The retractable stairway.

The stairs from the second to the third floor,
with perforated metal panels at right and a
large metal mesh divider at left. The steps are
made of blocks of Cuban mahogany. Rails on
the ceiling are for a suspended tray to
carry dishes.

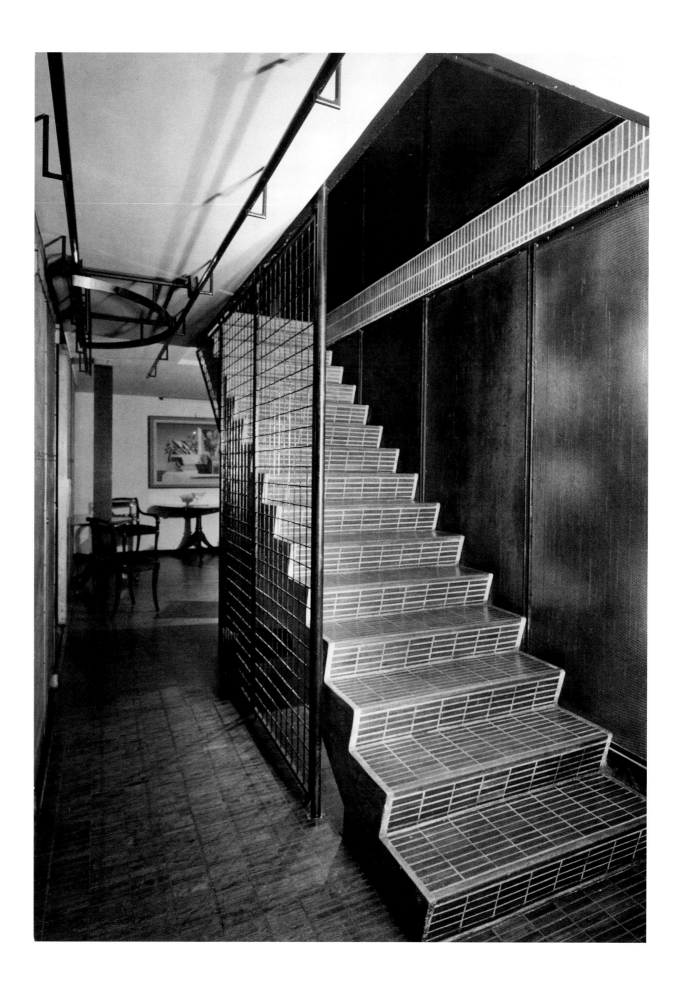

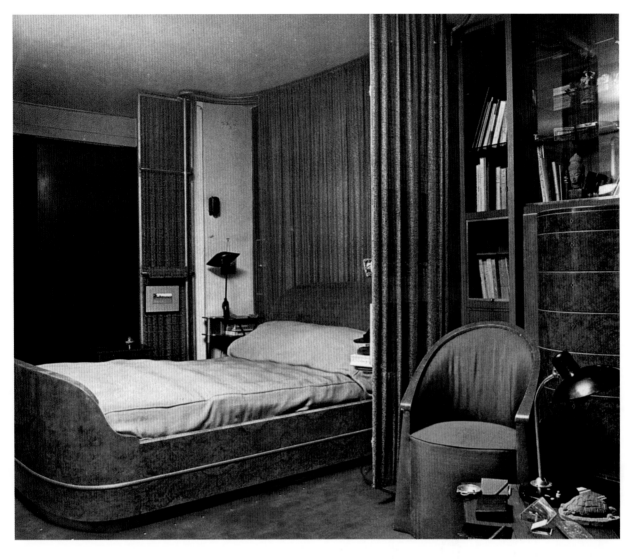

The master bedroom originally had folding
curtains of cellophane and silk around the
bed, as seen in a photograph from 1973.

at each end of the corridor.) Freestanding cabinets of
an aluminum alloy, Duralumin, which had been invented
only two decades earlier, divide the space into feminine
and masculine sides. Solid cabinet doors can be opened
to act as partial screening devices (page 213).

The adjacent bathtub and shower combination
provides for easy conjugal conversation when both are
in use simultaneously; these are separated by a pair of
perforated metal screens that swing open or shut to
regulate the degree of intimacy.[6] The bath and shower
are near the garden facade, but once again the glass
bricks provide a shield from the outside while allowing
in diffuse natural daylight.

While it might be appropriate to consider the bathroom
and master bedroom as one unit, in reality this is not the
case: the former has five entries, and the latter has four

entries, including the private toilet and mobile ladder that
arrives through the floor from the petit salon below. Pleated
screens of cellophane and silk mounted on pivoting metal
frames once flanked the head of the bed, their purpose
not entirely clear; nevertheless, they recall traditional beds
enclosed with curtains in rural France (see also page 66).
The retractable staircase from the second-floor petit salon
emerges near the windows (pages 203, 206).

In addition to the master bedroom, there are two
other bedrooms on the third floor, for the Dalsaces' son
and daughter, and one for a maid, a half-level up, just
above the kitchen. The most ingenious, and perhaps the
most voluptuous, space of the house is the daughter's
bedroom. It overlooks the garden and has a terrace.
Within, it has a private bathtub, hidden by a metal-frame
bookcase and perforated sheet-metal screens, painted
white, that swing open. At the head of the tub the wall
is partially composed of glass bricks; on the other side
of this wall are the brother's bathtub and toilet. Only the
daughter has a bathtub in her bedroom, and this was
extremely unusual by contemporary French standards

of hygiene. In contrast, the brother's bedroom is down the hall from his bath. Both children's bedrooms have a washbasin and bidet partially obscured by a pivoting metal screen (pages 208, 212). Screens such as these are comparable to the *paravent,* the French term for the folding screens behind which actresses in their dressing rooms retreat to change.[7]

THE CLIENTS

Who were the clients for this completely unusual dwelling, and what were their expectations? Jean Dalsace was born in 1893 in the Moselle region of eastern France. As a schoolboy in Épinal he became friends with Jean Lurçat, later the celebrated Cubist and Surrealist painter and tapestry designer, and also the brother of André Lurçat, the architect. Dalsace first obtained a degree in law. Then, while he was teaching French in Germany just before World War I, a doctor who was a student of his inspired him to study medicine. Mobilized for the war, he was a medical aide who volunteered to recover frontline wounded, during which he was once gassed and wounded himself.

Returning to his medical studies after 1918, he specialized in biology and gynecology, becoming a practicing gynecologist and hospital laboratory researcher, with a focus on problems of metabolism, immunology, and certain kinds of sterility in women. Believing that sexual problems were often the cause of gynecological ones, he became active in sexology and the French psychoanalytic movement, even undergoing didactic psychoanalysis so he could be better informed. His progressive beliefs led him to advocate for the prevention of clandestine abortions, and for changing the laws on contraception and family planning. This political activism in favor of women occasionally got him into difficult, even dangerous situations: attending an international conference on population in Berlin in 1935, Dalsace publicly protested against the eugenic sterilizations then in favor in Nazi Germany, after which he was advised to leave the country immediately for his own safety. He was, then, a man of international stature, deeply committed to an array of gender issues, human reproduction being only one of these.

Annie Bernheim, who became Jean Dalsace's wife in 1918, was raised in a wealthy bourgeois family and showed a talent early in life for music. She became an excellent pianist, with an interest in the visual arts and a proficiency in languages. Her English teacher from a young age was none other than Dollie Chareau, wife of Pierre Chareau. They formed a friendship that continued during World War I, when both Dalsace and

Chareau were away at the front, and after. The Dalsaces had two children, Aline and Bernard; the Chareaus never had any of their own. While the doctor's medical practice flourished, as did his family, Annie's devotion to music led to an increasing interest in contemporary art. In this she was aided by the Chareaus, who were acquainted with a large circle of avant-garde artists and designers, and Jean Lurçat, whose works the Dalsaces began collecting. They also acquired pieces by Pablo Picasso, Juan Gris, André Bauchant, and many others.[8]

DESIGN

During their early married life, the Dalsaces lived in an apartment on the Boulevard Saint-Germain that was in many ways typical of French bourgeois apartments of the mid-nineteenth century. In contrast, the house they commissioned Pierre Chareau to design in 1927, just a few blocks away, could hardly have been more radical. If the program was straightforward, the condition of the site was not. They had received the property as a gift from Annie's father. It was an eighteenth-century building that they intended to demolish and replace, but this plan was complicated by the fact that the tenants on the upper floors refused to vacate and were protected by law. They proposed a compromise: to demolish everything except the top floor, leaving the two party walls between which to build, a courtyard in front toward the street, and a long garden in the rear.

The first plans submitted by Pierre Chareau (cosigned by Dalsace) in November 1927 to the Paris authorities for a building permit offer us insights into the initial concept. Chareau planned to demolish two floors of the old building and insert three new floors. The drawings illustrate hesitant but progressive development focused on resolving two major constraints: the lack of natural light entering the site due to the surrounding buildings, and the low ceilings that resulted from inserting three floors where previously there had been two.

The first plans reveal the two principal strategies developed to capture natural light: to introduce facades of transparent or translucent glass, extended outward, that were completely independent of the structure supporting the upper floors; and to devise an interplay of double-height spaces inside that would bring light into the very heart of the new building. As the plans evolved, the monumental stairway to the grand salon,

Overleaf
Plans of the second-floor arrangement of spaces: first design (left); second design (right).

RUE ST. GUILLAUME
PLAN DU REZ-DE-CHAUSSÉE.
ECHELLE 2 CM PM

DEPENDANCE-
CUISINE

OFFICE

CUISINE

4.35

440

W.C

PETIT- SALON ANTICHAMBRE

LAVABO

45

48

OFFICE

270

560

HALL

1200

800

4.85

DEBARRAS

670

1620

SALLE A MANGER

925

BIBLIOTEQUE BUREAU.

LES MESURES INSCRITES
SONT APPROXIMATIVES.

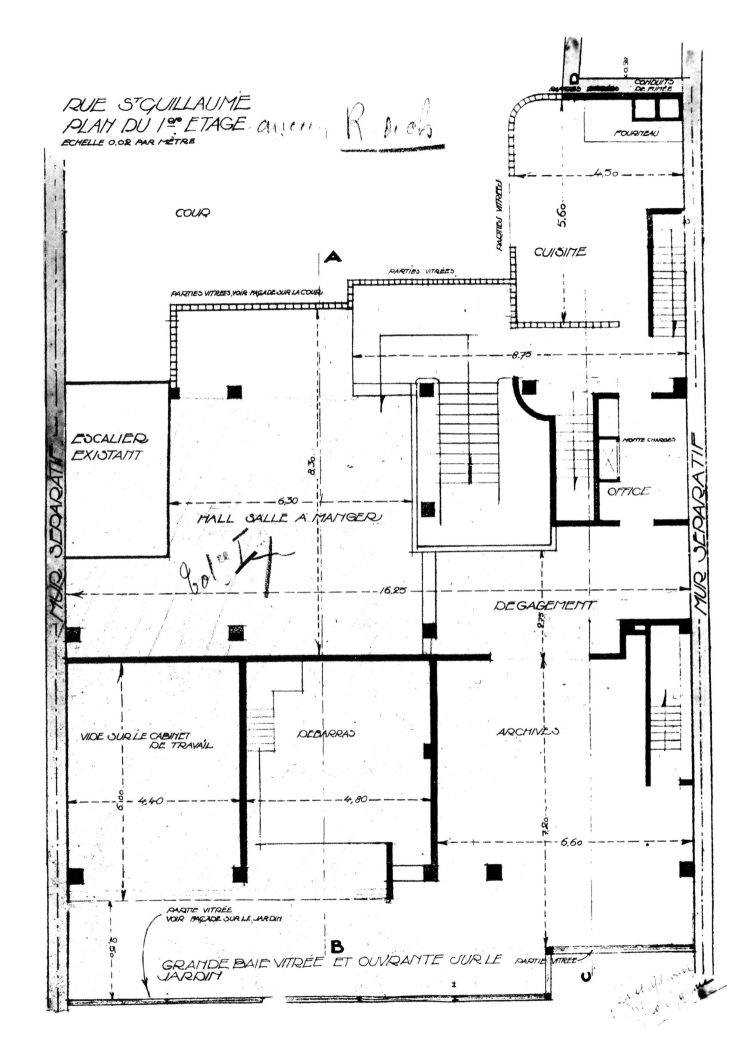

RUE ST·GUILLAUME
PLAN DU 1ᵉʳ ETAGE *ancien* R *Arch*
ECHELLE 0.02 PAR MÈTRE

COUR

A

PARTIES VITRÉES, VOIR FAÇADE SUR LA COUR

PARTIES VITRÉES

PARTIES VITRÉES

CONDUITS DE FUMÉE

FOURNEAU

4,50

5,60

CUISINE

8,75

ESCALIER EXISTANT

MONTE CHARGES

6,30

OFFICE

8,30

HALL SALLE A MANGER

16,25

DEGAGEMENT

2,75

VIDE SUR LE CABINET DE TRAVAIL

DEBARRAS

ARCHIVES

6,00

4,40

4,80

7,20

6,60

PARTIE VITRÉE VOIR FAÇADE SUR LE JARDIN

B

GRANDE BAIE VITRÉE ET OUVRANTE SUR LE JARDIN

PARTIE VITRÉE

C

MUR SÉPARATIF

MUR SÉPARATIF

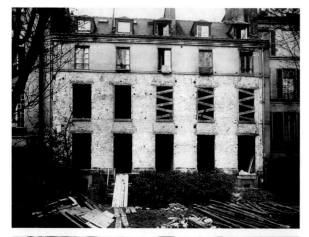

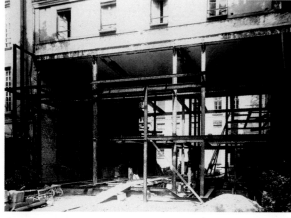

the salon itself, and the double-height space in front of the secretary's office served this purpose.

A Parisian building regulation at the time required a minimum ceiling height of just over eight feet. On this basis the permit for Chareau's first plans was denied, since some rooms didn't comply. In response, he transformed this regulatory constraint to his advantage. Since the entrance courtyard and the rear garden were on different levels, he was able to adjust his ceiling heights by lowering the level of the ground floor slightly. In so doing, he was also able to introduce changes in the relationship of open spaces in the floors above, mainly to accommodate the horizontal heating ducts. The effect was to enrich the interplay of open spaces. In addition, these subtle differences in floor levels by only a step or two, as well as the use of different materials such as slate, rubber, and parquet for flooring, aided in demarcating the spaces and differentiating their uses from one another.

These solutions were refined and expanded further in the second set of plans. The doctor's office was located solely on the first floor, while the main living area (the grand salon), the kitchen, and the utility spaces were on the second floor. This second project was clearer and more rational in terms of construction, eliminating the ambiguities and inconsistencies of the first project, such as load-bearing interior walls. The spaces between the two glazed facades were opened up, and most vertical piping and ducts, along with the secondary stairs were progressively located along one or the other party wall.

Such design choices became integral features of the final plans for the house. The crucial issue of too many rooms with illegal ceiling heights, especially those designated for living, was solved when Dalsace pledged in writing to the city authorities to install a heating and ventilating system that would assure the circulation of fresh air at the acceptable rate. This was to be accomplished by introducing a mechanical system, practically unheard of for a private house at the time, for extracting and pumping air. The building permit was granted in late August 1928.

BERNARD BIJVOET

Who actually designed the project? Information from people working in Chareau's office in the late 1920s is relatively scarce. The young Dutch engineer and architect Bernard Bijvoet must have had a significant role, although he was only occasionally seen in the Chareau studio, according to some of the assistants working there.[9] Notwithstanding Bijvoet's own modesty—he deferred to Chareau when questioned about the authorship of the Maison de Verre—his influence was no doubt crucial in an office where few people had real experience with construction. His knowledge of steel structures, the concept of glazed facades within a metal framework, and the notion of spatial openness bear witness to Bijvoet's contribution. He was the person capable of making Chareau's architectural ideas a concrete reality.

The finalization of construction drawings in Chareau's office in the Rue Nollet required tremendous effort. The architects had to determine the exact relationships and flow of space, take into account the constraints of ceiling heights and changes in floor levels, calculate exactly the courses of glass bricks, and integrate the rhythm of the grid for the panels throughout the house, since these were the basic units for composing the spatial divisions.[10] Although the technical details of the panels themselves fell to the master metalworker Louis Dalbet, Chareau's office must have completed all of the calculations for the Maison de Verre in 1929 so that structural blueprints at a precise scale could be provided to the builder.

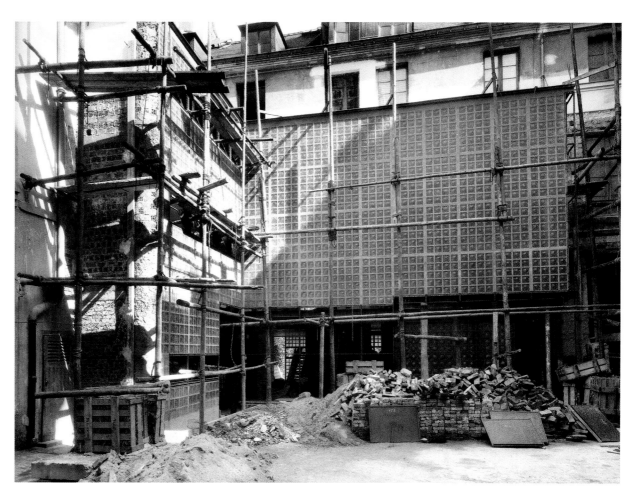

CONSTRUCTION

Demolition of the old house and construction of the new framework was a complicated and lengthy affair. New steel posts and beams (flat lengths of steel with four angle pieces riveted together to resemble today's I-beams) were placed underneath the upper floors of the old house as the old walls were progressively demolished. Their maximum length was twenty feet, and since more than one vertical length was needed to reach the upper floor that was retained, extensions were bolted to the main posts. Chareau decided to leave these joints and bolts visible, rather than covering them up. Thus, he emphasized their structural role—like that of a column and capital in classical architecture—in order to express a feature of tectonic importance. Horizontal steel beams composed in the same manner, but thicker, sat atop the posts, underpinning the old floors.

Once this skeletal steel cage was in place and the two facades of the old building were demolished, the contractor installed the steel framing for the floors of the new structure, as well as the metal frames to hold the glass bricks of the new facades.[11] With the exception of the concrete floors and cement holding the glass bricks, the greater part of the project was dry construction.

The architects' decision to employ glass brick in the manner that they did was audacious, both technologically and culturally. They chose a new material, Nevada brick, which the Saint-Gobain glass company began to market in 1928. It was distinctive for its modest size, thinness, and smooth, circular, concave inner surface that resembled a lens more than a brick. It measured approximately eight by eight inches, with a thickness of only one and a half inches. It is difficult to speak of "walls" in the Maison de Verre, when the membrane of the main facade is of translucent brick of a type that had only just been invented, had never previously been laid up vertically to such a height, and had barely been used at all for interior partitions. Chareau had considered using plate glass for the large openings of facades in the 1927 first design, but the availability of the new Nevada brick offered the opportunity to obtain a virtually limitless glass surface while avoiding the sense of void produced by plate glass. Ultimately, the repetition of this module of glass in a grid pattern had a major aesthetic impact on the project. For the facade, the bricks were assembled in panels of four horizontally by six vertically. The width of four bricks, about three feet, became the basic dimension of all the panels and screens in the Maison de Verre, inside as well as out.

Structural metalworkers built the thin, U-shaped metal channels in which the glass of the main facade

was inserted, following the advice of Saint-Gobain. According to their catalogue, the procedure involved building a flat wooden formwork on the inside of the future facade of the grand salon, with slats that were exactly the width of the future cement joints covering the U-shaped metal channels. The glass bricks were held in place by the channels as they were laid horizontally, with some metal reinforcing between the bricks, and cemented over; then the flat wooden formwork on the inside was taken down along with the slats, and the space where they had been was then easily also covered with cement. The resultant glass brick facade seems very solid, and heavy like masonry, but is in fact a relatively lightweight curtain wall.

When Louis Dalbet arrived on site, the house's metal structure, concrete floors, and facades of glass brick were already in place; the plasterers were at work. Dalbet was Chareau's close collaborator on furniture, light fixtures, and other projects, a master craftsman in ironwork who made wrought- and forged-iron grills, ornamental doors and gates, fireplaces, and religious objects, using artisanal methods.[12] He had worked with

In addition to the forced-air system and windows that swivel open, the house is furnished with industrial-style louvers for natural ventilation.

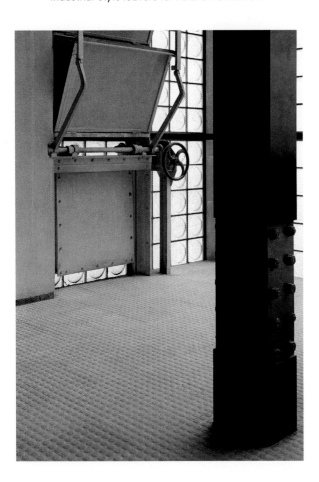

Chareau since 1923, but his collaboration on the Maison de Verre was to be his finest achievement. It must be emphasized that Dalbet's previous work with Chareau had been traditional, and that what Chareau required of him in the Maison de Verre was completely different, technically and stylistically.

Dalbet's entry on the scene of modern architecture in the 1920s, thanks to Chareau, came at a critical time in the history of his own métier, as traditional foundry work at a forge was slowly being transformed, updated, and mechanized. This was perhaps one of the last moments in the history of building in France when a craftsman at the pinnacle of his art collaborated fully with an architect in the way Dalbet did. In the Maison de Verre he employed essentially three techniques: the blacksmith's forge, an acetylene torch for welding, and screws and bolts for fastenings. Although forging hot metal by hand with a hammer lent itself well to the furniture designs of Chareau, where traces of the craftsman's tools on the metal complemented other natural materials such as leather, stone, and wood, the technology is less present in the Maison de Verre. The supports for the main stairway are one exception where it can be found.

Bolting or screwing elements together was employed extensively, especially for the interior panels, to avoid deformations. Joints executed in this manner gave an industrialized aspect to the finished product, and elements screwed together facilitated maintenance. The panels of the garden facade in the petit salon, for example, which were of brass on the interior and sheet metal on the exterior, were completely disassembled for maintenance in the 1990s. Other panels that held glass were screwed onto the frames of some facades.

Dalbet's expert use of the acetylene torch is evident in the small joints of steel sections, such as the bookshelf/balustrade in the grand salon (page 202). Another wonderful example of his work with the torch is in the curved sheet metal and Duralumin doors (pages 210, 213). The Duralumin had to be heated repeatedly and stretched gradually in order to obtain the desired curvature. It is extremely important to realize that these objects in metal were executed in small series, despite their appearance of industrialized production. After they were manufactured in Dalbet's workshop on the Rue Capron, they were disassembled and delivered by bicycle to the Maison de Verre building site.

The panels of thin perforated metal throughout the Maison de Verre reveal the exceptional quality of Dalbet's workmanship: it was a new industrial product, and the craftsman had to fold, shape, and solder this lacelike steel without burning it. His expert handling of the technique is clearly visible in the angle joints of

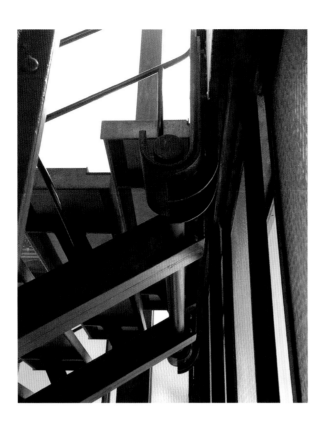

Underside of the grand staircase: two forged-steel
hooks support a steel bar at the top of the stairs.
The bar is not welded to the two hooks. The stairs
could easily be disassembled.

the screens; folding and welding these while keeping
the curvature smooth and even, without warping or
buckling, was an extraordinary feat. For Chareau,
these panels, like other handmade details in the house,
represent the ultimate expression of his idea of a total
integration of furniture into a dwelling. No other house
of the modern movement in architecture took this
concept as far as this one did with the industrialized
materials then available.

The Maison de Verre is the result of an extraordi-
nary conjuncture of circumstances, beginning with a
unique relationship of confidence between patrons and
architect. The Dalsaces extended their patience, friend-
ship, unwavering support (financial and emotional),
and constant participation over the four years it took
to complete the project. Just as conducive to a suc-
cessful outcome was the extraordinary mutual empa-
thy between Chareau the creator, obstinately pursuing
his ideas; Bijvoet the engineer, who rendered the ideas
buildable; and Dalbet the craftsman, who expertly exe-
cuted many of the ideas.

POETIC PROMENADE AND DOMESTIC REALITY

Whether or not the "Maison" de Verre is truly a house
or a large piece of furniture, as some have suggested,
is certainly debatable. That it was inhabited and made
homelike by the Dalsace family is evident. Yet there is
no one appropriate word to define its principal function.
The French term *maison,* like the English *house,*
suggests a freestanding, independent volume, which
ignores the constraints that shaped this building. Nor
was it an existing space that was renovated. The Maison
de Verre is unique in the history of French architecture:
typologically, formally, and aesthetically. It had no
precursors and it has had no sequel.

Residents and visitors experience its many peculiar-
ities. For instance, there are few places in which one
can be acoustically isolated; sound is easily transmitted
throughout. With the exception of the doctor's office
and examination room, which are entirely soundproof,
one is often heard without being seen. And, as men-
tioned at the outset, one can easily be under observation
while the observer remains hidden. In short, Chareau
succeeded before other modernist architects, including
Le Corbusier, in creating a free plan of spaces indepen-
dent of the structure. In the Maison de Verre, one result
of this utopian vision of fluid, interconnected space is
that it is extremely difficult to live autonomously or to
individualize one's living area.

In 1934 a performance was planned to take place
in the grand salon: a lecture by Walter Benjamin, the
renowned German Jewish social critic, cancelled at the
last minute due to illness. Benjamin had been invited to
speak by a French antifascist organization to which Jean
Dalsace belonged, and the doctor had offered his home
as the venue. Benjamin had written about the importance
of glass and steel in contemporary architecture, and had
noted: "It is no coincidence that glass is such a hard,
smooth material to which nothing can be fixed. . . .
Objects made of glass have no 'aura.' Glass is . . . the
enemy of secrets . . . [and] of possessions."[13]

The Maison de Verre embodies many of the features
Benjamin points out, where "secrets" are hard to hide
and "possessions" are difficult either to keep private or
to display in conventional ways. These possessions are
limited almost exclusively to the vast numbers of books
on the built-in bookshelves of the grand salon and works
of art exhibited on stands or hung from railings along
limited wall space. In stark contrast to the architecture,
the few pieces of furniture in textile and wood are
generally the movable ones designed by Chareau and
acquired by the Dalsaces. Benjamin was right: the
glass and metal of the Maison de Verre have no aura
in and of themselves—in his terms, no innate sense of

transcendent beauty and power. The magic lies in the spaces that have been created. As Dalsace's daughter recalled, "My mother loved plants, she had plants everywhere in the house." Perhaps the Maison de Verre is a sublime indoor garden and a set for performances as well as an utterly unique masterpiece of architecture. As Chareau once said, "Only new images give us emotion. The succession of these new images, which create or destroy, are the sure signs of the beginning of a fecund period whose grandeur we can barely begin to imagine."[14]

View of the grand salon from the third floor. In this archival photograph, the immense bookcase seen on page 199 is not yet in place.

NOTES

1. Marie-Louise Prevost, "La Première et Unique Maison de Verre Est Terminée," *L'Ami du Peuple* (October 29, 1931): 1. Other such reviews appeared in the *Daily Mail* (London) (May 27, 1931), and the *New York Herald* (May 28, 1931).

2. Quoted in René Chavance, "Applications et Techniques Nouvelles du Verre: Architecture Décorative," *Art et Décoration* 61 (1932): 312.

3. Others who worked on the Maison de Verre included Bernard Bijvoet, an engineer named André Salomon for lighting and electrical systems, and Louis Dalbet, who created much of the metalwork. The building was constructed between 1928 and 1932.

4. Jacques Lacan, *The Four Fundamental Concepts of Psycho-Analysis* (New York: Norton, 1978), 75. Lacan's notion of the *regard,* or gaze, is pertinent to Chareau's work, as it articulates his use of theatricality as a framing device for architectural spaces.

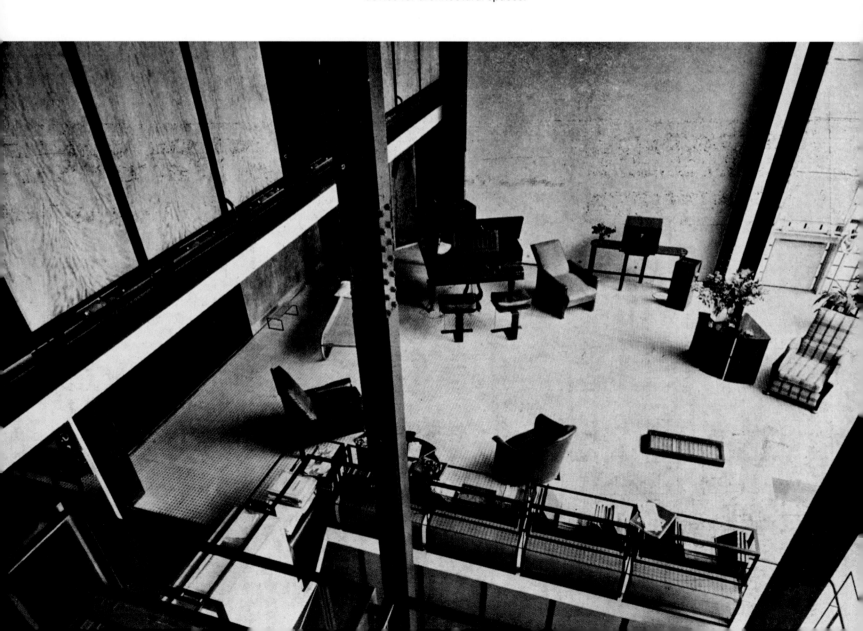

5. Pierre Chareau, "'La Maison de Verre,' de Pierre Chareau, Commenté par Lui-Même," *Le Point: Revue Artistique et Littéraire* 2 (Colmar) (May 1937): 51.

6. The cylindrical shape and its relative openness, spatially and visually, to other areas of the bathroom had a precursor in the exhibition of 1929 by Charlotte Perriand, Pierre Jeanneret, and Le Corbusier at the Salon d'Automne in Paris. There, in addition to exhibiting their latest furniture designs (and employing Nevada glass lenses in small quantities), the shower was cylindrical, partially visible from the living room, and it communicated visually with the bedrooms. See Mary McLeod, ed., *Charlotte Perriand* (New York: Abrams, 2003), 50–57.

7. *Paravents* were used in numerous new interiors in the 1920s designed by Émile-Jacques Ruhlmann, Eileen Gray, and many others besides Pierre Chareau. But uniquely, those in the Maison de Verre provide no privacy. Instead, the semitransparency of the perforated metal, like a veil, actually draws attention to whoever is behind the screen.

8. On the artists with whom the Chareaus were connected, see the essay by Kenneth E. Silver in this volume. The name L'Oeil Clair was adopted by a group of friends in the 1930s that included the Dalsaces, the Chareaus, Jean Lurçat, Jeanne Bucher, and others who regularly contributed a small amount of money to a common pot in order to purchase works by their favorite modern artists (for example, Picasso). They then "pulled numbers from a hat," and the winner would receive the work on deposit for display. It seems possible that such works were passed around among the group from time to time. This information was shared with the authors in July 2015 by Muriel Jaeger. Madame Jaeger is the daughter of Dr. André Cournand and Sibylle Blumer (daughter of Jeanne Bucher), who knew the Chareaus well in the 1920s and 1930s, collected Chareau furniture, and were members of L'Oeil Clair. The family immigrated to the United States in the 1930s and continued their friendship with the Chareaus when they arrived in New York during World War II. Cournand had met them through his friendship with Jean Lurçat, with whom he had served in the previous world war.

9. Bernard Bijvoet (1889–1979) was born in Amsterdam and received a degree in architecture and engineering from the University of Delft. He formed a partnership with his friend Johannes Duiker in 1916. Bijvoet met Chareau early in the Dutchman's career, and the two worked together after 1925 on the golf club in Beauvallon (1927) and subsequently on the Maison de Verre. While in Paris, Bijvoet also worked with the French architects Robert Mallet-Stevens and the team of Eugène Beaudouin and Marcel Lods. Bijvoet returned to Holland regularly, collaborating with Duiker on the sanatorium in Zonnestraal, the Netherlands (1926–31), and an Open Air School (1928–30). After Duiker's untimely death in 1935, Bijvoet worked on his own, completing the Hotel Gooiland in Hilversum, the Netherlands, begun by Duiker. After World War II he maintained his architectural practice in Holland until the end of his life.

10. Each unit of the grid was approximately three feet (ninety-one centimeters) square.

11. Invented in the late 1600s for the British navy to bring daylight to the lower decks of ships, the glass *pavé* (stone) was used horizontally well into the twentieth century. Typically it was embedded in concrete and called "translucent concrete." It was used for floors, vaults, and cupolas of banks, hotels, garages, and subways. The Saint-Gobain company of France, descendant of the seventeenth-century Manufacture Royale de Glaces de Miroirs, worked to develop *pavés* that were thinner yet more resistant, more transparent, and in a greater variety of shapes. They collaborated closely with French builders to perfect construction techniques that usually involved flat surfaces, or the laying of glass bricks into flat horizontal panels with cement joints that were then hoisted into place. One of these firms, Dindeleux, probably designed the framework of the Maison de Verre, which was unusual in adapting the *pavé* concept to a vertical use.

12. Termed a *ferronnier,* or sometimes *serrurier* in French, these craftsmen followed similar training as the celebrated *compagnon* (companion) carpenters in France, who were apprenticed and, after finishing their training, traveled around the country to gain experience. Historically, one had to achieve a masterwork in order to be accepted fully into the guild of peers.

13. Walter Benjamin, "Experience and Poverty" (1933), in *Walter Benjamin: Selected Writings,* vol. 2, *1927–1934,* ed. Michael W. Jennings, Howard Eiland, and Gary Smith, trans. Rodney Livingstone et al. (Cambridge, MA: Harvard University Press, 1999), 733–34. See also Maria Gough, "Paris, Capital of the Soviet Avant-Garde," *October* 101 (Summer 2002): 51–83.

14. Aline Vellay-Dalsace, conversation with Brian Brace Taylor, c. 1991. Pierre Chareau, "Meubles," *L'Art International d'Aujourd'hui,* no. 7 (1929), quoted in Olivier Cinqualbre et al., *Pierre Chareau, Architecte: Un Art Intérieur,* exh. cat. (Paris: Centre Pompidou, 1993), 22.

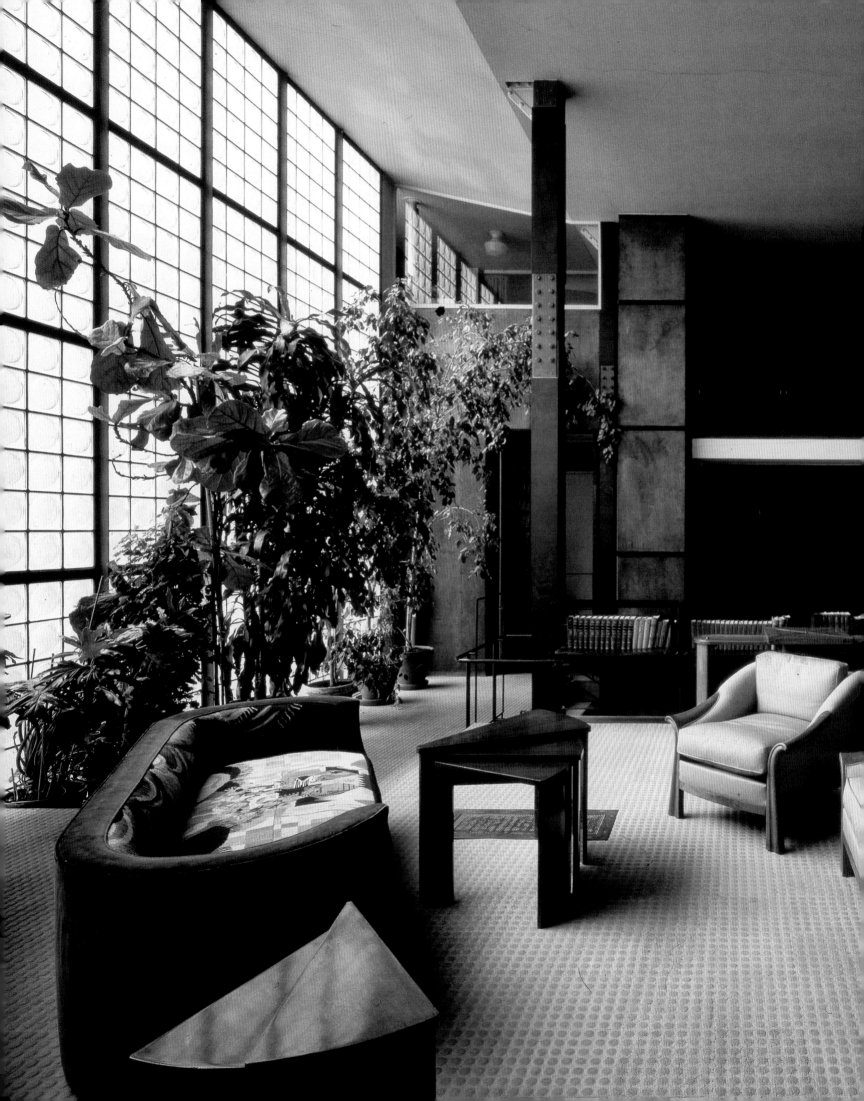

Living, Literally, in a Glass House: A User's Guide

Robert M. Rubin

How can one be an occupant of a historic house without being an occupier? How do you make a historic house a home, rather than a museum, or, worse yet, a mausoleum? These were the questions facing my wife, Stéphane, and me when we became the owners of the Maison de Verre in 2005.

We had been introduced to the family of the original owners in 2004. Brian Brace Taylor made the connection after he saw Jean Prouvé's 1950 Maison Tropicale, which we had restored outside of Paris after repatriating it from Brazzaville. In contrast to the Maison de Verre, the Maison Tropicale is as much about occupation (of the colonial kind) as it is about habitation. There was never any question of restoring it as something to inhabit in the present. It is a prototype of an unrealized building system for an extreme climate. The Maison de Verre is also a prototype (albeit of a poetic rather than a pragmatic sort), but it is first and foremost someone's home. We acquired it to live in it. By doing so, we hoped to bring it back to life, to demonstrate its continuing relevance to the practice of architecture in the twenty-first century.

Although it had not been lived in for some time, the house was eminently visitable. The family had kept it intact and maintained its originality with scrupulous care. Given the parlous state of the wiring, plumbing, and building systems generally, however, it was not really habitable. We saw it as our task to make the structure habitable while maintaining, and where possible enhancing, its visitability—that is, the legibility of its original program.

Building on the foundational work of Marc Vellay, Bernard Bauchet, and Inigo Fernandez de Castro, and drawing on our own experience with the Maison Tropicale, we developed the following guidelines:

1. Nothing original as of 1932 could be irreversibly modified. On the other hand, original elements that were missing did not need to be replicated. (The exception that proves the rule—the reproduction of the exterior light projectors—is discussed below.)

2. Anything done after 1932 could be undone.

3. Surfaces would be cleaned but not refinished.

4. Contemporary interventions would be reversible, overtly new, and not "contextual"; that is, they would be clearly identifiable.

5. All activity would be carefully documented and all removals archived.

The grand salon of the Maison de Verre.

The first major undertaking was the rewiring of the house. The Maison de Verre is famous for having all its wires in visible tubes (page 213), with control buttons and switch boxes affixed to those tubes, and for having a lighting system of theatrical complexity. On the other hand, it lacked the power for refrigerators and vacuum cleaners. We preserved all the original tubes, outlets, and switching systems while changing the wires within to bring them up to code. (We left one spot untouched and exposed for reference: the uplighting of the wood veneers in the grand salon.) Where we added outlets, they are clearly contemporary interventions.

This was followed by a series of relatively mundane (and invisible) but necessary revisions. The exposed service wing was given a new roof; the deterioration of the original one was a clue that the forced insertion of the building under the recalcitrant tenant in the attic apartment had been a blessing in disguise. A new hot-water heater was installed, and thousands of hours were spent cleaning the various surfaces by hand. The sophisticated forced-air heating system posed a particular problem. Heat in the house is conducted through a series of plaster ducts. In what was probably one of his last acts, Chareau made one access hole with an elegant trapdoor in a prominent duct, as if to show how to empty the ducts of eventual (and inevitable) accumulations of plaster dust. Rather than modernize, we chose to follow the "instruction" that had been left for us, and made another dozen apertures sufficient to receive an industrial vacuum. After a few hundred kilos of plaster dust had been removed, we had clean heat.

We are conscious of the legibility of the house's architecture and original program. In that spirit, we have chosen to furnish the house sparsely, so as to privilege Chareau's profusion of grids over our personal effects. Even where a room's original function has disappeared completely, we try to leave evidence of its intended use. The medical offices have hardly changed: the waiting room is our sitting room, the receptionist's office is occupied by our administrator, and the doctor's private office is my private office. Of course, the presence of the original examination table in the inner examination room is a pretty strong signifier of gynecological practice circa 1930, as is the exposed plumbing in the separate operating room. The latter provides a surprisingly effective context for a sculpture by the American artist Tom Sachs, *L'il T's Toilet* (2000), which channels the house's mid-century obsession with hygiene in a more lighthearted, postmodern spirit.

Apart from the medical offices, the room whose operations have evolved most considerably is the kitchen, which once accommodated several servants. Today, except on special occasions, we eat in the kitchen, and Stéphane does the cooking. None of the original appliances survive. We do avail ourselves of the natural refrigeration of the original *garde manger,* which we restored.

During the day, the house is flooded with natural light. Chareau's intention was to light it after dark principally by exterior projectors, or floodlights, that pointed at, and shone through, its translucent facades. There were five on the courtyard side and four on the garden side. Of the nine projectors, four survived, so we remade five, along with the courtyard armature, which had gone missing. (At some point the five courtyard projectors had been taken down, apparently because the light they emitted was bothersome to the young married homeowners and their small children, who were then occupying the newly renovated and expanded upstairs apartment.) Clearly, lighting the house from the outside is an integral element of the architecture. It needed to be put back. This artificial light, subaqueous in quality, is sufficient for most nocturnal activity.

The next major project may well be to refabricate the Nevada glass bricks to restore the courtyard facade, which failed in the 1960s. (Its manufacturer, Saint-Gobain, had predicted this when advised of the intended span of Chareau's facades.) At that time, the glass bricks were replaced with more pedestrian bricks, the only kind Saint-Gobain was then making. Were this to happen, the black metal cross-banding on the front facade would disappear. This was added when the bricks were replaced in order to shore up the span, but it is not what Chareau had in mind. This could be a shock to the system of architectural history, which has become accustomed over the years to an apparent Japanese influence in the house's facade, frequently featured in photographs.

Visitors to the house can immediately detect the difference between the two types of glass bricks. The garden facade, more protected from the elements by the third-floor balcony, has fared better than the exposed courtyard facade. Stepping into the garden, one sees the far more dematerializing effects of the bricks without cross-banding. From inside the house, the difference between the originals and the replacements is striking, especially when one turns on the exterior projectors. The originals create a wall of translucent depth, each brick housing a little green-hued glass dome specked with tiny bubbles, evidencing its artisanal fabrication. In comparison, the replacements are flat and industrial. Saint-Gobain is taking an interest in this project, and has graciously provided us with a full chemical analysis of the composition of an original Nevada glass brick from the house.

Having completed our first wave of interventions, we have recently commissioned a comprehensive structural study of the house. Our intention is to understand what may be necessary to secure it for its next century of existence, but also to determine with some precision why the glass facades are showing signs of accelerating deterioration. Is the cracking of the glass bricks due to structural loads, moisture, weather, modernity in general (for example, a large university was constructed next door in the 1950s, replacing a small *hôtel particulier*), or the properties of the cement in the joints itself—or all of the above?

In the meantime, we spend a few months a year in the house, and keep it a family affair. Stéphane, a landscape designer, has taken charge of the restoration of the garden. Our young son and his friends enjoy the house's techno-Surrealist gizmos in much the same way the Dalsace grandchildren did half a century ago. Our musician friends marvel at the perfect acoustics of the grand salon, and we never fail to be charmed by visitors who tell us the first time they came to the house was in vitro, because their mother was a patient of Dr. Dalsace or Dr. Vellay.

Windows in the service wing swivel open.

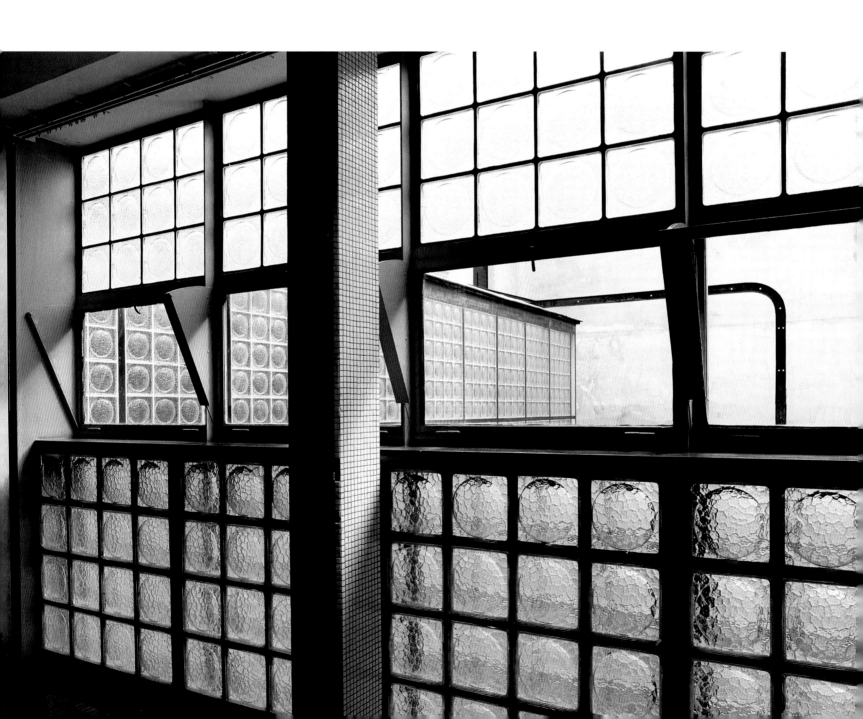

The Maison de Verre

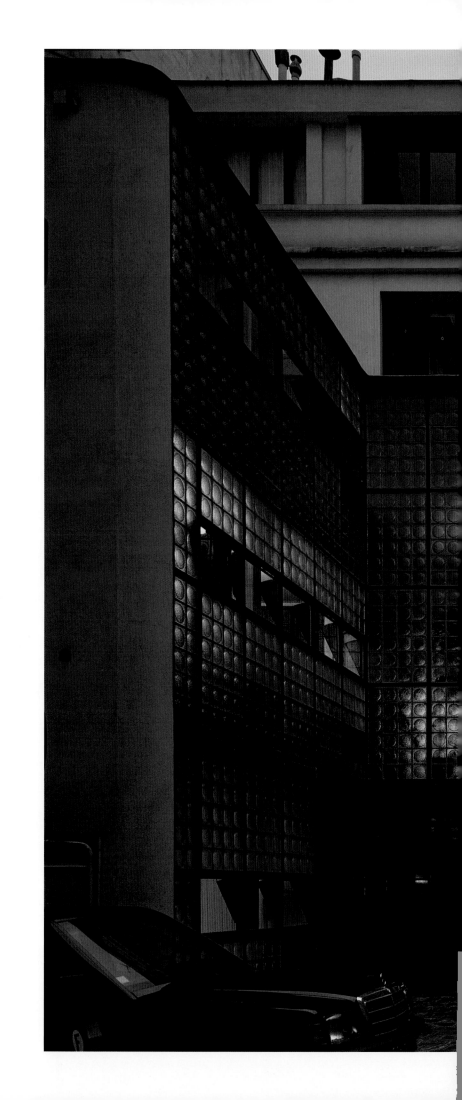

The front facade of Chareau's Maison de Verre at night, with interior lights lit. The house takes on an intense golden glow when illuminated from within.

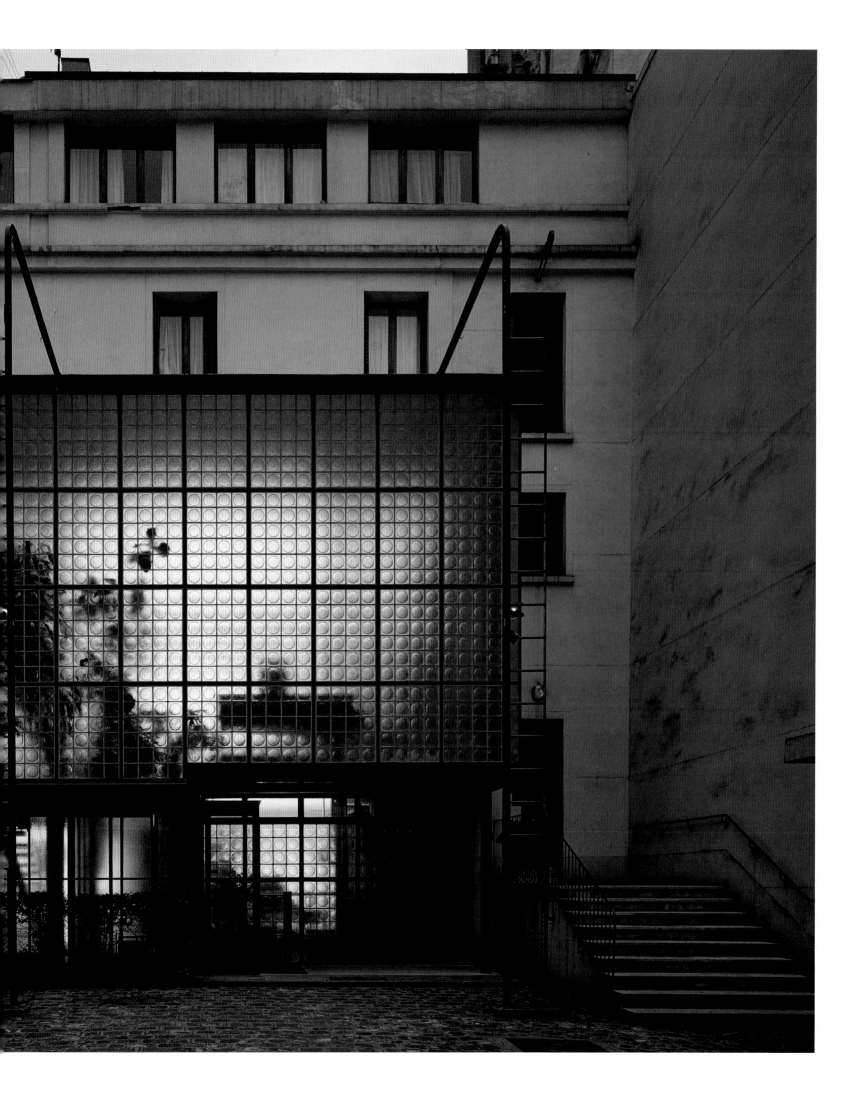

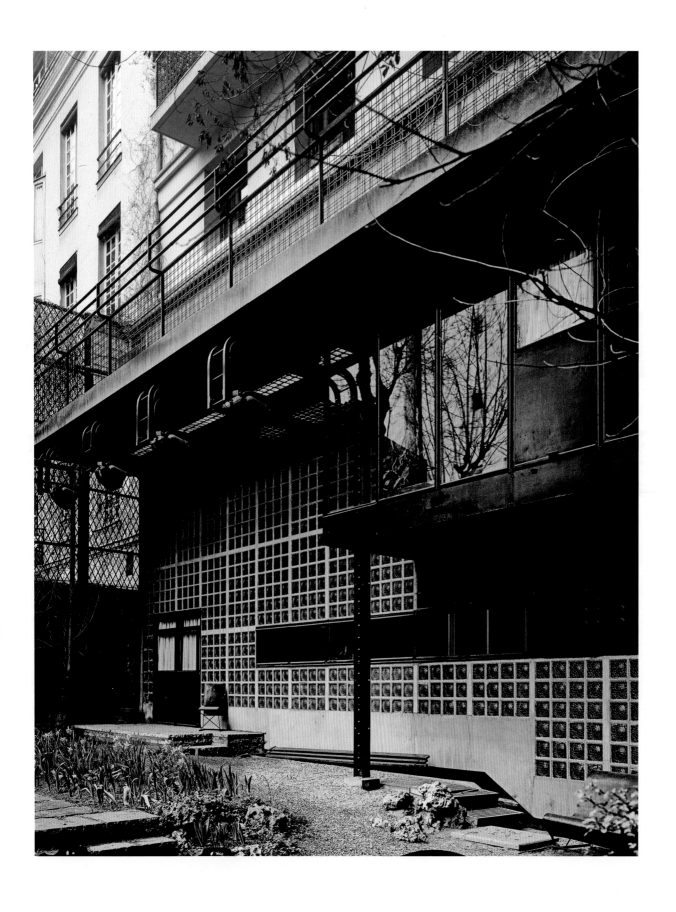

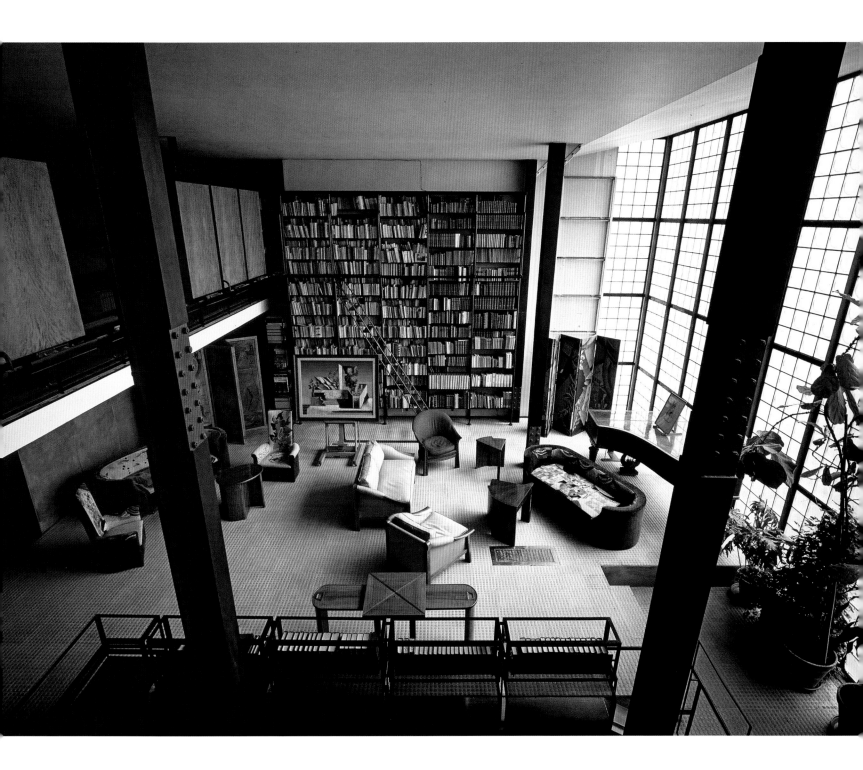

The grand salon, with the glass-brick facade at
right, facing the front courtyard.

Opposite
The exterior lighting system for the rear facade.
The spotlights project a diffuse light through
the glass bricks to the interior.

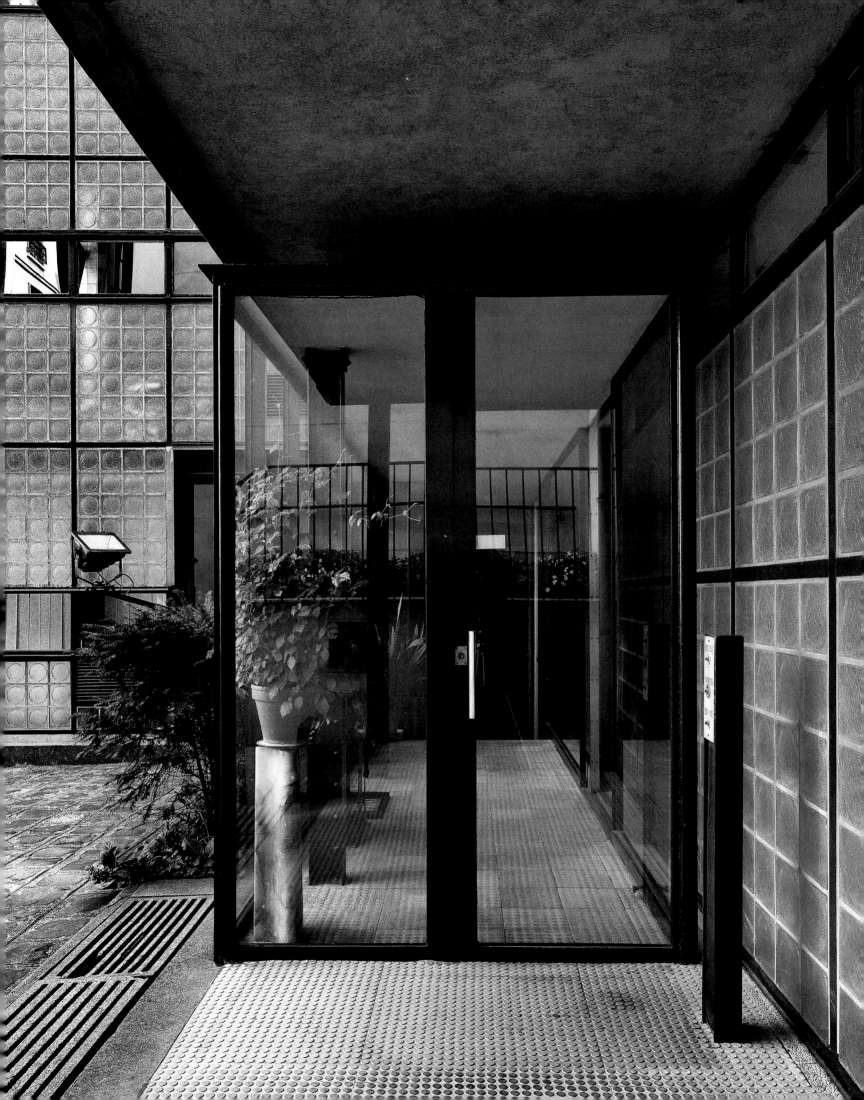

The waiting area is at the end of this corridor, which runs between the secretary's office at left and the garden facade at right. The double-height space can be glimpsed from the petit salon and the doctor's study on the second floor.

Opposite
The modest entrance to the house, leading into the lobby.

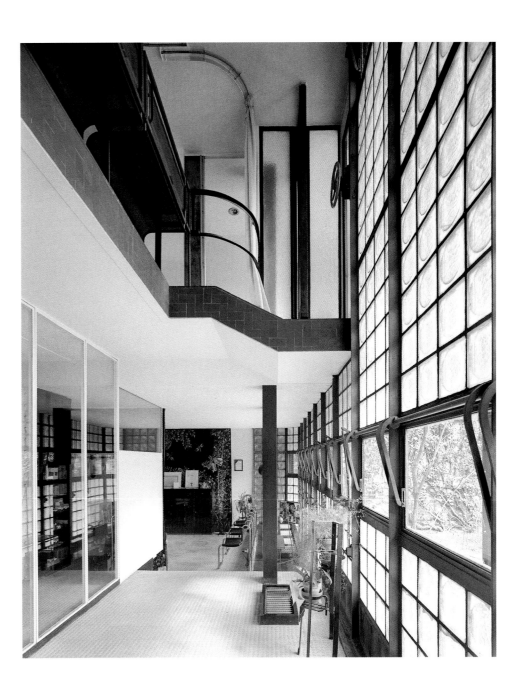

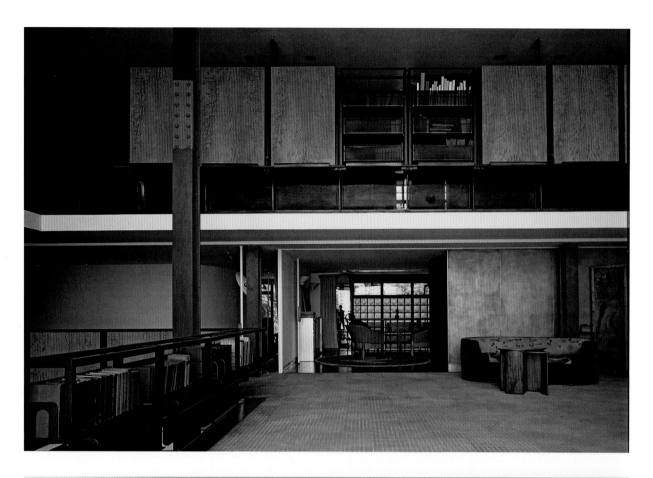

View from the second-floor grand salon toward the doctor's private study; above, the third floor is lined with cabinets and bookcases.

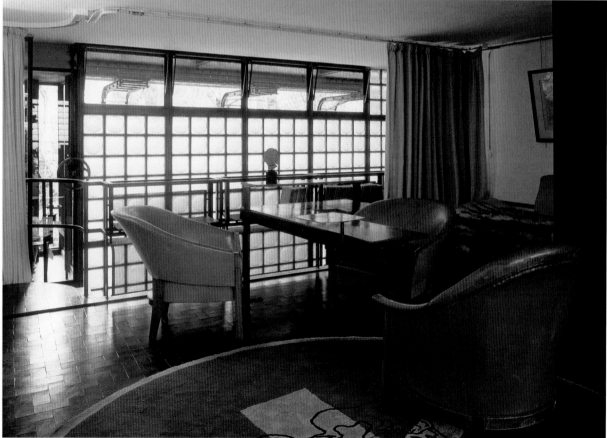

The doctor's private study.

Madame Dalsace's petit salon, with a retractable staircase to the couple's bedroom on the third floor.

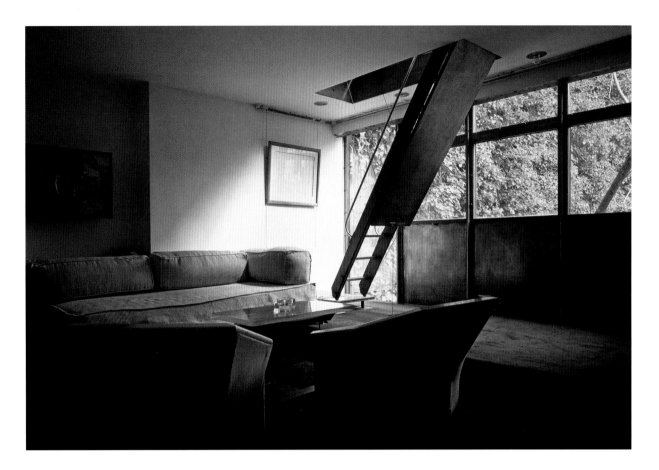

The fireplace in the petit salon, with a screen by Chareau, has a surround of slate tiles. Above the storage area for firewood at left is a service hatch with a built-in swiveling shelf for dishes, a kind of horizontal dumbwaiter or lazy Susan. Its purpose was to prevent servants from interrupting.

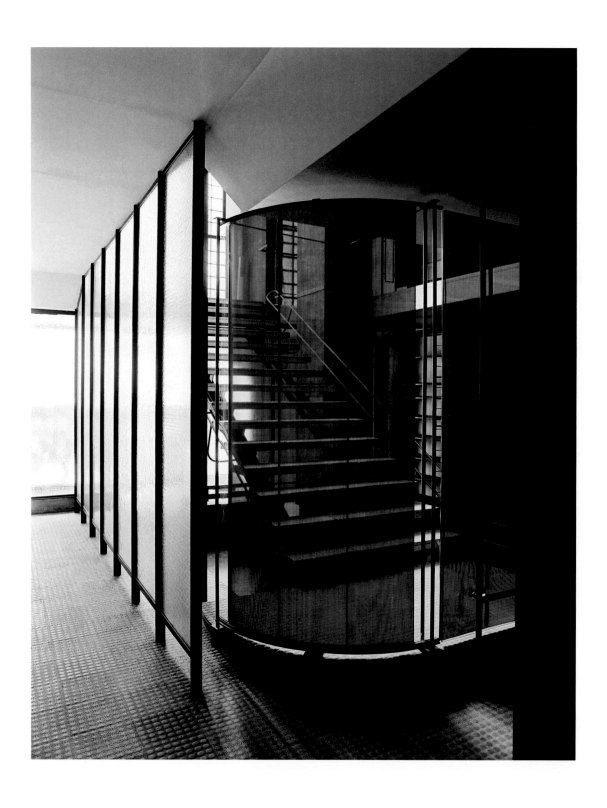

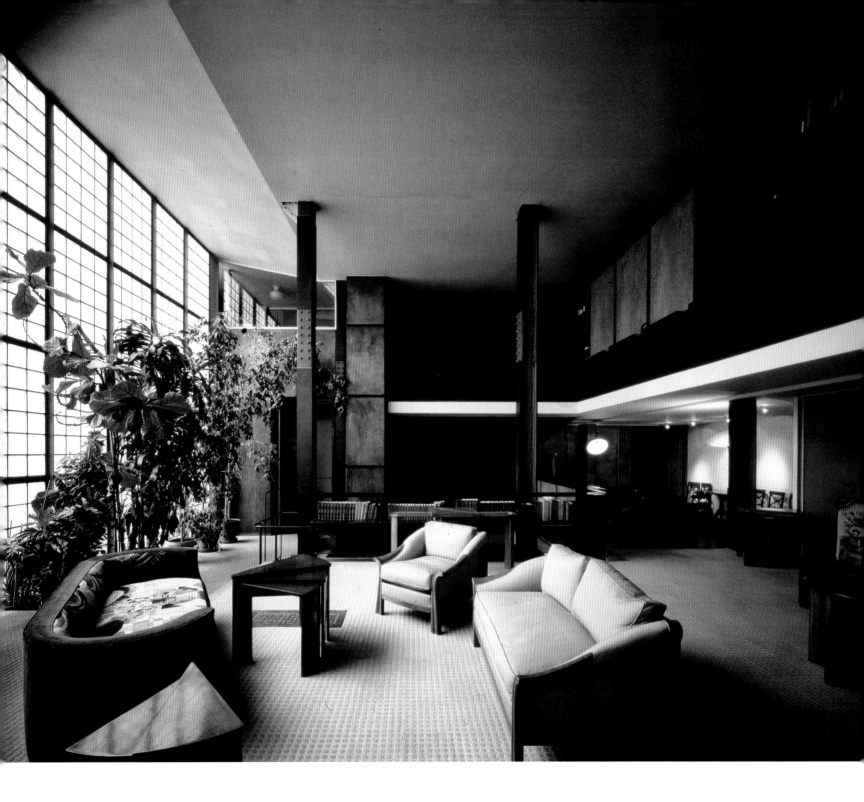

The grand salon, with exposed structural-
steel columns in a distinctive red paint and
black slate facing. The dining room is
at far right.

Opposite
The main stairway, with a movable
semicircular screen that separates the
medical offices from the entrance to
the private home.

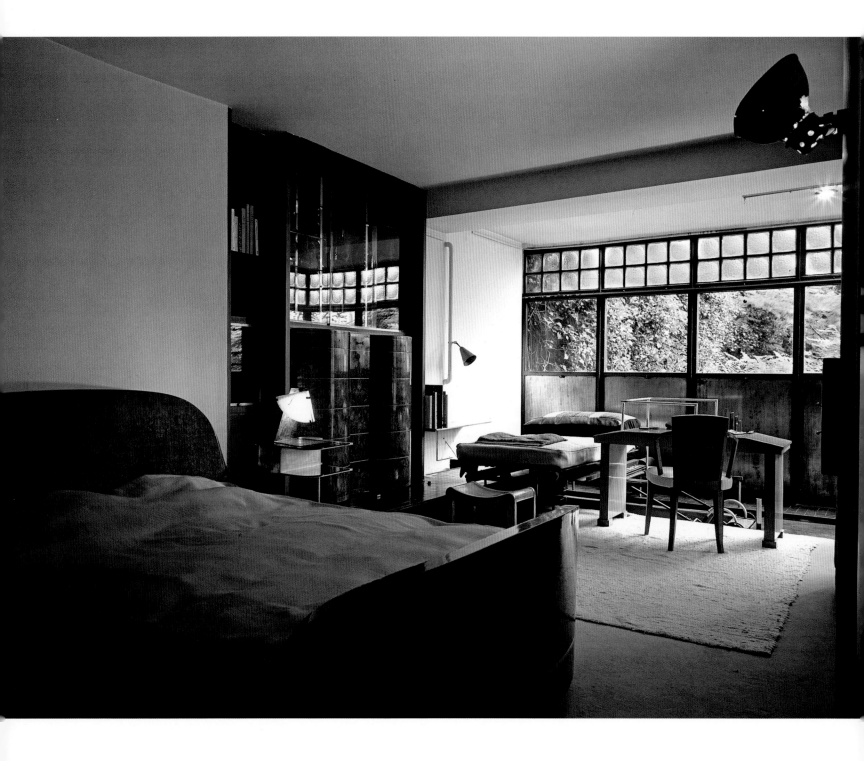

The master bedroom; the top of the retractable
staircase is visible in the background.

The furniture that actually attached to the
house was almost entirely designed by Chareau.
On either side of the bed in the master
bedroom stand a pair of swiveling bedside
tables in Duralumin and glass.

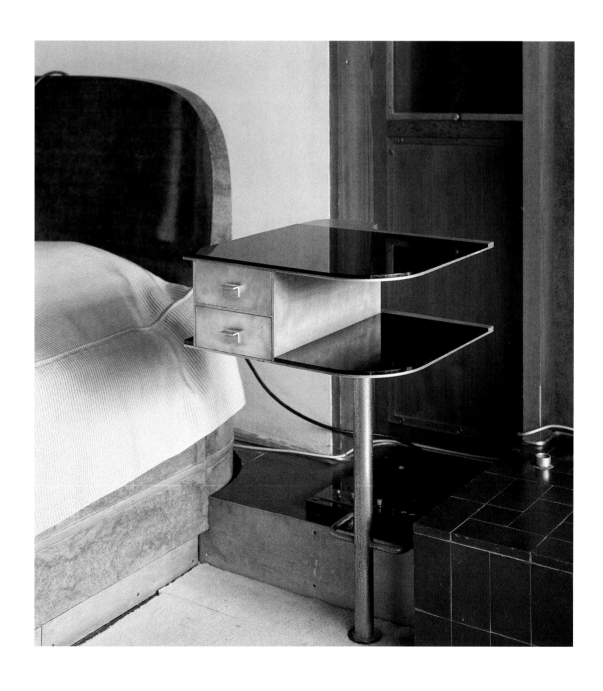

The washbasin and bidet behind a pivoting perforated-metal screen in the son's bedroom. Depending on lighting, the screen is nearly transparent.

This private stairway, which connects Dr. Dalsace's offices directly to his second-floor study, is an almost freestanding creation in steel by Dalbet and Chareau. The top rests on the floor above but is suspended away from the wall, except for one point where it turns ninety degrees. All of the treads are removable for cleaning.

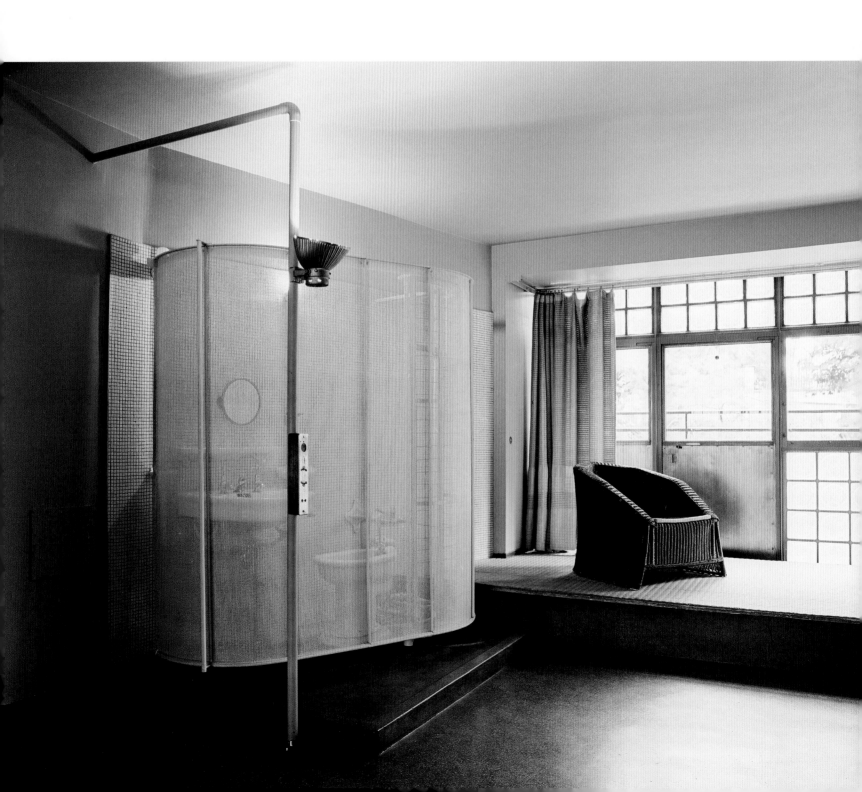

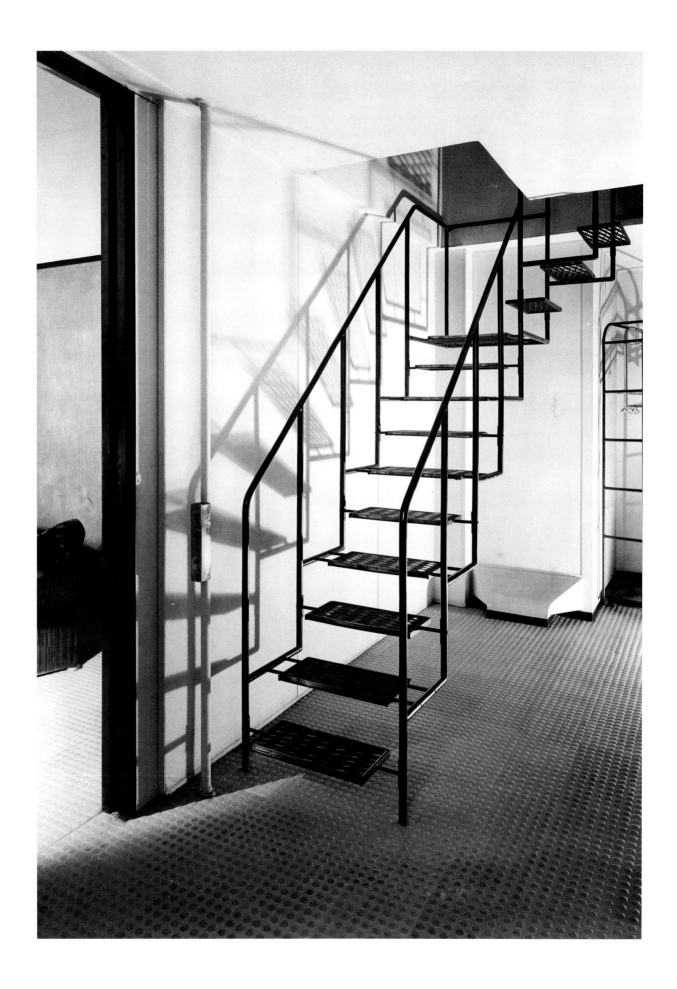

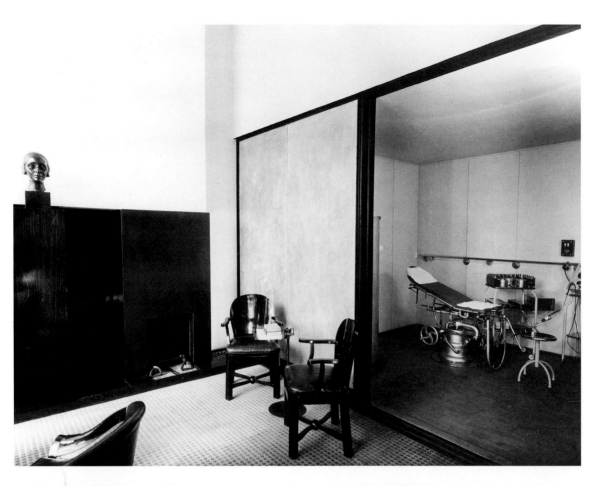

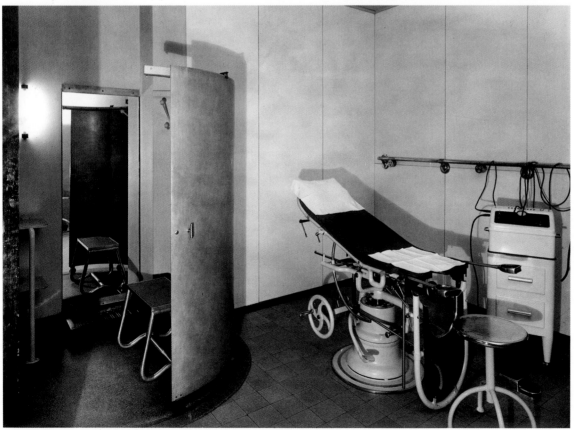

Above the petit salon, reachable by the retractable stairs, is Annie Dalsace's boudoir, with a daybed designed by Chareau.

Opposite, above
The doctor's office, with a sliding door into the examination room; Jacques Lipchitz's portrait sculpture of Annie Dalsace presides from the top of a bookcase (page 244).

Opposite, below
The examination room, with a small dressing room at left.

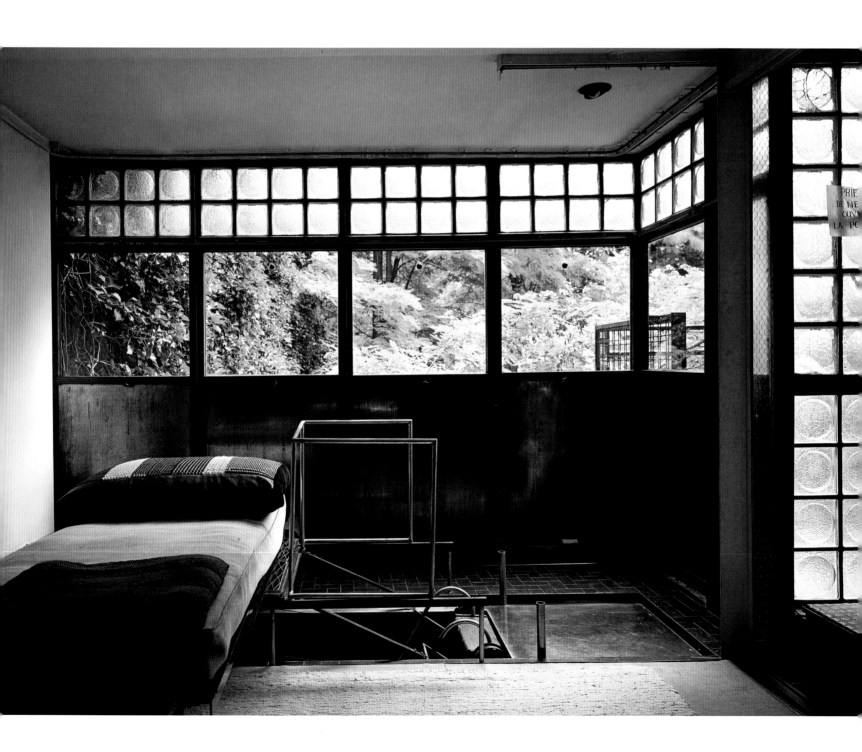

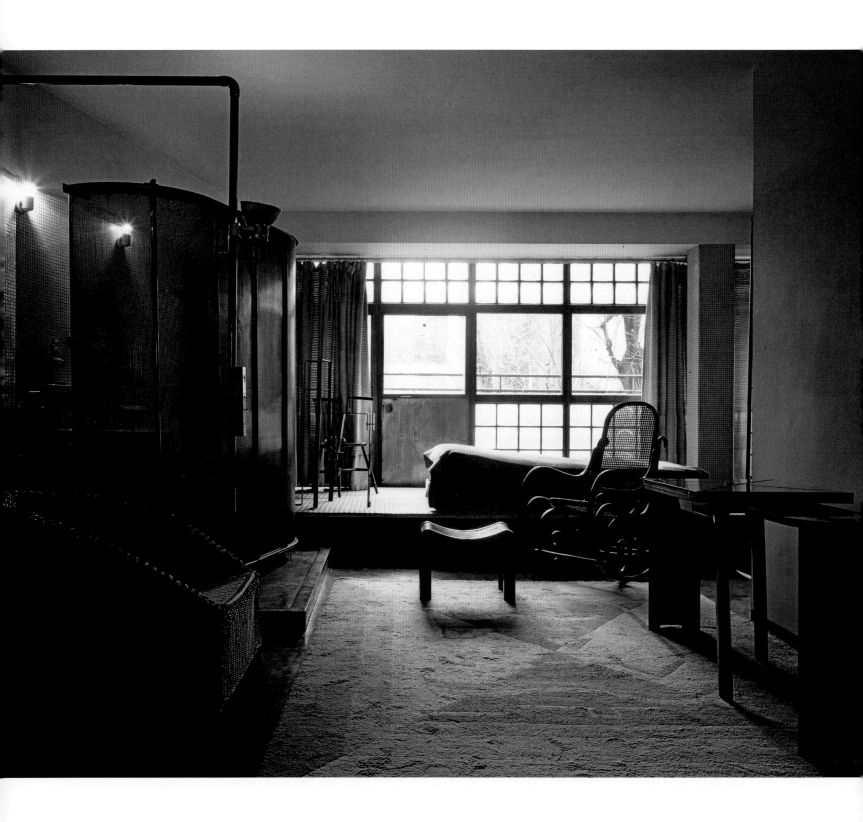

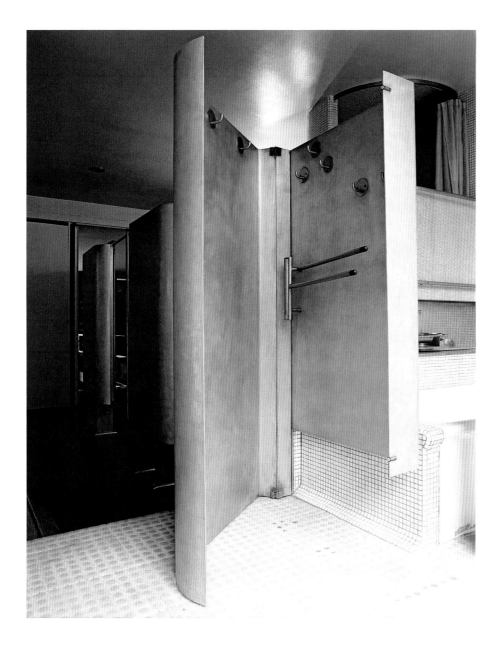

Thin Duralumin screens serve as partitions to provide some privacy.

Like the exposed structural beams, the electrical conduits of the Maison de Verre are visible, not hidden within the walls.

Opposite
The son's bedroom.

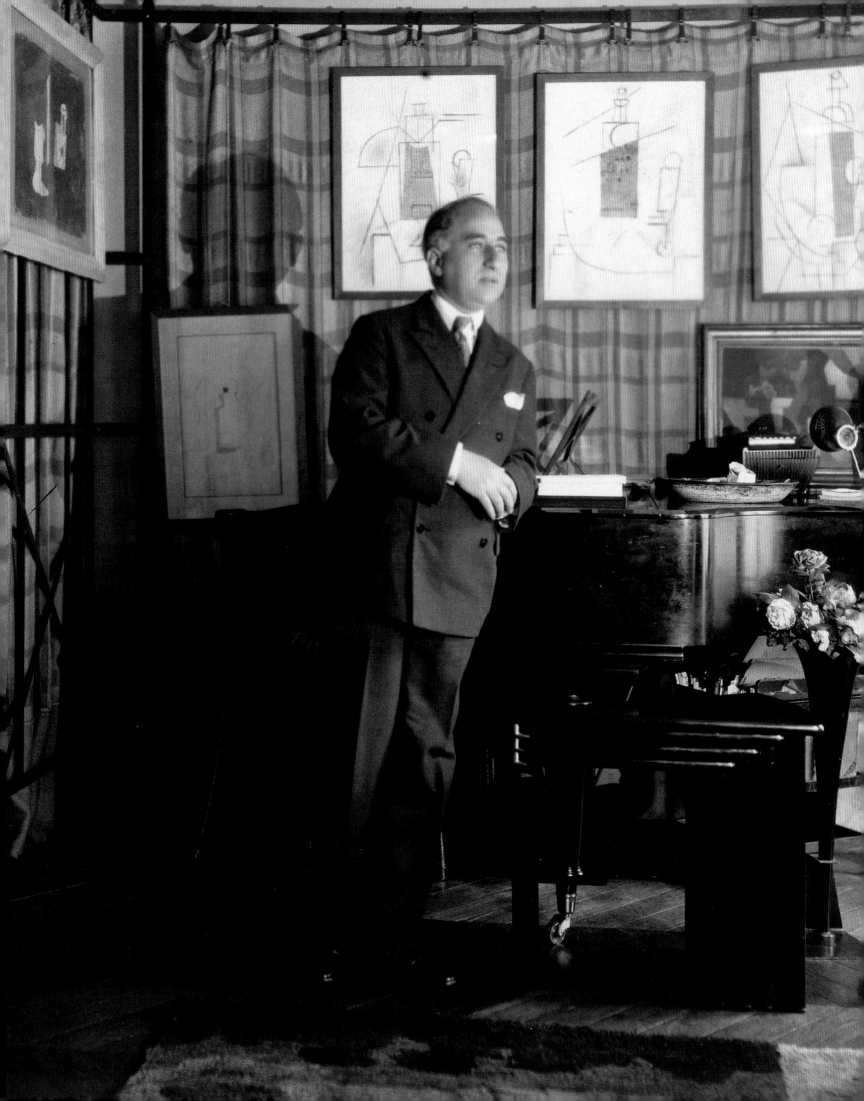

Pierre Chareau: Collector and Curator

Kenneth E. Silver

Pierre Chareau and his wife, Dollie, assembled a fine collection of modern art. Although records are lacking regarding much of what they owned, three key documents are extant. First are Dollie Chareau's reminiscences as recounted in a letter written from New York to the Parisian architect and designer René Herbst in the early 1950s:

> Pierre's first loves were the Impressionists and his painting continued to be influenced by them. I only have one painting by him now of our first country house.
>
> Later he was attracted to the Cubists and their architectural sense of structure. It was at that time, 1913–1914, and then on his return from the army in 1919 that we bought those "horrible" paintings, as my bourgeois friends used to call them: Juan Gris, Braque, Picasso, La Fresnaye, Miró, Masson, Pascin. Also during this period, Jean Lurçat painted a

very poetic mural for us, which we later had installed in my Louveciennes sitting room. Subsequently, we had a very fine Mondrian, the only picture in Pierre's office in Louveciennes. Torres-García, Max Ernst, Max Jacob, Arp, Bauchant, Campigli, Brignoni, Chagall, Charles Lapicque, Reichel, Vieira da Silva (the last present Pierre gave me before the war was a Vieira da Silva which I have here now). Then Robert Motherwell, a young Hungarian painter, and others. Pierre admired and believed in the art of Nicolas de Staël, who had two fine drawings sent to us here, and the same was true for that of Charles Lapicque. I also have a picture of Charles's which has been in our possession for twenty years.
>
> Pierre loved sculpture too. In 1919, at Jacques Lipchitz's suggestion, he bought the great caryatid by Modigliani, which was in our garden for over twenty years, on a plinth designed by Jacques. It is now in the Museum of Modern Art, New York. There's a curious story behind this. In 1939, on the occasion of the [New York] World's Fair, a request was made for it. We made the loan. Then the war

Chareau in his apartment at 54 Rue Nollet, c. 1927. On the wall behind him are, left to right: Picasso, *Glass and Bottle of Bass,* 1914, a drawing of a bottle; three 1912 Picasso collages; and a Lipchitz still life. Photograph by André Kertész.

came and the statue stayed here. We had a great deal of difficulty recovering it. It was thanks to an American, Mr. Catesly Jones, a lawyer and great art lover, that we were able to prove that we were the Chareaus from Paris who had made the loan. I had to sell it, along with the Mondrian.

We had seven small sculptures by Lipchitz. I've kept two; one is here, and the other is, as you know, in the Museum of Modern Art. Pierre was also fond of Laurens and Brancusi, but didn't own any examples of their work. . . . Later, in the hard years after 1932 . . . those "horrible" paintings saved us from ruin.[1]

Impressionism and Cubism were formative for Pierre Chareau; we would expect nothing else of an early twentieth-century pioneer in the visual arts, born two years after Pablo Picasso. Along with that of Juan Gris, Georges Braque, Roger de La Fresnaye, and the sculpture of Lipchitz, Picasso's Cubism seems to have been the art closest to Pierre's sensibility. International Constructivist abstractions, as represented by Mondrian, Joaquín Torres-García, and Maria Helena Vieira da Silva, were collected by the Chareaus, as was the Dada and Surrealist painting of Joan Miró, André Masson, and Ernst. Examples of the figurative art of Amedeo Modigliani, Marc Chagall, and Jules Pascin could all be found in the Chareau collection.[2] Even postwar abstract paintings by Robert Motherwell and Nicolas de Staël made their way into the holdings of the Chareaus once they had moved to the United States (pages 246–47).

Equally revealing of their taste are two photographs made in the mid- to late 1920s of the Chareaus' Paris apartment. In one image, taken by André Kertész, we see Pierre's 1927 wood-and-metal desk in the foreground and a baby grand piano against the far wall (page 226). Alongside it is poised a nest of four low, wooden triangular tables, which fan out around an axis. Reading from left to right, this art-filled corner includes, on the left wall: a 1913 Picasso collage, *Glass and Bass Bottle on a Table;* an Egyptian head (original or copy); in front of it on a pedestal, a Lipchitz sculpture; beyond that another Picasso collage closely related to the first, *Glass and Bottle of Bass,* 1914; and below that a Picasso drawing or collage of what appears to be a bottle (probably c. 1912). On the back wall we find a large Picasso charcoal drawing, *Guitar;* below it a small Picasso 1913 or 1914 gouache, *Newspaper, Wineglass, Bottle of Bass, and Guitar;* and to the right a major Georges Braque Cubist

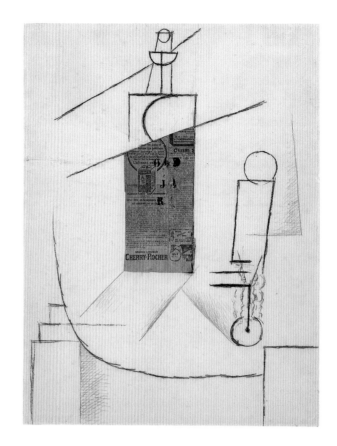

Pablo Picasso, *Table with Bottle and Wineglass,* 1912 or 1913. Charcoal, ink, and pencil collage on paper, 24¼ × 18½ in. (61.6 × 47 cm) Private collection, Stockholm

Pablo Picasso, *Bottle and Wineglass,* 1912 or 1913. Newspaper, charcoal, and pencil collage on paper, 24⁷⁄₁₆ × 18⁹⁄₁₆ in. (62 × 47.1 cm) Menil Collection, Houston

painting, *Homage to J. S. Bach.* Finally, atop the piano are four works (left to right): Lipchitz's bronze figure *Woman with Guitar;* what looks to be a small Picasso collage; Picasso's 1914 collage *Still-Life: "Almanacco Purgativo";* and Lipchitz's *Woman Reading* (page 229).[3]

In a second Kertész photograph, we observe the same corner of the Chareau apartment, with Pierre, a talented amateur musician, leaning gently against the piano (page 214). Picasso's *Glass and Bottle of Bass* remains in place, the Picasso drawing of a bottle has been moved slightly right, to the corner, and just a bit of the Lipchitz *Woman Reading* can be glimpsed atop the piano at the extreme right. But the other art is different. Gone from the back wall are Picasso's *Guitar; Newspaper, Wineglass, Bottle of Bass, and Guitar;* and the Braque *Homage to J. S. Bach.* Missing from the piano are Lipchitz's *Woman with Guitar;* the small Picasso collage; and *Still-Life: "Almanacco Purgativo."* Now, three closely related collages by Picasso, including *Table*

with Bottle and Wineglass and *Bottle and Wineglass,* both from late 1912 or early 1913, adorn the back wall. Propped up against the wall on the piano is a Lipchitz still-life painting, closely related to his 1918 polychrome relief later owned by the Dalsaces and hanging in the Maison de Verre (page 244).

Like his expanding and contracting furniture, room dividers, and wall-mounted units, Chareau's art collection was itself flexible. As new works were acquired, older ones presumably made way for the latest finds; winnowing and upgrading are standard operating procedure for most art collectors. Did the Picasso collages, for instance, take the place of the large Picasso drawing and the Braque painting, or vice versa? Was the appeal of putting together an ensemble of three of Picasso's finest prewar works, probably made within days or weeks of each other, too great to be resisted, or, on the contrary, were these relatively small works superseded by the major Picasso drawing and a major Braque painting, as a demonstration—if one made only to himself—of the ever-increasing stature of Pierre Chareau's high modernist omnium-gatherum? Dollie said in her letter that he was "attracted to the Cubists and their architectural sense of structure," and thus it couldn't have been accidental that he had himself photographed against the background of his Picasso collages, his head superimposed on Picasso's superb *Bottle and Wineglass,* one of the most abstract and conceptually rich of Picasso's prewar works. Doesn't it seem likely that works like these by Picasso, which Chareau would have seen every day, powerfully influenced his design work?[4] Don't his early 1930s black-painted tubular metal table with glass

top and tubular metal stool with leather seat look like Picasso Cubist line renderings of around 1912 that have come magically to full, three-dimensional life? Isn't there a lightness of touch, clarity of structure, and playfulness in these collages that reminds us of some of Chareau's greatest designs?

The flexibility of the collection extended far beyond its domestic reconfiguration in the Rue Nollet apartment. Many of these works did double duty by circulating in and out of Chareau's various displays of furniture and interior design. Further, he and a number of friends, colleagues, and perhaps clients seem to have had an informal consortium, buying artworks as a group and sharing or lending them to one another. This may partly explain why photographs of homes and exhibition installations sometimes show the same works in different locations.[5]

For instance, the Braque painting *Homage to J. S. Bach* and the Picasso collage *Still-Life: "Almanacco Purgativo"* both hung on the walls of a model study, replete with furniture and a fan partition, in Chareau's display at the Salon d'Automne in 1926.[6] The seven Lipchitz sculptures from his personal collection were especially busy, helping to embellish numerous interiors and displays: the Lipchitz still life that sat atop Pierre's piano, for example, also hung above a fireplace in a model room at the 1924 Salon d'Automne; Lipchitz's *Reader in an Armchair,* perhaps from the Chareau collection, sat on the mantel,

Furniture by Chareau with a Cubist influence: left, black-painted tubular metal table with glass top, c. 1932; right, tubular metal stool with leather seat, c. 1930.

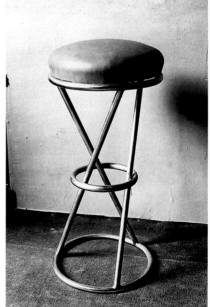

and Lipchitz firedogs like ones owned by Coco Chanel adorned the hearth (page 233). The Chareaus' *Musical Instruments (Hexagonal Shape) II* by Lipchitz appeared in 1923 above the fireplace in the apartment of a patron named Lanique, with interior decor by Chareau, and in 1925 it turned up in Chareau's celebrated design at the Exposition International des Arts Décoratifs et Industriels Modernes for a French embassy library; there it was mounted on a pedestal near a wall, much as it was in the Chareaus' home (page 235).

Other key modern works, apparently not in his and Dollie's private collection, were nonetheless used—perhaps borrowed—by Chareau in his displays; for instance, Giorgio De Chirico's *Mystery and Melancholy of a Street* appeared alongside Chareau's furniture at Galerie Barbazanges in Paris in 1926. Marc Chagall's *Praying Jew* was the centerpiece of Chareau's wrought-iron easel with attached light fixture (page 241). Two sculpted figures of *Maternity,* one seated and the other standing, created by the most important female sculptor in Paris, Chana Orloff, were chosen by Chareau for inclusion in his other major project at the 1925 Exposition Internationale des Arts Décoratifs: the model dining room for the Indochinese pavilion (page 42).

Orloff was also among the most sought-after portraitists of the 1920s, and her 1921 sculpted portrayal of Pierre Chareau, with its half-closed eyes and slight tilt of the head backward and to the side, is rendered in the schematized naturalistic style—a kind of classicized caricature—for which she was known (page 231). Lipchitz made a portrait, as well, of Annie Bernheim Dalsace, which is visible high atop a bookcase in photographs of Dr. Jean Dalsace's double-height consulting room at the Maison de Verre (page 210). The Dalsaces and their circle of relatives and friends were responsible for many of Pierre Chareau's architectural and interior-design commissions, but they were also linked by way of the art they collected and the artists they patronized; for instance, the writer Edmond Fleg, cousin by marriage of Annie Dalsace, also commissioned a portrait of himself by Orloff.[7]

It was Jean Dalsace who introduced Pierre Chareau to the painter and textile designer Jean Lurçat, his school chum from Épinal. Chareau and the Lorraine native collaborated on a number of projects, with Lurçat providing some of the fabric for Chareau's furniture, including the couches, armchairs, and folding screen for the grand salon of the Maison de Verre. A second, painted screen there is also by Lurçat, as is the canvas *The Olive Tree,* an abstracted 1928 landscape, visible on an easel. Lurçat also produced a full-length painted portrait of Annie for the house (page 199).

Dollie Chareau had tutored the young Annie Bernheim in English, and it was through this connection that she and Pierre found themselves embedded in the Alsace-Lorraine cultural circles of Paris. As his name suggests, Dr. Dalsace was Alsatian, as were Edmond and Berthe Bernheim, Annie's rich parents (who, like the Chareaus, commissioned Lurçat to paint a mural for their country house).

Also identifiable in early photographs of the Maison de Verre, hanging over the daybed in the petit salon (Annie Dalsace's sitting room), is the Lipchitz still-life relief, related to the work owned by Pierre and which hung above the fireplace at the Salon d'Automne of 1924.[8] Recalling Dollie Chareau's remark that "later, in the hard years after 1932 . . . those 'horrible' paintings saved us from ruin," might we not surmise that the Dalsaces, in order to keep their dearest friends afloat at the depths of the Great Depression, purchased the Lipchitz relief from the Chareaus? Alternatively, was this work perhaps one of those shared among a consortium of friends?

Chareau's affinity for the Cubist aesthetic is underscored again and again in archival photographs, where paintings by Braque and Gris are repeatedly paired with room designs—and on at least two occasions, a Léger (pages 236, 238, 54).

In the 1920s Chareau worked on several films of Marcel L'Herbier, collaborating with the extraordinary group of avant-garde artists the director had gathered. Among others, Chareau and Robert Mallet-Stevens designed sets and furniture. A number of artists and designers lent their works and other decor to the sets, including Fernand Léger, Robert Delaunay, Jean Lurçat, Joseph Csaky, and the glass designer René Lalique (page 73).[9]

Perhaps most important in the formation of the Chareau art collection, though, was yet one more Alsatian in Paris, Jeanne Bucher, who later became one of the French capital's most influential dealers in modern art. Thanks to Lurçat's introduction, Bucher in 1925 opened her first gallery and art-publishing enterprise in an annex of La Boutique, the showroom and retail space that Pierre Chareau had inaugurated the year before at 3 Rue du Cherche-Midi, just around the corner from the celebrated and forward-looking Théâtre du Vieux-Colombier. Operating under the auspices of the Swiss publisher and book dealer Jean Budry, Bucher's rented space at Chareau's shop was quite modest. Nonetheless, within two years, she published Max Ernst's *Histoire Naturelle* print portfolio (1926) and organized seven art exhibitions, including *Papiers Collés et Dessins de Picasso* (1925). Might this be how Chareau came to

acquire the three Picasso collages with which he posed near his piano?[10]

Whether or not he acquired his Picassos from his new tenant at La Boutique, the overlap between art in the Chareau collection and the artists Bucher exhibited or represented is striking. These included not only Picasso and Braque but also Ernst, Miró, Masson, André Bauchant, Massimo Campigli, Serge Brignoni, Vieira da Silva, Torres-García, De Staël, and Lipchitz. What are we to make of this? If it seems unlikely that Chareau, a design visionary and man of consummate refinement, was merely the recipient of Bucher's market savvy, it seems equally difficult to imagine that Bucher, a smart operator, built a thriving art business based on advice offered by Chareau, who hardly had time to trawl the studios of Montparnasse in search of new talent. It seems likely that, as in his collaborations with the metalworker Louis Dalbet and the textile artist Jean Lurçat, his relationship with Jeanne Bucher was mutually reinforcing, the taste and guidance of each enriching the scope of the other's sensibility. Each moved in discrete and highly sophisticated fields, making decisions about art independent of the other: it was Jacques Lipchitz, for instance, who advised the Chareaus to buy the beautiful Modigliani caryatid that sat in their garden for years (page 224). Yet Bucher had a role to play too: it was her friend T. Catesby Jones, "lawyer and great art lover," who facilitated the Chareaus' recovery of the work during their American exile, which allowed Dollie to sell it to the Museum of Modern Art, where it has now resided for well over half a century.[11]

More than once during their years in the United States, the Chareaus were saved from ruin by their art collection. A photograph of their apartment in New York, taken in the 1940s or 1950s, shows three Lipchitz works on paper on the wall together with Max Ernst's *Interior of the View* (pages 242–43). The painting had a history, as a friend of the family recalled:

The Chareaus had a picture by Ernst. Their house in Paris was full of pictures of the Cubist period. It was really their period. They had Picassos, they had Braques, Juan Gris, all those painters of that time—collage, canvases, and so on. And they had a picture of Max Ernst which [Dollie] sold recently, much to my regret. It was a black painting, on which there were five crystal glasses or vases; in each of them there was a different flower, all in whitish mauvish colours. When I was young, I couldn't stand the picture, but when I grew older, I changed and finally liked it very much. They told me a number of times that they met Max Ernst when he first came to Paris in the early 20's. He was very poor . . . the picture became the property of the Chareaus, and Pierre Chareau commented with a sentence which he coined and repeated many a time: "I am a wealthy poor man."[12]

World War II may have upended the Chareaus' lives, forcing them to flee France, but it did not end their passion for avant-garde art. In New York, they continued their friendships with other émigré artists, including Jacques Lipchitz. Among their new connections was the young American Robert Motherwell, then in his twenties, with whom Pierre worked on an art journal, and who commissioned one of his few projects in the United States.[13] The couple owned several works by Motherwell, including *Pierrot's Hat,* his first collage; an untitled drawing; and a print, inscribed to them in 1944. The delicate Cubist lines so crucial to Chareau's own creativity may be seen in these early inventions of one of the next generation's leading visionaries (pages 246–47).

NOTES

I am most grateful to Esther da Costa Meyer for her invitation to be part of the Pierre Chareau project, and to Olivier Cinqualbre for his helpful research guidance. Daniel S. Palmer, Leon Levy Assistant Curator at the Jewish Museum, has helped me identify many of the works of art in the Chareau collection, as well as many of the venues in which they were installed; his assistance has been invaluable to me.

1. The letter was written in New York on October 25, 1952, or 1953. Cited in Marc Vellay and Kenneth Frampton, *Pierre Chareau: Architect and Craftsman, 1883–1950* (New York: Rizzoli, 1984), 24–26. Dollie misspells the name of T. Catesby Jones (1880–1946).

2. See Kenneth E. Silver and Romy Golan, *The Circle of Montparnasse: Jewish Artists in Paris, 1905–1945,* exh. cat. (New York: Jewish Museum, 1985), for a discussion of the role of Jewish artists, collectors, and dealers of the period in which the Chareaus assembled their collection.

3. The Picasso drawing of a bottle has not been firmly identified, but a drawing or collage closely resembling it is visible on Picasso's studio wall at 242 Boulevard Raspail in a photograph of c. 1912 or after; see Anne Umland, *Picasso: Guitars, 1912–1914,* exh. cat. (New York: Museum of Modern Art, 2011), 45. The gouache *Newspaper, Wineglass, Bottle of Bass, and Guitar* of 1913 or 1914 is in a Paris private collection. The small collage on the piano has also not been identified with certainty. Picasso's *Still-Life: "Almanacco Purgativo,"* 1914, is in a private collection.

4. Although he does not discuss specific objects or works, for a general discussion of the relationship of Chareau's architecture and design to Cubism, see Joseph Abram, "Aux Confins de la Culture Cubiste," in *Pierre Chareau, Architecte: Un Art Intérieur,* exh. cat., by Olivier Cinqualbre et al. (Paris: Centre Pompidou, 1993), 43–50.

5. Evidence for this is described in an interview conducted by Brian Brace Taylor and Bernard Bauchet with Madame Muriel Jaeger, July 2015. See page 189 in the present volume, note 8. In this volume Olivier Cinqualbre further observes, "Artworks by Chareau's friends . . . often figured prominently in the ensembles that Chareau exhibited at the salons"; page 96, note 9.

6. Cinqualbre et al., *Pierre Chareau, Architecte,* 140, indicates that this exhibition took place in 1926; Vellay and Frampton, *Pierre Chareau,* 213, suggest that it took place in 1927. Several works from Chareau's collection are now in the Museum of Modern Art, New York. Provenance research at the museum confirms that Modigliani's *Caryatid* was owned by Chareau, who sold it to the museum in 1951. "For Picasso's *Guitar* and Braque's *Homage to J. S. Bach,*" the museum's researcher notes, "it seems to be unclear if the objects were owned by Pierre Chareau at all. From the documentation considered so far, it seems more likely that these two works were owned and lent by the Dalsace family to the Chareau 'showroom.'" Lynn Rother, Senior Provenance Specialist, Museum of Modern Art, correspondence with the author, December 16, 2015.

7. The Orloff portrait is visible in a photo of the Fleg apartment, decorated by Chareau in 1920, in Brian Brace Taylor, *Pierre Chareau: Designer and Architect* (Cologne: Taschen, 1992), 42, top.

8. See, for example, a photograph by Jean Collas, in Taylor, *Pierre Chareau,* 132. The Lipchitz relief still hangs in the Maison de Verre. I am grateful to Robert M. Rubin for granting access to the house and to Mary Johnson for guiding me through the remarkable building.

9. Other collaborators included Georges Antheil and Darius Milhaud, providing music; costumes by Paul Poiret, Sonia Terk Delaunay, and Louise Boulanger; and choreography by Jean Borlin. Yvette Guilbert and Antonin Artaud were among the actors. See Caroline Evans and Marketa Uhlirova, eds., *Marcel L'Herbier: Dossier* (London: Fashion in Film, 2014), http://www.fashioninfilm.com/wp-content/uploads/2014/06/doss-16-june-low-res.pdf.

10. Christian Derouet says of the Picasso show at Jeanne Bucher's space at La Boutique: "She hung some drawings on the wall, some collages of Picasso, no doubt the same ones that are visible in a photograph of Pierre Chareau's study"; Christian Derouet, ed., *Jeanne Bucher: Une Galerie d'Avant-Garde, 1925–1946: De Max Ernst à de Staël,* exh. cat. (Geneva: Skira; Strasbourg: Musées de la Ville de Strasbourg, 1994), 16.

11. On Bucher's relationship to T. Catesby Jones and his wife, Louisa Brooke Jones, see Derouet, *Jeanne Bucher,* 18, 160–62.

12. Arthur Drexler, architectural historian and friend of the Chareaus, interview with George D. Boinet, 1968, transcription, Museum of Modern Art Archives, New York.

13. On Chareau's house for Motherwell, see Robert S. Rubin's essay in this volume, page 249.

Chareau as Collector and Curator

Chareau and the Display of Modern Art

Chareau collected modern art and also borrowed works for display in the interior designs he presented at expositions. In addition, he was a member of a group called L'Oeil Clair, which bought works of art collectively and gave members the chance to install them in their own home by turns.

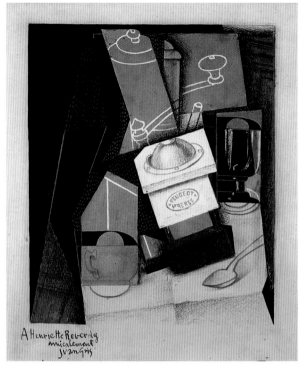

Juan Gris, *Coffee Grinder, Cup and Glass on Table*, 1915–16
Black chalk, pencil, oil, and collage on paper, 18⅛ × 11⅜ in. (46 × 29 cm)
Museo Nacional Centro de Arte Reina Sofía

Amedeo Modigliani, *Caryatid*, c. 1914
Limestone, 36¼ × 16⅜ × 16⅞ in. (92.1 × 41.6 × 42.9 cm)
Museum of Modern Art, New York, Mrs. Simon Guggenheim Fund

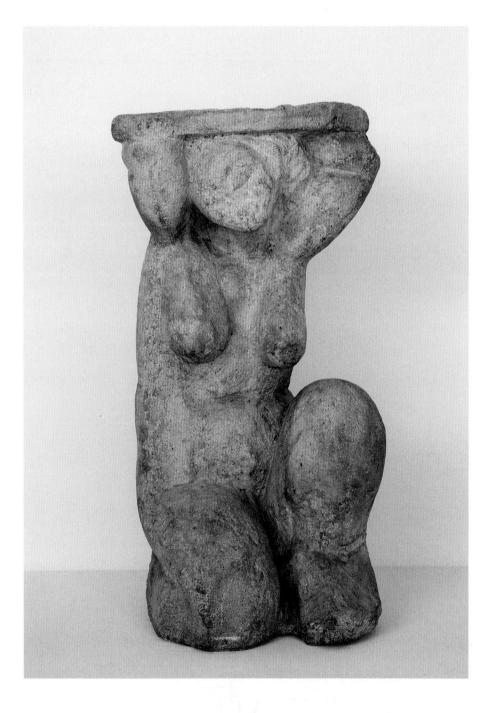

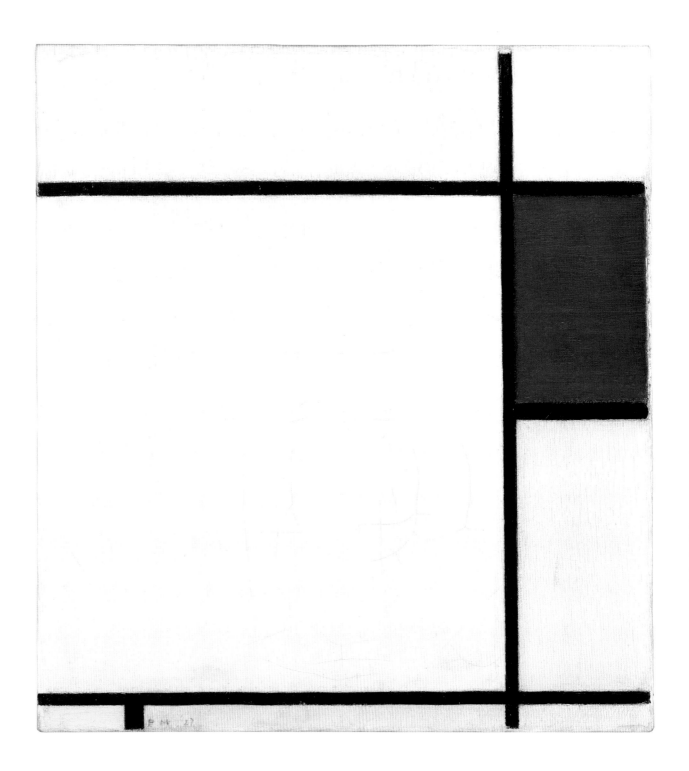

Piet Mondrian, *Composition V with
Blue and Yellow*, 1927
Oil on canvas, 15⅛ × 14 in.
(38.4 × 35.6 cm)
Baltimore Museum of Art,
Saidie A. May Bequest
Chareau and the Noailles family
were the first collectors in France to
purchase works by Mondrian.

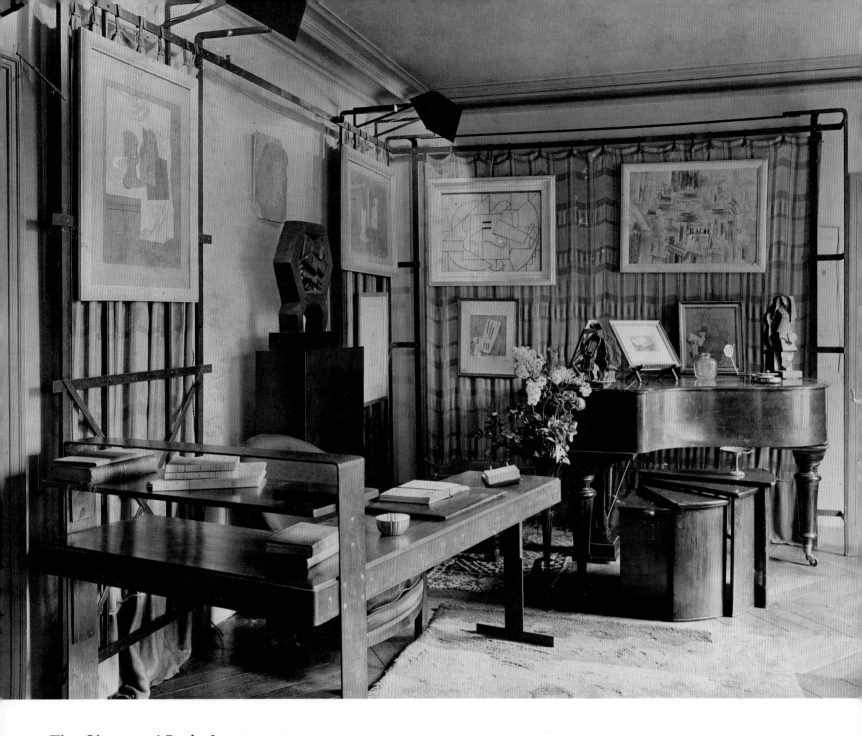

The Chareaus' Paris Apartment

At 54 Rue Nollet, Paris, probably c. 1927. On the walls,
from left to right: Picasso, *Glass and Bass Bottle on
a Table,* 1913; Lipchitz, *Musical Instruments,* 1923
(on pedestal); behind it a plaster cast of an Egyptian
fragment; Picasso, *Glass and Bottle of Bass,* 1914; a
Picasso drawing of a bottle; Picasso, *Guitar,* c. 1912;
Picasso, *Newspaper, Wineglass, Bottle of Bass, and
Guitar,* 1913 or 1914; Braque, *Homage to J. S. Bach,*
1911–12; and Picasso, *Still-Life: "Almanacco Purgativo,"*
1914. On the piano: Lipchitz's *Woman with Guitar,*
1926; *Still Life* relief, 1918; and *Woman Reading,* 1919.
In the foreground at left is Chareau's desk. Beneath
the piano are his nesting fan-shaped tables (page 117).
Photograph by André Kertész.

Pablo Picasso, *Guitar,* c. 1912
Charcoal on paper, 18½ × 24⅜ in. (47 × 61.9 cm)
Museum of Modern Art, New York,
Gift of Donald B. Marron

Georges Braque, *Homage to J. S. Bach,* 1911–12
Oil on canvas, 21¼ × 28¾ in. (54 × 73 cm)
Museum of Modern Art, New York, The Sidney and Harriet Janis Collection, acquired through the Nelson A. Rockefeller Bequest Fund and the Richard S. Zeisler Bequest (both by exchange) and gift of Leon D. and Debra Black

Pablo Picasso, *Glass and Bottle of Bass,* 1914
Oil, gouache, graphite, sawdust, and newspaper collage on paper, mounted on board, 18¾ × 24⅝ in. (47.7 × 62.6 cm)
Solomon R. Guggenheim Museum, New York

Jacques Lipchitz, *Woman Reading*, 1919
Stained terracotta, 15¼ in. (38.7 cm) high
Hood Museum of Art, Dartmouth College:
Purchased through the William B. and
Evelyn A. Jaffe Fund

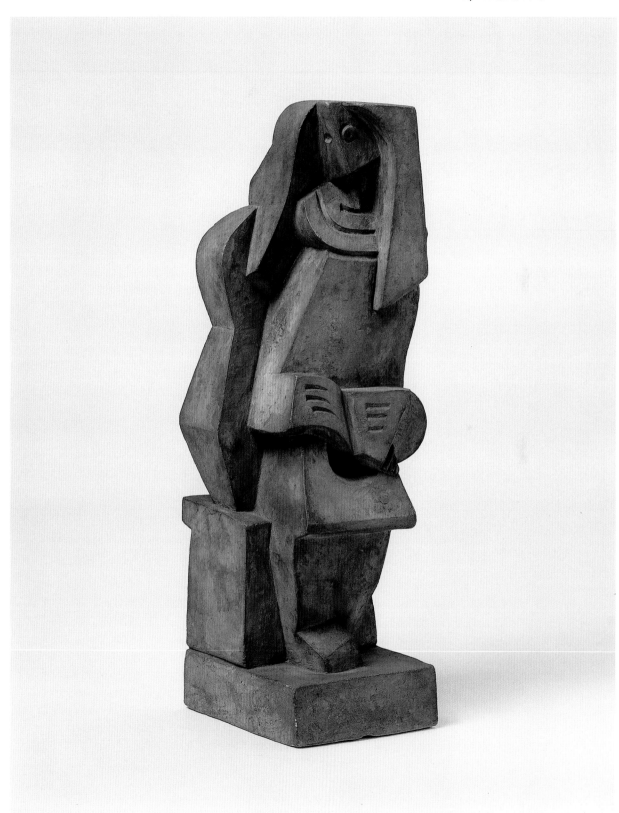

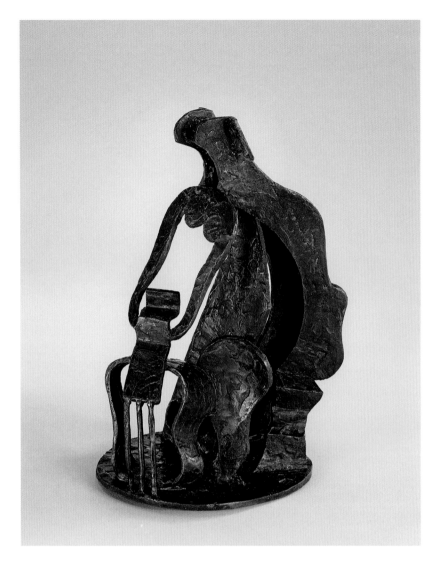

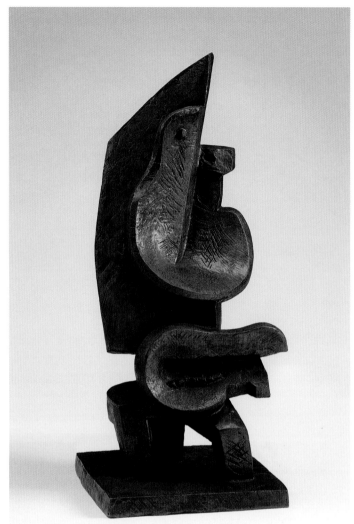

Jacques Lipchitz, *Woman with Guitar,* 1926
Bronze, 11 × 5⅞ × 7¼ in. (27.9 × 14.9 × 18.4 cm)
Hirshhorn Museum and Sculpture Garden,
Smithsonian Institution, Washington, DC

Jacques Lipchitz, *Man with a Mandolin,* 1925
Bronze, 17¾ × 8 × 7⅝ in. (45.2 × 20.3 × 19.4 cm)
Hirshhorn Museum and Sculpture Garden, Smithsonian
Institution, Washington, DC, the Joseph H. Hirshhorn
Bequest, 1981

Chana Orloff, *Bust of Pierre Chareau,* 1921
Plaster, 12¾ in. (32.5 cm) high
Private collection

Jacques Lipchitz, *Reader in an Armchair,* 1922
Lead, 9½ in. (24.1 cm) high
Private collection

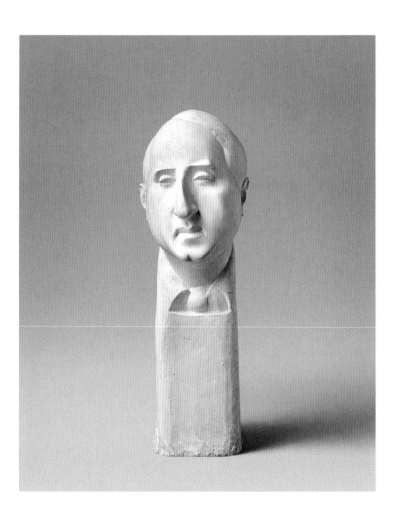

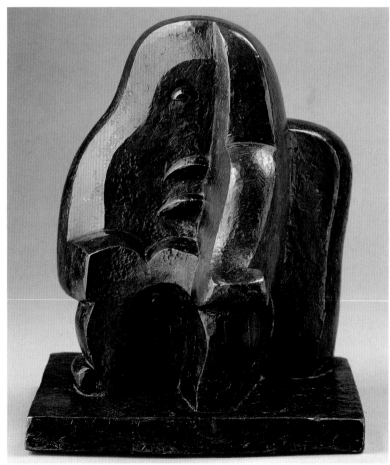

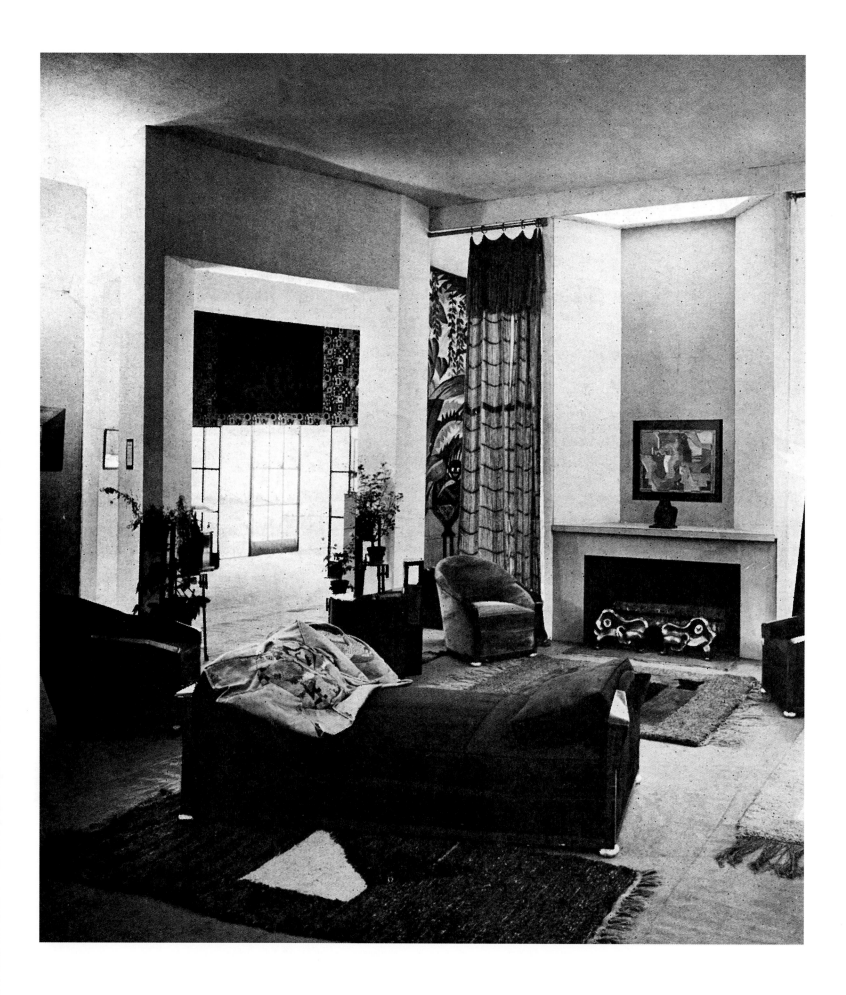

Jacques Lipchitz, *Still Life,* 1918
Polychrome stone, 14 × 18 in. (35.7 × 45.7 cm)
Musée National d'Art Moderne, Centre Pompidou, Paris
The work was owned by the Dalsaces and hung in Annie
Dalsace's petit salon in the Maison de Verre. It is similar
to a Lipchitz work that belonged to the Chareaus
(page 214).

Jacques Lipchitz, *Reclining Woman,* 1921
Bronze firedog, 13 × 18¾ × 6½ in.
(33 × 47.4 × 16.5 cm)
Private collection, through the Estate
of Jacques Lipchitz

Opposite
Chareau's work on display at the Salon d'Automne, 1924.
Seen are his armchair (MF732), couch (MP158), and
telephone table (MB152), and plant stands executed by
Louis Dalbet. The firedogs and bas-relief over the mantel
are by Jacques Lipchitz.

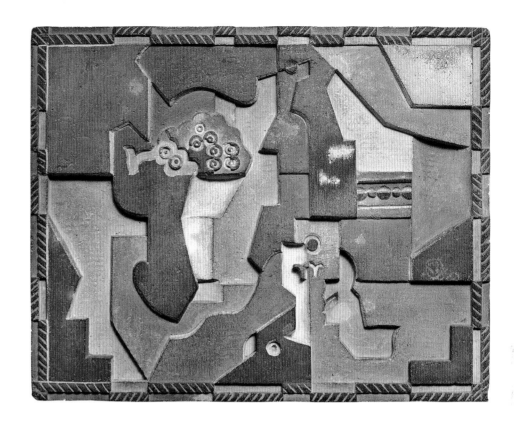

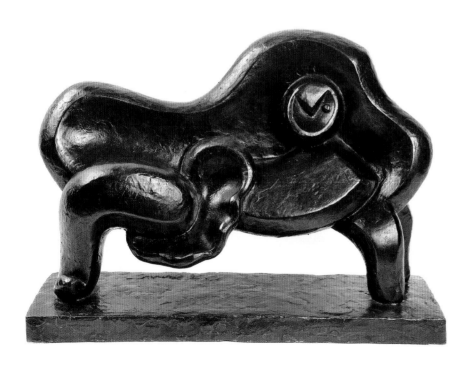

The Lanique Apartment

This Paris flat, designed in 1923 or 1924 by Chareau, displays Lipchitz's *Musical Instruments* above the fireplace. The sculpture also appears in photographs of Chareau's home, of homes whose interiors he designed, and of exhibitions, suggesting that it, like other artworks, may have been loaned or shared among a group of friends. The armchair (MF219) and mantelpiece are by Chareau; the plant stand, lighting fixtures, and shelves are by both Chareau and Louis Dalbet.

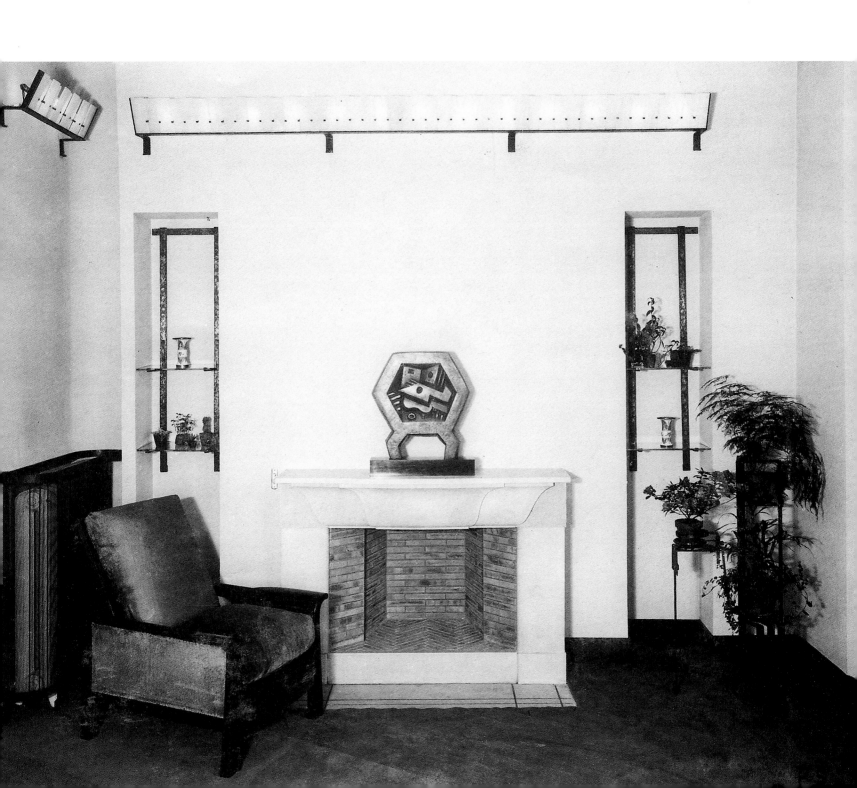

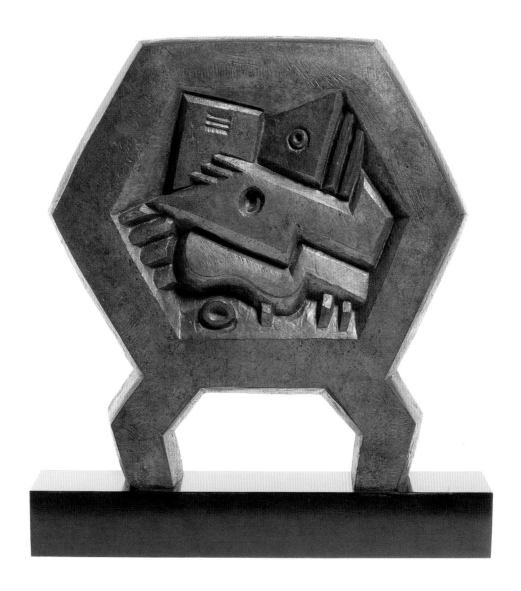

Jacques Lipchitz, *Musical Instruments (Hexagonal Shape) II*, 1923
Bronze, 19⅜ × 18⅜ × 3⅝ in.
(49.2 × 46.7 × 9.2 cm)
Musée des Arts Décoratifs, Paris

235

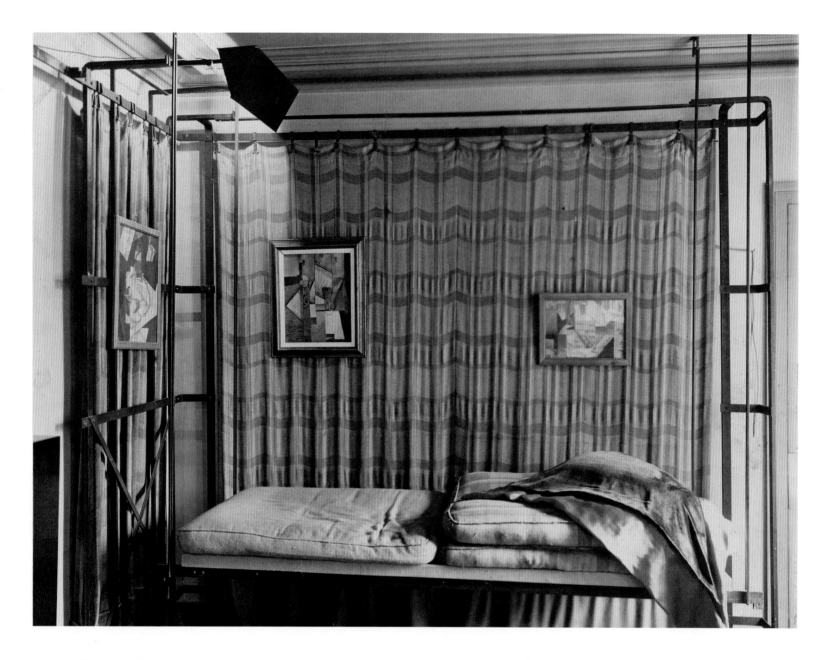

Art in Context

Chareau designed several daybeds like the one seen here—for the model French Embassy, the Villa Noailles, and the Lord and Taylor exhibition. Juan Gris's *Bowl of Fruit on a Striped Tablecloth, The Book,* and *Pen and Pipe* can be seen in this unidentified room.

Opposite

Juan Gris, *Bowl of Fruit on a Striped Tablecloth,* 1914
Paper collage, watercolor, ink, and crayon on canvas,
17¾ × 14⅝ in. (45 × 37 cm)
Frelinghuysen Morris House and Studio, Lenox,
Massachusetts

Juan Gris, *The Book,* 1913
Oil and collage paper on canvas, 16 × 13 in. (41 × 33 cm)
Musée d'Art Moderne de la Ville de Paris

Juan Gris, *Pen and Pipe,* 1913
Oil and paper on canvas, 10⅝ × 13¾ in. (27 × 35 cm)
Columbus Museum of Art, Ohio, gift of Howard D. and
Babette L. Sirak, the Donors to the Campaign for
Enduring Excellence, and the Derby Fund

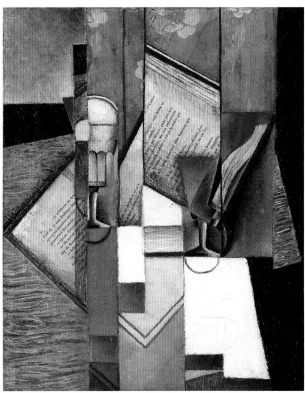

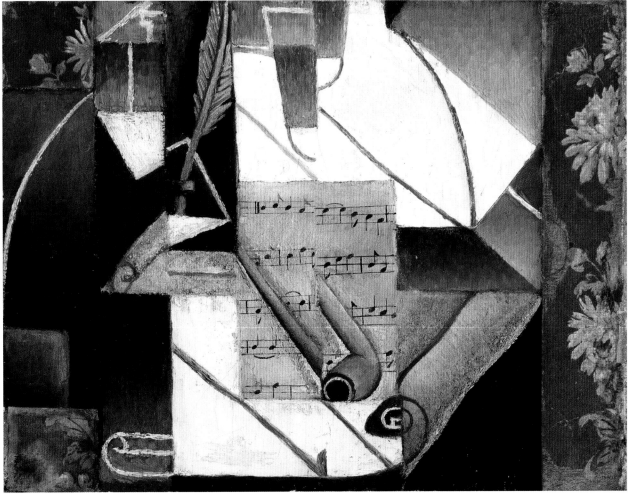

Georges Braque, *Woman with a Mandolin*, 1910
Oil on canvas, 36¼ × 28¾ in. (92 × 73 cm)
Bayerische Staatsgemäldesammlungen, Munich

Opposite
A wooden desk and chair (MD73) and an alabaster
and wrought-iron sconce, all by Chareau; Georges
Braque's painting *Woman with a Mandolin*, 1910; and
Jacques Lipchitz's sculpture *Woman with Guitar*, 1926.

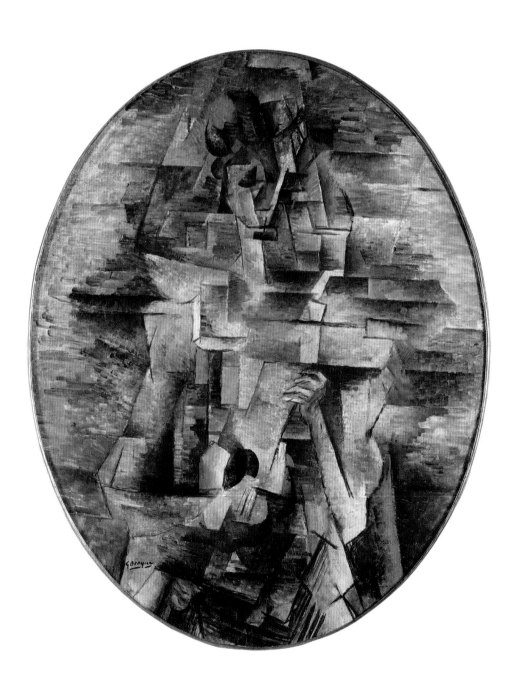

Robert Delaunay, *The Tower Behind Curtains*, 1910
Oil on canvas, 45⅝ × 38¼ in. (116 × 97 cm)
Kunstsammlung Nordrhein-Westfalen, Düsseldorf
Delaunay's theatrical view of the Eiffel Tower hangs
above a pair of sliding doors on the set of L'Herbier's
1926 film *Le Vertige,* for which Chareau and the
architect Robert Mallet-Stevens designed sets and
furniture and Robert and Sonia Terk Delaunay produced
costumes and decorations (page 72).

Marc Chagall, *The Praying Jew,* 1914
Oil on cardboard mounted on canvas,
42½ × 31½ in. (108 × 80 cm)
Kunstmuseum Basel, Sammlung Im Obersteg

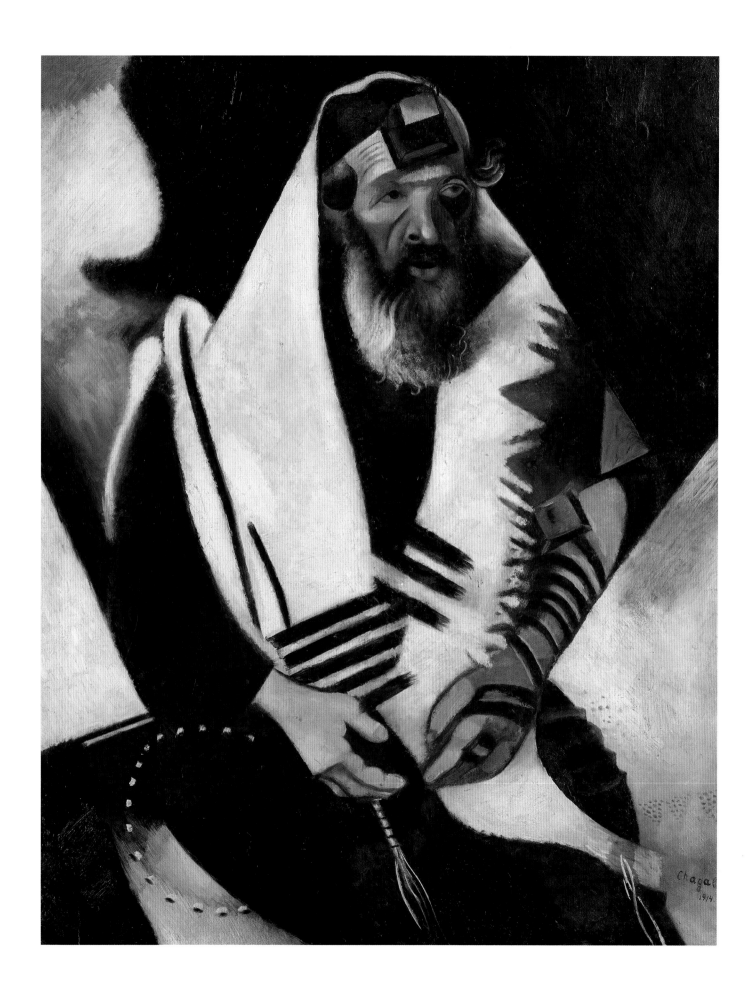

The Chareaus' New York Apartment

On the wall of the Chareaus' New York apartment in this photograph from the 1940s or 1950s are Max Ernst's painting *The Interior of the View*, and three works on paper by Jacques Lipchitz. Unable to find much work in the United States, they sold many artworks from their remarkable collection during and after World War II.

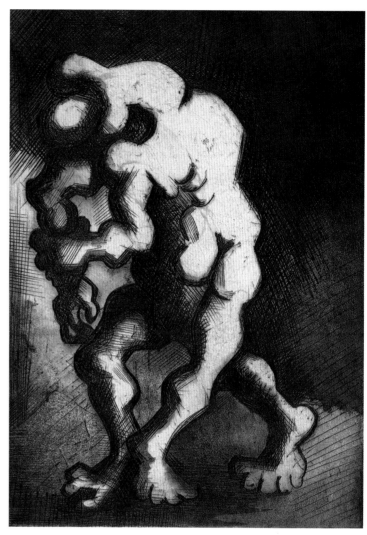

Max Ernst, *The Interior of the View*, 1922
Oil on canvas, 34 × 26 in. (86.5 × 66 cm)
Private collection

Jacques Lipchitz, *The Road to Exile*, 1945
Etching and aquatint, 13⅝ × 9⅞ in.
(34.6 × 25 cm)
Cleveland Museum of Art, John L.
Severance Fund

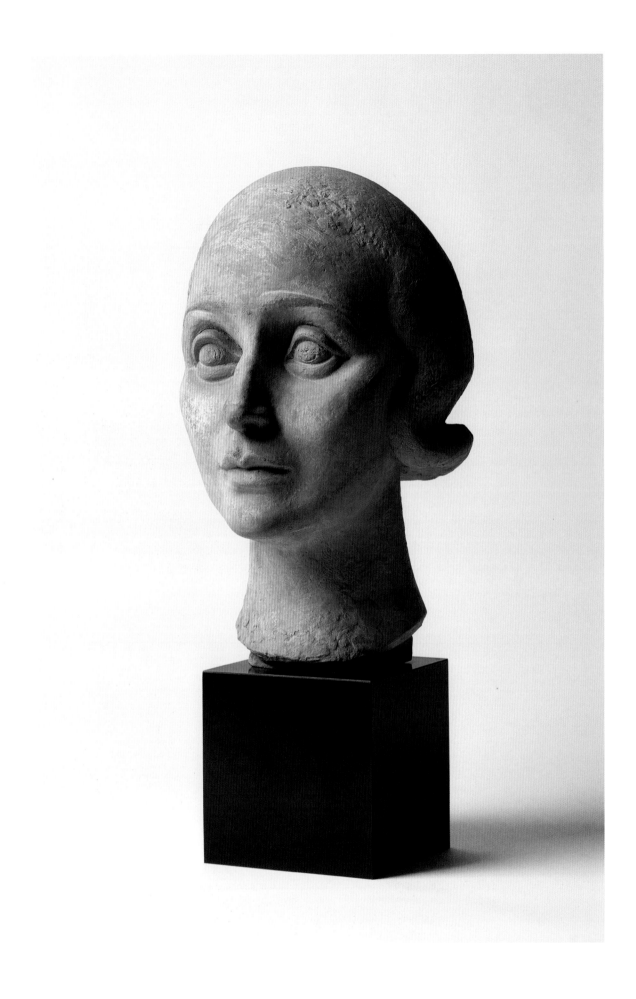

Dr. Jean Dalsace's office in the Maison de Verre,
with the bronze version of Lipchitz's portrait of his wife
on the bookcase.

Opposite
Jacques Lipchitz, *Bust of Annie (Bernheim) Dalsace,* 1925
Plaster coated with shellac, 16⅜ × 4½ × 7½ in.
(41.6 × 11.4 × 19.1 cm)
University of Arizona Museum of Art, Tucson
This is the maquette for a bronze portrait of Madame
Dalsace that presided over the office of her husband in the
Maison de Verre.

Robert Motherwell, *Personage*, 1944
Engraving, 8½ × 9 in. (21.6 × 22.9 cm)
Inscribed "Merry Xmas to Dollie + Pierre
Chareau—Bob and Maria"
Private collection

Robert Motherwell, *Pierrot's Hat*, 1943
Collage
Location unknown

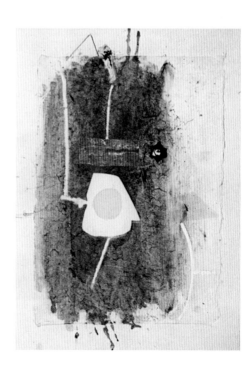

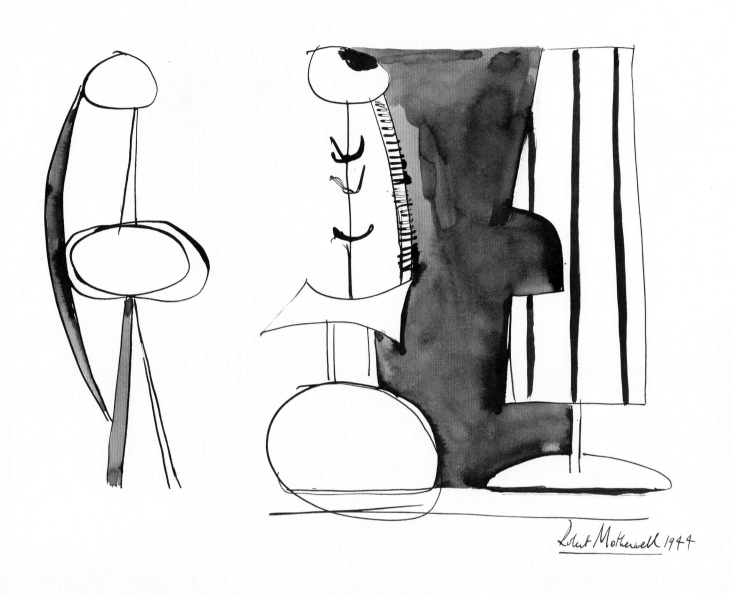

Robert Motherwell, untitled, 1944
Ink and ink wash on paper, 11⅝ × 14½ in.
(29.3 × 36.8 cm)
Private collection

delicious wa
there are no
living-dinin
balcony fro
and a bath.
ter of the c
hearth, oper

varnished h
wood. Red
circus-red,
are of oak
into cement
house nestle
corn tassels
At night, f
looks very
ously warm

Looking for Pierre: Chareau in Exile

Robert M. Rubin

Pierre Chareau fled France for America in 1940. He died in East Hampton, New York, ten years later. Archival traces of his decade of exile are frustratingly few. We know he participated in a few wartime events organized by the French enclave in New York—"Free French Week," "France Forever," "France Comes Back"—and was a speaker or otherwise a participant in symposia at cultural institutions such as the New School for Social Research and the New York Public Library. He was involved in preparations for General Charles de Gaulle's visit to New York in 1944. After the war, he designed what must have been very modest exhibitions at the French embassy in New York, among them installations on the architect Auguste Perret and the hundredth anniversary of the death of Honoré de Balzac. Although he continued to design furniture in the 1940s, very little seems to have been made (pages 168–71).[1]

His architectural work was similarly sparse, and in consequence has received relatively little attention. He designed a house and studio for the artist Robert Motherwell in East Hampton in 1947; in payment, he received the right to build his own little cottage on the premises. He designed one other built work in the United States: La Colline, in Spring Valley, New York (1950), a house for the pianist Germaine Monteux and the writer Nancy Laughlin (page 268).

Chareau and his wife, Dollie, seem to have known virtually everyone in New York's cultural circles, but there are few surviving traces where one might reasonably expect to find them. We know he had dealings with the Museum of Modern Art because he sold the museum art from his own collection as well as acting as agent for the Dalsace family (for whom he had built the Maison de Verre). The architect Philip Johnson certainly knew of him, but ignored him. While other refugee architects benefited from Johnson's networking, there is no documented contact between the museum and Chareau, other than relating to art acquisitions in which he played a role. Although Johnson had visited the Maison de Verre with Le Corbusier while it was under construction, the house was glaringly absent from Johnson's 1932 *International Exhibition of Modern Architecture* at the museum. As with the exclusion of another key French architect and rival of Le Corbusier, Robert Mallet-Stevens, from the same show, this was clearly a conscious omission.[2]

In 1943 Chareau was involved in the design and construction of the Cantine La Marseillaise, a Free French cafeteria and watering hole in Manhattan.[3] So was Alexander Calder, but no document or letter regarding their interaction is to be found in the Calder archives—which is surprising, given what a pack rat

The exterior of the Cantine La Marseillaise, New York, c. 1943–45. The facade, with its striking horizontal stripes, suggests a modernist aesthetic, but the design cannot be firmly attributed to Chareau.

Calder was. The architect Oscar Nitzchké, one of Calder's closest friends, drew and signed the plans for the Motherwell house on Chareau's behalf, since Chareau was not a licensed architect. He also helped Chareau get a small grant of $250 from the American Committee for Refugee Scholars, Writers, and Artists.[4] So Chareau and Calder are tantalizingly close from several angles, but no records of their relationship have been found.

Chareau reached outside New York architecture circles for a patron. The young painter Robert Motherwell was an active presence in the art scene of the 1940s, and had spent time before the war in Paris, absorbing its avant-garde cultures. He met Chareau during the war, and after its end invited him to serve as architecture editor of *Possibilities,* a new "occasional review," along with Motherwell himself (art), Harold Rosenberg (writing), and John Cage (music).[5] Among more extensive contributions from the other three, one finds from Chareau two pages of photographs of a 1946 church designed by Oscar Niemeyer, whose curvilinear forms evoke the Motherwell house, begun the same year. But there is no text—not even the name of the church or its location. Just this: "Oscar Niemeyer. Church. 1946. Reinforced concrete. Brazil." It is frustratingly elusive, but still a fragmentary clue as to what architecture Chareau was absorbing at the time when Motherwell approached him to design a house in the country.

The Motherwell house was a compound, made from easily found, inexpensive materials. It comprised a house, a studio, and a little cottage for Chareau himself. The house was a modified Quonset hut (a prefabricated metal structure developed by the military). Additional

materials were a found industrial greenhouse window, concrete blocks for retaining walls, and plywood. The floors were brick and (even more economical) disks sliced from oak logs, laid in poured concrete. "We wanted to use tiles," recalled Motherwell, "but I couldn't afford them." The curving metal crossbeams that supported the roof were exposed and painted bright red, evoking the vertical I-beams of the Maison de Verre. The design was an open plan, with two bedrooms and a bath off a second-floor balcony—perhaps also a nod to the Maison de Verre. The replacement of one wall with the salvaged greenhouse lent the space "a Mediterranean light." A second Quonset hut was converted into the artist's studio (pages 262–67).[6]

The cottage Chareau built for himself nearby, known as the Maison "Pièce Unique" or Petite Maison de Repos, was of concrete and terracotta block. Its modest dimensions (thirty-five by twenty-six feet) and sophisticated program anticipate Le Corbusier's Petit Cabanon of 1951, his tiny end-of-life retreat on the French Riviera, as if the concept of the "primitive hut"— so beloved of architectural theory—was in the postwar air. Le Corbusier may even have seen Chareau's cottage on one of his visits to East Hampton (page 269).

Chareau incorporated sleeping, dining, storage, and studio spaces around a central core with a wood-burning stove, bathroom, and kitchen. He combined this format with such subtle details as windows set at a slight angle, installed unframed in order to open onto the exterior, and cinder and terracotta blocks in alternating sections. Clearly, Chareau's subtlety was not extinguished, but rather stimulated, by the paltry budget.

The Motherwell house was written up in *Harper's Bazaar* in June 1948, but it was not until more than twenty years later, with the publication of the Yale architectural journal *Perspecta* 12, that Chareau's reputation in the wider architectural milieu began to be resurrected. The focus was on the Maison de Verre. The influential critic Reyner Banham went so far as to say that he might have featured it in his canonical *Theory and Design in the First Machine Age* (1960), had he been aware of it at the time of writing. Later, in *The Architecture of the Well-Tempered Environment* (1969), Banham described the house as a successful example of modern architecture, favoring it over the 1931 Aluminaire House by Le Corbusier's disciple Albert Frey.[7]

Against these hosannahs, the Motherwell house barely registered. There are several reasons for this. The Museum of Modern Art in New York was the leading tastemaker of the 1940s, and the artists of its circle were powerful. Neither the director of the architecture and design program, Philip Johnson, nor the department's

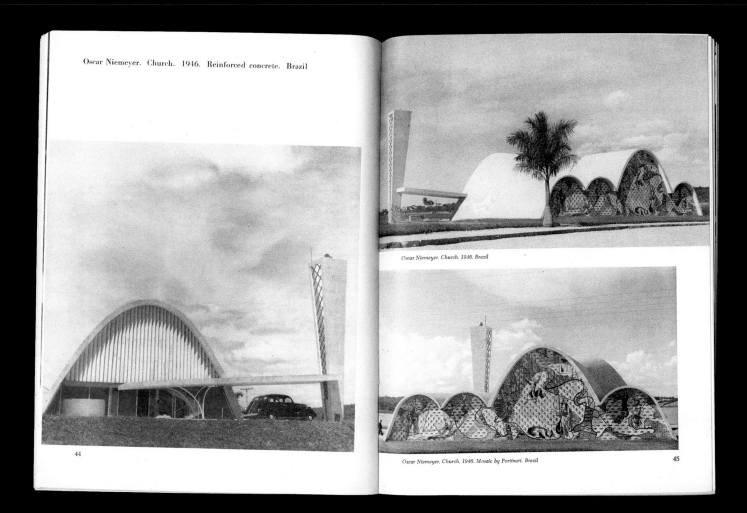

Oscar Niemeyer. Church. 1946. Reinforced concrete. Brazil

Oscar Niemeyer. Church. 1946. Brazil

Oscar Niemeyer. Church. 1946. Mosaic by Portinari. Brazil

44

45

Chareau's wordless article on Niemeyer's church, published in *Possibilities*, a short-lived journal published in 1946.

curator, the architect and critic Peter Blake, were fans of Chareau. Both Blake and Johnson were firmly in Le Corbusier's corner, and seem to have seen other French architects as rivals. Thus, Blake's later negative assessment of the house in his memoir is hardly surprising: Chareau's work was "rather uneven" and the Motherwell house was "a bit of a joke—Chareau, like other French visitors, was greatly impressed by American technology." Blake derided him for the idea that wartime Quonset or Nissen huts (which he likened to "sheet metal igloos," temporary shelter for soldiers in "inhospitable climes") were "just the thing to use in building a fairly luxurious summer house in the Hamptons." He asserted that Chareau's "exotic notions about interior finishes" were a financial burden and the reason Motherwell "never quite finished the house." Blake asserted that Chareau was among several French refugees whom Motherwell was supporting (though there is no evidence that their relationship continued beyond the architectural commission). The house, Blake concluded with a sneer, was "viewed as a landmark,

especially by those not condemned to living in it."[8]

Those French gentlemen supposedly blinded by technology had a somewhat different view of the house, as did the following generations of European architects. Jean Prouvé listed it in 1977 as one of the great landmarks of modern architecture, alongside American works by Walter Gropius, Marcel Breuer, Frank Lloyd Wright, and Ludwig Mies van der Rohe. Norman Foster and Richard Rogers visited the house while architecture students at Yale. The publisher Barney Rosset, who bought it in the winter of 1952, recalled regularly receiving architectural pilgrims and architourists of the time.[9]

It is always referred to as the Motherwell house, but it was Rosset who really took on the house for the long haul. Though not the original client, he deserves full credit for its custodianship: Motherwell occupied it for less than five years, Rosset for three decades. He took the time to deal with some of the ergonomic and climatic issues initially posed by the design and its low-budget finishes. He shingled the roof and took down a wall Motherwell had put in, because he thought it "knocked out the fireplace's usefulness" and "spoilt the craziness of the house."[10]

At the level of architectural preservation and what constitutes legitimate adaptive reuse, one can

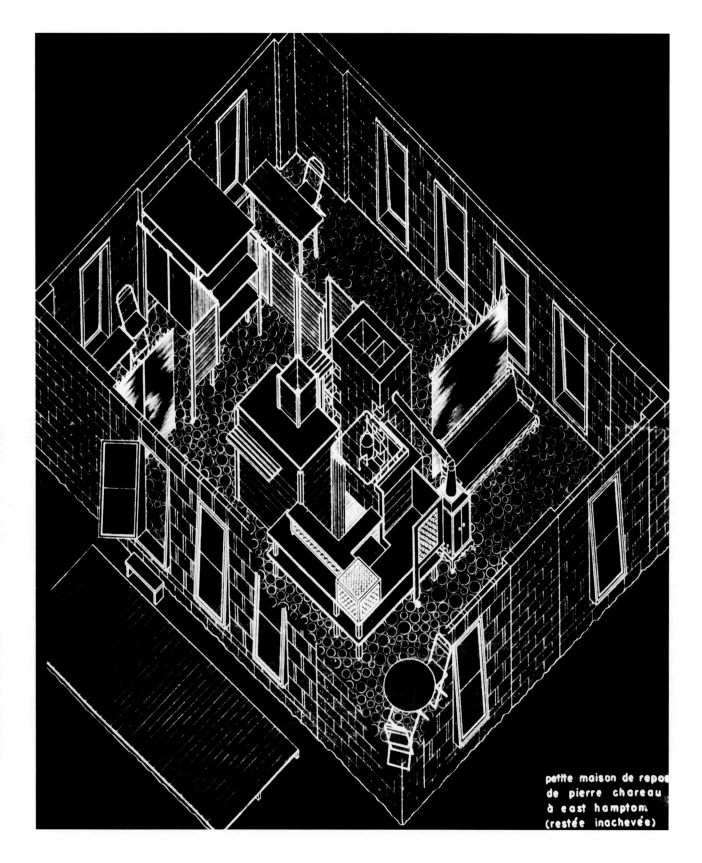

petite maison de repos
de pierre chareau
à east hamptom
(restée inachevée)

Axonometric drawing of the Maison Pièce
Unique, 1947.

The Motherwell house was covered by *Harper's Bazaar* in its June 1948 issue. The magazine referred to Chareau as "one of the foremost modern French architects."

AT NIGHT, THE LIGHTED HOUSE GLOWS LIKE A BEACON

RONNY JAQUES

ROBERT MOTHERWELL'S
QUONSET HOUSE

RIGHT, A LONG VIEW THROUGH THE
HOUSE; FAR RIGHT, THE FACADE
WITH FRONT DOOR; ABOVE IT, A FIRE
BURNS IN THE CENTERED FIREPLACE

• One hundred miles from New York, at Easthampton, Long Island, Robert Motherwell, the abstract painter, has made a home from a huge Army Quonset, in a setting of sand, scrub oak, and pine. It was designed by Pierre Chareau, builder of the revolutionary "Glass House" in Paris and one of the foremost modern French architects. The house has ends and sides of overlapping glass panes reclaimed from an ancient greenhouse; during the equinoctial storms the rains pour down the windows in a delicious waterfall. The interior is unusual: there are no partitions, only one big kitchen-living-dining room, partly shadowed by a balcony from which open two bedrooms and a bath. A chimney rises out of the center of the common room with a knee-high hearth, open on two sides. The woodwork is

STANDING, ANN MATTA, EX-WIFE OF
THE CHILEAN PAINTER; SEATED, MARIA
MOTHERWELL WITH THE MATTA TWINS

varnished hemlock; the walls, combed plywood. Red concrete floors are balanced by circus-red, curving crossbeams. The floors are of oak circlets, set like steppingstones into cement, then waxed. The rear of the house nestles close to a hill. In midsummer, corn tassels wave at the upstairs windows. At night, from without, the lighted house looks very much like an elongated, curiously warm and brilliant goldfish bowl

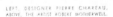

LEFT, DESIGNER PIERRE CHAREAU;
ABOVE, THE ARTIST ROBERT MOTHERWELL

Influences from the Maison de Verre can be seen in various touches throughout the Motherwell house: left, the main staircase in the Maison de Verre; opposite, the original staircase in the Motherwell house, before it was altered by Barney Rosset.

writer, and architect in the artistic enclaves of eastern Long Island was a guest or visitor at one time.[11]

Rosset sold the house in 1980 (the "stupidest single act of my life"), and it was torn down in 1985 to make way for an Adirondack-style Hamptons McMansion, despite efforts by the architectural historian Alastair Gordon and others to save it.[12]

One significant artifact of the house survives, however: Norman Mailer's idiosyncratic film *Maidstone,* shot there over five days in July 1968, with the nearby grand estate of the painter Alfonso Ossorio providing the *haute* Hamptons WASP establishment location. The film was screened at the Whitney Museum of American Art, New York, in fall 1970 and then failed commercially, but it is widely considered Mailer's most interesting and ambitious attempt at moviemaking. It is a frustrating film for a Chareau scholar to watch. There are no establishing shots of the exteriors of the main house, the studio, or Chareau's cottage. The interior of the latter, as depicted in the film, is more evocative of a sixties swingers' club than of poetic functionalism. Apart from fleeting glimpses of the original oak-and-concrete floor, there is not much grist for the researcher's mill. However, Mailer used five camera crews, and hours of unexamined outtakes survive. Perhaps some stills can be gleaned from these to fill out the visual chronology of the house started by Hans Namuth and Ronny Jaques in the Motherwell era and closed out by Alastair Gordon's haunting images of the empty house in 1985, just prior to its destruction.[13]

Setting aside architectural preservation and history, Chareau's inventiveness, even in this modest project, leads us to consider what architecture is supposed

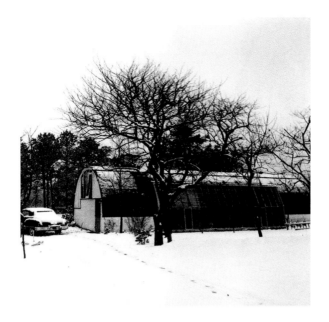

The Motherwell house in East Hampton, New York, designed by Chareau, 1947. The visual analogy between the Niemeyer design and Chareau's use of the Quonset hut is clear.

certainly question some of Rosset's interventions, but he did make the house a home. Rosset unabashedly loved it and embraced its impracticalities—it leaked and lacked insulation, among other things. As he said, he understood its "texture" and "playfulness." But the program of the compound changed significantly with his arrival. Motherwell's studio became a guest house-*cum*-studio and photo lab, with linoleum laid over the concrete floor. Rosset removed the central bath and kitchen facilities of Chareau's cottage, inserted a pool, and domed the ceiling. Perhaps owing to his reputation as a sexual libertine, this pool has often been described erroneously in oral testimonies as a hot tub.

For nearly four decades, the house was a busy intersection of diverse avant-gardes. Motherwell painted his early *Elegy to the Spanish Republic* paintings there. He recalled in an interview that Mies van der Rohe once stopped by to purchase a painting. In 1952 Willem de Kooning rented the studio for the summer. Rosset bought the property soon after he acquired the fledgling Grove Press; he was twenty-eight and dreamed of creating a compound around it for his extended publishing family. At one point he bought a tiny church, moved it to the site, and, by removing one wall, made a little theater out of it—the Evergreen Theater, named for his magazine, *Evergreen Review.* Samuel Beckett spent considerable time there, as Rosset was his American publisher. In addition to Motherwell and his friends and then Rosset's Grove Press entourage, virtually every painter,

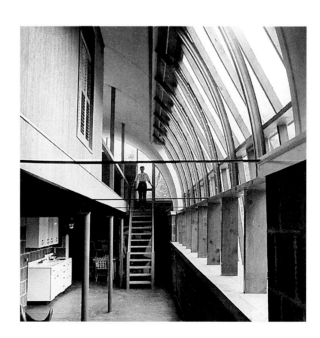

to *do,* in a broadly creative sense. It is particularly noteworthy that a man whose freestanding built structures can almost be counted on one hand created two residences that were avant-garde hothouses—live-work environments each of which is emblematic of the creative cutting edge of its time and place: interwar Paris and postwar New York.[14] In this respect, *Maidstone* crystallizes the bohemian East End scene out of which the Motherwell house emerged in much the same way that Marcel L'Herbier's 1924 film *L'Inhumaine* reflects the cultural milieu that produced the Maison de Verre. It is also a memory site of the influence on postwar American culture of refugee European avant-gardes. Motherwell (who had visited France before the war but did not meet Chareau until later) was a major conduit. So was Chareau, if a silent one. And *Maidstone*—a film about a Maileresque movie director filming a hard-core remake of Luis Buñuel's 1967 *Belle de Jour*—was likewise in the vanguard of American independent filmmaking in the era when directors in the United States were digesting European art-house cinema.[15]

Pierre Chareau was not an architect by training. He was licensed in France as an *ensemblier,* a term that literally means "one who puts things together" and that loosely translates as "interior designer." The Motherwell house is, in some sense, as much ensemble as unified concept. *Collage* is another word that comes to mind. The compound is a juxtaposition of Quonset hut, industrial greenhouse, concrete, and humble wood.[16] But Chareau's legacy—especially when the avant-garde *bouillabaisse* simmering around the Motherwell house is juxtaposed with the interwar avant-garde of Paris that gathered at the Maison de Verre—is also one of bringing together and collaging disparate iconoclastic milieus.

NOTES

1. Much of the biographical information about Chareau's years in the United States is gleaned from correspondence in the Dalsace/Vellay family archives, Paris. Where archival documents exist, they mention Chareau only in passing. (There is of course the usual rumored suitcase of what he brought from France, including plans for the Maison de Verre.) For a more detailed chronology, see Olivier Cinqualbre et al., *Pierre Chareau, Architecte: Un Art Intérieur,* exh. cat. (Paris: Centre Pompidou, 1993), 13–55; on the events named, see 31.

2. Adam Gopnik, "The Ghost of the Glass House," *New Yorker* (May 9, 1994): 54. Peter Blake discusses Chareau as being in the same circles as the Surrealists Yves Tanguy, André Masson, and André Breton, as well as knowing Piet Mondrian, Fernand Léger, and others; Peter Blake, *No Place Like Utopia: Modern Architecture and the Company We Kept* (New York: Alfred A. Knopf, 1993), 66. According to Barney Rosset, Chareau knew "a surprising number of people, considering there were no buildings!"; Leo Edelstein et al., "Interview with Barney Rosset," *Pataphysics,* Pirate Issue (2001): n.p., http://www.yanniflorence.net/pataphysicsmagazine/rosset_interview.html.

3. The Cantine La Marseillaise was established by Maria Jolas, founder of the École Bilingue and an influential translator in New York. Jolas was a critical link between American and French mid-century avant-gardes—but there is no mention of Chareau in her memoir, *Maria Jolas, Woman of Action,* ed. Mary Ann Caws (Columbia, SC: University of South Carolina Press, 2004). The Cantine was a meeting place for French refugees, artists, intellectuals, Free French sailors on leave, and others who supported the French Resistance. Jolas remembered: "Two empty Second Avenue shops" near 42nd Street "were soon turned into a gay French café; on April 17th 1943 [it] opened its doors"; ibid., 123. Extant photographs show only a glimpse of Chareau's design; the building survives, but the storefront and interior have long since been replaced. Eugène and Maria Jolas Papers, Beinecke Rare Book and Manuscript Library, Yale University, box 57, folder 1329, http://brbl-zoom.library.yale.edu/viewer/1021826.

4. Archives and Manuscripts Division, New York Public Library.

5. *Possibilities* 1 (Winter 1947–48), *Problems of Contemporary Art* series (New York: Wittenborn, Schultz, 1947). The journal published exactly one issue.

6. Robert Motherwell, quoted in Alastair Gordon, "Lost Houses, The End of an Era: Recalling Robert Motherwell's Landmark 1946 East Hampton Quonset Hut, Architecture by Pierre Chareau," *Architectural Digest* (October 2007): 134–41; and in James Brooke, "Trend-Setting Quonset Hut Is Demolished on L.I.," *New York Times* (August 3, 1985). For a detailed description and analysis of the Motherwell house, see Alastair Gordon, *Weekend Utopia: Modern Living in the Hamptons* (New York: Princeton Architectural Press, 2001), 48–53.

7. "Robert Motherwell's Quonset House," *Harper's Bazaar* (June 1948): 86–87; Kenneth Frampton, "Maison de Verre," *Perspecta: The Yale Architectural Journal* 12 (1969): 77–126; Reyner Banham, *The Architecture of the Well-Tempered Environment,* 2nd ed. (Chicago: University of Chicago Press, 1984), 163. Banham later extolled the Maison de Verre further: "This is not modern architecture as it is generally understood. . . . It's as if its architects, the French Art-Deco superstar Pierre Chareau, and the Dutch modernist Bernard Bijvoet, had invented an alternative Modernism to the one that is in all the books"; Reyner Banham, "Modern Monuments," *New Society* 78, no. 1246 (November 1986): 12–14; repr. in *A Critic Writes: Selected Essays by Reyner Banham* (Berkeley: University of California Press, 1996), 261–62.

8. Blake, *No Place Like Utopia,* 114–15. Blake, himself a German Jewish refugee from the Nazis (born Peter Blach), and nearly forty years younger than Chareau, was at the time establishing himself as a fixture in the Hamptons, where he later built a number of "fairly luxurious houses" himself. Motherwell assisted and sponsored various art projects on behalf of émigré artists. The art patron Peggy Guggenheim, who also aided refugee artists, may also have been involved, as the furnishings in the Motherwell house included pieces by Frederick Kiesler from the same series that equipped Guggenheim's Art of This Century gallery.

9. Jean Prouvé, "Influences Réciproques: Est-ce Exact?," in *Paris–New York,* exh. cat., by Pontus Hultén et al. (Paris: Musée National d'Art Moderne, Centre Pompidou, 1977; repr. 1991), 55 (Prouvé misdates the house to 1940); Norman Foster, conversation with the author, October 14, 2012.

10. Edelstein et al., "Interview with Barney Rosset." The article includes a detailed discussion by Rosset of the changes he made.

11. On Mies's visit to Motherwell, see Gordon, "Lost Houses," 140.

12. Edelstein et al., "Interview with Barney Rosset."

13. See Norman Mailer Collection, 1947–2007, Harvard Film Archive, Harvard University, Cambridge, MA, HFA items #16026, 16081, 16107, 16284, 16683, 16720, 16722, 16724, 17774, 17775, 17780, 17791, 17808, 17809, 17810, 17815, 17817, 17819, 17821, 17829, 17843, 17875, 17880, 17887, 18317, 20067. My thanks to Michael Chaiken, Mailer's cinema archivist, for this information. Namuth photographed the house in 1950; Jaques in 1948.

14. In addition to the Maison de Verre (1932) and the Motherwell house (1947), Chareau's works of architecture (as opposed to interior design) are a golf club at Beauvallon (with Bernard Bijvoet, 1927) and, nearby, the Villa Vent d'Aval, Saint-Tropez, France (1928), both commissioned by Edmond and Émile Bernheim; a weekend house for the dancer Djémil Anik outside of Paris (1937); and La Colline in Spring Valley, New York (1950). This last was a restructuring of an existing building.

15. On *L'Inhumaine* see Esther da Costa Meyer's essay in this volume; see also Richard Abel, *French Cinema: The First Wave, 1915–1929* (New York: Princeton University Press, 1984), 383–94; Prosper Hillairet, "L'Inhumaine, L'Herbier, Canudo et la Synthèse des Arts," in *Marcel L'Herbier: L'Art du Cinéma,* ed. Laurent Véray (Paris: Association Française de Recherche sur l'Histoire du Cinéma, 2007); Standish D. Lawder, "Léger, l'Herbier and l'Inhumaine," in *The Cubist Cinema* (New York: New York University Press, 1975), 99–115; Dorothee Binder, *Der Film "L'Inhumaine" und Sein Verhältnis zu Kunst und Architektur der Zwanziger Jahre* (Ph.D. diss., Ludwig Maximilian University, Munich, Germany, 2005); and Nieves Fernández Villalobos, "Mallet-Stevens, Modern Design, and French Cinema," in *Designing the French Interior: The Modern Home and Mass Media,* ed. Anca I. Lasc, Georgina Downey, and Mark Taylor (London: Bloomsbury, 2015), esp. 145.

16. As Kenneth E. Silver points out in this volume, Cubist aesthetics—particularly the drawings and collages of Picasso—were a key influence on Chareau's style. We may extend this idea: if Chareau's Maison de Verre is famous for the completeness and unity of its conception, his house for Motherwell encapsulates an equally nuanced grasp of the found element, the incongruous combination, the transformation of common materials. On this idea, see also Gordon, *Weekend Utopia,* 53.

Chareau's Other Buildings

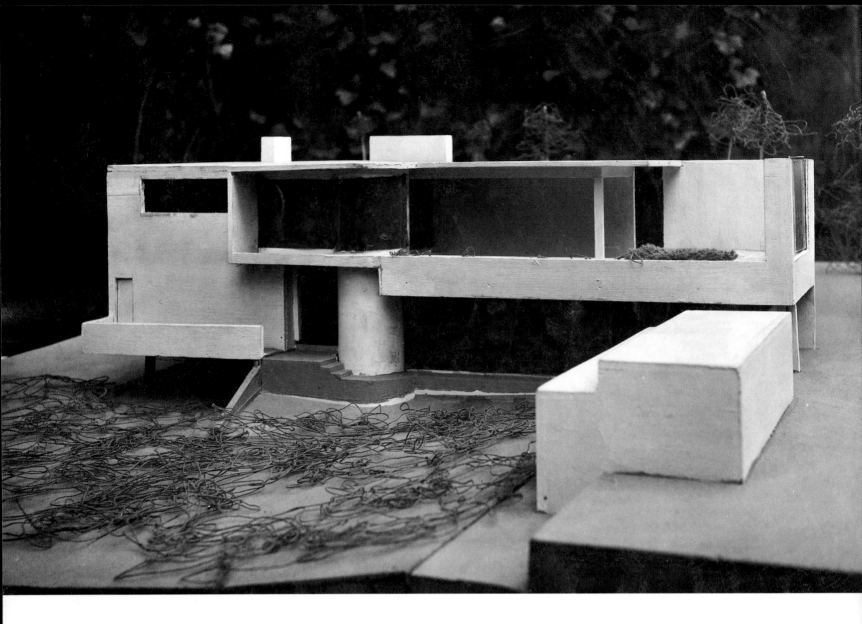

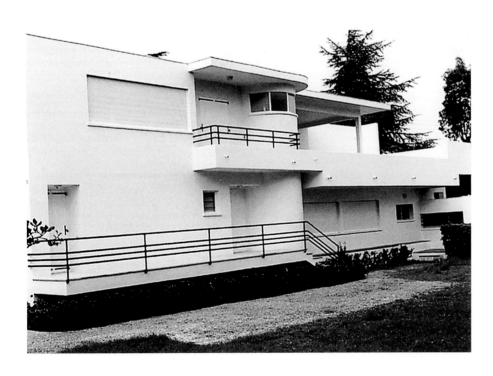

Maquette of the Vent d'Aval house
The Museum of Modern Art, New York,
Architecture and Design Study Center

Villa Vent d'Aval, Saint-Tropez, 1928.
Chareau designed this villa for Edmond
and Émile Bernheim shortly after the
Beauvallon golf clubhouse.

Clubhouse of the Hôtel de Beauvallon
golf course, near Saint-Tropez, 1927. The
clubhouse was commissioned by Edmond
and Émile Bernheim. Chareau designed it
together with Bernard Bijvoet.

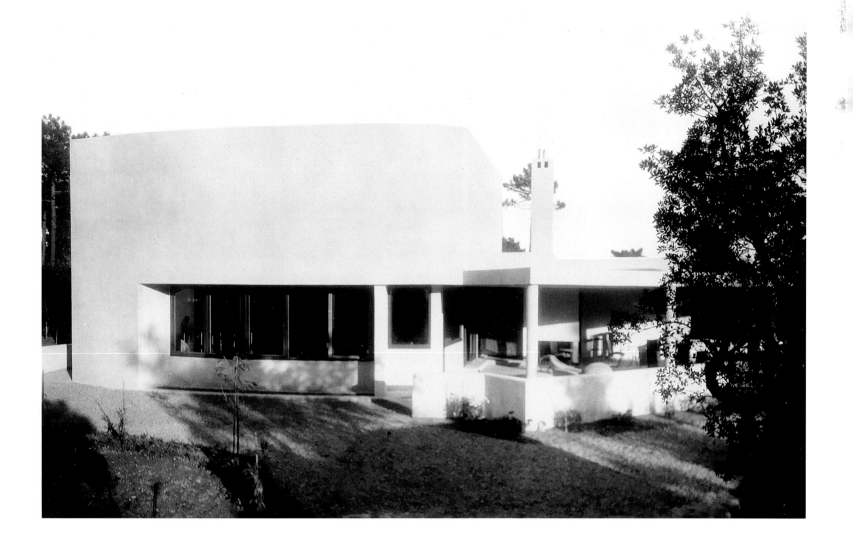

Tjinta Manis, the villa at Bazainville designed by Chareau for the dancer Djémil Anik, 1937.

The house Chareau designed for Robert Motherwell in East Hampton, New York, in 1947 was built from an existing army-surplus Quonset hut, with additions, including a glass wall made from a repurposed commercial greenhouse. Barney Rosset, who owned the house from 1952 to 1980, took numerous photographs of it, as did Alastair Gordon, who documented it shortly before its destruction in 1985.

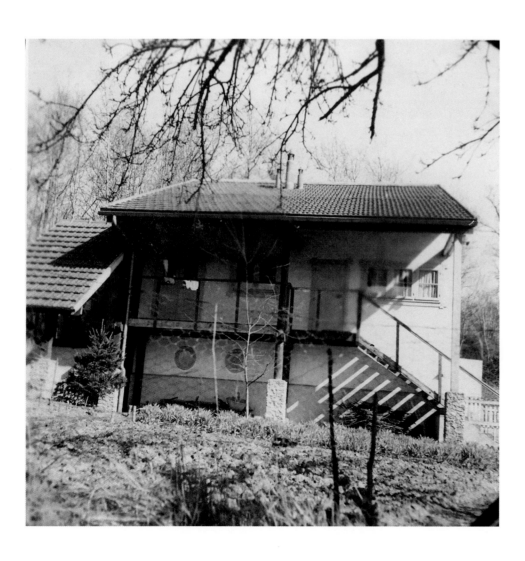

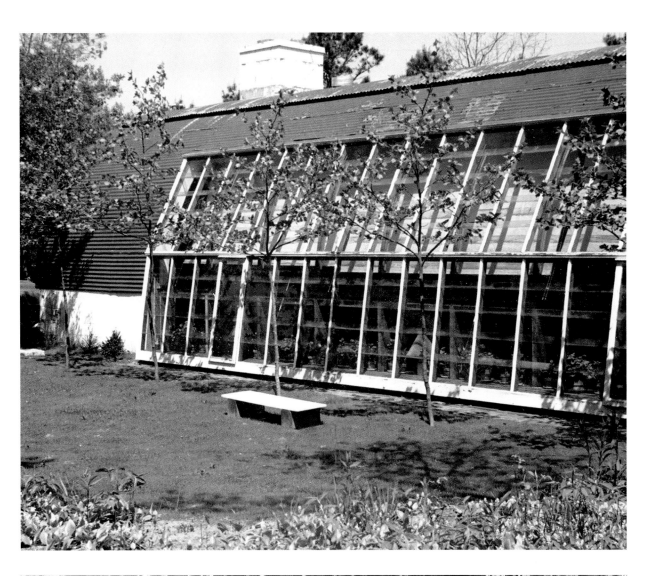

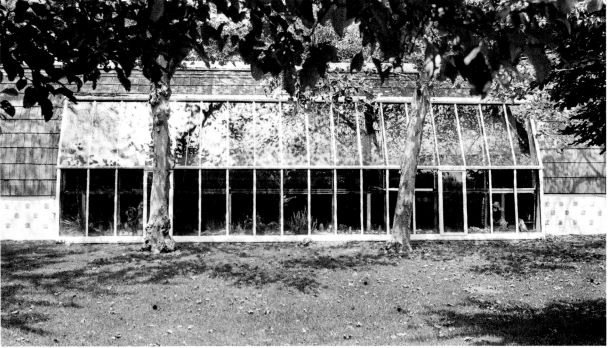

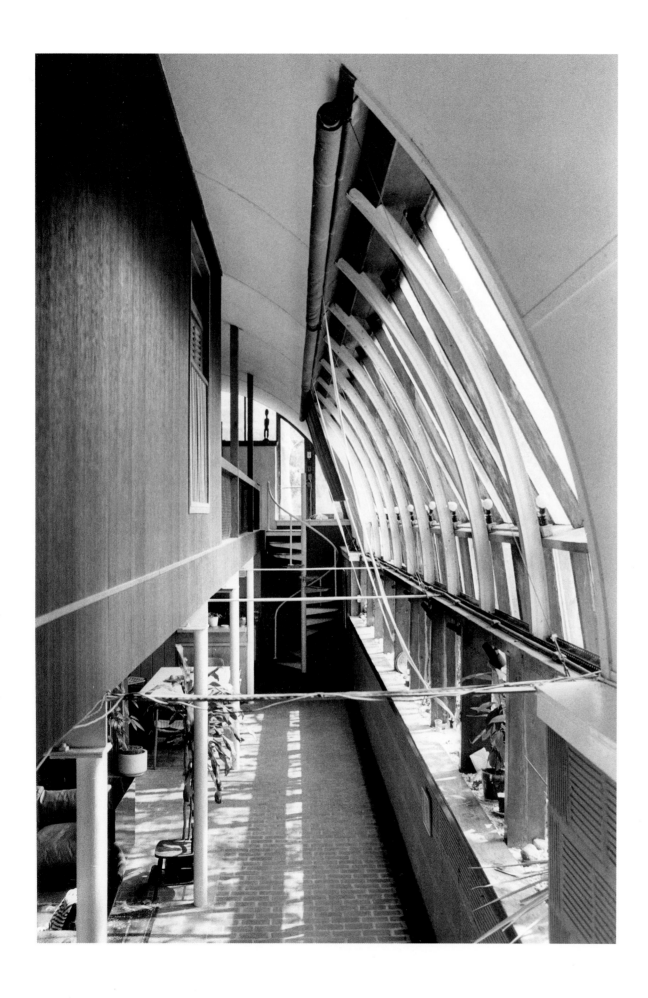

The distinctive flooring is of sliced
oak logs in concrete.

Opposite
Detail of the second-floor balcony.

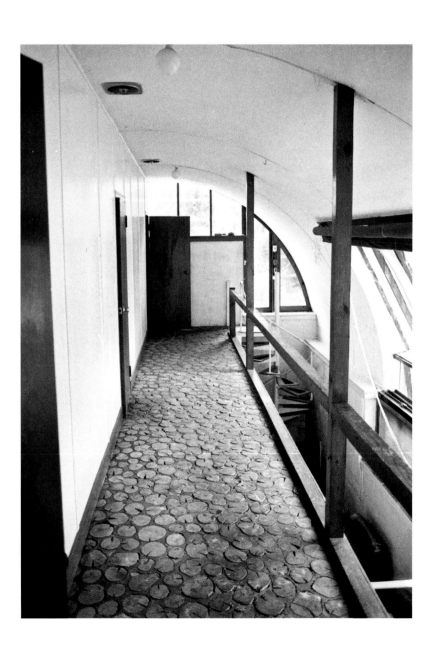

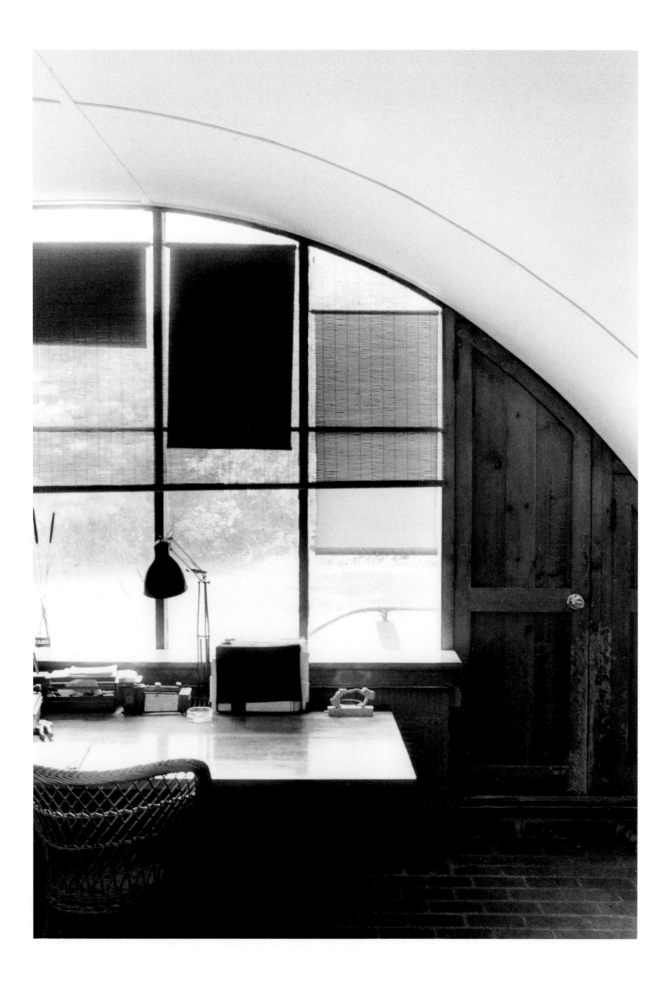

Exposed, painted crossbeams recall
the Maison de Verre.

Opposite
The short ends of the Quonset hut,
inset with windows.

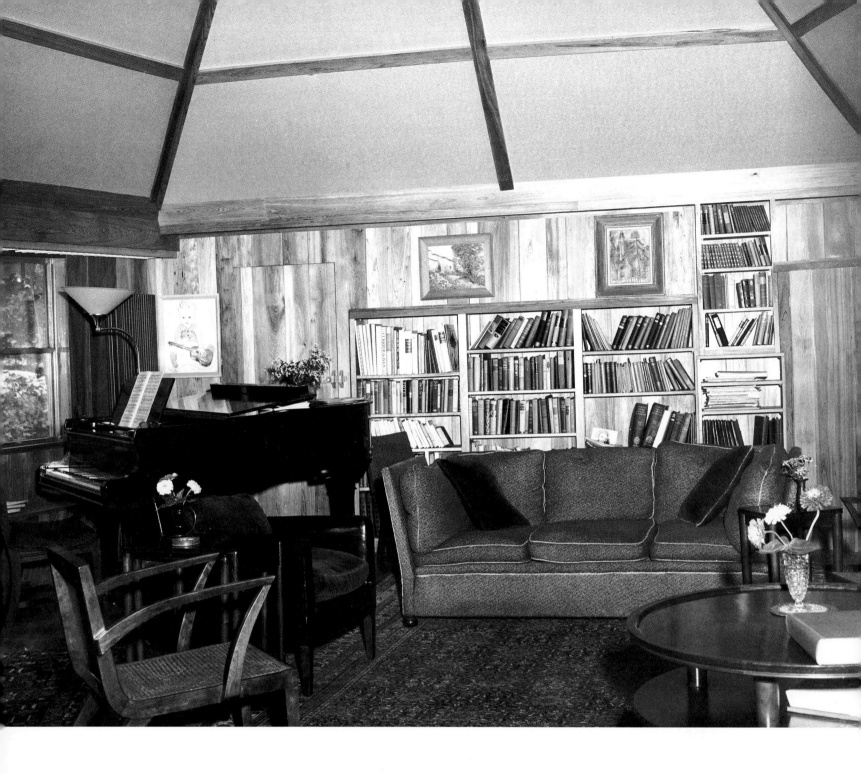

Interior of La Colline, the weekend house in Spring
Valley, New York, designed by Chareau in 1950, the
year of his death. The house is a reworking of an
existing structure. It was owned by the writer Nancy
Laughlin and the musician Germaine Monteux; the
vaulted roof controlled acoustics so that both could
work at the same time without disturbing
one another.

The placement of the fireplace, in a corner of
a square chimney of stepped brick, is a typical
Chareau touch.

The Maison Pièce Unique, Chareau's small cottage
in East Hampton, New York, on the grounds of the
Motherwell house.

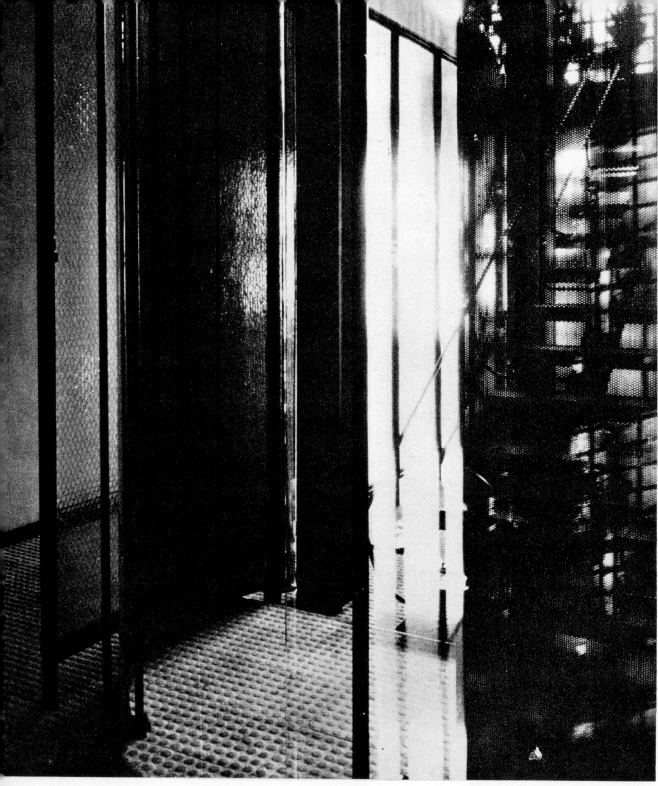

A pianterreno, la scala principale, c
sale al soggiorno, è isolata dal p
saggio per mezzo di uno scherr
semitrasparente, in parte fisso,
parte curvo e mobile, che circom
la piattaforma di partenza della s
la. Lo schermo è composto da u
parete in vetro, esterna, e da u
parete in rete metallica, interna.
disegno indica come il settore cur
dello schermo si muova, e come la
rete interna in rete metallica sia
sua volta o scorrevole o apribile ad e
ta, per graduare la visibilità e la lu

the moving mesh and glass screen of the staircase landing

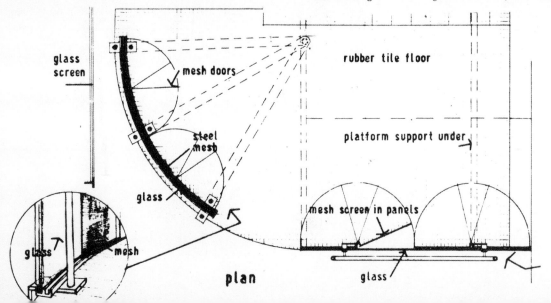

glass screen

mesh doors

rubber tile floor

steel mesh

platform support under

glass

glass mesh

mesh screen in panels

plan

glass

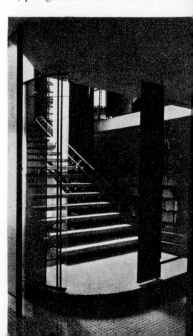

Pierre Chareau and the Networks of Modern Architecture

Jean-Louis Cohen

In 1966 the young British architect Richard Rogers published an article in the Milanese journal *Domus* on a house, built thirty-five years previously, which he described as "possibly the least known and the greatest of 20th century houses." The rather dark black-and-white photographs by Arno Hammacher lent support to Rogers's descriptions of a building ignored by the dominant architectural discourse of the time: the Maison de Verre on the Rue Saint-Guillaume in Paris. "The building," Rogers wrote, "is enclosed within a flexible envelope of translucent glass bricks with occasional glazed openings, giving privacy from the outside world while letting in a subdued but changing light. The facade is freed by cantilevering clear of the exposed steel structure. Horizontal spaces within this translucent fluid membrane are contained by movable, curved and straight screens and free-standing storage units." Rogers stressed that the house "was conceived in the workshop rather than at the drawing board," in explicit contrast to the procedures of Le Corbusier. While the buildings of the latter are "an active play of mass and solids, and are monumental in form, the Chareau house consists of a free-standing skeleton structure enclosed by an active skin, with non static screens poised in space."[1]

The main staircase in the Maison de Verre, as published in *Domus,* no. 443 (October 1966), with analysis by Richard Rogers.

This opposition between Le Corbusier and Pierre Chareau persists in contemporary architectural rhetoric. The French architect Jean Nouvel identifies his own work with the "architects linked to light"—a category that includes the thirteenth-century Gothic Sainte-Chapelle and the Maison de Verre.[2] Nouvel, the designer of the 1987 Institut du Monde Arabe in Paris, ritually invoked Chareau in his battles with the defenders of modernist orthodoxy, and references to Chareau became part of the vocabulary of the generation of Richard Rogers, despite the rather different conclusions these architects drew from them. Rogers, one of the authors of the Centre Pompidou, saw the Maison de Verre as a source for an architecture that could draw its aesthetic resources from technology left exposed. He thus grouped it with the Maison du Peuple (1939) in Clichy, by Eugène Beaudouin, Marcel Lods, and Jean Prouvé. The Dutch architect Herman Hertzberger, on the other hand, was primarily interested in the spatiality of the Maison de Verre. Writing in *L'Architecture d'Aujourd'hui* in 1984, on the occasion of the publication of Marc Vellay's monograph on Chareau, he cited antecedents far earlier than Le Corbusier. The house's exposed electrical system, he claimed, was in "the spirit of [Victor] Horta. Here you see the true functionality, arising from Art Nouveau. But also the spatiality of the house becomes less amazing once you've been inside the big houses designed by Horta. There, too, you already find, as a

concept, the principle of the continuous, articulated space, which can be expanded or contracted at will by means of adjustable elements, and in which there are no corridors, halls or stairways."[3]

In short, Chareau is drawn upstream in time toward Art Nouveau and downstream toward the proponents of high-tech strategies, and also inscribed within the modern movement itself, in opposition to the architecture of Le Corbusier. In fact, his own approach was extraordinarily elastic, without allegiance to any particular coterie within modernism. This should be no surprise; he was prudently ecumenical in his views on style. As his friend Francis Jourdain wrote, he was "*nuancé* to such a degree that he was at times disconcerting."[4] Chareau's own statements confirm this observation. In a lecture in 1925, addressing a feminine Parisian audience, he eschewed radicalism and the nihilistic tendency in modernism, affirming that "we cannot destroy what came before us." "In my opinion," he declared, "the modern movement is but a perceptible moment in a continuous creative process, whose origins can be traced back to the oldest forms of human knowledge. . . . I have essentially compared an architectural organism to a living being, one that is born and develops, that can give life as well as die, and evolve, all within a world that defines it."[5]

Chareau was no solitary individual, working in isolation. He was actively involved in setting up some of the most important networks of modern architecture. He maintained links to the writer, gallerist, and publisher Christian Zervos, who in 1924 issued the first serious analysis of his work, written by Edmond Fleg, a critic later known for his writings on Jewish identity and culture. Chareau was closely connected with the editor of *L'Architecture Vivante,* Jean Badovici, and he served on the editorial board of *L'Architecture d'Aujourd'hui,* founded by André Bloc in 1930—a governing body whose role was largely honorary. He was a member, too, of the Société des Artistes Décorateurs, and contributed a memorable design for a library and study to the group's presentation of a model French embassy at the Exposition Internationale des Arts Décoratifs et Industriels Modernes in 1925 (page 51). Starting in 1930, he took part in the Parisian exhibitions of the Union des

The participants in the first International Congress for Modern Architecture (CIAM), La Sarraz, Switzerland, June 1928. Chareau is standing second from left.

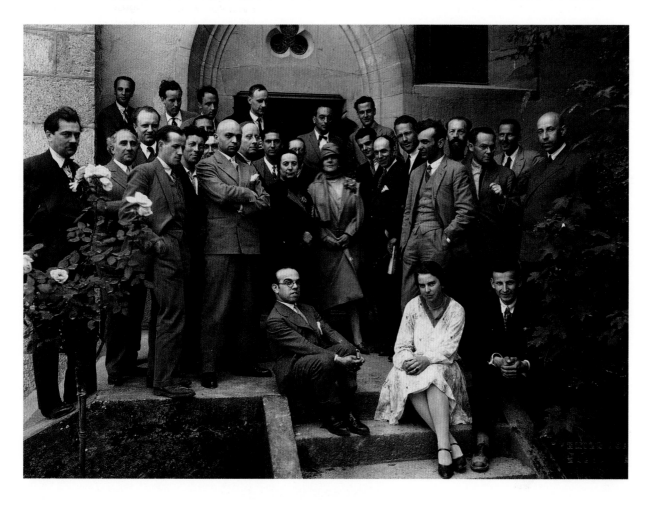

Artistes Modernes, which was both more radical than the Société and more pluralistic in its discourse—a point of view that came to be more clearly defined after 1934 through the manifesto "For Modern Art, the Framework of Contemporary Life," drafted by the journalist Louis Chéronnet.[6]

Most important, Chareau played an active role in the founding of CIAM, the International Congresses for Modern Architecture, the main network of modern architects and planners. He was invited to the first gathering, at La Sarraz, near Lausanne, in 1928, by the Persian architect Gabriel Guévrékian as part of the small Parisian contingent, along with Le Corbusier, Pierre Jeanneret, and André Lurçat. He remained relatively quiet during the debates that attended this meeting, and that were marked by clashes between the German Ernst May, the Swiss architect Hannes Meyer, and Le Corbusier. Along with that of the other participants, Chareau's handwriting was analyzed by the art critic and graphologist from Geneva, Gustave-Édouard Magnat, who described him as a "very astute individual who refuses to acknowledge it." He was subsequently considered as a potential member of the French CIAM group's board, and Le Corbusier proposed in 1929 that he be given the position of archivist. But the rival faction, dominated by Lurçat, attempted to marginalize Chareau, as is evident in a letter by Lurçat's assistant, Oscar Stonorov, which was hostile to "these gentlemen"— meaning Chareau, Georges Djo-Bourgeois, and Robert Mallet-Stevens. In the end, Chareau was not present at the subsequent meeting of September 1930, in which Guévrékian assumed temporary management of the group. He did, however, take part in the legendary maritime journey to Greece organized in July 1933 on the occasion of the fourth CIAM Congress.[7]

Chareau's reticence toward the CIAM did not prevent the functionalists from praising the Maison de Verre at the beginning of the 1930s. Without a doubt, the most eloquent analysis came from Johannes Duiker, the former partner of the Dutch architect Bernard Bijvoet.[8] It opened with the observation that the house did not conform to CIAM prescriptions on minimal dwelling. Nor did it employ the opposite extreme: fetishism of precious materials. Rather, it deserved praise for its spirit of "avant-garde experimentation." Duiker found this quality in the "spatial interpenetrations," which according to him recalled the analyses of Sigfried Giedion and László Moholy-Nagy; he compared them as well to some smaller projects by Le Corbusier and Gerrit Rietveld. For Duiker, the metal structure of the Maison de Verre made these comparisons possible. In a building that escaped the "anxious expectations of beauty"

The fourth CIAM meeting took place in 1933 on board the SS *Patris II,* as it sailed from Marseilles to Athens; the trip was filmed by László Moholy-Nagy; Chareau is seen at left.

of the earlier works, he saw not only the promise of a "scientific" architecture but also a set of issues that could be transposed to minimal dwelling, all the while underscoring the paradox that this particular house was built thanks to the "thick wallet" of the client.[9]

Paul Nelson, a disciple of Auguste Perret and an architect committed to technological and typological experimentation, saw the Maison de Verre as a "machine that augments the sensation of living," in which a fourth dimension is revealed through the "contrast between the dynamic and the static." Rather than restricting his analysis to purely architectural considerations, Nelson considered the house within other contextual fields: for one thing, it was "not immobile. It is not photographic, but is cinematographic instead." In addition, as he noted, "simply in terms of its technical research, the house is well ahead of Surrealist sculpture. [Alexander] Calder and [Alberto] Giacometti could consider it as working out their ideas."[10]

In the pages of *L'Architecture d'Aujourd'hui,* Nelson's suggestions are framed by two analyses taking opposing positions. Pierre Vago, Perret's agent at the journal, expressed the most virulent criticisms of the house:

> Is it absolutely necessary, in order to be men of the twentieth century, to spend one's days—one's time for leisure and repose—in a glass box, in the middle of scattered metal columns with exposed rivets, in a laboratory open on all sides, under the watchful eye of a nurse (servant, or secretary) observing us from her glass cage; to obtain one's roast from a suspended wagon, to gain access

**Nieuws over
het congres
in Athene.**

OPBOUW

14-DAAGSCH TIJDSCHRIFT VAN DE VER. ARCHITECTEN-KERN „DE 8" AMSTERDAM EN „OPBOUW" ROTTERDAM

OPGENOMEN IN BOUW EN TECHNIEK

REDACTIE-ADRES: SECRETARIAAT VEREENIGING ARCHITECTENKERN „DE 8" KEIZERS-GRACHT 574, AMSTERDAM C., TEL. 36605. ADMINISTRATIE: GELDERSCHEKADE 86, AMSTERDAM C., TEL. 48568. ABONNEMENTSPRIJS F 6,- PER JAAR. LOSSE NUM-MERS F. 0.30. ADVERTENTIES F 0.40 PER REGEL. BIJ CONTRACT SPECIAAL TARIEF

4e JAARGANG

2 SEPT.
1933

No. 18

Paul Nelson, "La Maison de la Rue St-Guillaume,"
L'Architecture d'Aujourd'hui 4, no. 9 (November–
December 1933): 9.

Opposite
Cover of *De 8 en Opbouw* 4, no. 18 (September 2,
1933), featuring the Maison de Verre.

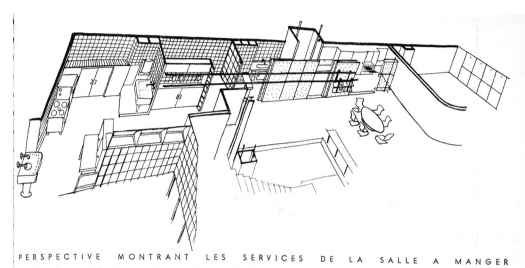

PERSPECTIVE MONTRANT LES SERVICES DE LA SALLE A MANGER

La table pour les repas est desservie par une charette suspendue à deux rails. Elle a la forme d'une lunette et ouvre automatiquement, en passant, les deux portes entre la grande salle et la cuisine, elles se referment automatiquement. Ces portes basculantes sont construites d'une manière spéciale, qui assure une étanchéité absolue et empêche les odeurs de cuisine de pénétrer dans la grande salle. Dans son trajet, la charrette passe par les armoires du petit couloir de service, dont les cloisons coulissantes s'ouvrent vers la grande salle, la laverie des verres, l'armoire pour la vaisselle et s'arrête au bac à laver. Outre ce transport, le dessin démontre nettement le jeu des espaces dans la maison.

LA MAISON DE LA RUE ST-GUILLAUME

L'époque actuelle a créé une vie aux sensibilités et aux réflexes neufs. Mais l'architecture n'a pas encore évolué assez pour pouvoir l'exprimer; car elle ne peut l'être uniquement par un détail, par une façade, par de la quincaillerie, par l'emploi de certains matériaux, ni par les formules: fenêtre horizontale ou fenêtre verticale. Et il est décourageant d'assister à cette application décorative du « moderne » transformé en mode pour habiller les plus pompiers des pompiers, et de voir ces bâtiments dits « purs » qui, tels une affiche, n'ont rien à voir avec le produit annoncé. Il y a autre chose à faire dans l'architecture contemporaine — peut-être avec moins d'éclat — mais où la sensibilité philosophique de l'architecte permettra d'établir le programme spirituel et physique de cette vie nouvelle, et de l'exprimer en plan; et où la connaissance technique de la construction permettra de réaliser ce plan pour qu'il fonctionne. Un médecin parisien a permis à Chareau d'en donner une preuve.

La démultiplication est la caractéristique essentielle de cette vie nouvelle. Depuis le moyen direct de la bicyclette qui a fixé une époque, l'homme a poussé la démultiplication de ses forces par des moyens mécaniques: téléphone, télégraphe, automobile, conquêtes des deux dimensions; jusqu'à l'avion, la T. S. F., la télévision, conquêtes des trois dimensions. La maison doit donc être une machine qui démultiplie la sensation de la vie. L'homme d'aujourd'hui connaît l'espace et plus encore le mouvement dans l'espace. Ce n'est plus une étude en plan et en coupe qui permettra à l'architecte de satisfaire ses exigences, mais la 4ème dimension, le temps, intervient. Il faut créer des espaces à parcourir dans un laps de temps relatif. Il faut sentir la 4ème dimension. Cette maison de la rue Saint-Guillaume excite cette sensation.

Il faut d'abord commencer par limiter l'espace pour pouvoir le créer. (La fenêtre, ou le mur transparent, est au fond une liaison directe avec l'extérieur et détruit l'impression de l'espace. Elle doit donc être employée avec beaucoup de discrétion, là où il existe une fonction définie). Il s'agit maintenant de faire valoir dans cet espace, limité par des dalles de verre translucide, la 4ème dimension par le contraste du dynamisme avec la statique. La statique dans l'architecture c'est l'ossature portant ce

qui est ou devrait être éternel, immobile. Complètement indépendant de celle-ci est le dynamisme exprimé par la distribution horizontale et verticale, par les cloisons fixes et mobiles, par les meubles limitatifs, par les escaliers, etc... Les colonnes sont des bornes placées régulièrement qui mesurent l'étape parcourue irrégulièrement à travers les distributions de fonctions.

La maison de Chareau n'est pas immobile, elle n'est pas photographique, elle est cinématographique. Il faut parcourir des espaces pour l'apprécier — autre point de liaison avec l'homme d'aujourd'hui.

En entrant dans cette maison on ressent d'abord une étrange impression de transplantation dans une autre planète. On s'habitue, on comprend, on a envie de l'habiter, d'y pénétrer intégralement, de la vivre.

Elle est construite. Elle fonctionne. Elle n'est pas seulement basée sur des idées directrices abstraites, mais ça marche. Les murs tiennent; les portes coulissantes coulissent; il n'y a pas de fuite. L'air conditionné fonctionne. On ne crève pas de froid ni de chaud, paraît-il. Elle est réalisée.

Cette maison est un point de départ sérieux. On y a attaqué des problèmes techniquement, et on les a résolus courageusement jusqu'aux moindres détails. La recherche purement esthétique n'en a pas été le but; mais il est curieux de constater que, uniquement par la recherche technique, cette maison a devancé la sculpture sur-réaliste. Calder et Giacometti pourraient y voir des réalisations. La porte pivotante suspendue devant le grand escalier est une sculpture sur-réaliste de toute beauté. Les armoires en métal en sont d'autres. Cela sans avoir voulu faire de « l'art pour l'art ».

« L'architecture moderne » se meurt. Elle est devenue un romantisme, un sentimentalisme mieux exprimés en littérature ou en musique. Maintenant vient l'architecture technologique, l'architecture de réalisation intégrale limitée aux exigences de la nouvelle vie, et aux connaissances réelles de la construction. Chareau a su le limiter; c'est pour cela qu'il a fait une belle chose, qui marque un point de départ vers une vraie architecture.
Paul NELSON.

to one's bedroom by means of a mobile ladder, and to experience the light of day through a plane of glass bricks that make the bluest of skies, the most glorious weather, appear dull and gray?"[11]

Vago invites the creator of this "plaything developed with love and intelligence by a superior talent" to renounce such "rigorous and abstract pseudo-philosophy" and "arid intellectualism." Although Perret seems to have been the driving force behind this critique, Chareau apparently bore him no grudge, and in spring 1950 installed an exhibition of Perret's work on the premises of the French cultural services on Fifth Avenue in New York.[12]

The third analysis was written by Julius Posener, under his frequent pseudonym, Julien Lepage. Posener was a young Jewish architect from Berlin and a disciple of Hans Poelzig, who had fled to Paris in the face of Nazi persecution, and was a ferocious critic of Walter Gropius's functionalism. He saw the Maison de Verre as an alternative to this excessively rigid design strategy, and made note of the qualities that are not conveyed in photographs: "the space, which develops constantly, which changes with the visitor's every step, and the details that make this space come to life" and stimulate the inhabitants. "One notices everywhere the same concern for rendering a function visible, to express the possibilities of function as far as possible, not only in the service of the real needs of the owner, but even to anticipate possible needs, or even to address and to satisfy in advance through some refined mechanism, new desires that the proprietor is not yet aware of." If the furnishings "express all the appeal of beautiful human tools"—also described as "amiable tools"—Posener saw "no cult of the machine" within the house. Indeed, Chareau succeeded in "creating an intimate character that is free and accommodating in the bedrooms, that is official and restrained in the waiting room for the patients, precise and scientific in the treatment rooms, as well as soft and feminine in the elevated boudoir with its view onto the garden."[13] He concluded that the "epoch of utopianism in architecture is now closed," a position that he was to develop in subsequent articles and in the texts he published after 1945 as a historian of architecture in London and, later, Berlin.[14]

Compared to the powerful sense of engagement that Johannes Duiker and the Parisians expressed in their evaluations of the Maison de Verre, reactions in Europe as a whole were curiously lacking, even though the theme of glass architecture had been broadly discussed, for example in *Glas im Bau und als*

Gebrauchsgegenstand by Arthur Korn, published in 1929, and in Sergei Eisenstein's unrealized project for a film entitled *Glass House,* which the director pursued from the mid-1920s until the early 1930s. A brief article did appear in *Wasmuths Monatshefte für Baukunst* in 1931, but this consisted merely of a recitation of the basic facts about the project and its construction. Other readings and interpretations of the Maison de Verre were limited to purely technical considerations, even as far away as Moscow, where it appeared in 1936 in the pages of *Architecture Abroad,* a journal still pleading for modernism in Stalin's Moscow.[15] Interestingly, when the French journal *Techniques et Architecture,* which in 1941 replaced *L'Architecture d'Aujourd'hui* (suspended by its owner under the threat of the Vichy government's anti-Semitic laws), published a special issue on glass in early 1944, it conspicuously omitted Chareau's building.[16]

This general lack of interest did not keep Chareau's work from having an effect on his Parisian contemporaries. In an homage paid by vice to virtue, Michel Roux-Spitz, who excelled at updating the methods of the École des Beaux-Arts, in 1932–33 encased the mute and peaceful storage units for periodicals belonging to the Bibliothèque Nationale in Versailles within a facade of glass brick and concrete. Le Corbusier, who we know frequently visited the Maison de Verre construction site on his way to his atelier, took an essentially fetishistic approach when he set panels of translucent glass

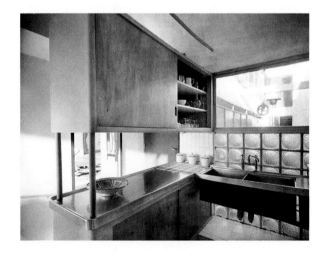

Glass Nevada bricks seen from inside Le Corbusier's kitchen, designed by Charlotte Perriand, in his apartment on Rue Nungesser et Coli, Paris.

The apartment house, Rue Nungesser et Coli, Paris, designed by Le Corbusier and Pierre Jeanneret, 1931–34.

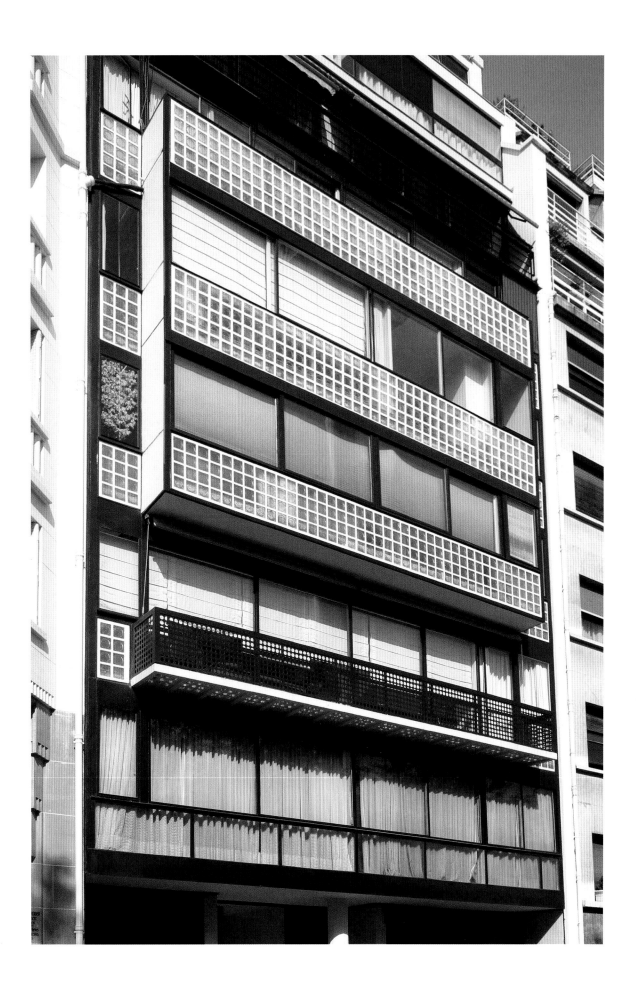

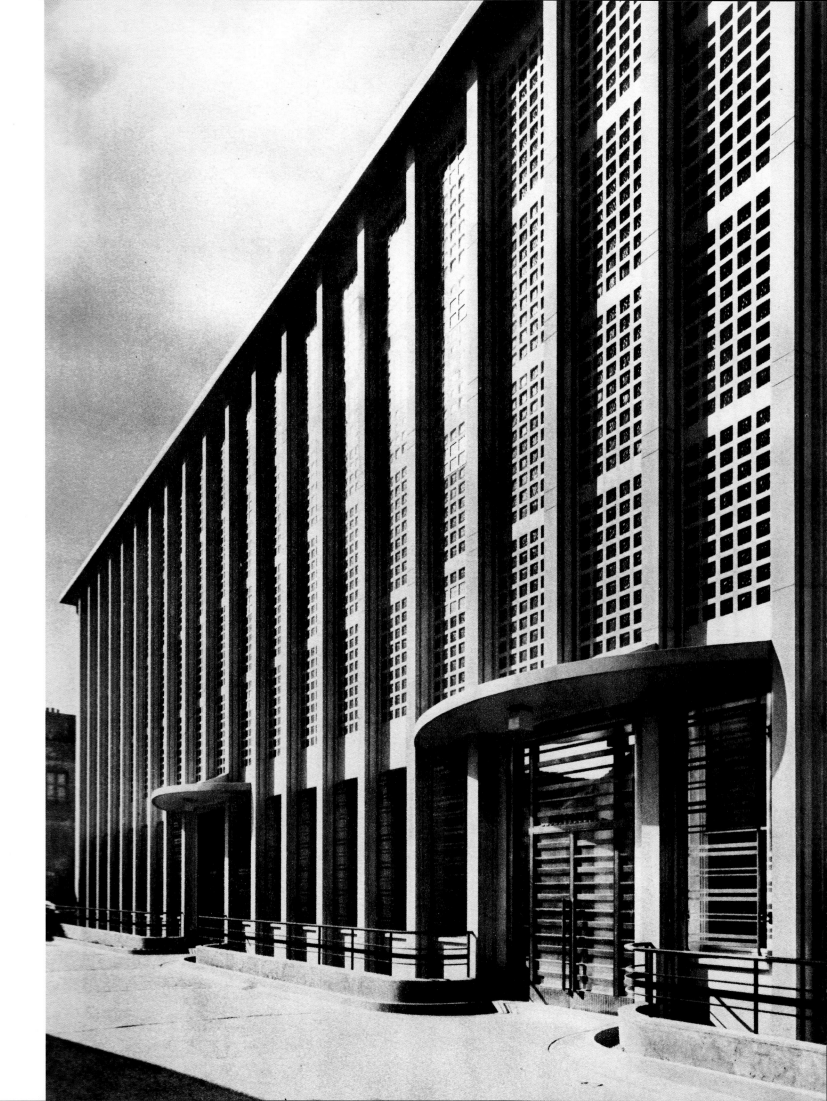

Jean Bossu's glass booth, reproduced in *L'Architecture
d'Aujourd'hui* 2, no. 9 (December 1931–January 1932): 9.

Maquette for a building with a glazed facade,
designed by Jean Bossu, 1931.

Opposite
Periodical storage for the Bibliothèque Nationale,
Versailles, designed by Michel Roux-Spitz,
1932–33, reproduced
in Michel Roux-Spitz, *Réalisations,* vol. 2, *1932–1939*
(Paris: Vincent, Fréal et Cie, n.d. [1959]), pl. 16.

Nevada bricks—panels that seemed to have escaped from the Maison de Verre—into the facade of the apartment building that he built and where he lived on the Rue Nungesser et Coli.

But the most fecund impact was on the youngest architects. Jean Bossu, a draftsman for Le Corbusier at the time, presented a project for an apartment building with a glazed facade at the 1931 Salon d'Automne in Paris. It was, in Raymond Fischer's unsparing description, "a booth inspired by the Maison de Verre of Pierre Chareau. . . . It shows a modular unit for a house which would employ a maximum amount of glass. The walls are of translucent glass. The floors are glass, the tables and chairs are of the same material. It is certainly an abuse of this material, but the exhibitor is still young and full of enthusiasm. He has tried to transpose absolute theories into practice." Bossu subsequently developed an exacting and original body of work.[17] As for the Maison de Verre enthusiast Paul Nelson, he extended his critical reflections in the Maison Suspendue (Suspended House), an unbuilt theoretical project that he developed between 1936 and 1938. In this attempt to go beyond Chareau's building, and freed from the logistical constraints of its enclosed Parisian site, Nelson inserted a sculpture by Calder, as if to embody the thesis he had advanced when he had visited the Rue Saint-Guillaume.[18]

Maison Suspendue (Suspended House), designed by Paul Nelson, 1936–38. View of the second model with a miniature sculpture by Alexander Calder. Museum of Modern Art, New York, gift of the Advisory Committee

NOTES

1. Richard Rogers, "Parigi 1930: La 'Casa di Vetro' di Pierre Chareau: Una Rivoluzione Che Non Continua," *Domus,* no. 443 (October 1966): 8.

2. Jean Nouvel, quoted by Julie Benhamou-Huet, "Jean Nouvel, l'Architecture en Grand," *Les Échos* (November 10, 2011).

3. Herman Hertzberger, "L'Espace de la Maison de Verre," *L'Architecture d'Aujourd'hui,* no. 236 (December 1984): 88.

4. Francis Jourdain, preface to René Herbst, *Un Inventeur: L'Architecte Pierre Chareau,* trans. Dollie Chareau (Paris: Éditions du Salon des Arts Ménagers, 1954), 6.

5. Pierre Chareau, "L'Architecture Intérieure," *Conferencia* 20, no. 23 (November 15, 1926): 538. The lecture transcribed here took place on March 18, 1925.

6. Arlette Barré-Desponds, *Union des Artistes Modernes* (Paris: Éditions du Regard, 1987); Chantal Bizot, Yvonne Brunhammer, and Suzanne Tise, eds., *Les Années UAM 1929–1958* (Paris: Musée des Arts Décoratifs, 1988). Edmond Fleg's essay on Chareau, "Nos Décorateurs: Pierre Chareau," appeared in *Les Arts de la Maison* 2 (Winter 1924): 17–27. Badovici was the editor of *L'Architecture Vivante,* an important voice of modernism. Chareau invited Badovici to a dinner for Paul Bernheim on December 11, 1927, at the Grand Hôtel in Tours, in the ultimately fruitless hope that Badovici would publish the lounge he had designed there; Pierre Chareau, letter to Jean Badovici, 5 December 1927, Badovici Collection, Getty Research Institute, Los Angeles, folder 1.

7. Gustave-Édouard Magnat, "Des Mots, des Mots, des Mots," graphological analysis of the participants in the La Sarraz Congress, undated typescript [June 1928], CIAM Archive, ETH Zurich. Magnat published the book *Poésie de l'Écriture* (Geneva: H. Sack, 1944). Le Corbusier, letter to Sigfried Giedion, 25 January 1929, CIAM Archive, ETH Zurich. Oscar Stonorov, letter to André Lurçat, 20 January 1929, Lurçat Archive, Cité de l'Architecture et du Patrimoine, Paris. Gabriel Guévrékian, letter to Karl Moser, 12 September 1929, CIAM Archive, ETH Zurich.

8. On the still-mysterious role of Bijvoet in the Paris project, see Jan Molema, "Maison de Verre/Zonnestraal: Un Relato de dos Edificios," *Cuaderno de Notas* 14 (Summer 2013): 98–132. See also the text by Bernard Bauchet and Brian Brace Taylor in the present volume.

9. Johannes Duiker, "Het Huis van Dr. Dalsace in de Rue St. Guillaume te Parijs," *De 8 en Opbouw* 4, no. 18 (September 2, 1933): 155–64. On Duiker's connection of the Maison de Verre to Moholy and Giedion, see Sigfried Giedion, *Bauen in Frankreich, Bauen in Eisen, Bauen in Eisenbeton* (Leipzig: Klinkhardt und Biermann, 1928), 22–23.

10. Paul Nelson, "La Maison de la Rue St-Guillaume," *L'Architecture d'Aujourd'hui* 4, no. 9 (November– December 1933): 9.

11. Pierre Vago, "Un Hôtel Particulier à Paris," *L'Architecture d'Aujourd'hui* 4, no. 9 (November– December 1933): 5–6.

12. F. G., "Exhibit Honors Perret, Master of Use of Concrete," *New York Herald Tribune* (May 21, 1950).

13. Julien Lepage [Julius Posener], "Observations en Visitant," *L'Architecture d'Aujourd'hui* 4, no. 9 (November–December 1933): 13, 15.

14. See his recollections in Julius Posener, *Fast So Alt Wie das Jahrhundert* (Berlin: Siedler, 1990).

15. Arthur Korn, *Glas im Bau und als Gebrauchsgegenstand* (Berlin: E. Pollak, 1929). On Eisenstein's film project, see François Albera, *S. M. Eisenstein, Glass House: Du Projet de Film au Film Comme Projet* (Dijon: Presses du Réel, 2009). Lonia Winternitz, "Glas/das Haus eines Arztes in Paris/Architekt: Pierre Chareau, Paris," *Wasmuths Monatshefte für Baukunst* (November–December 1931): 497–98. The caption of illustrations 17 and 20 in *Architecture Abroad,* reproduced from the technical magazine *Glaces et Verres,* is rather laconic: "Le Corbusier and several other architects have introduced glass blocks in residential architecture." See Pier Balter, "Steklo v Arkhitekture," *Arkhitektura za Rubezhom* 3, no. 6 (December 1936): 28–43.

16. André Wogenscky, ed., "Le Verre," *Techniques et Architecture* 5, nos. 3–4 (March–April 1944): 44–82.

17. Raymond Fischer, "Salon d'Automne," *L'Architecture d'Aujourd'hui* 2, no. 9 (December 1931–January 1932): 9. On Bossu see Xavier Dousson, *Jean Bossu* (Paris: Éditions du Patrimoine, 2014).

18. Paul Nelson, *La Maison Suspendue* (Paris: Albert Morancé, 1939).

Selected Bibliography

Badovici, Jean. *Intérieurs Français.* Paris: Éditions Albert Morancé, 1924.

———. "L'Espace et le Temps d'après Henri Poincaré." *L'Architecture Vivante* (Winter 1927): 17–20.

Bauchet, Bernard, and Marc Vellay. *La Maison de Verre: Pierre Chareau.* Edited and with photographs by Yukio Futagawa. Tokyo: ADA, 1988, 2002.

Bonney, Thérèse, and Louise Bonney. *Buying Antique and Modern Furniture in Paris.* New York: Robert M. McBride, 1929.

Brooke, James. "Trend-Setting Quonset Hut Is Demolished on L.I." *New York Times* (August 3, 1985).

Chareau, Dollie. "Maison d'Été pour un Peintre à Long Island." *L'Architecture d'Aujourd'hui,* no. 30 (July 1950): 51.

———. *My Father.* Pawlet, VT: Banyan, 1960.

———. "Pierre Chareau." *L'Architecture d'Aujourd'hui,* no. 31 (September 1950): vii.

Chareau, Pierre. "La Création Artistique et l'Imitation Commerciale." *L'Architecture d'Aujourd'hui,* no. 9 (September 1935): 68–69.

———. "'La Maison de Verre,' de Pierre Chareau, Commenté par Lui-Même." *Le Point: Revue Artistique et Littéraire* 2 (Colmar) (May 1937): 51–55.

———. *Meubles.* Paris: Éditions d'Art Charles Moreau, 1929.

Chavance, René. "Applications et Techniques Nouvelles du Verre: Architecture Décorative." *Art et Décoration* 61 (1932): 311–20.

Cinqualbre, Olivier, ed. *Architect Pierre Chareau: Architect of the House of Glass, a Modernist in the Time of Art Deco.* Tokyo: Shiodome Museum and Kajima Institute, 2014. In Japanese. Exhibition catalogue.

Cinqualbre, Olivier. *Pierre Chareau: La Maison de Verre, 1928–1933, Un Objet Singulier.* Paris: Jean-Michel Place, 2001.

Cinqualbre, Olivier, et al. *Pierre Chareau, Architecte: Un Art Intérieur.* Paris: Centre Pompidou, 1993. Exhibition catalogue.

Cogniat, Raymond. "La Maison de Verre de Pierre Chareau." *Art et Décoration* (February 1934): 49–56.

Dufet, Michel. "Deux Décorateurs Modernes Chareau et Lurçat." *Feuillets d'Art,* no. 1 (1921): 40.

Fleg, Edmond. "Nos Décorateurs: Pierre Chareau." *Les Arts de la Maison* 2 (Winter 1924): 17–27.

Frampton, Kenneth. "Maison de Verre." *Arena* (April 1966): 257–62.

———. "Maison de Verre." *Perspecta: The Yale Architectural Journal* 12 (1969): 77–126.

Futagawa, Yukio. "La Maison de Verre de Pierre Chareau et Bernard Bijvoet." *AMC: Architecture, Mouvement, Continuité,* no. 46 (December 1978): 27–43.

———. *Pierre Chareau: Maison de Verre.* GA Residential Masterpieces, series 13. Tokyo: Ada Edita, Global Architecture, 2012.

Gopnik, Adam. "The Ghost of the Glass House." *New Yorker* (May 9, 1994): 54

Gordon, Alastair. "Lost Houses, The End of an Era: Recalling Robert Motherwell's Landmark 1946 East Hampton Quonset Hut, Architecture by Pierre Chareau." *Architectural Digest* (October 2007): 134–41.

———. *Weekend Utopia: Modern Living in the Hamptons.* New York: Princeton Architectural Press, 2001.

Herbst, René. *Un Inventeur: L'Architecte Pierre Chareau.* Preface by Francis Jourdain. Translated by Dollie Chareau. Paris: Éditions du Salon des Arts Ménagers, 1954.

Hertzberger, Herman. "L'Espace de la Maison de Verre." *L'Architecture d'Aujourd'hui,* no. 236 (December 1984): 86–89.

"A House of Glass in Paris." *Architect and Building News* (April 1934): 40–43.

Janneau, Guillaume. *Formes Nouvelles et Programmes Nouveaux.* Paris: Bernheim Jeune, 1925.

Le Fèvre, Georges. "Déclarations de Quelques Décorateurs." *L'Art Vivant,* no. 12 (June 15, 1925): 28.

Lepage, Julien [Julius Posener]. "Observations en Visitant." *L'Architecture d'Aujourd'hui* 4, no. 9 (November–December 1933): 13–15.

"Le Verre." *L'Architecture d'Aujourd'hui*, no. 3 (January–February 1931): 64–72.

Mallet-Stevens, Robert. "Le Cinéma et les Arts, l'Architecture." *Les Cahiers du Mois,* nos. 16–17 (1925): 95–98.

———. *Le Décor Moderne au Cinéma.* Paris: Charles Meunier, 1928.

M. D. "Une Maison de Verre." *Glaces et Verres,* no. 17 (June 1930): 19–20.

Melis, Paolo. "Il Grande Vetro dell'Architettura." *Domus,* no. 640 (June 1983): 22–29.

Montès, Fernando. "La Maison de Verre de Pierre Chareau." *Beaux Arts Magazine,* no. 19 (December 1986): 62–67.

Moussinac, Léon. "Le Décor et le Costume au Cinéma." *Art et Décoration* (July 1926): 138.

———. *Le Meuble Français Moderne.* Paris: Hachette, 1925.

Nelson, Paul. "La Maison de la Rue Saint Guillaume." *L'Architecture d'Aujourd'hui* 4, no. 9 (November–December 1933): 9–11.

"Pierre Chareau." *L'Oeil,* no. 60 (December 1959): 97, 103–5.

"Pierre Chareau." *Mobilier et Décoration d'Intérieur,* no. 1 (November–December 1922): 27.

Pierre Chareau: Archives Louis Moret. Martigny, Switz.: Fondation Louis Moret, 1994.

Prevost, Marie-Louise. "La Première et Unique Maison de Verre Est Terminée." *L'Ami du Peuple* (October 29, 1931): 1.

Prist, Paul. "Une Curieuse Innovation: Le Béton Translucide." *Clarté,* no. 8 (August 1931): 12–14.

"Réalisations et Projets: Boudoir par Pierre Chareau." *Les Arts de la Maison* (Fall–Winter 1923): 46–48.

Répertoire du Goût Moderne. Paris: Albert Lévy, 1928–29.

"Robert Motherwell's Quonset House." *Harper's Bazaar* (June 1948): 86–87.

Rogers, Richard. "La 'Casa di Vetro' di Pierre Chareau: Una Rivoluzione Che Non Continua." *Domus,* no. 443 (October 1966): 8–20.

Roth, Alfred. "Maison de Verre, 31 Rue Saint Guillaume, Paris, 1931–1932." *Werk,* no. 2 (February 1965): 52–56.

Sedeyn, Émile. "La Décoration Moderne au Cinéma." *L'Art et les Artistes,* no. 20 (October 1921–February 1922).

Tallet, Margaret. "The Maison de Verre Revisited." *Architecture and Building* (May 1960): 52–56.

Taylor, Brian Brace. *Pierre Chareau: Designer and Architect.* Cologne: Taschen, 1992.

Tisserand, Ernest. "Chronique de l'Art Décoratif: La Chambre à Coucher, Le Métal." *L'Art Vivant,* no. 38 (July 1926): 536–39.

———. "Chronique de l'Art Décoratif: La Chambre à Coucher, pour Avoir Frais; L'Art Décoratif Au Cinéma." *L'Art Vivant,* no. 39 (August 1926): 585–88.

"Une Maison Française aux États-Unis." *Art et Décoration*, no. 27 (1952): 24–25.

Vago, Pierre. "Un Hôtel Particulier à Paris." *L'Architecture d'Aujourd'hui* 4, no. 9 (November–December 1933): 5–8.

Vellay, Dominique. *La Maison de Verre: Le Chef-d'Oeuvre de Pierre Chareau.* Paris: Actes Sud, 2007.

Vellay, Marc. "Agli Estremi del Mattone Nevada." *Rassegna,* no. 24 (1985): 6–17.

Vellay, Marc, and Kenneth Frampton. *Pierre Chareau: Architect and Craftsman, 1883–1950.* New York: Rizzoli, 1984, 1990.

———. *Pierre Chareau: Architecte-Meublier.* Paris: Éditions du Regard, 1984.

Verne, Henri, and René Chavance. *Pour Comprendre l'Art Décoratif Moderne en France.* Paris: Hachette, 1925.

"Visite de la Maison de Verre de Pierre Chareau, Commentée par Lui-Même." *Le Point* (May 1937): 51–52.

Winternitz, Lonia. "Glas/Das Haus Eines Arztes in Paris/Architekt: Pierre Chareau, Paris." *Wasmuths Monatshefte für Baukunst* (November–December 1931): 497–98.

Zervos, Christian. "Architecture Intérieure: Enquêtes." *Cahiers d'Art,* no. 1 (January 1926).

Contributors

The architect **Bernard Bauchet** is coauthor with Marc Vellay of *La Maison de Verre: Pierre Chareau* (Tokyo: ADA, 1988, 2002). He is an expert in technical conservation and restoration of modern architecture and has consulted on restorations of Chareau and Le Corbusier works, including the Maison du Brésil.

Olivier Cinqualbre, an architect and architectural historian, is chief curator of architecture at the Centre Pompidou in Paris. Cinqualbre has written numerous books on architectural history, including the monograph *Pierre Chareau: La Maison de Verre, 1928–1933, Un Objet Singulier* (Paris: Jean-Michel Place, 2001); he edited *Pierre Chareau, Architecte: Un Art Intérieur* (Paris: Centre Pompidou, 1993) and *Pierre Chareau: Architect of the House of Glass: A Modernist in the Time of Art Deco* (Tokyo: Panasonic Shiodome Museum, 2014).

Jean-Louis Cohen holds the Sheldon H. Solow Chair for the History of Architecture at New York University's Institute of Fine Arts. In 1997–2003 he developed the Cité de l'Architecture, a museum and research center that opened in the Palais de Chaillot, Paris, in 2007. During this period, he also directed the Cité's Institut Français d'Architecture and the Musée des Monuments Français. He has published widely on twentieth-century architecture and urban planning and has curated exhibitions at the Museum of Modern Art, New York; the Canadian Center for Architecture, Montreal; the Centre Pompidou, Paris; and other venues.

Esther da Costa Meyer is professor of modern architecture at Princeton University. Her published work has focused on issues of the interface of architecture and the other arts, and more recently on architecture and globalization. For the Jewish Museum she co-curated *Schoenberg, Kandinsky and the Blue Rider* with Fred Wasserman and coedited the catalogue of the same title (New York: Jewish Museum; London: Scala, 2003).

Robert M. Rubin is an independent curator and cultural historian. He is the coauthor, with Olivier Cinqualbre, of *Jean Prouvé: Maison Tropicale* (Paris: Centre Pompidou, 2011). He curated *Richard Prince: American Prayer at the Bibliotheque Nationale de France* (2011) and *Walkers: Hollywood Afterlives in Art and Artifact* at the Museum of the Moving Image in New York (2016), and edited both exhibition catalogues. He and his wife, Stéphane Samuel, acquired Pierre Chareau's Maison de Verre in 2005.

Kenneth E. Silver is professor of modern art at New York University, adjunct curator of art at the Bruce Museum in Greenwich, Connecticut, and a contributing editor to *Art in America* magazine. Among his publications are *Making Paradise: Art, Modernity, and the Myth of the French Riviera* (Cambridge, MA: MIT Press, 2001) and *Chaos and Classicism: France, Italy, and Germany, 1918–1936* (New York: Solomon R. Guggenheim Museum, 2011). For the Jewish Museum, most recently, he contributed the essay "Fluid Chaos Felt by the Soul: Chagall, Jews, and Jesus" to *Chagall: Love, War, and Exile,* ed. Susan Tumarkin (New York: Jewish Museum; New Haven: Yale University Press, 2012).

Brian Brace Taylor, an architectural historian and critic, is professor of history and theory of architecture at the New York Institute of Technology and a leading scholar on Pierre Chareau. He taught at the École d'Architecture de Paris–Belleville and was curator of drawings at the Fondation Le Corbusier, Paris. He has been an editor of several international architectural publications, including *L'Architecture d'Aujourd'hui* and *Mimar: Architecture in Development.* He has published numerous works on architecture, including *Pierre Chareau: Designer and Architect* (Cologne: Taschen, 1992) and *Le Corbusier: The City of Refuge, Paris 1929/33* (Chicago: University of Chicago Press, 1987).

Index

Italicized page numbers indicate illustrations.

abstract art, 90, 216, 218
Adler, Rose, 21, 26, 31, 34
L'Age d'Or (film), 26
Aluminaire House, 250
American Committee for Refugee
 Scholars, Writers, and Artists, 250
L'Amour de l'Art (magazine), 25
Anik, Djémil, 31, 94, 257n14, *262*
Antheil, Georges, 221n9
anti-Semitism, 36, 276
Aragon, Louis, 29
Architecture Abroad (journal), 276,
 281n15
Architecture and the Related Arts
 exhibition (1924), 93
L'Architecture d'Aujourd'hui, 271, 272,
 273, *275,* 276, *279*
architecture intérieure, 19. See also
 interior design
L'Architecture Vivante, 272, 281n6
L'Argent (film), 25, 26, 70, *71*
Arp, Jean, 215
Artaud, Antonin, 26, 221n9
Art Deco, 26, 94, 257n7
Art et Décoration (magazine), 25, 31
Art International d'Aujourd'hui, 94
artistes décorateurs or ensembliers, 16,
 19, 21, 63
Art Nouveau, 271
Art of This Century gallery, 257n8
Les Arts de la Maison (magazine), 25,
 31, *62–63, 66,* 90, *107, 162*
L'Art Vivant (magazine), 25
Atelier Martine, 26
Autant-Lara, Claude, 26
avant-garde, *18,* 21, 26, 31, 70, 181, 219,
 250, 256, 256n3, 273

Badovici, Jean, 272, 281n6; *Intérieurs
 Français, 63*
Ballets Suédois, 26
Balzac, Honoré de, 249
Banham, Reyner, 257n7; *The
 Architecture of the Well-Tempered
 Environment,* 250; *Theory and
 Design in the First Machine
 Age,* 250
Bauchant, André, 181, 215, 220
Baudelaire, Charles, "L'Invitation au
 Voyage," 16

Bauhaus, 27
Bayer, Herbert, *27*
Beaudouin, Eugène, 189n9, 271
Beauvallon. See Hôtel de Beauvallon
Beckett, Samuel, 255
Belle de Jour (film), 256
Benjamin, Walter, 187
Bernheim, Annie. See Dalsace, Annie
 Bernheim
Bernheim, Berthe, 219
Bernheim, Edmond, 29, 38n31, 219,
 257n14, *260–61*
Bernheim, Émile, 29, 257n14, *260–61*
Bernheim, Hélène, *17*
Bernheim, Madeleine. See Fleg,
 Madeleine Bernheim
Bernheim, Paul, 29, 58, 281n6
Bernheim family, 36
Bibliothèque Nationale, 276, *278*
Bifur (magazine), 36
Bijvoet, Bernard, 29, 38n32, 86,
 184–85, 187, 188n3, 189n9, 257n7,
 257n14, *261,* 273, 281n8
Blake, Peter, 251, 257n8
Börlin, Jean, 26, 221n9
Bossu, Jean, *279,* 280
Boulanger, Louise, 221n9
Boulevard Saint-Germain apartment
 (Paris), 29, *29*
La Boutique (Chareau's shop), *19,* 21,
 30, 76, 94, *102,* 219–20, 221n10
Brancusi, Constantin, 216
Braque, Georges, 21, 26, 215, 219, 220;
 Homage to J. S. Bach, 216, 218,
 221n6, *226, 228; Woman with a
 Mandolin, 239*
Breton, André, 29, 36, 256n2
Breuer, Marcel, *27,* 28, 251
Brignoni, Serge, 215, 220
Bucher, Jeanne, 21, 189n8, 219–20
Buñuel, Luis, 26, 256
Burkhalter, Jean, 21, 25, *74*

Cage, John, 250
Calder, Alexander, 249–50, 273,
 280, *280*
Campigli, Massimo, 215, 220
Cantine La Marseillaise, 249, *250,*
 256n3
Canudo, Ricciotto, 26
Carvallo, Esther (mother), 15, 34
Catelain, Jaque, 26, *73*
Cavalcanti, Alberto, 26, *73*

Chagall, Marc, 215, 216; *Praying Jew,
 20,* 151, *151,* 219, *241*
Chareau, Georges Adolphe Benjamin
 (father), 15
Chareau, Louise Dorothee Dyte
 (Dollie, wife): on art collection of
 Chareaus, 215–16, 218; Bernheim
 and Dalsace relationships, 29, 181,
 219; cushions and linens designed
 by, *32;* exhibition (1939), 39n40;
 furniture Pierre designed for, *140;*
 life of, 31–33; marriage, 15; New
 York life of, 249; photograph of,
 16; on Pierre as architect, 38n31;
 on Pierre's early life, 15; on Pierre's
 employment at Waring and
 Gillow, 86; portrait of (Power), *33;*
 reminiscing after Pierre's death, 34;
 selling artworks during and after
 World War II, 216, 219, 220, 221n6,
 242; as translator, 31, 39n41; during
 World War II in France and later
 departure, 36
Chareau, Pierre: as architect, 38n31,
 85–86, 89, 94, 173, 249, 257n14;
 art collection of, 215–21, 224;
 bust of (Orloff), 219, *231;* career
 of, 85, 173–76; Catholicism and,
 34; critical appreciation of,
 89–90, 93, 97n13; death of, 249;
 difficulty in classifying work of,
 85–86; early life of, 15; film and,
 25–26, 219; financial troubles of,
 28, 219; on the future and design
 of dwellings, 96n9; influences
 on, 16, 86, *146,* 215, 218, *218;*
 International Congresses for
 Modern Architecture (CIAM)
 role of, 273; Jewish roots of, 34;
 Légion d'Honneur received by, 94;
 marriage, 15; New York apartment
 of, 221, *243;* Paris apartment of,
 26, 31, *214,* 216, *226;* patronage,
 28–32, 36, 86; personality of,
 85–86, 175; photograph of, *214,*
 216; as rationalist, 25; salon of
 and L'Oeil Clair, 31, 38n25, 189n8,
 224; selling artwork during and
 after World War II, 249; signature
 style of, 16, 25, *63,* 89, *92,* 93, 177;
 in United States, 36, 85, 168, 220,
 249–57, 256n1; U.S. exhibitions of
 furniture and metalwork, 37n15;

Waring and Gillow employment,
 15, 86, 173; World War II departure
 from France, 34, 36, 85. See also
 Chareau, Louise Dorothee Dyte
 (Dollie, wife); Hôtel de Beauvallon;
 La Boutique; Maison de Verre;
 Maison "Pièce Unique"; Motherwell
 house; Vent d'Aval villa
Chinese furniture, *128*
CIAM. See International Congresses
 for Modern Architecture
cinema. See film
Citroën, 16, *76*
La Ciutat y la Casa (magazine), *23,* 25
Claudel, Paul, 25
Clute, Eugene: *The Treatment of
 Interiors,* 25
Cocteau, Jean, 26
Cogniat, Raymond, 86
collage, 218, 256. See also Gris, Juan;
 Picasso, Pablo
Comédie Française, 31
Compagnie Parisienne
 d'Ameublement, *28*
Congrès International du Cinéma
 Indépendant, 26
Congrès Internationaux d'Architecture
 Moderne. See International
 Congresses for Modern
 Architecture
Coopérative Internationale du Film
 Indépendant, 26
Cubism, 215, 216, 218, *218,* 219, 220,
 257n16

Dada, 216
Dalbet, Louis, 19, *20,* 28, 36, 48, 94,
 97n16, *102,* 130, 168, 184–87, 188n3,
 209, 220, *232, 234*
Dalsace, Aline, 181, 188
Dalsace, Annie Bernheim, 29, *29,* 31,
 86, 175–76, 181, 187, *203,* 219, *233;*
 Lipchitz's bust of, 175, *210,* 219,
 244–45. See also Maison de Verre
Dalsace, Bernard, 181
Dalsace, Jean, 29, *29,* 86, *86–87,*
 175–76, 181, 187, 193, 218, 219, *245.*
 See also Maison de Verre
Dalsace, Robert, *35,* 37, 39n61, *136, 167*
Dalsace family, 36, 38n24, *65,* 89,
 96n1, 175, 180–81, 187, 189n8, 193,
 218, 221n6, *233,* 249. See also
 Maison de Verre

Credits and Permissions

The photographers, sources of visual material other than the owners indicated in the captions, and copyright holders are listed below. Every reasonable effort has been made to supply complete and correct credits; if there are errors or omissions, please contact Yale University Press or the Jewish Museum so that corrections can be addressed in any subsequent edition. Material in copyright is reprinted by permission of copyright holders or under fair use. Images may be listed in more than one location.

Photograph © Laure Albin-Guillot, CNAC / MNAM / Dist. RMN-Grand Palais / Art Resource, NY: **14.** Architecture and Design Study Center, Museum of Modern Art / digital image © Museum of Modern Art / licensed by SCALA / Art Resource, NY: **22, 30 top, 32 right, 45 top right, 48, 51–55, 57, 60 bottom, 62 left, 71, 72 bottom, 86 bottom, 102, 134, 136 top and bottom, 140 bottom right, 146, 149, 150, 151 left and right, 156, 157 top and bottom, 214, 226, 232, 234, 236, 238, 242, 260 top, 261, 266.** Archives Center, Behring Center, National Museum of American History, Smithsonian Institution, Washington, DC: **24.** Archives de la Ville de Paris: **182–83.** Artcurial / S. Briolant, courtesy of Chana Orloff Association, Paris: **231 left.** Artwork © Artists Rights Society (ARS), New York / ADAGP, Paris: **228 top, 239, 241, 243 left, 277.** Bernard Bauchet: **178 bottom, 186, 187, 203 bottom.** Bauhaus-Archiv Museum für Gestaltung, Berlin: **27.** John Blazejewski, Marquand Library, Princeton University: **23, 62 right, 63, 64, 65 top and bottom, 66, 107, 112, 162 bottom.** Fabrice Boissière: **218 left.** Photographs by Thérèse Bonney © Bancroft Library, University of California, Berkeley: **29 left, 45 bottom left, 56, 58, 59 top and bottom, 60 top and bottom, 61, 79, 82, 83, 88 top, 126, 127, 135 top and bottom.** bpk, Berlin / Pinakothek der Moderne, Bayerische Staatsgemaeldesammlungen, Munich / Art Resource, NY: **239.** Brooklyn Museum Libraries: **248, 253.** Bundesarchiv Koblenz: **35 top.** Photograph © Christie's Images / Bridgeman Images: **10, 12, 104, 108–9, 111, 114, 118, 121, 124, 125, 129 bottom,**

130 left, 131, 138 left, 139, 140 top left, 152–55, 161 left, 247. Cinémathèque Française, Paris: **70, 72 top, 73.** CNAC / MNAM / Dist. RMN-Grand Palais / Art Resource, NY: **117 left, 184 bottom.** Jean Collas: **179, 209, 210 bottom.** Ken Collins, courtesy of Galerie Vallois, Paris: **6, 100, 116, 132, 133, 143 left and right, 161 right.** Gianni Dagli Orti / Art Archive at Art Resource, NY: **158 bottom.** Artwork © Dedalus Foundation, Inc. / Licensed by VAGA, New York, NY: **246 top left and bottom right, 247.** Photograph © Charles Delepelaire, Musée d'Art Moderne / Roger-Viollet: **119.** DeLorenzo Gallery, New York: **130 right.** Photograph by Matt Flynn, Cooper Hewitt, Smithsonian Design Museum, New York / Art Resource, NY: **77, 78, 80.** Frelinghuysen Morris House and Studio, Lenox, Massachusetts: **237 bottom.** Photograph by Travis Fullerton, image © Virginia Museum of Fine Arts, Richmond: **101, 103.** Photograph Yukio Futagawa, courtesy of Yoshio Futagawa / GA Photographers: **Front cover, 2, 145, 178 top, 190, 196–202, 203 top, 205–7, 211, 212.** Galerie Anne-Sophie Duval, Paris: **105, 162 top.** Galerie Karsten Greve, Cologne: **106, 120, 137.** Getty Research Institute, Los Angeles: **274, 275, 279 top and bottom.** Photograph © Alastair Gordon / Gordon de Vries Studio: **267, 269 bottom left.** Grand Hôtel Tours: **58, 59 top and bottom, 60 top and bottom, 61.** gta Archives / ETH Zurich (CIAM archives): **272.** Paul Hester: **217.** Mitro Hood: **225.** Photograph © Estate of André Kertész / Higher Pictures: **214, 226.** Kharbine-Tapabor / Art Archive at Art Resource, NY: **43.** Paolo Kind, London: **167 top.** Photograph by Walter Klein, bpk, Berlin / Kunstsammlung Nordrhein-Westfalen, Düsseldorf / Art Resource, NY: **240.** Les Arts Décoratifs, Paris: **17 bottom, 28 left and right, 32 left, 34, 42, 49 top and bottom, 50, 87 top, 95, 110 bottom, 158 top, 168–70, 171 top and bottom, 235.** Les Arts Décoratifs, Paris, De Agostini Picture Library / Bridgeman Images: **141 top.** Artwork © Estate of Jacques Lipchitz: **229, 230 left and right, 231 right, 233 bottom left and top right, 235, 243 right, 244.** Mark Lyon: **193, 204, 208, 213 top left.** Photograph by Georges Meguerditchian, CNAC / MNAM /

Dist. RMN-Grand Palais / Art Resource, NY: **138 right, 164, 165, 166 top left and bottom right.** Photograph by Marion Mennicken, Rheinisches Bildarchiv, Cologne: **110 top.** Ministère de la Culture / Médiathèque du Patrimoine, Dist. RMN-Grand Palais / Art Resource, NY: **56, 82, 83, 127, 135 bottom.** Artwork © Successió Miró / Artists Rights Society (ARS), New York / ADAGP, Paris: **33 right.** MOMAT / DNPartcom: **142.** Artwork © Mondrian / Holtzman: **18.** Musée d'Art Moderne / Roger-Viollet: **237 bottom right.** Digital image © Museum of Modern Art / licensed by SCALA / Art Resource, NY: **224 bottom left, 227, 228 top, 280.** Photos 12 / Alamy: **277.** Artwork © Estate of Pablo Picasso / Artists Rights Society (ARS), New York: **216, 217, 227, 228 bottom.** Photograph by Bertrand Prévost, CNAC / MNAM / Dist. RMN-Grand Palais / Art Resource, NY: **84 right, 144, 147, 159 left and right, 160.** Princeton University: **17 top, 20, 29 right, 172, 177 left, 270.** Department of Rare Books and Special Collections, Princeton University Library, Pierre and Dollie Chareau Collection, box 1: **16.** Rare Books and Special Collections, University of Sydney: **33 left.** RIBA Collections: **19.** Barney Rosset Estate: **254, 255 top left and bottom right, 263–67, 269 bottom left and top right.** Miguel Saco Furniture and Restoration, Inc., New York: **163.** Lee Stalsworth: **230 left and right.** Brian Brace Taylor: **88 bottom left and bottom right, 177 right, 178 bottom, 179, 182–87, 203 bottom, 209.** G. Thieret: **210 top.** Jacques Vassuer: **88 bottom left and bottom right, 122, 123.** Victoria and Albert Museum, London: **74, 75 top.**

Museum Accession Numbers, by Page
Endpapers and 75 bottom, 84 left: Art Institute of Chicago, Grace R. Smith Textile Endowment, 1992.384. **14, 84 right and 159, 165, 166 top left, 166 bottom right:** Musée National d'Art Moderne, Centre Georges Pompidou, Paris, AM1988-671, AM2008-1-105, AM1999-1-141, AM1999-1-140(1), AM1999-1-140(2). **27:** Bauhaus-Archiv Museum für Gestaltung, Berlin, 6751/2. **35 top right:** Bundesarchiv Koblenz, Album B 323-311-80. **77,**

78, 80, 81: Cooper Hewitt, Smithsonian Design Museum, New York, 1930-21-1-f, 1930-21-1-c, 1930-21-1-d, 1930-21-1-e. **95, 168, 169, 170, 171 top and bottom:** Musée des Arts Décoratifs, Paris, reversement de la Bibliothèque des Arts Décoratifs, 2010, CD 2941, CD 2942.4, CD 2942.5, CD 2942.3, CD 2942.8, CD 2942.6. **101, 103:** Virginia Museum of Fine Arts, Richmond, Gift of Sydney and Frances Lewis, 85.96, 85.95. **164:** Musée National d'Art Moderne, Centre Pompidou, Paris, Julie Ullmann bequest, 1998, AM1999-1-138. **217:** Menil Collection, Houston, V 819. **225:** Baltimore Museum of Art, Saidie A. May Bequest, BMA 1951.343. **227:** Museum of Modern Art, New York, Gift of Donald B. Marron, 48.1985. **228 top:** Museum of Modern Art, New York, The Sidney and Harriet Janis Collection, acquired through the Nelson A. Rockefeller Bequest Fund and the Richard S. Zeisler Bequest (both by exchange) and gift of Leon D. and Debra Black, 544.2008. **228 bottom:** Solomon R. Guggenheim Museum, New York, 38.540. **229:** Hood Museum of Art, Dartmouth College, Hanover, New Hampshire: Purchased through the William B. and Evelyn A. Jaffe Fund, S.965.13. **230 left:** Hirshhorn Museum and Sculpture Garden, Smithsonian Institution, Washington, DC, Gift of Joseph H. Hirshhorn, 1972, 72.178. **230 right:** Hirshhorn Museum and Sculpture Garden, Smithsonian Institution, Washington, DC, the Joseph H. Hirshhorn Bequest, 1981, 86.3052. **237 top:** Frelinghuysen Morris House and Studio, Lenox, Massachusetts, FAP8.18. **237 bottom:** Columbus Museum of Art, Ohio, gift of Howard D. and Babette L. Sirak, the Donors to the Campaign for Enduring Excellence, and the Derby Fund, 1991.001.019. **239:** Bayerische Staatsgemäldesammlungen, Munich, 13824. **240:** Kunstsammlung Nordrhein-Westfalen, Düsseldorf, 1018. **241:** Kunstmuseum Basel, Sammlung Im Obersteg, Im Obersteg Foundation, permanent loan to the Kunstmuseum Basel, Im 1084. **243 right:** Cleveland Museum of Art, John L. Severance Fund, 1995.212. **244:** University of Arizona Museum of Art, Tucson, Gift of the Jacques and Yulla Lipchitz Foundation, 1979.023.059.